WHY

PLOT NEVER MATTERS

Telling the screen stories in your heart

W. REED
MORAN

Kendall Hunt
publishing company

Cover image © Shutterstock, Inc. Used under license.

Kendall Hunt
publishing company

www.kendallhunt.com
Send all inquiries to:
4050 Westmark Drive
Dubuque, IA 52004-1840

Copyright © 2015 by W. Reed Moran

ISBN 978-1-4652-8173-9

Printed in the United States of America

To Cathy:

Loving and supportive best friend, wife,
and mother of our three children.

CONTENTS

ACKNOWLEDGMENTS

First, I would like to thank Ryan L. Schrodt, Senior Project Coordinator at Kendall Hunt Publishing, for his guidance, patience, and encouragement on this project all the way from "FADE IN" to "FADE OUT." I would also like to thank John V. Coniglio, Senior Managing Editor, for giving me the trust and creative freedom necessary to express my original ideas regarding the theory and practice of screenwriting contained herein.

This book would not have been possible without the editorial assistance of my middle daughter, Kelly Moran, or without the critical eye of editor and life-long friend, George Bain. I also benefitted immensely from the religious knowledge and wisdom of friend and former student Matt Hodges. I am also grateful to Tom Horvath for suggesting the title of this book.

I want to thank the mentors who both taught and supported me in my youthful dream to pursue the writing life. I am only one of the many students who owes his creative career to the late, great English teachers Fred Tremallo, Rod Marriott, and Charlie Terry at Phillips Exeter Academy. I also credit the late Noel Perrin at Dartmouth College for his kindness and for setting the example that creative writing can and should be approached as a lifelong journey. I can only hope to have part of the impact they had in their teaching careers.

While a writer's life is often a solitary one, I have been blessed by never having to walk this path alone. Close friends and writers Brian Lane, Tom Blomquist, Casey Kelly, Mick Kleber, Grant Moran, Jim Polianites, Herbie DiFonzo, Pat Bonavitacola, Steve Ellis, Ryan Dixon, Jack Brebbia, Ted Mooney, Adrian Mazcote, Allan Tolkoff, producer Stew Lyons, and the late Mike Piller all have contributed to my sanity throughout my creative development in ways that have been and continue to be invaluable.

I also thank the faculty and staff at Cal State Long Beach for their support of my teaching methods outlined in this volume. I particularly thank

Donna Thomas, coordinator of the Film & Electronic Arts Department, for her essential contribution to making this book possible.

Finally, I would like to thank my family for allowing me to quit my safe and sensible legal career to pursue the uncertain life of an ink-stained wretch. None of my accomplishments would have been possible without the love and support of my father, Bill Moran, my late mother Judith, my brothers Dick and Grant, my wife Cathy, and my daughters Katie, Kelly, and Glenna. I would never have had the courage to speak my emotional truths without you.

PREFACE

This book is designed to fill a significant and widely ignored gap between the theory and the practice of screenwriting. Its approach is equally applicable to all modes of writing popular fiction, including movies, television, novels, and stage plays.

In the course of thirty years of professional writing and teaching, I have read and evaluated the most popular books on the subject of screenwriting and creative writing in general. What I found lacking in almost all instances was a guide to helping new writers both discover their personal artistic voice and learn the overlooked creative methods all professional screenwriters actually use to build their stories.

In my experience, creative voice and thematic structure are the most important elements to master in order to break into the business and to distinguish oneself as a professional writer. New writers only searching for a quick and dirty "cook book" of objective elements and checklists as a magical means of achieving professional writing success may find themselves disappointed by this approach. But this is not how art works, even the commercial art of show business.

Instead, new and aspiring writers of all backgrounds must first come to understand who they are as artists: their worldview, their core beliefs, and the hard-earned lessons they've learned on the rocky road of life, before they start writing. Only then can a writer begin to learn to structure a unique and compelling story.

And as demonstrated in this book, professionally written stories are built around a theme or life lesson, and are never structured through a primary focus on plot.

This concept is initially counterintuitive, I know.

Most people who watch movies and television feel they are following the external events (plot) of a story. But it is my contention that what viewers respond to emotionally, whether they are aware of it or not, is the worldview and the personal life lessons the writer wants to share

with the audience. And the most important undisclosed fact in almost all books on screenwriting is that Hollywood readers, agents, and executives also evaluate all scripts in terms of character and theme, not on the familiar, overused series of external events that constitute the plot of a story.

Thus, in attempting to create an original story idea, it is essential to know that while plot archetypes are extremely few and limited, stories based on character and theme are infinitely variable.

This book explains how and why writing from the perspective of plot is creatively constricting, derivative, superficial, and therefore almost never leads to a sale. Instead, I take the reader on a journey of self-discovery, one that reveals the core beliefs and life lessons that constitute the unique creative voice of every writer. Then, in later chapters, we apply my original writing model designed to create thematically meaningful stories from the inside out.

Trust the process. When you write about the life lessons in your heart, plot will naturally follow. Not the other way around.

Welcome to the path of creating fiction that all professional fiction writers tread, whether or not they disclose it to the general public.

You're now on the inside track. Time to start your journey of self-discovery, and to create the successful stories only you can write.

W. Reed Moran
Los Angeles, CA—November 2014

1

WHY PLOT NEVER MATTERS

This book contains a new and bold theory of screenwriting—that plot truly never matters in the creation of your story. In fact, it's my contention that writing a story from the point of view of plot is the secret enemy of all good writing.

And this is especially the case for new writers struggling to discover what story they want to tell, and how and why they want to tell it.

Why?

It's been my experience as a screenwriter and teacher over three decades that focusing on plot—the series of external events in a story—distracts young and new writers from the heart and soul of what they want to say, and why they wanted to write in the first place.

Worse yet, thinking of a story solely in terms of plot (action) seduces and entangles the writer into writing a series of meaningless, if splashy, melodramatic events haphazardly strung together with no more purpose than the events themselves.

The inevitable, fatal, effect of this approach to writing is that the big, dramatic series of events don't make any sense as a whole, don't honestly engage the audience emotionally, and the story ends up making no sense. Yes, watching an alien spaceship vaporize the White House is visually compelling, but only for about five seconds. What's missing is the emotional/thematic point to the scene.

In our own writing, we want to avoid bombarding the audience with only superficial exciting events, which taken together still don't satisfy as a coherent story.

Again, why?

Story is not a string of exciting events ultimately unrelated to each other, as if it were an amusement park ride.

This is the first and most important lesson a new writer must learn. And it is the most difficult because it goes against the grain of what new writers hope and pray will make their story sell.

My point is there has to be a reason for telling the stories we choose to write—and that reason (theme/life lesson) should serve as our main creative goal when thinking about what we hope to communicate, as well as how to approach organizing and writing our projects.

And that's how new writers break into Hollywood. By creating an emotionally compelling life lesson their protagonists come to believe in and act upon.

Trust me on this.

But everyone in the world thinks of story as a plot, right?

No. Not most professionals. And not this book on screenwriting.

Then what's the right approach to building a compelling, emotionally honest story that succeeds in captivating its audience and is also commercially viable?

The secret of all professional writers is they write from theme and character. Not from plot, or exterior action.

Always start with theme—the truth or life lesson you are trying to convey and illustrate through the course of the script. And then as you write, rely on theme as the true north of your internal, emotional compass. The plot will follow naturally and believably.

The story will then take your characters on a journey from ignorance of the life lesson, to embracing your theme and incorporating it into their new, reevaluated lives.

Again, trust me on this. Writing from theme and character is what the pros do, and it's the approach that ultimately leads to a sale.

And this book is designed to show you exactly how to do it.

That's the point in a nutshell. Story is a character's journey from a flawed set of beliefs and actions, to incorporating new, specific values you want your character and the whole world to affirm as better or more meaningful.

What we're talking about here is writing from the heart. But how do new writers find those important, meaningful stories buried deep inside themselves?

The most important problem new writers encounter is the question of what to write about and why.

And the answer to that question should never start with a cool, hip, high-concept plot idea. It should begin with an introspective examination of what aspects of life a writer has been personally struggling to resolve.

These are the internal problems that both challenge us and show us the path to changing our core beliefs in a way that matures us into new, more compassionate and courageous human beings.

So storytelling is about sharing the lessons you've picked up along the way down the bumpy road of life. Even if it's a comedy. It's OK if you don't have the answers to some of your life problems yet—the goal is to recognize them and your struggle.

That's the first step, addressing what aspects of life are most important to you. From there, you can see possible solutions, and that naturally becomes the point of your story.

Pick a solution to an issue that's bedeviling you now or a solution that you have learned and already resonates within you and write that into your story. It will then more easily become your story. And trust yourself—no one has a better handle on your life than you do. The answers, when they come, are not only personally meaningful, but important to all of us, as we share our common humanity.

So this book explains how to write from a values-based approach, as opposed to the nearly ubiquitous practice of trying to write exciting, whiz-bang comic book stuff that just happens.

It's essential to learn from the beginning that plot is never interesting or meaningful on its own. It needs more. It needs your take on life, your core beliefs, what you believe is most important for your audience to learn about themselves and others.

Why this radical upending of a writer's approach to writing fiction?

Not only are bare events (plot) devoid of any inherent meaning (meaning comes from people's reaction to the events in their lives), but there is the conundrum that any plot a writer comes up with has been told many times before.

And it is often the case that it's been done by famous, immensely talented storytellers from Shakespeare to biblical authors, to those prominent in pop culture.

So how do we go about writing anything new?

The answer is best told as a story in itself. I was once asked by Disney to come up with a sequel to one of its most successful family movies.

The executive claimed that Disney had spent millions of dollars and years of work attempting to ferret out every story (plot) that had ever been told. The answer, I was told, is that they had determined how many stories exist—between twenty-eight and thirty-five!

Now the question was clear—how could I come up with a new story for the sequel of their movie? I understood the challenge: Don't pitch this executive a plot—he and the rest of the studio have already heard them all, over and over.

Then the executive upped the stakes by stating that he had reduced the number of possible stories to only two: "A man goes on a journey, or someone comes to visit." And he was speaking only in half jest. He was right, and how could I come up with something they hadn't already considered and dismissed?

My first reaction was to agree with him further. I said I could reduce the number of stories to one: "Whoever comes to visit had to go on a journey to get there." Now I was speaking in half jest, too.

So what was the point of all this intellectual jousting between two professional storytellers? Simple. Crucial to Disney's massive success was the deep understanding that it's never plot that matters. How could it, with so few plots capable of being written, as they had discovered in their research?

And this is where the point comes around to the thesis of this book. While plot archetypes are few, and reused over and over, the solution to creating new, original stories lies elsewhere.

But where?

The answer lies in two arenas—character and theme/life lesson.

There are billions of people in the world, each of them unique in behavior and worldview. The number of characters one could write about is virtually limitless. And the number of life lessons they could learn to apply to their character flaws is in the thousands, if not much more.

Putting theme and character together as the central variables in the creation of a story even creates a multiplier effect. The total number of potential stories can be seen as the number of potential characters multiplied by the number of themes.

And with this understanding comes the realization that we are not boxed in repeating the same stories told by others. We're suddenly free to talk about character and life lessons from our individual points of view, in a way no one else ever has before.

And that's because only we have lived our own particular internal and external lives—and thus we each have a unique perspective on life in general and on what is most important to us to believe and why.

So anything you write from your personal point of view and personal truth is destined to be original. No one can say, feel, or write about issues in life the same way as you do.

Ever.

This is true as long as you resist the (sometimes strong, occasionally inevitable) temptation to build your stories based on what happens externally in the world.

Instead, from the beginning, work with your core beliefs and take your character on an emotional, internal journey to overcome false and hurtful beliefs and obtain the wisdom you, the author, already have learned and consider important to share with the world.

That way, in a very real sense, your fiction will serve as an emotional proof of the point you're trying to make—and therein lies the chance to connect and to have your beliefs resonate with your audience.

Your worldview, extrapolated from your personal experience, is the fuel and substance of your original writing. Good original stories are both unique to the author's experience and beliefs and share in the common predicaments of all mankind.

And when your core beliefs are able to be shown in the context of writing a script, you not only can make human connections, but you also invite your audience to participate in your vision of your central values the story contains.

And that leads directly to writing stories that sell.

Most importantly, this is how all professional writers construct their stories, from the inside out. What screenwriters have to say about life—and how they decide to say it—becomes the focus, purpose, and goal of the writing life.

And then plot—the often myopic, surface-level obsession with external action—slowly and naturally fades away as a critical consideration (and a prison). This is because the characters' actions (the plot) are now the result of each step on the path to the realization of a new self, a new set of values, which constitute the essential elements of your theme.

The purpose of this book is to show you how to write compelling stories (drama, comedy, tragedy, satire) starting with the life lesson you want to illustrate.

And doing this requires creating (but not necessarily telling) a story structure *in media res*—from the middle of the personal crisis your character is going through.

The concept of *in media res* was first articulated in 13 BCE in *Ars Poetica*, written by the Roman poet Horace. Horace noted that this literary

technique has roots that go back to the *Iliad* and the *Odyssey,* first told in an oral traditions dating back to the ninth century BCE.

And while this technique often entails telling the story from the mid-point crisis, with flashbacks, exposition, and non-linear narrative, this is not always the case.

And it's dangerous! Especially for new writers.

Instead, for the purposes of this book, the concept of *in media res* is essential for writers during the planning process to determine both how and why their story needs to be told.

Simply put, it's a great way to discover the theme or life lesson of a story.

But new writers should never use flashbacks or non-linear storytelling techniques in the actual writing of their scripts.

That's because their stories almost inevitably become clunky and obvious, or completely confused. Worse yet, flashbacks in the hands of new writers stop the story in its tracks, leaving the audience behind, suddenly eager for some popcorn or a bathroom visit.

More on this later.

For now, just know that I've never read a student script that didn't crumble under its own weight when written with blithely written flashbacks and endless exposition—the factual information the audience needs to know to make sense of the story or scene.

Flashbacks are a creative poison new writers use to prop up a meaningless story. And it's an obvious impediment to the reader's or viewer's understanding of the forward motion of any story.

But movies that employ *in media res* in execution as well as story planning do exist, not that I would encourage new writers to copy this structure. Examples include crime thrillers such as *The Usual Suspects* and James Bond films.

We must recognize that writing scripts using flashbacks and non-linear storytelling is using an advanced technique, and even then those scripts do not always succeed.

Thus for our purposes, using the concept of *in media res* is essential when outlining and discovering the theme/life lesson of a new story.

But then the new writer must learn how to take that realization, and turn it into a three-act structure, with a traditional beginning, middle, and end told in a linear fashion.

The point is to start creating your story from the high point of crisis, thereby uncovering the theme instead of the plot.

Give your character an honest choice at the end of act two to learn and believe in your theme/life lesson, or fail to learn it, leading then to what would be considered a tragic ending.

Then start writing your story from beginning to end, without the crutch and resulting confusion of leaning on flashbacks and exposition.

This concept of discovering theme at the high point of emotional crisis is essential to understanding and outlining commercially recognizable stories that sell.

It is equally important to avoid flashbacks and pure exposition in the actual writing of your story.

So at one point should we begin the actual writing of our stories?

The character's main flaw. Always. Start with showing the main flaw in our protagonist's view of life and resulting dysfunctional behavior.

We all are captivated by a particular personal flaw that's presented to us in the beginning of a well-written story. That's because we are in some sense witnesses in our own lives to similar problems either in ourselves or in other people we know best.

Simply put, we can relate the story's characters.

And our attention stays riveted as the story unfolds, because, if written well, we see how and why the characters overcome their limited, erroneous worldviews and grow to incorporate a deeper understanding of themselves and life's most pressing issues.

In the process of viewing or reading the story, we also come to understand the power and possibility of changing our own limited, flawed selves. We finally feel and believe in the importance of the existential

demand of discarding our self-deluded and self-constricting beliefs in favor of a more wise and compassionate way of thinking and behaving.

That is both the path and the purpose of writing fiction—to change how we all view the world and our place in it.

So, before writing "FADE IN:" how do we go about embarking on this particular, if counterintuitive, all-important creative path?

That is the purpose of the rest of this book.

We start with some exercises designed to elicit our core beliefs and then reflect on the problems, contradictions, and tensions of our view of ourselves and the world. Through this process, we also discover the hardearned personal values that have worked well for us, often after a long period of suffering and confusion.

All well-written stories start with a writer's belief in how the world and the people in it should act and how to make it a reality. They also address how we should best react to the inevitable slings and arrows of outrageous fortune that we can't change.

But storytelling all starts and ends within the mystical, uterine walls of theme. When your life lesson permeates every line and constitutes the path of your character's growth, you never have to worry about plot.

Not that writing from theme is writing without structure. I present a universal, all-encompassing structure to values-based screenwriting (and novel and playwriting) later in this book. But it's a structure firmly grounded on the emotional journey, not on a series of dramatic plot points.

Plot will then follow as a natural effect of your character's internal conflict and need to grow. And thus plot should never be determined beforehand when first approaching your story.

Plot is secondary, and I can't emphasize this enough.

Plot should be thought of as the natural result of the choices your character makes each step along the way of a quest to learn your theme or life lesson.

Thus plot is only the vessel that holds and illustrates what you want to say as an artist.

In the screenwriting world, this vessel (the external events in your story) is called the "A" story. What values you personally want to convey to your audience, what your protagonist comes to believe or understand, is referred to as the "B" story.

Don't put the cart before the horse, as most new writers do, and lead from plot, or the "A" story. Plot is always a seductively convenient trap for new writers and must be consciously avoided when approaching every writing session on a daily basis. Why? Because plot, in and of itself, has no personal, interior meaning. The meaning of a story must be dragged out of your subconscious, expressed overtly and put on the page with confidence that the story is going in the right direction.

And, in case you were wondering, the struggle to avoid being drowned by plot doesn't necessarily get any easier with experience. Only the conviction that plot is never the answer grows stronger with practice.

In essence, plot is a drug that makes new writers think they are on an interesting important path to storytelling, when in fact they are fooling themselves (but not the audience) into creating a failed, incoherent narrative.

If a story is plot-driven, it never has a chance of resonating with the audience. The audience members might not be able to say what's missing, but their interior compass of the heart will tell them that the story leaves them cold.

What's missing?

Plot-driven stories end up being junk food for the soul. So while some stories will sell that are all "A" story action (pick any youth-oriented, action, summer, comic-book movie), it's not a method on which you want to bet your future career.

Screenwriters are recognized and hired for their ability to write stories with a well thought out "B" story that illustrates the writer's theme/life lesson.

The truth is that Hollywood studios and production companies are desperately looking for new writers—but only writers who can both understand and deliver a solid, thematically based "B" story.

OK, we know that a story isn't just plot. But how do we recognize we're on the right path?

When you let the character lead the action instead of having the action lead the character, you're on solid creative and thematic ground. And while seemingly simple, this is the most difficult creative point for new writers—trusting and understanding their thematic approach to writing.

Yes, writing from the point of view of character and theme still involves plot points and a solid, universally recognized structure.

We'll get around to that. Just be prepared—a values-based structure has rules of its own, and new writers come to discover it's not what they originally, instinctively thought that structure looks like on the page.

But right now let's work on how to start thinking about what kinds of stories you want to tell, and why.

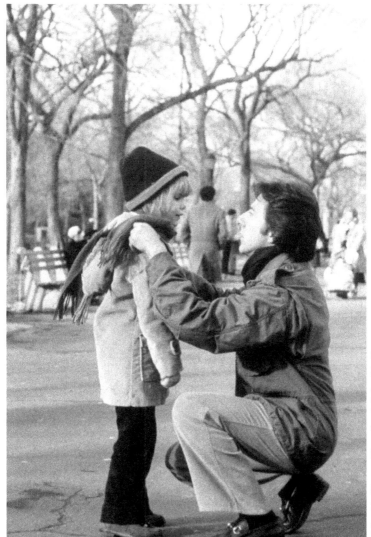

Columbia Pictures/Photofest © Columbia Pictures

Kramer vs. Kramer

Ted Kramer (Dustin Hoffman) is a workaholic advertising executive whose neglected wife Joanna (Meryl Streep) leaves him and their young son. Over time, Ted learns to sacrifice his career in favor of becoming a loving and devoted father. Joanna returns to New York after 18 months, and after initially winning custody of their child, learns that her ex-husband has changed, and finally offers to let their son live with his father.

2

THE TROUBLE WITH MOST "HOW TO" BOOKS ON SCREENWRITING

So, you've been bitten by the bug. Something has put the nagging thought in your mind that you want to write great stories for the screen.

Great. That's what we're here for.

Welcome to the incipient swells of passion and pangs of frustration inherent in the tempestuous life of having a creative calling, or vocation in the original sense of the word.

Dorothy Parker quipped that the two greatest things one could do for fresh, new writers is first to give them a copy of *The Elements of Style* and, second, to shoot them while they're still happy.

Writing fiction, let us be clear, is not for the faint of heart.

If you think the professional writing life relies on unpredictable lightning bolts of inspiration or boring memorization of endless objective creative writing checklists in some textbook—beware.

The good news is that neither extreme of inherent talent or an objective recipe approach to writing reflects the reality of the process of writing fiction. I know that many people upon reading this will still groan in despair: "Wait, can't I just rely on my confidence in my talent along with the story assembly instructions of a respectably successful textbook? Isn't that what this book—this course—is supposed to teach me?"

Ah, no. Because both are roads to hell—paved with the unconscious belief or desperate hope that fiction writing is either a God-given talent, thus intuitive (no planning required) or an objective list of easy, practical rules (simply applying a book's screenplay assembly instructions).

And the trouble is that almost all books teaching screenwriting lean heavily on one of these two faulty premises. Either they drown the reader in a bog of invented theories and technical language a computer engineer couldn't untangle, or they falsely empower the student reader by touting easily understood tricks of the trade that guarantee that ever-elusive million-dollar sale.

Writing fiction for the screen is both way more simple and way more complicated—it's both an art and a skill that takes enormous craftsmanship. And it requires lots of time and practice. Whether you want to hear this or not, it inevitably takes years and years of practice before a new writer can even begin to compete at the professional level.

What I want to emphasize from the beginning is there are no easy, certain roads to becoming a professional writer, and no tricks of the trade, no matter how useful, can catapult a new writer over the treacherous and necessarily painful gap that is the process of learning how to write.

But neither is learning to write fiction an intimidating list of incomprehensible rules and theories that read like a top-secret treatise on rocket science.

Why are these contrasting misconceptions so pervasive in the world of books promising to open the gates of Hollywood to the next generation of writers?

Easy. They sells books. Lots of books. The good old American way.

Americans in particular have been brainwashed by the ease and accessibility of self-help books that promise to change our lives without much studying, practice, insight, or effort. And the publishing world knows this sales tactic works. The more daunting the problem or goal, from losing weight to fixing your personal relationships, to addressing spiritual pain, desuetude, and despair—the more books are out there claiming there are secret, professional rules, easy to master, that will ease your pain and give you all you want in life.

Now that's what I call American fiction in the sense of utter falsity. And the pervasive "Oprah-ization" of television makes this mythology all the harder to shake. Just look for the next headline or television spot promising "30 days and 30 simple steps to a better you." It's everywhere, like an easily contracted disease lurking on the surface of our popular culture. If you've made it this far in this book, something I've said has resonated with you about the confusing, contradicting, and I'd wager disingenuous nature of this advice, especially to those who aspire to follow a creative path.

And you would be right.

Let's just take a few examples that underscore how silly and misleading this ubiquitous mindset is when talking about creative writing. How would you react to a book claiming, "You, too, can be a famous rock star/songwriter in a month!"? Or, "Everything you need to know to be an effective lawyer or doctor in 300 pages." Or closer to home, "Thirty-three rules and three weeks to writing a professional screenplay, that sells!"

They've got to be kidding. This is ridiculous, right? Whom do you know who has ever accomplished any of these things in this way?

But as you wander through a bookstore or online on Amazon, you immediately and almost exclusively find yourself enmeshed in this blithely misleading approach to screenwriting, along with its companion, books describing an opaque and madly confusing set of theories that offer no helpful, real-world advice about how, why, and what to write. The former approach breeds a form of false hope for the lazy and uncommitted, and the latter destroys hope, making the task seem as much fun as having to learn quantum physics in your spare time, and on your own.

So, what to do, given this state of affairs?

This book is created to avoid both of these hugely unhelpful and misleading approaches to writing fiction. We are here to navigate between the Scylla of simplistic, undisciplined advice promising immediate success, and the Charybdis of convoluted, incomprehensible formulas, theories, and systems no real writer would ever understand or agree with. The latter format is usually written by people who are extremely successful selling books teaching writing but who really only have their nose

pressed against the glass of the writer's world, since they are not usually actual screenwriters themselves.

Warning: If an author promises too much, too fast, or weighs you down with too much (self-invented) theory, step back and get some perspective. Are you left with what feels like empty promises? Chances are they're writing their book as a potential best seller—"anyone can do it, and everyone should buy this!" On the other hand, is the writer's advice opaque and convoluted, filled with theories and rules that leave your head spinning? That's the mark of an outsider (no matter how famous the name) who forever is doomed to describe the creative process as an observer—unable to feel and thus unable to describe the internal journey and the maddeningly subjective interstices a writer must bridge along the path.

As a result, this book is designed to speak directly from me to you—writer-to-writer. It both respects your ambition and intelligence and guides you through the actual process to which all (successful and emotionally honest) writers of fiction adhere.

And I promise you will eventually be happy to learn the real-life process, the personal, internal journey is neither magic nor a chemistry cookbook.

But let's be honest. I know all writers initially wish it were otherwise. Myself included. Wouldn't it be nice if there were a way to learn the craft of writing that would guarantee a successful creative outcome every time?

Sure. But it would be about as interesting as selling shoes. Learn how to fit a customer's foot and how to make the sales pitch once, and you're good to go—literally for as long as you want, and as many times as you want to.

If that's the kind of certainty and assurance you want in your working life, there is nothing wrong in pursuing it. But make sure it's a profession that lends itself to objective and measurable goals. Certainty and self-assurance are anathema to the creative process. They're feelings tied to the desire or the need for measurable results. Accountants, engineers, scientists, people with law degrees and MBAs feel most comfortable in this world. For them, if they're right, it's somehow provable, and if they

make a mistake, there's a tried and true way to fix it, where they will be comfortably right in a way no one can logically dispute.

But not in the creative world.

In the art and craft of writing, there are often several successful creative solutions to any single problem. And there are also as many ways to conceive of the problem you are attempting to solve.

Does this mean that I'm advising fledgling writers to let go of the safety of their nest of rules and simply jump out on a wing, a prayer, and a keyboard? No. That's going to the opposite extreme.

Writing from instantaneous and untutored inspiration isn't the answer, either. Otherwise, anyone with a great story idea would see himself (or herself) published or produced often and easily, and enjoy the fame and fortune that one hopes will come as a popular, professional writer.

Again, how often have you seen this happen? Time again for some common-sense perspective.

If you bought this book, in some sense you've already decided you want to explore the lineaments of your creative soul. In some way you already know it's a never-ending quest. And that attracts you—the possibility of learning about life and yourself through your work during every chapter of your existence.

And you also instinctively understand that if you're dedicated and courageous enough, you'll eventually find something important to say in your writing.

Important to you . . . and hopefully to your audience.

That's the holy grail of all serious writers: acquiring your hard-earned wisdom and picking this artistic outlet to share your insights with the world.

Let me be clear about this most important step: If you set out to write a story devoid of a point of view or a life lesson essential to you and others, your writing will be hollow, and readers or the audience will sense it and be left cold.

Story is about coping with the slings and arrows of your existence—wounds that afflict us all.

And learning to do this requires lots of reading, writing, and introspection as well as the willingness to show your wounds to others on the page.

This can be a lonely, dispiriting, even scary path to follow in order to learn your craft.

If you're lucky, you'll be able to find a community of good friends, people you can trust, who feel just like you do, people who are on the same path, and who are generous, supportive, and eager to share the fear and thrills of learning about themselves and the writing life. If not, make an effort to create this community. Otherwise, the solitary life of a writer just got significantly lonelier. And that's no help to you or your craft.

And common sense, coupled with experience, will show when you've decided to take the courageous step into an unknown, and therefore perilous, world of learning how to write a story, and more importantly, why you want to tell it.

So, before we can start discussing how to learn to become a professional writer, a much bigger and essential question needs to be answered:

"Why bother in the first place?"

This may sound self-explanatory, and maybe even trivial to you at first blush. But take an intentional, sober, big step back again before you dismiss this question and try to skip ahead to the rock-solid how-to rules you hope lie in this or any other book on writing fiction.

Why do you want to become a professional screenwriter?

There are lots of answers to this question, and most of them unfortunately will undercut, and thus frustrate, your ability to learn how to write.

That's the sad but completely unvarnished truth.

Want to score that million-dollar spec script deal before you're 30? Want to be famous and revered as a genius or a pop-culture icon?

Play the lottery.

But let's be real—aren't those goals exactly what all new writers secretly desire and obsess about in their private dreams and nightmares?

Yes they are. And one of the first essential bits of advice in this book is to learn to fight back against these twisted, demoniacal, self-defeating motivations from the start.

Why?

Because they kill all chances of actually finishing a writing project that has any chance of meaning something either to you or to your intended audience.

But how could that be? Because you're trying to write for a market, instead of writing to explore the truth of yourself and your place in the world.

The easy and true answer is that success will be agonizingly elusive as long as you remain a stranger to yourself and instead try to ply your writing trade by creating stories you guess other people are dying to see and hear.

On that way, trust me, lies madness.

Learning how to write effective and meaningful fiction is first and foremost an internal journey into the discovery of self.

Sound intimidating? Vague? Too precious or artsy-fartsy? Or just a matter of taking yourself too damn seriously? Then it's time to understand why you think you want to devote your professional life to screenwriting.

Let's start with what I call the four major sins of current American culture—the singular and obsessive pursuit of money, status, power, and fame for their own sake. Only when you dig below these superficial goals do you realize they are not truly goals at all. They're tools. Tools you can do a lot with, but hollow and soulless as goals in and of themselves.

Money, power, status, and fame do not a life make. But that does not stop most Americans from pursuing these with the fanaticism of a national secular religion. How many stories, in real life or fiction, do we

know of people who have everything, according to the above criteria, yet are besieged with the terrifying feelings of worthlessness, unloved and lacking real purpose in life, all leading to desperation, depression, and spiritual disorientation?

Tons, if you've been paying attention to the people in the world around you. And, coincidentally, where do we find the most wildly successful people careening from disillusionment to disillusionment, and from panic attacks to addiction, serial relationships, and other life-destroying unhealthy habits?

Hollywood. Right?

Come on, you've read the tabloid headlines as you're waiting in the checkout line of the supermarket. How, we ask with incredulity, are these celebrated celebrities so deeply unhappy? Power? Check. Money? Check. Status? Check. Fame? Check. What's missing?

What's missing is a sense of a meaningful purpose in their lives, a hole in the soul they're unable to fill by the selfish and self-seeking behaviors required in the blind pursuit of conventional success. And we're all in danger of following that poisoned path, one that doesn't solely snare the rich and famous.

Still don't believe me?

How many of the most famous and influential stories in the world have just this theme or life lesson? Again, tons. Pick any of dozens from the Old and New Testament and other traditions' religious texts, to endless secular stories from prose fiction such as *A Christmas Carol*, TV series such as *The Sopranos*, and films including *It's a Wonderful Life, Ordinary People,* and *American Beauty.*

And guess what—all these and other equally influential stories point to the value of a life lived for principles, connectedness, and self-sacrifice for the greater good of others. Can you live life from this perspective, and be rich and famous too?

Sure. But anyone in this position will tell you how difficult it was to get from the lonely peak of making it to the deep interconnected world of living for and among one's fellow, suffering, all too fleetingly mortal human beings.

During my tenure as a medical journalist for *USA Today*, I once interviewed a successful screenwriter/producer about the caretaking of his father who suffered a severe, protracted, and ultimately fatal stroke. He recounted a painful epiphany: at his father's bedside, he realized he had both everything and nothing at the same time. He had reached the top of the mountain of his career, looked over the peak, and was shocked to see only equally sterile hills he could climb alone, for his individual glory.

His father's illness was grounded, tangible, and terrifyingly real—in the dark valley of all the confusing, painful events, circumstances, and challenges we all face and have little control over. Suddenly, being rich, famous, and universally admired felt tauntingly hollow—his father was incapacitated and dying, and wait, wasn't that the same fate that awaited us all?

This compassionate and insightful revelation both changed and solidified his world vision. And one day he found himself sitting outside on his patio, at home among the wild wind, floating leaves, delicate flowers, and hummingbirds . . . and realized for the first time that his hard-earned mansion and all its amenities were nothing more than an expensive prison. A prison he had bought as a reward for all his hard work and success, one that ended up only separating him from nature and the human interactions that provide all the purpose, connection, and joy in life.

A cynical wag might complain at this juncture—"Sure, easy for him to say. He already had all the stuff and recognition a person could want." But I offer a different analysis. It was his recognition of the deepest human needs we all share, in the midst of the uncontrollable fragility of life, that brought him to an appreciation of what true blessings life has to offer all of us, no matter what our external circumstances.

Did this revelation make him stop his writing, sell all his belongings, and dedicate himself entirely to solving the problems of world health? No. For that was not his calling, experience, or expertise. He's an individual human first, with life values he's exceptionally talented expressing in writing. And comedy writing at that. It's just his motivation, perspective, and expectations that changed.

And that, as they say, changed everything.

All of a sudden, that itch to chase writing success, in any form, for any reason, and at any cost, simply vanished. And in its place, the "why" replaced the "what" of writing as the first creative question he asked himself. Yes, his stories always expressed his evolving values, but over the course of a successful career, those personal values and beliefs became central to the process and purpose of his writing.

This often painfully trodden path to discover what personally matters to you is what critics point to when saying that an artist's work has matured. Over time they notice a shift in emphasis from an artist's prodigious creative efforts to simply sparkle, surprise, and seduce an audience. Suddenly, new stories center on a sincere desire to connect with each and every human being on topics and values that have developed as searingly essential to the writer—because the writer discovered these stories express the meaning of the limited time we all share on this planet.

Where's the fun in all this?

Don't worry; comedy can often serve as an equally effective and more palatable means of delivering these eternal truths. That doesn't mean that comedy avoids the painful and serious in life. It just distances itself enough to not be immediately threatening to the audience and its values. Comedy, when done with skill, doesn't avoid the harsh issues we face. It allows us to take a look at these problems, while still feeling safe in our own skin. The challenge in the comic story is still to correct our course, to create a more meaningful life for ourselves, but it's held at a distance.

I once wrote on the board of a screenwriting class, "Pain + time (or emotional distance) = comedy." That's not a bad shorthand for writing meaningful comic writing. Think of your own life. How many hilarious stories have you heard or told that seemed tragic or scary at the time they occurred? My guess is lots . . . and the more painful, the more funny—through recognition, empathy, and the commonality of our hopes and dreams, and fears and failures.

So good writing isn't glum. It certainly needn't be. But it must be serious and sincere, even if we're laughing all the way to the end.

OK, we've dealt with the "why" of becoming a professional screenwriter. Or at least we've asked you this all-important first question.

How did you respond? Why do you want to set out on this path that might absorb every minute of your entire professional career?

This is a bit of a trick question. No one can delve deeply and that accurately into the human heart by just thinking and feeling by reading a book.

It requires writing it down. And I can't emphasize this enough.

Write it down, everything and anything you feel strongly. Check it for wishful thinking, self-destructive thoughts, or for complete bullshit.

And keep writing what you feel—because writing is the most formal and accurate way of teaching and discovering yourself. Why this is true is hard to say, but one clue is that writing is the most permanent form of thinking and analyzing. Once it's written down, one's formerly drifting thoughts somehow feel as if they've been etched in granite. And they feel like you own them.

Then you read them with a cold, honest, analytical eye. Is that really what you wanted to say? Is it more complicated than you'd like to admit, and you're still not sure if it's true for you? Are you not sure what you hate, love, fear, and feel shame about?

Fine. Just take more written notes on your writing—give yourself the honest feedback only you can provide—and get comfortable with the process of getting to know yourself, through reading and writing.

But let me offer one person's answer to the question of why we write. I hope this will inspire you to come to a similar, but individual conclusion yourself.

The following is William Faulkner's speech as he accepted the Nobel Prize for literature in 1949:

"Ladies and gentlemen,

"I feel that this award was not made to me as a man, but to my work—a life's work in the agony and sweat of the human spirit, not for glory and least of all for profit, but to create out of the materials of the human spirit something which did not exist before. So this award is only mine in trust.

"It will not be difficult to find a dedication for the money part of it commensurate with the purpose and significance of its origin. But I would like to do the same with the acclaim too, by using this moment as a pinnacle from which I might be listened to by the young men and women already dedicated to the same anguish and travail, among whom is already that one who will some day stand here where I am standing.

"Our tragedy today is a general and universal physical fear so long sustained by now that we can even bear it. There are no longer problems of the spirit. There is only the question: When will I be blown up? Because of this, the young man or woman writing today has forgotten the problems of the human heart in conflict with itself which alone can make good writing because only that is worth writing about, worth the agony and the sweat.

"He must learn them again. He must teach himself that the basest of all things is to be afraid; and, teaching himself that, forget it forever, leaving no room in his workshop for anything but the old verities and truths of the heart, the old universal truths lacking which any story is ephemeral and doomed—love and honor and pity and pride and compassion and sacrifice.

"Until he does so, he labors under a curse. He writes not of love but of lust, of defeats in which nobody loses anything of value, of victories without hope and, worst of all, without pity or compassion. His griefs grieve on no universal bones, leaving no scars. He writes not of the heart but of the glands. Until he relearns these things, he will write as though he stood among and watched the end of man.

"I decline to accept the end of man. It is easy enough to say that man is immortal simply because he will endure: that when the last dingdong of doom has clanged and faded from the last worthless rock hanging tideless in the last red and dying evening, that even then there will still be one more sound: that of his puny inexhaustible voice, still talking.

"I refuse to accept this. I believe that man will not merely endure: he will prevail. He is immortal, not because he alone among creatures has an inexhaustible voice, but because he has a soul, a spirit capable of compassion and sacrifice and endurance.

"The poet's, the writer's, duty is to write about these things. It is his privilege to help man endure by lifting his heart, by reminding him of the courage and honor and hope and pride and compassion and pity and sacrifice which have been the glory of his past. The poet's voice need not merely be the record of man, it can be one of the props, the pillars to help him endure and prevail."

From *Nobel Lectures, Literature 1901–1967*, Editor Horst Frenz, Elsevier Publishing Company, Amsterdam, 1969

So, the writer's duty, according to Faulkner, is to lift our viewers' or readers' hearts, reminding all of us of the "courage, and honor and hope and pride and compassion and pity and sacrifice," which speaks to and illustrates the best in us, and helps us to prevail through the trials and suffering which none of us can avoid in life.

Is that too much? Is some snooty Nobel laureate speaking over our heads, addressing an elite 1 percent who have the time and interest to read the classics?

Not at all. Faulkner was a very successful commercial screenwriter as well. And the point here is he also put his heart and values in the subtext of great screenplays and screen adaptations he wrote, including *The Big Sleep*, *To Have and Have Not,* and a substantial amount of television— both TV movies and episodic scripts.

So Faulkner wasn't some snob who reveled in the self-appointed role of an ink-stained wretch. He could connect with an audience for popular entertainment and was extremely commercially successful in Hollywood.

But what was his advice to commercial writers as well those who write rarified art?

More of the same:

"Always dream and shoot higher than you know you can do," he says. "Don't bother just to be better than your contemporaries or predecessors. Try to be better than yourself."

I would like you to keep Faulkner's challenges to writers in mind. Think for a minute: How can it specifically apply to you?

Simple.

Just constantly ask yourself, "Where is the heart and soul of my commercial screenwriting ideas?"

My good friend Stewart Lyons, line producer for the series *Breaking Bad*, offers this optimistic, flexible perspective on deciding what to write. He says: "Popularity does not exclude excellence. And the high purpose of art doesn't guarantee success."

What Stewart is saying is that it's all about you, and what you find important and moving. That's liberating. But he knows some types of creative rules help us hit the mark.

Stewart adds: "The best we can do for those students who are serious about writing is to guide them to be the best they can be." (Sound familiar?) "And that means to be honest about the emotions and motivations of the people/characters they portray."

And he concludes, "Whether they do it in a sci-fi setting, a detective setting, or a noir is beside the point."

What then is the point? Bringing your emotional honesty and your burning message to your audience. No matter what genre and medium you've chosen to write in.

Now that shouldn't seem like too intimidating a task: honesty and a message. You can do that. You should know yourself better than anyone else does. And with a little thought and some writing exercises, you can begin to explore how your mind, heart, and values form a personal bottomless well of all your current and future creative ideas.

Respect yourself. Make friends with yourself and your beliefs. Start noticing what matters to you in your life, your reading and in your television and movie viewing.

This should be a calm and playful process—and it's fascinating, because as an observer of yourself and others, you see all your deeply held beliefs begin to suddenly become visible, laid out before you.

OK, given that this is a book that teaches screenwriting, what's the next step?

Easy and difficult: Know thyself. And make sure to explore your conscious and unconscious belief systems.

When Socrates said the unexamined life is not worth living, he was not advocating suicide. It was a wake-up call to the majority of humans who drift through their days as a passive, uniformed player in their own lives. They don't question the "why" of their preferences and prejudices and, most importantly, never stop to ask why they believe all the little and essential things they do that make them who they are.

As writers, and before we put pen to paper, we need to know as precisely as possible why we are the way we are.

So where to begin?

We start with our conscious beliefs.

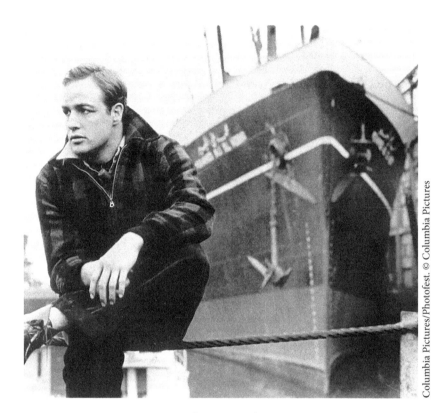

On the Waterfront

Terry Malloy (Marlon Brando), a washed-up prizefighter, develops the courage to stand up to the corrupt mob boss who controls the New York docks.

CHAPTER

3

ALL CREATIVE IDEAS SPRING FROM OUR CORE BELIEFS

Remember this parental advice regarding avoiding conflict while socializing with strangers? "Never discuss sex, politics, or religion."

Why?

Because if you think about this carefully, people are deeply attached to their beliefs on these subjects precisely because there is no way to prove anyone right or wrong. This is why these subjects are so dangerous to bring up with others. These kinds of discussions easily threaten our core beliefs about ourselves and our place in the world. Because we can't prove to ourselves or others what constitutes a good person and a good life.

And so we are left adrift with our beliefs as we try to navigate all the situations that challenge us—without any guarantee that we're living our lives the right way. Abortion. Foreign policy. War. Taxes. Euthanasia. There's no objective proof of any opinion on these central issues in our lives, but we have to live and make decisions on these and other important values anyway. There's no escape.

That's the human condition.

And no one is exempt from this struggle to align our views with what we hope is an ethical and spiritual life. We live in confusion and with internally conflicting values all the time. And yet we must carry on as if

we knew we were right and yet still learning from our belief and value conflicts that roil inside all of us, day and night.

Out of that maelstrom of conscious, unconscious, and conflicting beliefs will come all your story ideas. Storytelling is about communicating and trying to convince the audience of the emotional truth and the internally resonating values you've learned to live by.

And it has to be discovered by ourselves. We hope, by our introspective efforts, to discover our truths buried deep inside ourselves that we hope will connect with others. The great mythology expert Joseph Campbell wrote the following about the individual quest for one's own truth:

> "The idea of Truth with a capital 'T'—that there is something called Truth that's beyond the range of the relativity of the human mind trying to think—is what I call 'the error of the found truth.' The trouble with all of these damned preachers is the error of the found truth. When they get that tremolo in their voice and tell you what God has said, you know you've got a faker. When people think that they, or their guru, have The Truth—'This is It!'—they are what Nietzsche calls 'epileptics of the concept:' people who have gotten an idea that's driven them crazy."
>
> (Excerpt From: Campbell, Joseph. "A Joseph Campbell Companion: Reflections on the Art of Living." Joseph Campbell Foundation, 2011-08-01. iBooks.)

And the same goes for writers.

But, paradoxically, in our lonely explorations of our heart, we hope to find the struggles, beliefs, values, and stories that are in some sense universal to all humans.

Find yourself, and you can see others more clearly. But know that we share only some emotional truths with others. As a writer, be diligent listening to others, paying attention to how they justify their beliefs and actions. Without this particular skill, the development of empathy for others, how could any of us faithfully portray characters different from ourselves?

But know that all of us are severely limited in our daily quest for what is good and true in life. As an artist, know that we all operate from a

flawed and constricted perspective—and as a result, we all come to see our lives in different and incomplete ways.

We always have something important to learn about the meaning of our own lives and those of others—and that provides the opportunity for personal growth through an introspective journey to becoming the people we consciously want to become.

And that is a perfect reason for and purpose of telling stories in the first place.

Stories, if they are to be effective to our audience, are about the challenge to grow from behavior based on immature, selfish beliefs, to behavior that reflects our higher purposes in life, in effect embracing the better angels of our nature.

This is where a writer's personal life experience comes into play. We are inspired, warned, encouraged, or challenged by a writer's fictional description of a person's growth to become a more whole, harmonious, and conscious self.

But how do we develop and trust our beliefs in the first place?

Without going into needless detail, this question has haunted philosophers and theologians for millennia. Philosophical skepticism claims we can't prove the reliability of our beliefs, even the most basic belief—that the sources of our beliefs are even sometimes reliable. That's because our beliefs are axioms. They can't be supported by any other more primary evidence, because beliefs are our primary evidence of the truths we come to believe in our lives. So what is our anchor to reality?

Let's take an example posed by the twentieth-century philosopher Bertrand Russell, called the Five-Minute Hypothesis: According to Russell, there is no way to prove that the entire universe wasn't created five minutes ago, with all our memories, history, and the state of the world, as it is, already pre-programmed and intact.

A radical hypothesis . . . but one only raised to show how difficult it is to explain the source of our beliefs. The main point: Don't be so sure of your beliefs without testing and examining them. They're not built on as solid ground as you think.

Rene Descartes, the seventeenth-century French philosopher, came at this problem a slightly different way. How, he asks, do we know that our entire existence isn't some form of dream or nightmare? He also asked if our present life could all be one delusion created by some evil demon who planted beliefs in our head. (Descartes concluded there is one thing we can't deny, the act of doubting our beliefs requires thinking, and that leads to the belief that we do indeed exist: "I think, therefore I am.") And with that foundation Descartes felt he could develop a rational and reliable body of knowledge he could trust. Modern philosophers have come to doubt Descartes' reasoning on this subject . . . so where are we left to turn?

How do we, as twenty-first-century people, individually refute these radical challenges of the Five-Minute Hypothesis and Descartes' dreams and demons?

On one level, we can't.

However, we still rely on our most basic beliefs all the time. Why is that? Part of the reason is that it's literally impossible to suspend all our beliefs, and even if we could, it wouldn't be practical. Literally, how could we do any purposeful activities in our daily lives without trusting our beliefs?

So the skeptic's question is really just trying to serve as a warning—showing that humans are complex creatures living their lives with incomplete and thus inaccurate core views about themselves and the world. There is no independent evidence available of these views' truth, by the nature of belief itself.

But since we must operate from our beliefs, we come to trust them through practical experience of how they conform to our entire integrated, intricate, and consistent belief system. Always ask, "Are my beliefs consistent with each other?" We all have conflicting beliefs, and it's our job to bring those to light and examine them. They are the source of the most important stories we create.

When writing stories that are compelling and resonate with our audience, we are playing with the ways people grow internally by testing and changing their beliefs.

On one level, stories could be said to show how and why people come to change their beliefs. And as writers, we are always trying to dig one level deeper, asking ourselves why we believe one thing and not another. If you can come up with a "because" statement, a more basic reason for your belief has been revealed that you can work with. But in the end, we may have no other reason for our beliefs except they work for us in navigating our lives.

As writers, we live in the world where our job is to show characters developing and changing their beliefs. We want to be able to go back and ask why we believe what we do, and why our characters do, as well—and most importantly, why and how we change our beliefs.

And even if we have problems identifying and articulating a God-given set of objective beliefs we can all rely on, it does not suggest our own lives are devoid of meaning.

We need not have a divinely ordained purpose to live a good life. We can create meaning in our lives by close examination of what we value, what actions we take as a consequence, and how our behavior affects others. But we never can stop looking for reasons to grow and mature, because we are often in situations that point out the conflicts in our beliefs, as well as our limited understanding as humans of our heart in conflict with itself.

Playing with our beliefs is one of the most fruitful means of gaining access to the creative center within us. The more we get to know ourselves, and our inconsistencies and imperfections, the greater the likelihood we will discover important themes and life lessons to write about in our fiction.

So one of the first tasks of new writers is to create an inventory of the most basic beliefs about themselves, others, and the world around them. And pay special attention to core beliefs in conflict with one another, as well as to beliefs that might not be working any more.

So, where to start?

How about something basic? What most people in our culture claim to believe to be true and valuable.

What about the Ten Commandments? What about the fact that most Americans can't name all ten of them off the top of their heads? How

central are these supposed beliefs to everyday life if they aren't branded in the forefront of our minds?

OK, you try. Pick up a piece of paper, and write the Ten Commandments, in order.

Right now is a good time for this exercise. Just ignore the answers, below, before you try at least once.

The Ten Commandments (Decalogue) play a fundamental role in Judaism, Christianity, Mormonism, and Islam. Different groups do follow slight variations in numbering and interpreting them. They appear in both Exodus 20:1-17 and Deuteronomy 5:4-21.

Now, how do your answers conform to the summary of the biblical list below from Exodus 20:1-17?

1. I am the LORD your God … you shall have no other gods before me.

2. You shall not make yourself carved images and bow down to them or serve them. (For your God is a jealous God, visiting the iniquity of the fathers to the children to the third or fourth generation of those who hate me)

3. You should not take the name of the Lord your God in vain (because the LORD will not hold him guiltless who takes his name in vain).

4. Remember the Sabbath and keep it holy (On it you shall not do any work, nor shall your family, servants, and guests.)

5. Honor your father and your mother. (So that your days may be long in the land that the LORD your God has given you.)

6. You shall not murder.

7. You shall not commit adultery.

8. You shall not steal.

9. You shall not bear false witness against your neighbor.

10. You shall not covet your neighbor's house, or his wife . . . nor anything that is your neighbor's.

Now let's take a deep breath and look at this with new eyes. What values are promoted by these commandments? Are these values outdated, unclear, or just plain ignored in modern life?

Obeying the first commandment requires we define who God is in the first place. That is essential to all writers, and we'll get back to that later. For right now, think of the "other gods" we, as Americans worship. Do we live our lives as if money, power, status, and fame are the gods worth worshiping? How do you feel about that in your own life, in your family, in your community?

And how do you feel about the second commandment against worshiping images that, if broken, will send punishment from God raining down on your (innocent) children to the third and fourth generation? Do you really believe it is true or just that great-grandchildren endure punishment for the sins of their forefathers? This is a troublesome part of the Ten Commandments for most modern people.

Do you really believe any god would really do this and consider it just? If not, what is happening to your examination of your feelings toward these commandments? Are they becoming somewhat alien, are your feelings becoming less certain, more flexible?

What's your reaction to the third commandment? Have you ever sworn, even once, even in jest, using God's name in the process? Most people would be hard-pressed to say "no." But do you still believe God will punish us for doing so? Do you really believe God will hold it against us?

And to our modern ears, is swearing "By God!" really that big a deal that its prohibition deserves to be in the top three of all of God's rules? What is the inconsistency in your own life? Do you just ignore this commandment as ancient and superstitious?

If so, stop for a minute. What are the criteria for the commandments you try to obey, versus the ones you ignore or lay aside?

Think of this as we move on to the commandment to remember the Sabbath day and keep it holy, and do no work. Some people go to church

or temple or mosque as a way of keeping the Sabbath holy. Even if you do, have you consistently and completely refrained from work on the seventh day?

Is that even possible in this modern, fast-paced, and secular world we live in today? And since I bet almost everyone does some kind of work on this day—how does that affect your respect and understanding of this commandment? Does your God really care about this? Do you feel guilty by working on the Sabbath, and if not, why not?

You know what I'm getting at: how seriously and literally do we and should we take these commandments that serve as some of the basic moral rules of Judaism, Christianity, and Islam? And if we pick and choose the rules to follow, how do we go about that selection process?

The commandment to honor your father and your mother is said to be rewarded by the promise that "your days may be long in the land your LORD God is giving you."

Does that mean the God of the Ten Commandments is saying he will cut short the lives of those who don't sufficiently honor their parents? It sure seems so. Is that what you believe? Do you think it's fair? Have you ever seen it happen? How often? Or is this just an embarrassing part of old religion to you? If so, why? What if the parents are abusive, selfish, and emotionally cruel? Does that change a child's obligation to this commandment? Does this change anything?

The rest of the commandments seem to make more practical sense— those proscribing murder, adultery, stealing, bearing false witness against your neighbor (lying), and coveting (envying) anything that is your neighbor's. But even so, all of these prohibitions require interpretation, given the particular circumstances we find ourselves in at the time.

And more importantly, even if we include Jesus' dictum in Matthew 19:16-19 in the King James Version: "Thou shalt love thy neighbor as thyself," have we covered all the moral ground necessary to live a good life?

For better or for worse, life is substantially more complicated than that. For instance, the Hebrew Bible allows for justified killing in the context

of warfare (1 Kings 2:5-6), capital punishment (Leviticus 20:9-16), and self-defense (Exodus 22:2-3).

What is missing and what can be deleted from this list when cataloging the most basic beliefs and morals you live by? This is the primary, most basic, and essential task for a beginning writer.

Our most basic values (the ones most interesting to write about) are the result of our inevitably convoluted and contradicting belief system. Once consciously aware of our beliefs, and struggles with them, we can then construct a narrative of what we most value in life. And these core values are what we impress upon our readers or viewers, with the hope that we are ethically and emotionally convincing.

From *Kabbalah: The Way of The Jewish Mystic*, we read a course of instruction enumerated by the teacher Moses Cordovero, which consists of:

1. Forbearance in the face of insult

2. Patience in enduring evil

3. Pardon, to the point of erasing the evil suffered

4. Total identification with one's neighbor

5. Complete absence of anger, combined with appropriate action

6. Mercy, to the point of recalling only the good qualities of one's tormentor

7. Eliminating all traces of vengefulness

8. Forgetting suffering inflicted on oneself by others and remembering the good

9. Compassion for the suffering without judging them

10. Truthfulness

11. Mercy beyond the letter of the Law

12. Assisting the wicked to improve without judging them

13. Remembering all human beings always in the innocence of their infancy

How do these admonitions feel differently from the Ten Commandments Jews and Christians are told to believe?

It could be said that these are a call to action for specific virtuous behavior—not simply prohibitions against selfishness and a lack of respect for the God of the Old Testament. Can you feel how these ethical points seem much more personal and specific than mere prohibitions on certain thoughts and behavior?

Well, that's what we're getting at. What are your values, and why? That's the first step in learning to become a writer.

Even if you consider yourself a practicing Christian, how much do you know about the specific beliefs and consequent values of your chosen denomination? Even for the most educated and moral of modern Americans, the answer is simply "not much."

Are Christians justified through faith in Jesus' death and resurrection, or are we saved through social awareness, feeding the poor, and attending to the sick and incarcerated? Depends on what part of the New Testament you read. Paul says one thing; John says another.

The same confusion results from asking other basic questions answered differently in the Gospels themselves. Depending on what part of the New Testament you read, there are different answers to such central questions such as why Jesus had to die, whether he overtly suffered while on the cross, whether Jesus was in some sense God, what cosmic judgment Jesus believed would happen on earth while his disciples were still alive, and whether "the Kingdom of God" was to be an immanent change on earth or to occur at an unnamed later date in heaven.

This is serious stuff—and all these complications and more explain why there are so many different essential beliefs across the millennia and across different Christian denominations.

Simply put, we have a huge number of choices when it comes to what to believe in. And it's essential we all know what our beliefs are, and how and why we came to believe in them.

Otherwise, we will remain ignorant of ourselves and thus unable to tell stories that convey the most important values we have in life.

OK, we can hear this question coming: What if you grew up in a Judeo-Christian culture, but don't believe the cosmology and subsequent morality of any biblical story? Does that make the task of recognizing and enumerating our moral beliefs about the world and ourselves easier?

The simple answer is no. Even with no belief in God, we are still left here with the obligation to create meaning out of our lives. Humans are meaning–makers, meaning that fills our lives with purpose and direction. For many, it is unthinkable to live in a universe that may have no purpose even if they don't believe in an intelligent creator.

But what if you do come to think the universe and yourself were created without any particular divine action or purpose? Is this notion liberating or frightening?

One thing for sure, it doesn't answer the question of how, what, and why we come to find purpose in our lives. We have to answer those questions anyway, just to get through the day. And the more we work at finding meaning in our activities and interactions with others, the more we discover about ourselves and the values we hold dear. Agnosticism, or even atheism, doesn't answer the core question of the meaning we make of our lives and our obligation to create it for ourselves.

The poet Ted Hughes (from *Letters of Ted Hughes*) wrote to his then 24-year-old son, Nicholas, saying that everybody tries to protect the vulnerable 8-year-old inside him through acquiring skills that threaten to overwhelm it. So everybody, Hughes adds, develops a whole armor of an artificially constructed second self that deals with the outer world—and this is how we generally deal with ourselves and with each other. That is, superficially and by protecting our artificially created self.

But Hughes adds that this inner child is precisely what's most valid and real within people. "And in fact," he adds, "that child is the only real thing in them. It's their humanity, their real individuality, the one that can't understand why it was born and knows it will have to die" Hughes wrote that what doesn't come out of our childlike, unprotected selves isn't worth having, it being the center of all possible magic and revelation in our lives.

"But since that artificial secondary self took control of life around the age of eight, and relegated the real, vulnerable, supersensitive suffering

self back into its nursery, it has lacked training, this inner prisoner," he says.

And so whenever life takes us by surprise, this inner self is unprepared, yet this is the moment it wants. "That's the paradox," wrote Hughes, "the only time most people feel alive is when they are suffering, when something overwhelms their ordinary, careful armor, and the naked child is flung out into the world."

But Hughes warns that if the inner child gets buried under a person's adaptive and protective shells and coping mechanisms, "he becomes one of the walking dead, a monster." So if it's been awhile and you haven't felt the awful struggle with your child-like self, he says, you know you've stopped growing and gone some distance losing touch with yourself.

Hughes concludes, "The only calibration that counts is how much heart people invest, how much they ignore their fears of being hurt or caught out or humiliated. And the only thing people regret is that they didn't live boldly enough, that they didn't invest enough heart, didn't love enough. Nothing else really counts at all."

Is that the answer to the agnostic or atheistic among us? Is it about being bravely open to our delicate child-selves, honoring it in ourselves and others, and living boldly through faith in the meaning made of loving ourselves and others, as we truly are? Hughes writes that every single person is exposed to unexpected defeat in this innermost emotional self. Yet it is our duty to recognize the honor and opportunity to engage this unprotected self with others and the world. Hughes concludes that's where we come alive, "even if only to be overwhelmed and bewildered and hurt." And that's where we find our real values and real resources to carry on—still residing in our innermost, youngest, and most easily wounded selves.

Thus, the most important thing to do when starting a course in creative writing is to first identify your core beliefs. These core, deep, sometimes unconscious beliefs create our values in life, our behavior, and our dysfunctional but seemingly necessary coping mechanisms when we feel threatened or incompetent.

And stories are primarily about characters with maladaptive core beliefs that are challenged over the course of a fictional narrative. The essence of any story is whether the main character(s) will meet the challenge to

change their core beliefs and thus change their values and their behavior. And the challenge is always to discard these old dysfunctional values in favor of those values that show personal growth.

Dysfunctional beliefs tend to be both selfish and at the same time self-damaging and inaccurate, while new healthier beliefs are selfless and compassionate to self and others, often changing the whole dynamic of why and how a maturing person sees his/her place in the world.

So, time for some fun. Let's take a little test to identify our personal core beliefs, both positive and negative, and see the values, behavior, and attitudes that result from them.

Remember story is about how and why an individual becomes aware of his/her maladaptive core beliefs. And with that self-knowledge, well-crafted stories map how a character drops dysfunctional beliefs and coping mechanisms (the Band-Aids on our soul) and grows into a person who has learned a deep life lesson about necessity of the journey of change into a more authentic, moral, compassionate self.

The following questions come from *Prisoners of Belief*, by Matthew McKay, Ph.D., and Patrick Fanning. They were adapted from Jeffrey Young's (1990) *Schema Questionnaire*.

Mostly True OR
Mostly False

1. _____ I am worthy of love and respect.

2. _____ My world is a pretty safe place.

3. _____ I perform many tasks well.

4. _____ I am in control of my life.

5. _____ I feel loved and cared for.

6. _____ I can rely on myself.

7. _____ The world is neither fair nor unfair.

8. _____ I feel a strong sense of belonging in my family and community.

9. _____ Most people can be trusted.

10. _____ I set reasonable standards for myself.

11. _____ I often feel flawed and defective.

12. _____ Life is dangerous. A medical, natural, or financial disaster could strike at any time.

13. _____ I'm basically incompetent.

14. _____ I have very little control over my life.

15. _____ I've never felt really cared for by my family.

16. _____ Others can care for me better than I can care for myself.

17. _____ I get upset when I don't get what I want. I hate to take no for an answer.

18. _____ I frequently feel left out of groups.

19. _____ Many people would like to hurt me or take advantage of me.

20. _____ Very little of what I do satisfies me. I usually think I can do better.

21. _____ I feel OK about myself.

22. _____ I can protect myself from most dangers.

23. _____ Doing some things comes easy for me.

24. _____ I have the power I need to solve most of my problems.

25. _____ I have at least one satisfying intimate relationship.

26. _____ It's OK to disagree with others.

27. _____ I accept it when I don't get what I want.

28. _____ I fit in well with my circle of friends.

29. _____ I rarely need to protect or guard myself with other people.

30. _____ I can forgive myself for failure.

31. _____ Nobody I desire would desire me if they really got to know me.

32. _____ I worry about getting sick and hurt.

33. _____ When I trust my own judgment, I make wrong decisions.

34. _____ Events just bowl me over sometimes.

35. _____ My relationships are shallow. If I disappeared tomorrow, no one would notice.

36. _____ I find myself going along with others' plans.

37. _____ There are certain things I simply must have to be happy.

38. _____ I feel like an outsider.

39. _____ Most people think only of themselves.

40. _____ I'm a perfectionist; I must be the best at whatever I do.

41. _____ I have legitimate needs I deserve to fill.

42. _____ I am willing to take risks.

43. _____ I am a competent person, as capable as most people.

44. _____ My impulses don't control me.

45. _____ I feel nurtured by my family.

46. _____ I don't need the approval of others for everything I do.

47. _____ Things tend to work out, even in the end.

48. _____ People usually accept me as I am.

49. _____ I seldom feel taken advantage of.

50 _____ I set achievable goals for myself.

51. _____ I'm dull and boring and can't make interesting conversation.

52. _____ If I'm not careful with my money, I might end up with nothing.

53. _____ I tend to avoid new challenges.

54. _____ I fear I'll give in to overwhelming crying, anger, or sexual impulses.

55. _____ I'm afraid of being abandoned, that a loved one will die or reject me.

56. _____ I don't function well on my own.

57. _____ I feel I shouldn't have to accept some of the limitations placed on ordinary people.

58. _____ People don't usually include me in what they're doing.

59. _____ Most people can't be trusted.

60. _____ Failure is very upsetting to me.

61. _____ I count for something in this world.

62. _____ I can take care of myself and my loved ones.

63. _____ I can learn new skills if I try.

64. _____ I can usually control my feelings.

65. _____ I can get the care and attention I need.

66. _____ I like to spend time by myself.

67. _____ Most of the time I feel fairly treated.

68. _____ My hopes and dreams are much like everyone else's.

69. _____ I give people the benefit of the doubt.

70. _____ I'm not perfect, and that's OK.

71. _____ I'm unattractive.

72. _____ I choose my old, familiar ways of doing things over risking the unexpected.

73 _____ I don't perform well under stress.

74. _____ I'm powerless to change many of the situations I'm in.

75. _____ There's no one I can count on for support and advice.

76. _____ I try hard to please others, and I put their needs before my own.

77. _____ I tend to expect the worst.

78. _____ Sometimes I feel like an alien, very different from everybody else.

79 _____ I must be on my guard against others' lies and hostile remarks.

80. _____ I push myself so hard that I harm my relationships, my health, or my happiness.

81. _____ People I like and respect often like and respect me.

82. _____ I don't worry much about health or money.

83. _____ Most of my decisions are sound.

84. _____ I can take charge when I need to.

85. _____ I can depend on my friends for advice and emotional support.

86. _____ I think for myself. I can stand up for my ideas.

87. _____ I'm treated fairly most of the time.

88. _____ I could change jobs or join a club and soon fit in.

89. _____ I'd rather be too gullible than too suspicious.

90. _____ It's OK to make mistakes.

91 _____ I don't deserve much attention or
 respect.

92. _____ I feel uneasy when I go very far from
 home alone.

93. _____ I mess up everything I attempt.

94. _____ I'm often a victim of circumstances.

95. _____ I have no one who hugs me, shares
 secrets with me, or really cares about
 what happens to me.

96. _____ I have trouble making my own wants
 and needs known.

97. _____ Although life is objectively OK, I have
 lots of trouble accepting the parts that
 aren't the way I'd like them to be.

98. _____ I don't feel I belong where I am.

99. _____ Most people will break their promises
 and lie.

100. _____ I have clear, black and white rules for
 myself.

SCORING YOUR CORE BELIEFS

This inventory covers ten essential areas where everyone has some sort of central belief, and these beliefs are needed as the foundation and direction of any values and behavior we exhibit.

Pay close attention to how your views emerge, and imagine how your evaluation of these topics affect your behavior (or that of a fictional character you're writing).

1. VALUE _____ points.

Give yourself one point for each of these questions you marked as "Mostly True": 1, 21, 41, 61, and 81. Give yourself one point for these questions marked "Mostly False": 11, 31, 51, 71, and 91.

This measures the strength of the statement, "I am worthy." The higher the score, the more valuable you believe you are as a person.

2. SECURITY _____ points.

One point for the following questions marked "True": 2, 22, 42, 62, and 82. One point for the following questions marked "False": 12, 32, 52, 72, and 92. This indicates how much you agree with the statement, "I am safe."

3. PERFORMANCE _____ points.

One point for these questions marked "True": 3, 23, 43, 63, and 83. One point for these marked "False": 13, 33, 53, 73, and 93. The higher the score, the more you believe the statement, "I am competent."

4. CONTROL _____ points.

Look for the following questions marked "True": 4, 24, 44, 64, and 84. Also add a point for these marked "False": 14, 34, 54, 74, and 94. The higher the score, the more you feel "I am powerful and feel in control of my life."

5. LOVE _____ points.

Mark a point for these questions marked "True": 5, 25, 45, 65, and 85, and for the following questions marked "False": 15, 35, 55, 75, and 95. This measures your agreement with the statement "I am loved and feel nurtured."

6. AUTONOMY _____ points.

Give yourself one point for responding "True" to the following: 6, 26, 46, 66, and 86. And one point for these questions marked "False": 16, 36, 56, 76, and 96. A high score indicates you believe, "I am autonomous and independent."

7. JUSTICE _____ points.

One point for the following marked "True": 7, 27, 47, 67, and 87. Add one point for these questions marked "False": 17, 37, 57, 77, and 97. This measures how much you believe "I am treated justly" and think people and the world are fair and reasonable.

8. BELONGING _____ points.

One point for answering "True" to questions 8, 28, 48, 68, and 88. Another point to each "False" answer to numbers 18, 38, 58, 78, and 98. A higher score indicates how much you believe, "I belong" and how much you feel secure and connected to others you know and humanity in general.

9. OTHERS _____ points.

One point for "True" answers to questions 9, 29, 49, 69, and 89. One point for "False" answers to 19, 39, 59, 79, and 99. This measures your agreement with the statement, "People are good" and how much you trust others to behave positively toward you.

10. STANDARDS _____ points.

One point for "True" answers to items 10, 30, 50, 70, and 90. Another point for "False" answers to 20, 40, 60, 80, and 100. A higher score indicates you believe "My standards are reasonable and flexible." And you are more likely to judge your own and others' actions compassionately.

Making sense of your scores:

The higher the scores on each of the "Healthy Core Beliefs" listed above, the more a person feels emotionally and psychologically balanced, connected, purposeful, safe, in control, and loved.

Even more importantly, lower scores do a wonderful job of identifying the issues we writers are still struggling with in life. They show how our views on these central life issues are out of balance, inaccurate, overly threatening, painful, frightening, and dysfunctional.

And our job as writers is to demonstrate how we can cope with the effects these central troublesome issues cause in our lives—and how we can overcome these limitations and grow practically, emotionally, and spiritually—incorporating a new and more accurate system of beliefs about ourselves and the world.

So the theme of a story based on a person's journey to self-compassion, acceptance of self, and developing loving relationships with self and others—is a story of how and why to change a fundamental aspect of one's views on one's lovability.

In effect, all your stories can be looked at as an effort to make an emotional proof of the life lesson or theme you hold to be important and true. And in good writing, the audience is convinced by your argument, as shown by the character's choices before and after exposing the flaw of one of these essential beliefs.

Reread the paragraph above. We're saying our positive and negative experiences in life are the stuff of writing, because they show where we find joy, where we suffer, and where we find transcendence. And the most important factor in these different outcomes involves our personal beliefs about the situations we find ourselves in.

And this is precisely where we start to identify the stories that are close to our heart and soul. Your issues are our issues, as we all share our humanity and its limitations, as well as our dysfunctions, coping mechanisms, internal conflicts, and yearning for growth. We want to know how we can handle our own problems through the example of the fictional narrative you create. And trust that everyone has problems dealing appropriately with our core beliefs listed above, so the struggle is universally understandable and relevant.

In essence, everyone is fighting the battle for emotional growth, every day, and the nature of our partially formed, immature belief systems creates many, if not most, of the problems we encounter in life. Thus, starting from the application of our beliefs, we are always half-blind to their effects on our daily decisions about how we act and how we see our role in the world.

And it's the role of the writer of fiction to show us our flaws in our beliefs on these central issues and how to recognize and repair them—even if we writers are wrestling with those same problems ourselves. We don't have to know it all or be wise beyond our years to tackle erroneous beliefs we share in common. The accuracy of the struggle, along with the skill of demonstrating a path out of our misconceptions, is all that's needed.

So, we're back to the issue of self-knowledge. Doing the Core Belief Inventory should help start bringing our often unconscious beliefs to the surface for an examination and evaluation of their accuracy and usefulness in guiding us through life.

Let's take an example: Suppose you want to work with the effects of a low score on the LOVE item. What dysfunctional behavior would you expect from a character who believes in his/her unlovability? Would the character avoid exposing his personal feelings and attitudes to rejection? Would he be shy or aggressive in the face of inferred rejection by others? What coping mechanism would such a person use to feel better? And finally, what emotional journey could cause this person to have a more balanced, accurate belief in his lovability?

This is extremely important: The path to a new core belief is your story!

The specific initial answers to the survey questions dealing with lovability (or any other core issue) will provide particular maladaptive personality and behavior traits we recognize as signs of that problem. You then have the ability to craft a fully formed character by showing the behaviors and attitudes both before and after the new belief and life lesson of your story has been learned.

When you apply your characters' core beliefs to all the situations they encounter in your story, we feel we both trust the writer and know the character much better. We feel we know them through what they think and do. Maladaptive beliefs bleed through every aspect of our lives, and occur in the most ordinary of situations. We recognize that in ourselves and others. And that's how we create believable and compelling characters who are clearly suffering from what is an unspoken dysfunctional belief we want to explore in our story.

Let's take the core belief category of JUSTICE. We don't have to specifically mention the characters' attitude toward the fairness or unfairness of this world. We see that belief in how he tries to protect himself, his attitudes toward others' accomplishments, what kind of job he holds, how he deals with and lacks trust in his friends and others, and how he has a deeply pessimistic view of accomplishing what he wants in life. If the behavior is recognizable as coming from a belief that life is fundamentally unfair, the audience will instinctively understand, because we too have felt that way before.

The word "justice" never has to be mentioned explicitly. In a well-written story, we see a character's attitude through his beliefs and behavior. If the writer has a good handle on how people try to cope with this or another negative belief, we become convinced of the authenticity

of the struggle, and see the initial coping strategies as both faulty and recognizable as our own.

The writer's job is then to open our hearts to how we feel when threatened by this or other hurtful beliefs, and to create empathy with the protagonist who is going through the necessary, painful changes to be able to see himself and the world in a more accurate, and usually more benevolent way.

Even if the character still believes in the inherent unfairness of life, the writer can show the audience how to best cope with setbacks in an imperfect world. We pay attention because everyone needs to learn the lesson of how to deal with the vagaries of fate. We all are faced with the same basic challenges in life—and it's a writer's duty to show us how best to deal with them.

Now we move on from identifying individual flawed beliefs to constructing your characters' overall personality and worldview.

School of Rock

Dewey Finn (Jack Black), a self-absorbed would-be rock star, discovers a more meaningful connection to music through his young students who become more important to him than his drive for personal success.

CHAPTER

4

CREATING CHARACTERS' OVERALL PERSONALITIES AND FLAWED BELIEFS

Our job as writers demands we create three-dimensional characters—those the audience will both believe and care about. This requires we write our characters with identifiable personalities, complete with believable reasons for their flaws we both wish to highlight and have them overcome in the course of our fictional narrative.

The truth is that we all incorporate our flawed beliefs into a more general worldview. It's important to see how that broader view affects our attitudes and behavior and values, especially if these are the belief systems we want to explore and change within our main characters.

The following list of problematic belief systems shows how flawed views can negatively affect our perceptions on many and broad levels—and helps explain how and why our characters develop their recognizable three-dimensional, flawed personalities.

Jeffery Young, Ph.D., has developed a list of Early Maladaptive Schemas we are going to use [Schema Therapy Institute, 561 10th Ave., Suite 43D, New York, NY 10036], which could also be called a list of generally inaccurate, painful, and dysfunctional worldviews based on flawed beliefs.

Read them and think how each allows you to portray and chart a character's journey toward learning the important positive life lesson you wish to share with your audience.

Of course, our characters can learn their lesson too late or not at all. In those cases, we could call these types of stories tragedies or cautionary tales. But your emotional case is still made because your audience has learned the lesson your protagonist didn't.

OK, here are eighteen generally flawed worldviews (schemas) fiction writers have explored for thousands of years, across age, gender, nationality, race, status, and various religious and political beliefs. These categories are, in effect, universal, and that's why audiences both bond with and root for your characters to overcome their inherent limitations.

1. ABANDONMENT/INSTABILITY

The perceived instability or unreliability of significant others for support, connection, and protection, because they are viewed as emotionally unstable, unpredictable, or likely to abandon and/or disappoint others.

You can see this as creating a way of life leading to isolation, paranoia, lack of close friendships, and a lack of trust in others, and even in yourself. The resulting loneliness, coupled with a lack of self-regard, can turn into anger against the world and against the self. This can lead to disastrous interpersonal relationships, shaky job performance, and a reluctance to collaborate with and trust others.

Now, thinking as a writer, what contrary circumstances and events could challenge this warped worldview into something more balanced that portrays others in life more accurately in terms of their general reliability and emotional stability?

What coping mechanisms would a person with this unbalanced view use to protect him or herself? Would he be perceived as cold, too independent, non-cooperative, or anti-social? And how else will this view interfere with a fully mature response to new circumstances and relationships?

And even if your theme or life lesson is that people close to us are significantly unstable and unreliable, and we need to be wary, what journey and personal values do your characters need to best learn and deal with that fact?

That's how we begin to sketch out a character's journey from one world-view to another. We start by understanding why and how a character has fallen into and adopted this overarching maladaptive perspective and how it displays itself in the character's daily life. We then start to map out a journey that challenges this worldview and leads our character to shed these dysfunctional, broad, and deep perspectives.

We'll get into exactly how to write and structure these journeys (stories) in later chapters, but for now it's only important that you can see how these neurotic, wounded, general beliefs come to be and how they define central aspects of a character's overall (initial, dysfunctional) personality.

Once you can truly understand how they reflect real people's struggles in life, the easier it is to connect with your audience and to structure a story that teaches how to let go of these warped and hurtful attitudes in favor of a more healthy perspective.

Here are the rest of Young's maladaptive schemas. Look to each as the beginning of a potential story idea that personally resonates with you. Once you recognize your own relationship to these misguided perspectives, the more you can write a persuasive, fictional, maturing character. And this works even if you only recognize these traits in others. With this knowledge, you can write other characters with a compelling sense of emotional truth.

OK, let's see how the rest of these maladaptive schemas are perfect jumping off points for storytelling.

2. MISTRUST/ABUSE

This schema outlines a character's expectation that others will hurt, abuse, humiliate, cheat, lie, or take advantage. It leads to the belief that one is cheated out of what one wants or deserves in life.

Can you come up with coping mechanisms a character would use in the face of this view of fate and other human beings?

That's where we meet our main characters—watching them using their dysfunctional coping mechanisms.

Would this kind of character be more likely to be overly aggressive and greedy? Or would a person like this bitterly remove himself from any situation in which trusting another person is necessary? And how would you think the course of the story you create could illuminate a more accurate, healthy, and benevolent worldview?

3. EMOTIONAL DEPRIVATION

This leads to the belief that a normal amount of emotional support will be absent in life. Emotional deprivation can include an absence of affection, understanding, sharing of feelings, and guidance from others. In effect, these can be listed as general deprivations of nurturance, empathy, and protection.

Everyone's felt this way to one degree or another. Dig into yourself. How did these beliefs make you feel? Were they accurate assessments? If so, how do you want your character to best cope with this view? If the character did suffer from emotional deprivation, how did it create initial dysfunctional coping strategies? How, given your insight, do you want to portray your character's struggle in a world where he initially believes everyone is on his own?

4. DEFECTIVENESS/SHAME

This includes the feeling that one is defective, bad, unwanted, inferior, or invalid in important respects—or that one would be unlovable to others if exposed.

What kind of behaviors and attitudes are illustrative of this problematic and inaccurate attitude? Your character could express this view through hypersensitivity to criticism, rejection, and blame, along with a disproportionate feeling of shame regarding one's perceived flaws.

Or these overarching reactions can result in shame over one's private feelings or shame about external characteristics such as physical appearance or social awkwardness.

How would you tell a story about a character's path to a more healthy sense of self-esteem? Can you use any of the lessons you've learned in your own life that will give the audience a sense of hope and healing? What would that path—written as a story—look like?

5. SOCIAL ISOLATION/ALIENATION

The feeling of being isolated from the rest of the world, different from other people, and/or not being part of any group or community.

How would a character you create initially react to or cope with this skewed view of self? Would a person like this be more likely, for instance, to be addicted to the Internet—in a desperate attempt to connect with, yet keep a safe distance from, others? Would a person with this attitude be more likely to fall into the perceived safety of role-playing games, creating avatars, and investing way too much emotional capital in living the life of a created, virtual personality? Would this person avoid being caught in situations with strangers? Avoid social engagements? Retreat to work that can only be done alone? Would this person develop a fear of venturing outside, becoming housebound and agoraphobic?

And for the storyteller in you—how would you create a narrative through which your character challenges and ultimately defeats this harmful, constricting view?

6. DEPENDENCE/INCOMPETENCE

The view that one can't competently deal with everyday responsibilities without significant and continuous help from others.

This creates a generalized feeling of helplessness with regard to self-care, tackling new problems, and making good decisions.

Does this schema remind you of yourself at any point in your life? What was the situation? Did it relate to school, job performance, choice of friends, or intimate relationships? How did you learn to feel less dependent on others and how did you finally build a more healthy sense of general competence and independence?

This is an easy area to illustrate with life examples. We enter life completely dependent on others, and we all share the same types of trials as we attempt to be independent and competent adults. Where does your creativity take you when you let your imagination run free? Do you remember particularly difficult chapters growing up? We all have them. What would be your most important coming-of-age story?

Or does your mind take you to your current life situation? Do you feel you rely too much on others to get through the demands of your day? How does that attitude affect your decisions regarding new challenges and opportunities that present themselves?

Do you feel you depend too much on people whom you believe don't really have your best interests at heart? Are you in an intimate relationship plagued with an unhealthy degree of dependence on your partner? What would that unhealthy dependence look like in your story, and how would you lead your character to learn to create more balanced and mature relationships?

7. VULNERABILITY TO HARM OR ILLNESS

This involves the exaggerated belief that catastrophe waits just around the corner, which the person feels unable to prevent. These unfounded beliefs can manifest as extremely unlikely medical concerns, fear of imminent emotional breakdowns, and unreasonable fears of external disasters such as earthquakes and of becoming the victim of crime.

What kind of character backstory would generate these beliefs of overestimated vulnerability? What events or examples gave rise to this problematic view by your character?

And again, if your considered belief is that the world is much more dangerous than people acknowledge or prepare themselves for, how do you demonstrate that? What does your lead character need to encounter, get hurt by, and learn from to convince the audience, along with himself, of the precarious nature of human existence?

Take note that the course of your story will serve as the emotional proof of your message to your audience. So, whether your message is one of learning to trust one's sense of general safety in the world, or the oppo-

site, our job as writers is to create a journey of events and character reactions that illustrate our point of view.

In other words, the story you create must serve your theme or life lesson. And to do that, we must both see and know how a person credibly moves from one set of beliefs to another.

What are the specific encounters and decisions that lead your character to a belief system you're trying to promote? And is your character's behavior convincing as the story unfolds?

Remember, if your character's reactions to events in the story don't ring true, you've both lost the argument and your audience. We must believe what the character thinks, believes, and acts every step of the way in the stories we create.

Keeping ourselves emotionally honest in everything we write is the *sine qua non* of professional and meaningful storytelling. Indeed, the emotional honesty of your story, and the verisimilitude of your worldview, is the only real currency needed or useful in creating effective, emotionally convincing fiction.

8. ENMESHMENT/UNDEVELOPED SELF

This involves an unhealthy emotional closeness to others that stultifies both personal and social development. This also can be referred to as co-dependence, the belief that the self or a significant other cannot function or be fulfilled without the constant support of the other.

This insufficient sense of individual identity can spring from various dysfunctions appearing early in life. Is your character's father controlling? Is the mother smothering, trying to protect her offspring from all the challenges that are needed to promote growth, maturity, and individuation? Is a couple so enmeshed that each partner loses a sense of individual identity and individual self-worth? Why is your character so prone to latching on to others instead of having the confidence to rely on himself or herself?

Another arena where this dysfunction plays out regularly is in situations involving divorce. How many divorced custodial parents fill their emotional void by modifying the relationship with their children to that

of the missing adult? How many parents fail to raise their teenage children to be independent by treating them as friends and fully developed adults long before they have the necessary emotional and social skills to succeed?

And the situation is even more clear in the case of addiction. Does a parent, a partner, a child, or a friend protect the addict by covering up all the damage the addiction causes in personal, work, or social situations? How does the addict control those close to him? What does the non-addicted person in the relationship get out of this detrimental attitude and behavior? And how can both or one of them break out of this dysfunctional dance?

Addiction manifests itself in many areas other than merely substance abuse. And they all result in emotional enmeshment and a failure to develop a maturely interdependent relationship. Work, food, money, sex, Internet, exercise, even hobbies, and other benign goals and activities can be abused in an addictive manner. And when so misused, it's a sign that a person is trying to make up for some other deficiency or trauma he feels he can't control without the temporary relief the addictive behavior provides.

The goal then, across all issues of enmeshment, is to develop more independent, reliable, and balanced responses to one's perceived insufficiency and painful experiences. These stories deal with how and why a character initially turns to the relief of addiction and how he or she fights her way out of these pernicious coping mechanisms.

These are all burning, real-life questions, with serious, negative consequences for those trapped in these kinds of hurtful, emotionally and medically dangerous life strategies.

What is your personal answer to the question of your responsibility to those who are overly dependent on you or others? What does your experience have to say about times you've been too dependent and insecure about your sense of self?

Where do you personally draw the line between a loving, concerned relationship and a smothering, immature dependence of one person on another? If you've had to work through relevant situations in your own life, what were your mistakes and successes? What has been your journey out of the pain caused by covering up one problem with another,

more dangerous one? And how do we, the audience, become convinced of the hope provided by your example?

9. FAILURE TO ACHIEVE

The exaggerated, dysfunctional feeling that one has and will continue to inevitably fail in traditional arenas of competition, such as school, jobs, and sports. This is often tied to the belief that one is inherently inept, stupid, untalented, and thus lower in career status than others. It also includes the false belief that there is no hope for change in this area of life.

OK, we've all been here at one time or another, but the difference between normal disappointment in self and this powerful negative schema is one of magnitude, breadth, and depth of this painful belief system.

How did you react when occasionally feeling this way about the professional aspects of your life? Can this give you a clue how bone-crushing this self-limiting belief is when generalized into a worldview about how one doesn't fit in or isn't as valuable a person as others?

What would your fictional character do to cope with this generalized negative self-assessment of professional competence? Would the character stay on the job for hours every night just to catch up with what he perceives his peers are accomplishing?

Would the person lie to others (and himself) about his accomplishments to cover his feeling of inadequacy? Would such a person be tempted to take credit for the work and success of others?

Or would the character be reluctant to enter the fray of competition at all, feeling that participation would only result in more stinging, obvious failure? Would this warped worldview result in low expectations in the quest for work competence and fulfillment of life?

How empty and painful are the results of such a belief, and how does that damage other aspects of life?

For instance, how would this attitude reflect itself in dysfunctional strategies for romance and interpersonal intimacy? Would such a per-

son aim low in the quest for a life partner, believing that one had little to offer compared to most other people?

What kind of parent would this person be? What implicit messages would such a parent be giving to his children? In what way might this painful belief be passed on from one generation to another, both consciously and unconsciously?

And since we've all been there at one time or another, how did you break free from these self-limiting and severely self-critical beliefs as they popped up in your life? What contrary evidence in your life finally exposed this feeling as inaccurate, and how were you finally able to practically overcome this problem?

Were you ever able to help others out of this or a similar issue? What advice would you give or have you given to a friend who was suffering from an exaggerated negative belief in his professional worth? And where did these more healthy beliefs come from in your life? What experience helped you to see yourself and your accomplishments in a more balanced, and thus accurate, way?

I hope that this category, experienced by all, reminds you of both the pain it induces and your path out of it. Whether you as a writer see this in yourself or others, you're focusing on a universal dysfunction, and that should spark your imagination and help construct stories that illustrate both the problem and its solution.

It is essential that any story you write have this universal appeal. We care when we can empathize with the character's plight when we've been down a similar road ourselves. That's where self-knowledge helps define the problem and our way out of it. Personal experience brings a sense of emotional truth to the entire situation and is therefore a powerfully effective tool to use in your writing.

10. ENTITLEMENT/GRADIOSITY

On the surface, this manifests as the belief that one is inherently superior to other people and thus not bound by the rules of civility or cooperation with society in general. This results in the belief that one deserves whatever one wants, without regard to others.

It also can turn into an intense competitive need to be extraordinary in the fields of success, wealth, fame, power, and influence. And this sometimes shows as the need to control or dominate others, without concern for the needs, feelings, and welfare of others.

At first glance, this category seems like the opposite of the one previous, Failure to Achieve. When viewed in others, it seems it results from an unappealing combination of selfishness, self-centeredness, and egocentricity. And on one level it is.

But both your experience and intuition have probably taught you that others with a grossly expanded sense of self-importance are really enmeshed in desperately creating a desired reality out of an often unconsciously perceived need for self-deception.

These very people who drive us crazy with their vocal self-importance are the same ones who privately (and admittedly sometimes unconsciously) have the lowest self-esteem of all.

This category is intimately tied to the last one, Failure to Achieve. Once we see this issue as two sides of the same dysfunction, we can pierce through the layers of self-defensiveness and self-delusion that lead to this gross and false elevation of self-importance.

This emotional investigation reveals the exact same base-level insecurity that tortures those with low overt self-esteem and feelings of incompetence.

This raises the question of how a character would choose this behavior and attitude as a coping mechanism for a damaged sense of self and significance.

Would the character you write be aware (or even partially aware) of this self-deceptive attitude? How deeply do you believe this kind of self-deception burrows into the soul of an afflicted individual?

Do you believe people with this problem can grow out of this painfully immature attitude alone, through a rigorous self-examination? Can people be loved out of this distorted view of self? Or does your experience with people like this lead you to believe that only severe, punishing consequences will ever be able to stop people from using this crutch to feel better about themselves?

Whatever journey you pick for your character should reflect your optimism or pessimism regarding people's ability to change and grow.

11. INSUFFICIENT SELF-CONTROL/SELF-DISCIPLINE

The lack of self-control can result in the inability or lack of desire to restrain one's difficult emotions and impulses. You can see how this belief leads to behavior that artificially limits one's productivity.

More importantly, a lack of appropriate self-control can lead to intimate relationship breakdowns, loss of jobs, and an alienation of friends and acquaintances. It can also result in anti-social behaviors that are extremely damaging to self and others.

Surprisingly, in its less severe manifestations, this emotional insufficiency often results in general avoidance of the normal challenges in life. To feel in control, these characters excessively value the avoidance of pain, conflict, responsibility, and overexertion. The price paid by this life strategy is a serious diminution of personal fulfillment, trustworthiness, commitment, and credibility.

And even more commonly, a deficiency in self-discipline damages more personal, private aspects of a person's life. Over-eating, substance abuse, lack of financial responsibility, and a perceived lack of concern for others are typical results of this deficiency of self-control.

From a writer's point of view, how would you paint this kind of character in your narrative? Do you want the audience to feel sympathy for your character's self-destructive behavior? Are we supposed to be outraged, and demand punishment for a character's emotionally stunted reaction to life and relationships?

What in your character's backstory lead to this inability to control self at the most basic levels? What is your relationship and attitude toward those you know who exhibit these behaviors?

What makes you angry and what makes you sympathetic? What kind of story will you construct to convince us of your belief? How do you see a person growing out of this destructive constellation of behaviors?

12. SUBJUGATION

The excessive relinquishing of control to others as a result of feeling coerced. This coping strategy is typically used to avoid anger, retribution, or abandonment. It can manifest as an unhealthy deferral of one's preferences and desires to another.

This stems from a belief that one's feelings and opinions are not valid or important to others. The attitude can result in inappropriate compliance, coupled with the feeling of being trapped, resentful, and ignored in personal and professional relationships.

This results in pent-up anger that can't be expressed appropriately and therefore often leads to passive-aggressive behavior, outbursts of temper, withholding of affection, and substance abuse.

This schema is another that most people have experience with in their personal lives, to one degree or another. What is your experience of unhealthy deferral of your opinion and needs to a co-worker, boss, or emotionally significant other? How, in your experience, did you overcome situations and relationships like this?

Or is this a maladaptive coping strategy you've seen manifested in others? How did you feel about people in your life misbehaving in this way? Since we can't really change others—especially their core dysfunctional coping mechanisms—how did you solve a problem like this? Did you talk it out, fight it out, or abandon the relationship? Or did your journey take you through all of the above?

How would you take a character with this attitude through a narrative leading to self-respect, emotional growth, and independence? What hurtful behaviors result on both sides of a relationship because of this skewed belief?

Whom do you feel primarily responsible for continuing and solving this pattern? Is it the passive or the demanding party? Who is most responsible for creating and ending this painful style of interaction?

And when do you believe a person hurt by this dysfunctional, domineering dance has the right to fight back—and in what way? How do you believe a healthy adult should respond to situations that devolve to this level of dysfunction?

Are there good guys and bad guys in this scenario, or are both equally guilty of not respecting the personal, emotional boundaries of self and other? Your answer to these questions determines the plot of your story and the message it gives to your audience.

13. SELF-SACRIFICE

Usually thought of as one of the greatest human virtues, self-sacrifice can be severely destructive to ourselves and our relationships. This occurs when a person feels compelled to meet the demands or perceived needs of others at the expense of his own core needs.

This can develop from an attempt to avoid guilt or accusations of self-ishness by deferring one's needs to an unhealthy extent and from a desperate attempt to maintain connections to those who are perceived or declare themselves to be needy.

A common reaction to this kind of unbalanced relationship is an acute, and sometimes unconscious, resentment of those one feels duty-bound to protect or take care of. And this type of codependent relationship rarely solves itself on its own. So what would be your strategies to identify and disentangle this pattern of behavior?

Where have you seen this dynamic in your life? Do you see friends and family members trapped by this self-depleting attitude? How do you feel when those close to you are suffering from this type of self-neglect, with the justification that they are simply being a loving and caring spouse, parent, or friend?

Can you see this dysfunction more easily in others than you do in yourself? What kind of justifications have you made for sacrificing yourself in the name of love, morality, or expediency? How would you, as a writer, talk or write yourself into a healthier means of relating to others? What arguments or contrary values are more compelling to you?

And how would you define the healthy limits of entanglement in other people's lives? It's not a virtue to be selfish, but where and in what situations do you draw the line, and why?

The answers to this can be situation-specific and fluid, but the danger remains in avoiding one's legitimate expectation of emotional reciproc-

ity with those close to you. The answer is in seeking a mature give-and-take with others. But can you dig deep inside yourself and see why you (and your characters) might find a compulsive, dysfunctional emphasis on self-sacrifice to be a difficult pattern to break?

What is the most helpful attitude toward sacrifice in your life? How much one-sided sacrifice do you really believe is necessary to being a good person, lover, or parent?

Remember, our society lauds stories of sacrifice, and these stories can help generate genuine compassion, tolerance, and understanding in others. The question here is how and why this selfless instinct can transmogrify into an unhealthy, self-limiting chain, preventing a person from having a free, balanced relationship with self and other. And your stories based on this schema should show a specific path to this necessary illumination.

14. APPROVAL-SEEKING/RECOGNITION SEEKING

Again, a painful attitude and pattern of behavior that is familiar to most of us. The core of this dysfunction is an inappropriate and extreme emphasis on fitting in, by gaining the external approval or recognition of others, at the expense of developing an accurate and secure sense of self.

When a person's sense of self-esteem is primarily dependent on the reactions of others, as opposed to one's personal values, an overemphasis on status, appearance, money, and public success is the strategy employed to achieve people's approval and admiration.

Have you ever looked back on your life and seen this pattern in yourself or others close to you? Did you ever pursue a job offering traditional success, only to be blindsided after its attainment by the realization you hated doing the actual work? That's a good litmus test for the soul-sick ailment of pursuing artificial goals in the quest of external societal approval.

Approval seeking is something to grow out of as we mature and discover it is useless to our general need to live by our core values and beliefs.

And it's important to realize the obsessive pursuit of recognition and approval blocks out huge areas of joy, creativity, connection, and fulfillment, whose softer, internal voices are heard only when the siren call of false values is discovered to be empty.

This is a rich area for American storytelling, as our society has yet to learn this lesson, and people need to find a more selfless set of values once their old, dysfunctional ones are abandoned.

15. NEGATIVITY/PESSIMISM

Characterized by a general, intense focus on the negative parts of life, including death, loss, betrayal, difficult personal problems, as well as the belief that anything could go catastrophically wrong in life at any time. At the same time, people suffering from this maladaptive schema almost always minimize or ignore the positive and optimistic aspects of life.

This unbalanced worldview includes the belief that the areas in life which are going well are only temporary conditions, and that anything that is going well is ultimately doomed to fall apart—permanently and often with no notice.

The exaggerated fears of people or characters caught in this negative schema focus on the likelihood of making mistakes that will result in serious loss, humiliation, and a feeling of being trapped by life circumstances.

The symptoms that signal these overblown fearful, negative beliefs also include chronic worry, hyper-vigilance, complaining, and indecision. You can see how a character suffering from these inaccurate negative views of life can feel hopeless, ineffective, and even resentful that the world is against them.

Making things worse, this kind of overarching pessimistic and fatalistic view of life contributes to a universal sense of paralysis and futility in personal action and responsibility.

How would you write such a character? Would you picture him or her as depressed, sluggish, and lacking in ambition? Is this kind of person

likely to exhibit self-harming or unhealthy habits to cover the pain of disappointment in life? Or would you imagine the character feeling intense rage at the unfairness of life and acting out in an antisocial manner? Would this warped worldview lead to passivity and a tendency to latch on to others whom the character believes are more in control of the vicissitudes of existence?

And most importantly, how would you write the journey of such a character to the realization of a genuine assessment and appreciation for the positive in life?

Also, if the worldview you want to communicate to the audience is one of danger and disappointment, how would you write a narrative that helps prove this view? If you as an artist are convinced your audience needs to be warned against being too optimistic and naïve, how would you lead your character to this realization over the course of a story?

Either way, this schema challenges us to have the courage to look life straight in the eye. And that same courage is a lifeline to developing a new, reconsidered sense of one's meaningful place in life, be it a negative or positive view of one's ability to influence circumstances, both internal and external.

16. EMOTIONAL INHIBITION

This involves a character's intentional or unconscious squelching of emotional or behavioral spontaneity—out of fear of disapproval, shame, or losing control of one's impulses. It typically involves the coping mechanism of excessive emphasis on rationality at the expense of ignoring or dismissing important core feelings, beliefs, and emotional and spiritual connections to life and others.

The most common areas of emotional inhibition involve suppression of our anger and aggression; the strangling of positive emotional impulses such as joy, play, and affection; the difficulty of expressing one's vulnerability and private needs; and a destructively defensive dependence on rationality at the expense of experiencing the totality of our real emotional selves.

It's easy to see how this life strategy can cause severe stagnation in a person's emotional development. The most important, personal aspects of life demand an emotional response from us, for that is how we identify and place value on the most intimate of our experiences.

A stiff, overly rational and emotionally controlled reaction to our lives cuts out half of our humanity, and we become blind to that part of ourselves that recognizes and responds to the deepest unplumbed emotional forces in our consciousness.

The challenge is not to avoid pain or confusion in life, but to delve into the unknown and initially frightening aspects of our interior selves. An acute awareness, willingness, and courage to become familiar with our contradicting, unconscious, emotional selves place us on the path to becoming a fully developed human being.

Joseph Campbell, the mythologist of the hero's internal journey, encourages a full immersion into the unfamiliar, amoral, emotional, essential parts of ourselves to find spiritual depth that defines the full flowering range of the human experience "It is by going down into the abyss that we recover the treasures of life. Where you stumble, there lies your treasure. The very cave you are afraid to enter turns out to be the source of what you are looking for. The damned thing in the cave that was so dreaded has become the center."

17. UNRELENTING STANDARDS/HYPERCRITICALNESS

This is the debilitating belief that one must hold oneself to exaggerated, internally, perfectionist standards to avoid what is perceived as unbearable criticism from others. This dysfunctional view of one's competence and self-worth can also lead to overly demanding standards for others.

This damaging schema results in a significant reduction in a person's sense of pleasure, relaxation, health, self-esteem, feelings of accomplishment, and satisfaction in personal relationships.

Characters struggling with this skewed worldview typically underestimate the quality of their own performance relative to others, build rigid rules in many areas of their lives, including unreasonably high moral

and religious standards, and are preoccupied with the notion that there is never enough time to accomplish their essential tasks.

Do you have any personal experience with the negative results of adopting unrelenting standards in often varying areas of life? Is it a battle you are aware as having raged inside you? Do you see it in others, along with the resulting pain and diminution of healthy, happy experiences in their lives?

How would you, as a writer, describe the effects of a character being hypercritical of self and other in routine aspects of life outside of work? How would this worldview affect friendships and intimate relationships or the assessment of the quality of one's private life?

What would a person with this oppressive, intertwined, and inaccurate belief system feel with large amounts of free time, not tied to any resulting sense of approval or disapproval from others? Would he feel timid and paralyzed without positive feedback from others? Or would you see this type of character as a gruff, humorless, workaholic, intolerant of others' weakness and foibles?

How would this perfectionist attitude affect one's self-care and physical health? Would such a person avoid going on a diet or starting an exercise program without first believing in the certainty of significantly uncommon success?

How would this view relate to a person's sense of the value of risk-taking? Would such a person reach for impossibly high personal and professional goals—or would he make a point of avoiding any challenge that isn't guaranteed to work out favorably, as judged against these self-imposed unreasonably demanding standards?

Would such a person lean heavily on others' assistance and support out of a fear of never meeting high internal standards? Or do you see a character with this view as fiercely independent, private, and secretive about his activities and goals out of a fear of public failure and humiliation?

What would be your solution to this kind of debilitating problem? How would you describe a balanced worldview of self and other, and what narrative journey would lead your character and your audience to this more healthy realization?

18. PUNITIVENESS

This is a related attitude to that of unrelenting standards and unwarranted self-criticism. You can see how these impossibly high standards could lead to the belief that people should be harshly punished for making mistakes.

When caught up in this mindset, people can behave in an angry, intolerant, impatient, and punishing manner with those who do not meet their expectations. Again, this abusive attitude can be turned against oneself as well, with devastating, life-constricting consequences.

One of the most destructive results of this belief system is an ossified inability to forgive.

This is fueled by a refusal to allow for human imperfection, or an inability to understand and empathize with the struggles and difficult feelings of others. The result is often a self-imposed isolation as a result of one's demonstrated harsh judgment of the people who would normally be part of a healthy, interconnected set of friends, workmates, and family.

Those with a punitive worldview might also find it difficult to find the value in compromise or to see the merit in diverse views and beliefs. This can lead to a myopically self-centered, offensive, and stagnant view of right and wrong.

All of these dysfunctional behaviors interfere with the flexibility needed to learn new values or a broader, more tolerant, accepting view of people and the world.

Thus, people acting on this stiff and brittle platform of belief can appear to be overbearing, aloof, and full of negativity. Friendships can become superficial and tangential to what's important in a relationship as a way of avoiding arguments and the constant alienation of others.

And such people inevitably also suffer from loneliness, self-loathing, despair, and distrust of others.

Do you see this maladaptive trait appear occasionally in yourself or those around you? What do you tell yourself when caught in a feeling of punitiveness? How have you seen it hurt yourself and your relationships?

And most importantly, how would you use your creative writing to demonstrate the harmfulness of this attitude, as well to show the path out of this self-imposed pain and alienation? What kind of journey would you write for your character? What do you believe a person with this problem needs to learn? And how would your character behave believably every step of the way out of this dark night of the soul?

In essence, do you feel people misbehaving in this way should be punished themselves, or do you see a more compassionate means of helping them be more forgiving and accepting of their own and others' real-life imperfections?

What do you do when life goes wrong and you feel you have to take a corrective course of action?

Joseph Campbell presents the challenge to let go of punitive, self-harming beliefs and assessments.

> "Whatever your fate is, whatever the hell happens, you say, 'This is what I need.' It may look like a wreck, but go at it as though it were an opportunity, a challenge.

> "If you bring love to that moment—not discouragement—you will find the strength there. Any disaster you can survive is an improvement in your character, your stature, and your life. What a privilege!! This is when the spontaneity of your own nature will have a chance to flow.

> "Then, when looking back at your life, you will see that the moments which seemed to be great failures, followed by wreckage, were the incidents that shaped the life you have now. You'll see this is really true.

> "Nothing can happen to you that is not positive. Even though it looks and feels at the moment like a negative crisis, it is not. The crisis throws you back, and when you are required to exhibit strength, it comes."

> ~ Joseph Campbell Quotes

Can you chart the necessary emotional steps in the transformation from punishing negativity to a more benign view of difficulties and imperfections life presents? How real does it feel to you? Are you convinced by your own arguments? What would a person's behavior look like before, during, and after embarking on such a belief-altering journey?

You might initially think and feel that some of the previous maladaptive views of life are devoid of the specificity and particular examples you need in your quest to build a story.

That's OK. But know it's your job as an artist and writer to ultimately discover the particular ways your character manifests these faults and the path to their resolution. In the end, it's all personal. But we can provide some guidelines in the following chapter.

What matters first is you understand the general foundation or source of the misbehavior you want to portray in your character at the beginning of the narrative.

And you can add to and modify this list of maladaptive views of life. You're the writer. You have the power to convince us of other general human flaws that need to be addressed to create a better life, both individually and collectively.

And now we move on to creating the individual characters you choose to follow the emotional path to learning your life lesson.

Groundhog Day

Phil Connors (Bill Murray) is an arrogant and egocentric TV weather-man who during an assignment to cover the annual Groundhog Day event finds himself in a time loop, repeating the same day and his personal flaws again and again. He finally learns to re-examine his life and priorities, using his experience to help local townspeople, save lives, and ultimately to find love.

CHAPTER

5

CREATING AND USING THE SPECIFIC CHARACTER TRAITS OF YOUR FLAWED PROTAGONIST

Character sketches/outlines—you've probably heard writers talk about creating them first—are the particular traits that cover and explain all aspects of their individual characters in the story they are trying to create.

Some call this creating an individual fictional biography, outlining everything about your characters' lives from infancy to adulthood.

This can cover everything from what kind of cereal and toothpaste they prefer to what interesting quirks they might have that make them seem unique. It also can include what they hold in common with all of us, thus making the characters believable and recognizable.

Often, character sketches can be enormously detailed, covering every emotion, attitude, and behavior that make a character seem real to the audience.

New writers often describe the backstory of their characters in minute detail (creating biographies the viewer or reader never sees), hoping that will be their key to understanding their own characters' behavior and attitudes from the story's beginning to its end.

What I'd like to propose here is that character sketches, including back-stories, while potentially enlightening and emotionally true, can end up as writers' handcuffs.

Detailed character sketches can easily shackle the writer into writing scenes that are off point or don't make sense.

More dangerously, these jumbled sets of personality traits can careen off theme into myriad dead ends and pointless avenues of action that inevitably morph the story into mere plot.

And remember, mere plot on its own is only a series of events with no inherent meaning when taken together as a whole. This is true no matter how dramatic these events might be to the viewer or the writer.

Thus plot is the mortal enemy of attempting to write a meaningful story that reflects your worldview and the particular life lesson you want your character to finally embrace.

Cramming in every random interesting detail that comes to mind while creating characters forces writers to fruitlessly explore each of those as plot points.

This tactic inevitably gets writers and characters entangled in dramatic event after dramatic event, ultimately becoming unconnected and leading nowhere, creating a hollow, unsatisfied feeling in both the viewer and the writer.

Working from a convoluted character outline comes at the expense of creating a well-chiseled protagonist who otherwise would be believably written, thematically relevant, and who embarks on a focused thematic journey to learning the life lesson the writer originally intended.

In essence, there is a double threat to writers at the beginning stages of creating a story.

The first danger is starting the story having created a preconceived set of events (plot), with no coherent theme or life lesson the story events must conform to and illustrate.

The second and more insidious threat at the beginning stages of creating your story is creating detailed, intricate, emotional true biographies that inevitably end up as a hindrance or a complete roadblock when putting your characters into action.

How can this happen, especially if the character sketch and backstory make some sort of sense on the page? How could a believable character outline be the biggest impediment to getting your story told?

The answer is that character outlines are like nitroglycerin in the hands of a new writer.

When delving too deeply, widely, and specifically into a particular character out of context, there is always the likely threat that the whole story will blow up in a new writer's face.

And all the while the writer is befuddled as to why the character has suddenly become intransigently out of control, hell-bent to take another path (plot) from that which the writer expected or wanted.

For instance, it might seem fascinating that a character is a Mensa genius, a wounded and proud Iraq war veteran who has a phobia of spiders and bugs, a person who doesn't trust or like children (because of his backstory of being bullied), who dreams of becoming an astronaut, and is simultaneously grieving the loss of his alcoholic mother who ignored him during his youth.

That's an interesting character, no doubt. And it could be argued that all those aspects of his personality can fit together in a coherent and believable way.

But where does that take the writer who is now stuck with this character and has to put the entirety of this fictional construct of a personality into action?

The answer is that overly detailed, non-thematic backstories always take writers into a mindset of creating multiple, unrelated, plot-driven story threads.

This approach to storytelling results in writing mostly plot and creates a combination of scenes that ultimately don't fit together.

And thematically irrelevant character sketches can easily hijack the narrative into merely showing a series of unrelated dramatic events, thus destroying the comprehensibility and meaning of the writer's original story idea.

Why is this so gravely important, and why is this true?

Because a well-written story isn't about everything interesting you could say about a given character. A story has its own emotional logic,

and that logic should always center on the intended theme or life lesson you want your character and audience to learn.

This idea of thematic coherence is one of the most important concepts to understand before beginning to create character.

Almost all new writers make the mistake of either telling too little or too much about what's relevant to the protagonist learning the life lesson of their stories.

And new writers then get hopelessly lost and frustrated when trying to write characters that embody all the possible aspects of a thematically disjointed personality they have cobbled together.

And this is the point when their stories crumble into dust.

Trust me, the biggest problem new writers have is substituting shocking plot points like a murder or a fatal car crash or addiction or break-up, for emotionally coherent characters who come to challenge their central, dysfunctional beliefs.

So it's not really interesting or relevant that a character is all of these things:

A driven long-distance swimmer, and crooked Wall Street investment banker who's addicted to porn, a secret anti-Semite, a poor role model for his younger, impressionable cousin when it comes to dealing with women, a person who yearns to become a famous rock star in his spare time, who walks with a limp, and who is simultaneously a superstitious gambler and a devoutly, if hypocritically, religious fundamentalist.

If the theme of the story is about only one of these things, or worse yet, is thematically about something entirely different from and unrelated to what incidents take up most of the space in the story, the writer, and the character, become lost.

The lack of congruity between a character sketch and a theme can be illustrated by the example of a story where the personality characteristics outlined above are jammed into a theme centered on how a character comes to find peace with a cold and distant father with cancer.

In a case like this, everything is mixed up. And it makes no emotional sense.

There's just too much irrelevant information in the character sketch, and the theme (how to forgive a dying father) ends up having no relationship at all with the preconceived personality of the protagonist.

Whether we like it or not, writers must stick to theme as the true compass of how the actions of their characters play out.

We always should be working backward from the middle crisis point, starting with theme, before going forward writing the beginning of the story. There's simply no other way to organize and discover what we want to say.

I know this can seem counterintuitive to new writers, but bear with me on this. Think, how could a writer approach creating the beginning of a story idea a different way, maybe just with dramatic action, and move confidently forward from there? Would the following pages of the story outline simultaneously make sense to the writer, character, and the viewer/reader?

If you came up with "no way," you're beginning to understand.

Working from an infatuation with plot or a character's elaborate but incoherent story outline is the road to hell—paved with all the good intentions new writers always have.

I'm going to emphasize this point:

If writers start with plot and overly detailed character sketches, nothing they can do after the fact will save their stories from sinking in the quicksand of irrelevant scenes and pointless character behavior and action.

This is true no matter how cool and arresting you think your scenes and characters are.

That's the hard truth and the tough love I give to all my student writers on a daily basis. You must be willing to kill your darlings to have the perspective on what you're trying to write and why.

If you don't believe me at first, that's fine. As a teacher and as a writer, I understand how hard it is to let go of what comes naturally to us when approaching a new story idea.

But I'm here to say that what comes naturally is almost always a fatal error of perspective. There is no way to write a successful story without first addressing the central question of what a writer wants to say and why.

And even if you find yourself in love with all your scenes and characters, you must be willing to jettison them into oblivion when you notice that they don't fit with what you're trying to say.

And tossing out pages we were in love with is painful—always.

So you must always be ready, willing, and able to kill your darlings for the greater good of your original fiction when they cease to function solely as a handmaiden to your story's theme.

This advice is ubiquitous in all books aimed at helping new writers find their voice and worldview. This is not something I made up that applies only to my work and me.

This central piece of advice is so widespread that people argue about who came up with this phrase.

Variously stated as "kill your babies" and "murder your darlings," this phrase has been attributed to a string of writers from Faulkner, Wilde, and Chekov, to Stephen King.

It was actually conceived by the lesser-known writer Arthur Quiller-Couch in his 1914 Cambridge lectures "On the Art of Writing." He rephrased it in his 1914 lecture, "On Style," the theme of which was an attack on what he called the "Extraneous Ornament" of scenes and characters dear to writers that are unnecessary and irrelevant:

> "If you here require a practical rule of me, I will present you with this: 'Whenever you feel an impulse to perpetuate a piece of exceptionally fine writing obey it—whole-heartedly—and delete it before sending your manuscript to press. *Murder your darlings* (emphasis his).'"

Other writers have echoed this tough love approach to the teaching of creative writing. I like the quote from Stephen King:

> "Kill your darlings, kill your darlings, even when it breaks your egocentric little scribbler's heart, kill your darlings."

Why is this counterintuitive advice hammered home so coldly and unflinchingly? Because we as writers—young, old, famous, and new—all get caught in the trap of falling in love with a particular way of telling a story, and/or creating a character.

We writers deal with uncertainty, confusion, fear, and despair every time we sit down to write. This terror of facing the blank page is an unfortunate but unavoidable part of the creative process.

And it's a bitch.

I'm not going to tell you that this terror fades away with experience or professional success.

It doesn't. And thus it's important to face this fact and deal with it.

All writers, in the foggy process of creating a new story, yearn for certainty that they and their characters are taking the right path.

But, unfortunately, the desire for an objective assessment of creative success often drives writers to cling to the favorite parts of their work in a death grip of wishful thinking.

It doesn't take a grizzled professional to understand how this superstitious, needy clinging to certain parts of a story can come back to bite us.

We all repeatedly have to let go of the precious parts of our stories and characters that simply don't make overall sense and/or impede our vision of the solutions to our story problems.

And this takes guts as well as practice.

We have to learn to be at peace with the continuous and enormous feeling of uncertainty when tackling a story day-by-day and page-by-page.

We have to be able to step back and coldly, objectively assess the story as it progresses as a whole, with the mindset of a viewer or reader who has no attachment to any aspect of what is being created.

In essence, we all have to learn to be our most stringent, unforgiving critic, while at the same time learning to keep our ego, optimism, and faith in ourselves intact.

As creators of stories, we must rely on and trust in our emotional internal compass.

And that's a tall order.

When writing, we're walking on a tightrope with no net. And we know it. We want to be safe, at the same time realizing creative safety is an oxymoron and thus an illusion. Worse yet, writing safely chokes the life out of a story.

So how do we go about determining which of our babies need to be killed? That's a difficult question, but a crucially important one.

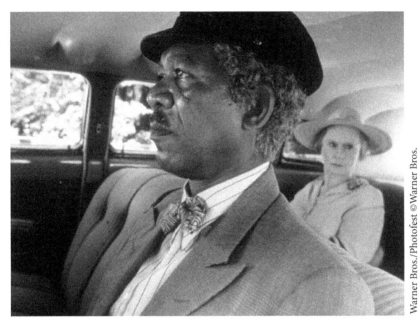

Driving Miss Daisy

Miss Daisy (Jessica Tandy) learns late in life to overcome racial preju-
dice and understand that her devoted driver, Hoke Colburn (Morgan
Freeman), is her closest friend.

CHAPTER

6

THE IMPORTANCE AND DANGERS OF FEEDBACK AND CRITICISM

It is not advisable to have no opinion on the quality of our work in progress. That is a passive way of making the same mistake described earlier, uncritically clinging on to what's already been written.

To evaluate our own work, we as writers need to be able to see the entirety of our script, novel, or play and all its component elements at the same time.

And that's tough, especially in the beginning of one's writing life. But the good news is that other people can often see what we miss when we become too enmeshed and too close to our work.

So feedback is essential.

However, new writers also make the error of asking for feedback from all the wrong people—in essence looking for love (of your story) in all the wrong places.

What are the most common examples of this? And what are the dangers?

The most pervasive mistake new writers make in looking for feedback on their stories is asking the opinion of friends and relatives.

Why?

It seems good friends and loving family members would be the perfect choice when asking for reactions to our nascent work.

The first reason to avoid approaching them for feedback is that it's almost certain that the friends and relatives aren't professional writers themselves.

This leads to all sorts of well-intentioned comments that totally miss the mark when it comes to helpful criticism.

Either they say, "This is wonderful, absolute genius—don't change a thing." Or they take a more critical stance, in effect saying, "Change everything, and write the story I would have written."

Neither of these approaches is helpful in the least. And that doesn't mean your friends and relatives aren't trying to be loving and supportive. They just don't understand how to offer comments in critical support of your project.

And often, all too often, the writer is actually being disingenuous when asking for feedback. We've all been there, asking for 100 percent unstinting praise and applause for what we've written and have no intention of changing.

That's not asking for feedback. That's a manifestation of our insecure egos dying for some third-party recognition of our inherent genius.

Again, all writers have been guilty of this craving for the uncritical validation of an audience.

At best, this kind of recognition is hollow and offers no advice on how to improve a story. At worst, we believe in the misguided advice to change nothing, or to change everything to fit another person's completely different story idea.

The most important things to avoid are kidding ourselves about our inherent greatness, or being too critical of ourselves and losing all faith in the story's potential for improvement.

And that's the tightrope.

This is a good time to make a distinction regarding the different perspectives people have when engaging in a story.

I call the different perspectives on a story "The Three C's":

Consumers of stories,

Critics of stories, and

Creators of stories.

What's important to recognize is that these three perspectives are incompatible with each other. They may well have nothing to do with each other at all.

Consumers (moviegoers, TV viewers, novel readers) are the least critically aware of why they like or dislike a given story. It's almost cruel to ask them why their gut reaction is either positive or negative.

That's how they consume storytelling, as an overall emotional experience, combined with their preconceived ideas when selecting the types of stories to which they gravitate.

Consumers can only tell writers if their reaction was positive or negative—but it's almost a certainty that they don't know why.

And that's OK. Their job is to react viscerally to the stories they encounter.

Writers live and die by consumers' reactions, but writers can't look to them for writing advice. That's the tough reality. We need them, but they can't help us.

Professional critics of stories seem like a better choice when looking for feedback. But they, too, have their limitations.

First of all, many, if not most, teachers of screenwriting have few or no professional writing credits themselves. That's an enormous red flag when it comes to reacting to and evaluating their criticism.

But talented, well-educated, broadly read critics do have the career experience and hard-earned insight it takes to identify and highlight the essential component parts of a story and to evaluate their effectiveness in creating a coherent worldview and theme.

Again, be careful which critics you adopt as your truth-tellers when it comes to evaluating a given piece of creative writing.

First, ask yourself, "Does this critic even like the same kind of stories I do?" Critics usually aren't able to tell us why they like or dislike a particular TV series or movie genre. It's in their blood, an almost gut reaction to the stage on which your life lesson or theme is placed.

Is the critic a fan of science fiction or family dramas, a harsh critic of teen movies or horror scripts? Is the critic left cold by melodrama, mere physical comedy, or farce? Is the critic an aficionado of romantic comedies or political intrigue stories?

It's important to understand critics' unconscious reactions to the various types of stories that make it to the screen.

Why?

Because that's the first overall attitude a critic unconsciously or consciously brings to another person's fiction writing.

It's essential to know these often unconscious attitudes critics bring to various writing genres, because critics' initial reactions to the type of story colors everything, right from the beginning at "FADE IN:"

For example, as a screenwriting teacher, I have to admit to my students and readers that I hold a strong prejudice against students mimicking traditional horror scripts.

And I equally dislike student scripts that are centered on action as the most important element, like those modeled on spy, sci-fi, and action thrillers.

But I also try to explain why those genres leave me cold, especially in new writers' hands.

And here's my reason: I'm both bored and irritated by student scripts that rely on plot to create the totality of what a script has to say.

And, believe me, studios, networks, and production companies feel the same way when evaluating a new writer.

OK, you're not shocked by my admission. This entire book is an attempt to get writers to approach their work from the perspective of theme and character.

But honestly, did you know why I dislike the action and horror genres in the hands of new writers before I mentioned it just now?

Step back. What do these story genres have in common that I (and potential buyers) consider professional suicide in the hands of new writers?

If you've been able to work backward from my reaction to various genres/types of stories, you will have seen that horror, thriller, and action scripts are almost always plot-driven and plot-centered, by their nature.

And what's the problem with that? You know by now.

Plot-centered scripts ignore the central necessity of taking a flawed character on a journey to learn a life lesson important to the writer and audience.

What is there for the audience to learn from the vast majority of action and shock-based stories?

The answer is nothing. Absolutely zero.

And why is this so important for new writers to understand and avoid in their own work?

First, plot-based stories seduce the writer into thinking that what happens in a story is inherently interesting and important.

It isn't. Ever. Please, trust me on this.

And no matter what you think, professionals who already are masters of plot-based story techniques have done it all before, often, and well. What room is there, then, for a new writer to say anything unique?

None.

Blindly adhering to the plot flow of a favorite genre-based movie gets the writer nowhere. Merely copying genre-based plot structures only scratches the surface of a story and shows a complete lack of understanding of what makes for a good, meaningful narrative.

Instead, creators of stories must learn the only thing that's important is a character's reaction to what happens. And that reaction is what

speaks to an audience and draws it in. We wait with anticipation for the protagonist to learn, or not learn, the life lesson the writer is trying to convey to us.

We also want to see part of ourselves in the story, and the only way for the writer to connect with us, the audience, is through the portrayal of a character who learns a life lesson we both can understand and appreciate.

Now, you might be thinking, "But I love horror or action movies and television. What's the harm in that?"

The answer is there's nothing wrong with enjoying what I call the guilty pleasure of viewing a movie or TV show that is solely intended to deliver smash-bang jolts of dramatic plot.

But these types of stories are generally hollow junk food for the soul. And studios looking for new creators of stories agree, even if they produce occasional plot-based stories themselves.

Buyers are looking for quality writing samples from new writers. And they judge them on the basis of theme and character, not plot or story concept.

As a mentor of mine at Universal Studios told me at the beginning of my career, "We're hiring you because of your ability to write theme and character; we can teach you the rest."

As mentioned earlier, there are few types of stories out there. Maybe the twenty-eight to thirty-five that the Disney executive asserted, but arguably one or two—a man goes on a journey, or someone comes to visit.

My mentor taught me that because the same few stories end up being repeated over and over, there's nothing original for a studio or network to evaluate in a plot-based writing sample.

These stories are usually told with no more engagement with the protagonist other than our interest in whether the character survives and finally vanquishes the bad guy.

I'm not saying that writing an action thriller or horror plot is easy. It took me many, many years of practice to be able to write an hour (TV)

or two (movies) of action and suspense that carries audience interest from beginning to end.

In the real world of my writing career, I've been hired to write my share of action and sci-fi scripts from *MacGyver* and *Baywatch* to *Swamp Thing* to what was judged as one of the top 10 scripts for *Star Trek, The Next Generation.*

Keeping the audience interested from beginning to end is a major challenge when writing what could be superficial action and sci-fi scripts.

My secret? No matter what the genre, I always make a point of writing a character who's flawed and learns an important life lesson in the context of the show's plot requirements.

But I also know when new writers rely solely on genre type or plot alone, they have drunk the Kool-Aid and no longer can assess the meaning and value in their stories.

That's why it is so, so important for writers to have a constant reality check at their disposal. And that only comes from having a small and trusted circle of other creators who understand the often-subliminal goal of all good storytelling.

Writers, both new and seasoned, always need feedback on their stories in progress. It's one of my central contentions that no one can have an accurate assessment of a developing story from an isolated writer's point of view.

But in choosing whom to trust with feedback, it's my contention that all writers should solely be guided by the opinions of fellow story creators, and the more experienced these people are, the better.

Critics might be good at explaining which elements of a story they like or dislike. But it's not the critics' job or area of expertise to understand and to explain how to fix the story elements they find lacking.

Just read or watch any critic's review of a movie or TV show. It is virtually never the case that the critic is able to communicate how and why a writer can improve a story they're reviewing.

Critics are closer to consumers of stories than writers when it comes to their lack of understanding of how to improve a given story.

And even if they could, critics' feedback would most likely only entail how to change the character or theme of your story into elements of their liking and preference.

So, unintentionally or not, critics and consumers of stories are uniformly unhelpful when it comes to offering advice as to how to adjust the character and theme to clarify the writer's life lesson from the writer's point of view.

We have to know and accept that limitation and not look to consumers or critics for guidance in creating or rewriting our story. Ultimately it has to be the writer's unique story and reason for writing it that counts.

No other reactions are useful.

If critics or consumers of stories knew how to write and to improve a script or novel, believe me, they would all be writers themselves.

It's not a matter of writers being superior to critics or consumers of stories. That's not my point. It's just a stark reality that only fellow writers understand how we create stories, from the inside out.

And thus only creators know the interior process that can help other writers improve and clarify the story and life lesson that was originally intended.

But one more caveat.

It's also not helpful for new writers to solicit opinions from other equally new writers. This happens often, and seems like a natural way to get feedback from people who are going through the same process with their own projects.

When new writers seek each other out for feedback, the inevitable result is as useless as the blind leading the blind. And thus the story in progress either becomes incoherent or drifts off into pure plot.

The only exception is when two or more new writers are in the same class, using the same book, and are taught the same theory and method of story creation.

Then, and only then, can new writers help each other build a story based on a book or teacher's well-tested writing model.

The circle of your trusted creator friends ideally should include writers who are much more experienced than you are. When tackling a particular story problem, it's often invaluable to have feedback from writers who have been there, done that—writers who have faced the same or similar problems and made the same mistakes themselves.

And you can judge the quality and effectiveness of any fellow writer's feedback easily. If the input helps guide a new writer to constantly rewrite and re-center each scene and character focusing on theme, the feedback is a helpful perspective to trust and incorporate.

If any writer's comments discard your theme and try to replace it with the life lesson they'd have preferred to write instead, such feedback is not only irrelevant, but harmful as well.

Valuable feedback is therefore any perspective and assistance that clarifies the new writer's theme and the character's journey to learning that life lesson.

When seeking feedback, it's important to know there's a trick to writing genre-based sci-fi, horror, and action scripts so they don't end up feeling like empty calories.

The trick is simple, but all too often ignored by new writers and by the people who offer their comments and perspective on a script.

And it is this: The action or plot of a genre story, no matter how shocking or surprising, must serve primarily as the vessel that both holds and protects the theme or life lesson.

Plot, even in horror, suspense, and action scripts, must only be of secondary interest to the writer and viewer.

Always.

Plot only works well when it supplements, but does not get in the way of, the thematic lesson.

Even in plot-heavy genres, writers can always rise above the usual limitations of those types of stories by following the same thematic rules applied to other scripts and genres.

So, before even coming up with the first steps of a plot-based story, the new writer in particular must understand and appreciate the central goal of telling any story.

And that goal, across all story types, is the creation of a flawed main character who learns (or fails to learn) an important life lesson that is of crucial, personal importance to the individual writer.

It doesn't matter whether audiences understand which elements of a story engage them on a deeper level or not.

It's only imperative that the professional creator offering feedback always understands a deep connection with an audience only comes from sharing a worldview and particular life lesson presented in the story.

It is not the job of consumers, critics, or even fellow creators to offer feedback in terms of their own personal view of life.

After all, it's not their story in the first place.

Even the most esteemed critics can approach the evaluation of a piece of fiction from an erroneous, unhelpful, or completely idiosyncratic point of view.

It's nearly impossible for even professional critics to eliminate all the inherent biases and prejudices they unconsciously bring to a work of fiction.

Even the late, great film critic Roger Ebert brought his personal, emotional reactions to bear on the movies he critiqued.

And there's nothing wrong with that. Indeed, it's necessary for critics to be good at their job. But it is never a critic's job to tell writers how to fix our creative writing.

So it is foolish for writers to look for answers from nonwriters.

As consumers and critics, we all are entitled to bring our individual subjective reactions to our evaluation of a piece of fiction—and there often is no right or objective way to evaluate our overall emotional response to a story.

Often, half the fun is listening to or reading a critic's reaction to a movie or TV show we have seen as well. We can agree or disagree with a critic's assessment of the writer's theme, characters, and story structure and its emotional clarity, and still understand and appreciate the critic's point of view.

Art, even the commercial art of movies and television, can be open to many personal reactions and interpretations, even incongruent ones.

We will never be able to get a uniform, univocal response from our entire audience, family, or from all professional critics. So we must be careful about whose reaction we take to heart and why.

And there's one more judge of our writing that really matters in the end.

While we should listen to the input of experienced writer-creators, ultimately, from a practical point of view, the final arbiter of our work will always be the potential buyer—the studio, network, or production company.

They alone are in a position to both buy and produce our scripts. And without them, our stories would languish unknown and untouched in our sock drawers or hard drives forever.

This is ultimately good news, even if we don't immediately perceive it as such.

It's true that not every potential buyer is going to appreciate and want to acquire every story we create, even the objectively good ones.

Buyers have their own, often individual, preferences regarding story types. No buyer is equally sanguine about every kind of story and its writer's point of view.

What buyers almost always have in common is a means of judging a story's creative effectiveness.

But purchasers of scripts have their own limitations when it comes to evaluating a script. Even they often fall into the trap of evaluating a script on the basis of its series of plot points.

Again, why is this the case?

Simple. Even buyers aren't writers themselves, and as a result they only have their noses pressed against the glass of the writer's creative process.

Studios and networks almost always employ their own internal readers of submitted material. And again, these young, professional readers almost always have no credits of their own.

They can see what is objectively on the page and try to judge scripts on the basis of pre-formed, measurable criteria.

But they can never know the inevitably internal process of creating a story. And that internal perspective is the only way to work with and understand the quality of an original piece of creative writing.

For instance, one of my scripts ended up being the first to air for a new show, *Hollywood Detective*, on the A&E network. As such, it was the only episode critics were able to view in time for their publication deadlines.

And their reviews mostly savaged both me and the episode itself. The critics were merciless in their hatred of the show and its first episode to air. And they went to great lengths to explain their reactions.

These overwhelmingly negative reviews were mostly literate and coherent attacks on my work. I couldn't just brush them off.

But if I took all their criticisms directly to heart, I might have thought I had either lost my mind, my talent, or my ability to evaluate my own work.

I admit I was both confused and disheartened by the negative reactions by these professional national critics. But I listened, trying to find a commonality in their critiques.

But I looked in vain to find one. Each critic seemed to hate the script for different reasons.

This lack of uniformity in reactions left me pained and paralyzed, as if I'd been jabbed by a stingray.

I was unable to step back and find the answers to their various critiques and was left with no idea how to improve the work in a way that would garner their overall approval.

But what I didn't know was that six months later, the same episode would be nominated for a Cable Ace Award, for Best Writing On A Dramatic Series. So now my episode took me to a red-carpet event, celebrating its success.

How to make sense of all this?

Sometimes Hollywood doesn't make any sense. That's just a fact.

Therefore, we must find our own emotional truth in our writing and use that as the beacon that both illuminates the path and exposes our writing's vulnerabilities, limitations, and confusions.

So we must be totally prepared to kill our darlings in the process of reshaping and rewriting our work.

But, given the anecdote above, how do we determine which criticisms to react to as helpful and which to ignore?

The answer lies in two areas—both in the clarity and in the personal nature of theme.

First, we must take a hard look at our theme and evaluate whether the story clearly and persuasively reflects that particular life lesson. If it doesn't, we must admit to ourselves that we have missed the mark. It's time to kill our darlings.

We then must determine how and why our story goes off course in the telling of the central thematic point. It's up to us to fix our story in the essential creative quest for thematic coherence.

And no reader or critic can do this hard work for us.

However, this is the kind of reaction that is covered by the term "helpful criticism." And this then functions as a kind of gift, even if it's hard for us to hear.

Writing is rewriting. We've all heard that. It's not only annoying and challenging, but true, and there's no way around it.

Hemingway had it right when he said, "The first draft of anything is shit."

But in what way? How do we determine that? And what do we do about it?

The task is to be ruthless in our rewrites, as long as in doing so we feel we have a greater connection to our characters and theme. This is a creative imperative we can't shirk.

Hemingway also said, "There is nothing to writing. All you do is sit down at a typewriter and bleed."

In other words, write from the heart and don't judge your work while writing the first draft, as long as you are being honest with yourself and your personal emotional reasons for writing the story.

Without that initial shot of emotional honesty in our writing, the work will seem stiff, distant, or emotionally cold and self-protective. In other words, emotional honesty gives the writer permission to work with the darkness and confusion that always accompanies a first draft.

One way of restating this is the first draft should come from the heart, and all further drafts should come from the head.

And that leads us again to the type of criticism to avoid.

Even professional critics almost always fall into the trap of reacting to a script or novel as if it were their own work.

We are being led into emotional dishonesty when trying to please a particular critic's idea of what the story should be about.

And critics' universal approval always results in a bland, watering down of our thematic point or, worse, ends up reflecting the theme the critics want, in place of our own.

Let's go back to the critics' reaction to my *Hollywood Detective* script, which centered on a fictional encounter between F. Scott Fitzgerald and the main character of the series.

After my honest attempt to see the writing through the eyes of its critics, I finally determined that it wasn't a lack of coherence in the theme that elicited the critics' wrath.

Instead, it was the critics' need to see a different portrayal of the character of Fitzgerald, one that fit their view of the author. And as a result,

they needed to see a different theme or life lesson that their version of the character would learn.

The problem was their dislike of the character portrayal and their desire to see a different life lesson, not mine.

More specifically, many critics were offended by my portrayal of their Fitzgerald. Not just a few voiced their outrage that a mere screenwriter like myself dared to opine on a national artistic hero's internal struggles and failures.

Was my Fitzgerald too much of a cold stone drunk for them? Too self-deprecating? Too self-critical? Too frightened and depressed to regain faith in the power and truth of his own writing? Too seemingly lost and incompetent?

What could a screenwriter say about the flaws of the iconic author of *The Great Gatsby* and other American literary treasures?

Part of my theme in that script was my belief that all writers suffer from these or related internal demons. I wanted to show that there is no escape from dealing with corrosive self-doubt that whispers in the ears of all writers, no escape from the fact that fame and recognition are fickle, fleeting, and as a result often betray the writer in the end.

And those very demons and public betrayals are those that haunted Fitzgerald later in life.

Like it or not, the historical truth is by the time Fitzgerald tried his hand in Hollywood, he had already been forgotten by the critics and consumers of the upscale literary world.

He had become a serious alcoholic, so desperate for money that he was forced to look for work in what he considered to be low-brow, commercial Hollywood.

To his frustration and deep confusion, Fitzgerald's experience in the screenwriting world was a disaster.

Fitzgerald had the presence of mind to write about this final chapter in his life through his lesser-known "Pat Hobby" stories.

These stories unflinchingly chronicled his alter ego's humiliations and defeat in the Hollywood system and also confessed with dark humor his powerlessness over his alcohol addiction.

Fitzgerald and his alter ego, Pat Hobby, had cut down to dozens of beers a day before the former's fatal heart attack.

This was the Fitzgerald I found bravely honest about the unexpected, tragic, last chapter of his writing life. And his Pat Hobby stories were also written as a candidly desperate and futile attempt to understand how to write for the Hollywood system.

This portrayal of Fitzgerald was not how the critics of my script wanted him to be written about and remembered.

And once I understood the attitudes critics brought to my work, it finally became clear why they hated my script.

They didn't like the character and thematic point of a great man who stumbled ignominiously and failed at the end of his short writing life.

Finally, the critics' reactions made sense to me. They were not reacting negatively to the quality of my characterization and theme of my writing, but took umbrage at my efforts to portray one of their heroes in a less than reverential light.

Their reactions, therefore, weren't helpful criticism, and I was left to stand or fall on the quality of my writing, irrespective of the critics' attitude toward Fitzgerald in the last chapter of his life.

In situations like this, it's essential to know how the critics are reacting and why. And it's important in cases like this that we, as writers, learn to stand up for our work when the criticism is irrelevant to what we intended to say.

This is not to say that critics never understand the elements that make for a successful script.

All studios, networks, and production companies have an objective template of the criteria they use to evaluate a script.

These written evaluations are called "coverage," and all of them have a list of aspects of a script to evaluate.

And here is a good place to outline the major categories of coverage of my feature script *Acts of God* by the independent service, ScriptShark, a division of The New York Times Company.(Turn to the full coverage in Appendix A and the script in Appendix B.)

The general categories of ScriptShark's evaluation template are listed here: (*additions in parentheses are mine*)

MECHANICS

1. The script effectively manifests a compelling theme (*life lesson*) and adheres to it throughout the story.

2. Scenes avoid the problem of continuing beyond optimal length.

3. Dialog (*consistent with character; show, don't tell*).

4. Action lines clearly and concisely manifest visual action and literal context.

5. The script's physical presentation (format).

6. Spelling, grammar, and proofreading.

7. Page count.

CHARACTER

1. The protagonist clearly changes/has an arc (*learns the life lesson*).

2. All of the characters are authentic to their backgrounds (*character sketches/outlines*).

3. The supporting characters are unique (*distinguishable*) and add value to the story.

4. The protagonist is sympathetic and/or engages our emotional investment.

5. The protagonist has consistent opposition to his/her goals.

6. The script has an effective antagonistic force, direct or indirect.

7. The protagonist clearly manifests both internal and external goals.

STRUCTURE

1. Every scene has relevance (*to character development/theme/life lesson*).

2. The script has a strong structural foundation that serves the story, classic three-act structure or otherwise.

3. Transitions are effective and appropriate to the story (*theme/life lesson*).

4. The story has well-designed reversals.

5. The set-up (*initial story problem*) is concise, and effective.

6. Plots and subplots (*story sequences*) work together.

7. Dramatic conflict and tension build across scenes, throughout the plot.

8. A catalytic situation drives the plot (*"story sequences"*).

9. The set-up (*initial story problem*) is resolved effectively.

10. The story includes an effective dramatic climax/payoff.

MARKET VALUE

1. Originality/freshness (*character and life lesson*).

2. The story has mass audience (*universal*) appeal.

3. The story includes a conceptual hook that could potentially be used to effectively market the film.

4. The story has a clearly defined target audience.

PRODUCTION VALUE

1. The visual arena of the script is stimulating.

2. The lead character is castable/has star appeal.

3. The project has international appeal.

It's easy to see that studio or network coverage centers on why and how the script succeeds or fails to deliver a believably flawed protagonist who is given the opportunity to learn an important life lesson.

As my mentor told me, all the other story elements are strictly mechanical and objective, thus easy to fix in subsequent rewrites.

So remember and take to heart how your script will be judged by the people who matter most: the buyers.

Be sure to understand and believe that getting a positive reaction from potential buyers is a matter of telling a story of personal growth or stagnation in a convincing way through the use of character.

The good and bad news is that nothing else matters.

Writing theme through the prism of character is the holy grail of all creative writing.

And know all writers, especially those trying to break into Hollywood, will be held to that same high standard.

Before moving on to the next chapter, it's important to actually read and study a real, professional piece of coverage.

Turn to ScriptShark's full coverage of my script *Acts of God* in Appendix A.

Yes, it's flattering, but that's not the point. What's essential is understanding why the professional reader reacted as he did to the coverage criteria listed above.

Once you have digested what the professional reader has to say and why, you'll have a better idea of the importance of the story elements discussed in the following chapter.

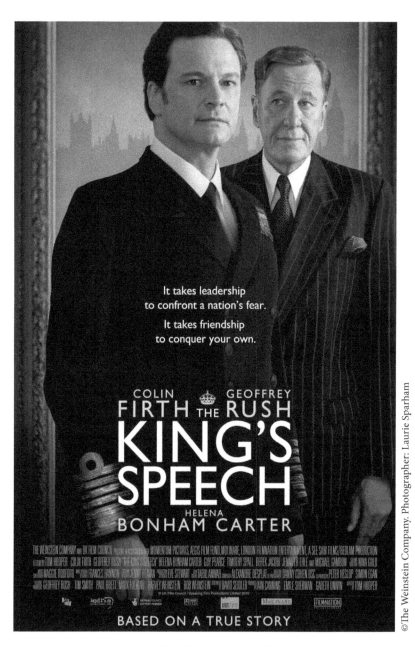

The King's Speech

King George VI (Colin Firth) learns to have the courage to overcome a paralyzing speech impediment in time to rally Britain on the verge of war.

CHAPTER

7

WRITER'S WORLDVIEW—THE INVISIBLE BASELINE OF ALL PERSONAL STORYTELLING

Before putting pen to paper, before even thinking of a story's theme or character, all writers must become aware of the often unseen assumptions they bring to their lives and to their creative work.

If you've filled out and studied the 100 questions in Chapter Three ("All Creative Ideas Spring from Our Core Beliefs"), you will have a jump-start on delineating your personal worldview, only parts of which are actively conscious at all times.

Now is a good opportunity to go back and review your answers in light of what you have learned in the intervening chapters of this book.

And if you haven't yet spent the time answering and reflecting on these questions designed to elicit your core beliefs, don't move forward in this book or your writing until you've done so.

Why?

Because your conscious and unconscious core beliefs are always what dictate how and why you are drawn to certain stories and not others.

And your core beliefs are the eyeglasses with which you interpret the meaning of anything that happens to you in life.

Remember, stories are not about the dramatic things that happen to you or a character.

Stories are always about how a person reacts to the particular events in one's life, given the worldview and core beliefs the character brings to the situation.

If this is initially difficult to understand, think of some dramatic events that might be considered the basis of your story ideas, preferably based on your life history.

A death in the family? A divorce? The birth of a child? A car accident? Winning the lottery? Falling in love?

All these events and many more are seemingly important and dramatic enough on their own to serve as the spine of a story idea.

But the truth is quite the opposite.

Step back again and think for a moment. Everyone reacts differently to his or her important life events. Indeed, people differ wildly on what they consider to be an important life moment when telling the stories of their lives.

How did that death, divorce, birth, or love affect you personally? And why? And why would other people react the same or differently?

Most importantly, what life lessons did these events reveal to you over time? What changed in you as a result of these experiences, both positively and negatively?

The reasons for your changed beliefs are the real, if hidden, spine of any story you choose to write.

Again, and I can't emphasize this enough, the events themselves are never a sufficient and meaningful basis for creating a story. Events have to be interpreted in light of your changing worldview and core beliefs for a story to make sense to yourself and your audience.

You may still be thinking that people must react similarly to the bad and good things that happen to them. How could we, as humans, have significantly different reactions to things as basic to our common experience as love and death?

That's a good question, one that deserves a clear, emotionally insightful answer and examples.

Let's take the subject of death. How could anyone confronted by death react in a way that's not filled with fear and grief? Is there another way to deal honestly with anyone's death?

Your mind might be searching out other possible reactions, given the circumstances of any particular death. You can, for example, imagine specific responses such as "She had a full, good life," or "At least he isn't suffering anymore."

But that's not the point. Not at the base level of our unseen assumptions regarding the fact that death comes to us all.

So how big a difference in unconscious assumptions can writers have when confronting such a brute fact of existence?

Maybe it's a larger difference than you can initially imagine, because you're stuck in your own unconscious assumptions regarding life and death.

Bringing those assumptions to light will help demonstrate your individual, unconscious worldview.

Let's start with two poets writing on this subject from disparate worldviews.

The first poem is "Do Not Go Gentle Into That Good Night" by Dylan Thomas, written for his dying father. In the poem, Thomas repeatedly pleads with his father to not go "gentle" into the arms of death, but to "rage" against the dying of his internal light.

What is the poet's worldview regarding the inevitability of death? It's certainly not everyone's emotional response. Is it defiance? Self-righteous anger? An unconscious belief that death is the meaningless, tragic, and bitter end?

Maybe all of these, and more. And just as importantly, it's important to see that we cannot judge the poet's reaction as objectively right or wrong.

All that matters is that the reaction is emotionally true for the writer. And while the writer is trying to persuade readers that his emotional truth pertains to us and others as well (how else could we relate?), he knows the reader is free to have a different opinion on the subject at hand.

So, when trying to relate to an audience, the writer is dealing with his own deep, partially unconscious personal belief system and worldview that causes the readers' emotional reaction and identification with what is written in the poem.

What other worldviews are possible regarding death?

Here is another famous poem on the subject, written by metaphysical poet John Donne in the wake of his nearly fatal illness in 1610.

Death Be Not Proud

Death be not proud, though some have called thee
Mighty and dreadful, for, thou art not so,
For, those, whom thou think'st, thou dost overthrow,
Die not, poore death, nor yet canst thou kill me.
From rest and sleepe, which but thy pictures bee,
Much pleasure, then from thee, much more must flow,
And soonest our best men with thee doe goe,
Rest of their bones, and souls deliverie.
Thou art slave to Fate, Chance, kings and desperate men,
And dost with poison, warre, and sicknesse dwell,
And poppie, or charmes can make us sleepe as well,
And better then thy stroake; why swell'st thou then;
One short sleepe past, we wake eternally,
And death shall be no more; Death, thou shalt die.

Is there any common ground in these poets' reaction to the fact that death comes to us all?

Outside of their unspoken agreement on the importance of the subject of death, they share little, if anything regarding how one should react to the inevitability of the end of mortal life.

Dylan Thomas' clinging and rage isn't John Donne's dismissal of death as an impotent bully.

Donne sees no tragedy in the inevitable fact that all living things eventually die. Death is not the tragic, meaningless end of human existence. Death is powerless over him.

Why?

Because of the most basic and broad implications of his worldview. Donne was devoutly religious in the Judeo-Christian sense of the term.

And what's the source of solace in his worldview? The last two lines of the poem give us the answer:

> "*One short sleepe past, we wake eternally,*
> *And death shall be no more; Death, thou shalt die.*"

Donne is saying that what we fearfully perceive as the end of life is merely "one short sleepe" before we awaken to eternal life in heaven. Thus, whether we believe it or not, Donne believes the main and only truly important part of our lives happens only after our short time on earth.

And so Donne wants us to reevaluate our priorities in this earthly life while we're still here.

Donne is implying that we should avoid becoming attached to merely mortal accomplishments and goals, in favor of living with values and actions that prepare us for what really matters—our eternal spiritual destiny.

Where do you come out on this issue? No matter what your belief, be aware of it, because it underlies your worldview in a way few subjects can.

Here's another perspective on death, this time from the famous tale of the Buddha and the mustard seed.

The story goes that a distraught young mother named Kisogotami had just lost her infant child to death and was inconsolable.

She also was unable to accept that her child would no longer be with her in this mortal life, so she went from house to house in her village, holding her child and pleading for anything that could revive him.

The neighbors, thinking her mad with grief, did their best to ignore and avoid her pleas for help. But one man felt pity for her and directed the mother to the Buddha, telling her the Buddha had the medicine she was seeking.

Kisogotami found the Buddha and frantically asked him to bring her infant back to life.

The Buddha agreed to help the grieving mother on one condition—that she return to him with only a single mustard seed from a house where no child, parent, husband, wife, or servant had died.

You might be able to begin to see where the Buddha was going with this seemingly simple and effortless request.

Kisogotami roamed from village to village, searched far and wide for a house that filled the Buddha's single condition. She met with hundreds and hundreds of people, telling them of her quest to return the symbolic mustard seed and regain her child's life.

This quest went on for months, until the mother became utterly exhausted and fell into despair.

She was unable to find one house that death hadn't visited, so the request for a single mustard seed finally seemed a cruel, impossible task.

Kisogotami ultimately laid her child to rest in a forest and started the long journey back to the Buddha.

Upon her arrival, the Buddha asked her, "Have you come to me with the single mustard seed?" Kisogotami admitted that she had not. She told him, "All the people in the villages told me, 'The living are few, but the dead are many.'"

The Buddha replied, "You thought that you alone had lost a son. The law of death is that among all living creatures there is no permanence."

The point the Buddha was making was that humans should not cling desperately to life, no matter how sweet, because nothing is permanent: Change, and death, are inevitable.

Therefore the mother should not grieve over something that would ultimately pass away. Peace comes from the understanding that everything, both good and bad, is fleeting and impermanent.

There is no need to fear or grieve the inevitable in life, especially, as the mother found out, since there are no exceptions to the law of impermanence.

Later, after Kisogotami had become a follower of the Buddha, she stood on a hill at night and saw the lights shining in the houses of a nearby village.

She suddenly was taken by the full wisdom of the Buddha's teaching on death. "My state is like those lamp lights," she thought.

The Buddha confirmed her understanding with a vision in which he said, "All living beings are like the flame of these lamps, one moment lighted, the next extinguished. Only those who have reached Nirvana are at rest."

Now this story contains a unique view on the subject of death. It certainly isn't a typical Western view of the proper reaction to death and certainly not like the worldview of either of the European poets, Dylan Thomas or John Donne.

What is this worldview also not like? The story of Jesus and Lazarus in the New Testament (John, chapter 11).

In this story, Martha and Mary, friends of Jesus, send a messenger to him, seeking his help in healing Lazarus, who was gravely ill.

But Jesus waited before acting.

By the time Jesus arrived, Lazarus had been dead for four days. Jesus even confirmed to his disciples that Lazarus was dead.

When he arrived, Martha told him, "Lord, if you had been there, my brother would not have died. But even now I know that whatever you ask from God, God will give you."

But Jesus had a special agenda in waiting till Lazarus was truly and by then long dead before acting. When he first heard of Lazarus' illness, he said, "This sickness is not unto death, but for the glory of God, that the Son of God might be glorified thereby."

So this impending miracle had a special purpose and life lesson for his disciples and all who witnessed the extraordinary event.

In this story, however, Jesus agreed to help, but did not ask for anything, not even a mustard seed.

Jesus' point in bringing Lazarus back to life was quite different from the Buddha's message.

Jesus said, "Thy brother shall rise again," but Martha thought that he meant in the coming resurrection at the end of times.

Jesus corrected her, saying "I am the resurrection, and the life: he that believeth in me, though he were dead, yet shall he live: And whosoever liveth and believeth in me shall never die. Believest thou this?"

Martha replied, "Yea, Lord, I believe that thou art the Christ, the Son of God, which should come into the world."

Jesus then approached Lazarus' tomb and had people roll away the stone outside the cave.

Then Jesus called out in a loud voice for Lazarus to come forth. And Lazarus emerged, alive from the tomb.

"Then many of the Jews which came to Mary, and had seen the things which Jesus did, believed in him."

Jesus' point was not the Buddha's. Jesus wanted to give proof that he is the resurrection, the truth, and the life—and has the power of life and death.

The Buddha's message was that all life is impermanent—that all things ultimately pass away. There is no heaven or afterlife awaiting Buddha's followers, or anyone else.

This story of Lazarus also serves as an example to the living, that we too can have eternal life if we believe in Jesus.

In effect, Jesus' central point is that whoever believes in him receives life that even physical death can never take away.

The Buddha, and even the poet Dylan Thomas, have wildly different worldviews not only from each other, but also from that of Jesus.

So, for a writer, it's of the utmost importance to understand that all the elements of your personal worldview make you the unique individuals that you are.

In essence, your worldview is what you have to discover first, and only then implement as you begin writing.

Let's take another example about personal views about God.

You know by now that individual beliefs regarding God's existence, personality, powers, and agenda for humankind are all essential for a

writer to discover before attempting to write any particular theme or life lesson.

So, let us ask the question:

Is God real for you? Does your God have the power to intervene and affect individual lives on earth? Does prayer work? If so, what prayers are appropriate to direct to God? Does praying to God affect the outcome of something as superficial and meaningless as professional football and hockey games?

If not, why do some players cross themselves and offer a prayer before big moments in a professional sporting event?

What are your God's moral imperatives, and how are they communicated to humans on earth?

Is your God one of love or one of judgment? Are we all born innocent or deeply flawed? What is God's purpose in creating humans? Can we see with God's eyes, or are we forever blinded by our limited human perspective? Does God even care whether or not we believe in him/her?

If your God is omniscient, does that mean your God knows which humans are predestined to leading good or evil lives—that our personal, individual moral efforts are futile, having no affect on the kind of people we become?

New Testament writer Paul, classical Catholic theologian Augustine, and even the father of Protestantism, Martin Luther, believed that we are saved by faith alone. Our moral behavior on earth isn't sufficient to save us, although it is an inevitable outcome of faith.

Certain parts of the New Testament say something a bit different. In James 2:14-26 it says:

"What does it profit, my brethren, if someone says he has faith but does not have works? Can faith save him? If a brother or sister is naked and destitute of daily food . . . but you do not give them the things which are needed for the body, what does it profit?"

"You believe that there is one God. You do well. Even demons believe—and tremble! But do you know, O foolish man, that faith without works is dead?"

"You see then that a man is justified by works, and not by faith only."

I hope you can see how your conception of God underlies every single element of the stories you want to tell. It's the largely unconscious source of all your other beliefs.

The central question of the basis of reality and our moral freedom doesn't go away just because a writer is an atheist or agnostic. All writers must face the issue of how they view human nature and the possibility for positive moral change.

So, knowing your worldview and resulting moral imperatives are absolutely essential before starting to write, whether or not you believe that any God exists at all.

For some people, belief in God even comes down to a practical bet. If we don't know the answer, we then have to guess before we can tell any meaningful story.

Mathematician and philosopher Blaise Pascal came up with such a practical reason for belief in the Judeo-Christian God.

It's important to understand that "Pascal's Wager" was an attempt to justify belief in God on the basis of practical self-interest, not faith.

Pascal argued that if we believe in the Judeo-Christian God, and it turns out that this God exists, we will have directed our behavior on earth in a way that will give us an infinite reward in heaven.

And if it turns out this God doesn't exist, the argument runs, we will have lost nothing by acting virtuously in this life.

However, Pascal continues, if we don't believe this God exists, and it turns out that he does, we risk an infinite punishment in hell.

So, according to Pascal, belief in the Judeo-Christian God is a rational course of action, even if there's no evidence that such a God exists.

Pascal concluded it's in our self-interest to believe in God, and therefore it is rational for us to do so. It is not a matter of faith.

To protect ourselves, our souls, our destiny, no matter what the truth, Pascal claims it is a rational and practical necessity to believe in God's reality and moral imperatives.

Does a practical bet on the existence of God offend you? Does it seem selfish, cold, calculating? If so, why? If not, why not? Dig in the dirt of your deep beliefs and bring them into the light.

The answer is and will always be truly and deeply personal. No one has proof one way or another regarding God's existence, purpose, and powers over humanity.

But Pascal's Wager points out that we can make no sense of our lives and our beliefs without first answering this central question.

We as human beings have to rely on our subjective beliefs, not objective proofs, in order to do so. And on our individual answers hang the reasoning behind every other belief we have in life.

How does our worldview affect other values and beliefs in our lives and in our writing?

It's simply that our worldview precedes all writing, whether we are aware of it or not. And thus it is the duty for all writers not only to know their core beliefs, but to communicate them clearly to their audience as well.

Another important example of the central importance of worldview is the particular significance of our view of human nature. The range of writers' views of human nature is delineated in the fundamental difference between two published versions of Anthony Burgess' 1962 novel *A Clockwork Orange.*

And here, while a coherent worldview of human nature is necessary for understanding any meaning, the contrasting views at the end of the novel completely contradict each other.

One version ends with a formerly sociopathic Alex maturing and turning away from random violence. The second, darker version deletes the final chapter, leaving Alex unchanged by the government's ruthless attempt to impose a civilized set of beliefs in the depths of his character.

Now this sounds crazy, right? How could the central point of the novel allow itself to have two conflicting views of human nature?

The answer is it can't.

Everything, all meaning, depends on the addition or deletion of the hopeful ending.

The first version, published in England, contains the hopeful final chapter. But the editor of the American edition thought that worldview was too naïve about the evil inherent in human nature and therefore published the novel without the last chapter.

Burgess himself believed that all human beings, even those as morally lost as Alex, could ultimately reform because human nature is such that ethical growth can come with age and maturation. Thus came the inclusion of the final chapter of the novel in the English version.

But the American version took on a completely different meaning, showing Alex as an example of the implacability of evil in human nature, and as a result, in all of humanity.

In creating the filmed adaptation, director Stanley Kubrick had only read the American publisher's version, and when later made aware of the brighter English ending, Kubrick still preferred the worldview contained in the darker one.

This, in spite of author Burgess' statement that the only reason he allowed the American version to be published was the stark fact that he needed the money.

And while Burgess initially praised the power of Kubrick's adaptation of the American version, he later lamented the change from the novel's original intention.

Because Kubrick and Burgess fundamentally disagreed on the optimistic view of human nature contained in the author's original English version, the novel and film end up having completely different, clearly incompatible meanings.

Which version is right? That depends on your worldview and core beliefs about human nature.

Ultimately, it comes down to your final verdict on humanity and its potential for change.

And this applies both practically and directly to the meaning conveyed in your writing. Worldview, particularly of God and human nature,

is primary and indispensible in creating the underlying meaning of a story.

The worldview of *Taxi Driver* has nothing in common with the worldview of *E.T.*—and both of them are completely different from the worldview underlying movies like *The Hangover* and its sequels.

One's assumptions about the meaning of life are everything, so it's essential that you know your assumptions before trying to start writing any story.

Rain Man

Charlie Babbitt (Tom Cruise), a selfish and angry young man, learns to love and care for a mentally challenged brother he never knew he had.

Interestingly, the brother Raymond (Dustin Hoffman) cannot change due to his mental impairment. Instead, over the course of a road trip, his influence is what changes Charlie for the better.

CHAPTER

8

THE BEGINNING STEPS IN WRITING YOUR STORY

OK, you're almost ready to begin building your own personal, meaningful story.

You have answered the 100 personal core belief questions in Chapter Two. In summary, these questions cover the following topics:

1. Value: This measures the strength of the statement, "I am worthy."

2. Security: This indicates how much you agree with the statement, "I am safe."

3. Performance: The higher the score, the more you believe the statement, "I am competent."

4. Control: This indicates to what degree you believe the statement, "I am powerful and feel in control of my life."

5. Love: This category illuminates how much you feel "I am loved and feel nurtured."

6. Autonomy: A high score on this metric shows you believe, "I am autonomous and independent."

7. Justice: This evaluates how much you believe, "I am treated justly" and believe, "People in the world are fair and reasonable."

8. Belonging: This category of belief shows how much you feel "I belong" and that you are connected to others you know and humanity in general.

9. Others: This measures your agreement with the statement "People are good" and how much you trust others to behave positively toward you.

10. Standards: A high score in this category indicates how much you believe "My standards are reasonable and flexible" and to what degree you are likely to judge your own and others' actions compassionately.

By this time, you have also studied the eighteen general flawed personality types and flawed worldviews outlined in Chapter Three.

We, as writers, refer to these flawed personality types as a starting point when taking a character on a journey from one of these restrictive, crippling beliefs to a positive life lesson that is the centerpiece of your story.

It's good to have them on hand and summarized here to remind you of the many different journeys your characters can pursue out of darkness into the light of a better self:

1. Abandonment/Instability: The perceived inability to rely on others for support, connection, and protection.

2. Mistrust/Abuse: The expectation that others will hurt, abuse, humiliate, or take advantage of you.

3. Emotional Deprivation: The belief that sufficient emotional support from others will be absent in your life. This includes the belief that others will not be able or willing to provide empathy, affection, and guidance.

4. Defectiveness/Shame: This covers the feeling that you are somehow defective, bad, unwanted, and inferior and that you would be unlovable to others if exposed.

5. Social Isolation/Alienation: The feeling of being isolated from the world, different from others in a bad way, and not being part of an important group or community.

6. Dependence/Incompetence: The belief that you can't deal with daily responsibilities without the significant and continuous help from others.

7. Vulnerability to Harm or Illness: The exaggerated belief that personal tragedy is always imminent and that these catastrophes are unable to be prevented.

8. Enmeshment/Undeveloped Self: An insufficient sense of individual identity that hinders personal and social development. This results in a perceived inability to care for self, often manifesting in various addictions and/or a belief that one has to tolerate the addictions or the serious character defects of others.

9. Failure to Achieve: The dysfunctional feeling that you will not be able to succeed in competitive situations, such as school, job, sports, or love because of your inherent ignorance, stupidity, or lack of talent.

10. Entitlement/Grandiosity: The surface belief that you are inherently superior to others. This results in the dysfunctional belief that a character deserves what he wants, without regard to others. Deeper down, this can be the result of a low self-esteem, resulting from a belief in your character's Failure to Achieve, above.

11. Insufficient Self-Control/Self-Discipline: The inability or lack of desire to restrain your difficult and dysfunctional emotions and impulses. This can lead to a breakdown in jobs and personal relationships. Most commonly, this negatively manifests itself in the personal aspects of one's life, such as over-eating, substance abuse, lack of financial stability, and the loss of friends and allies.

12. Subjugation: The excessive and damaging deferral of one's preferences and goals to others. This strategy to avoid the anger or abandonment of others often results in pent-up rage that leads to passive-aggressive behavior, outbursts of temper, and withholding of affection. This unhealthy compliance with others' wishes often creates feelings of being trapped and resentful toward others.

13. Self-Sacrifice: Usually seen as an important virtue, Self-Sacrifice can actually damage ourselves and relationships in an attempt to avoid guilt or accusations of selfishness by others. Related to Subjugation, above, Self-Sacrifice can lead to ignoring one's core needs in a desperate attempt to maintain connections to others, especially to those who declare themselves to be needy.

14. Approval Seeking/Recognition Seeking: The center of this dysfunctional belief is the inappropriate and extreme emphasis on fitting in by constantly seeking approval from others. This undeveloped, insecure sense of self can result in a dependence on the reactions of others and a resulting overemphasis on external qualities, such as status, appearance, money, and public success.

15. Negativity/Pessimism: An inaccurate worldview of the pervasiveness of danger and disappointment and an intense focus on what a person considers to be the negative aspects of life. This fatalistic view can make people feel hopeless, ineffective, paralyzed, or resentful and ultimately lead to a sense of futility of personal action and responsibility.

16. Emotional Inhibition: The suppression of our feelings such as anger, joy, and affection out of a fear of disapproval, shame, and a loss of emotional control. This can result in an overly rigid dependence on the rational aspects of life, at the expense of our true emotional depths and a full embrace of both the rational and emotional aspects of our whole humanity.

17. Unrelenting Standards/Perfectionism: This is the debilitating belief that you must adhere to exaggerated standards for yourself to avoid what is considered to be unbearable criticism from others. This can result in a lack of a healthy sense of self-esteem, feelings of accomplishment, relaxation, and satisfaction in personal relationships.

18. Punitiveness: The dysfunctional belief, related to Hyper-Criticalness, above, that people, including yourself, should be harshly punished for their mistakes. This is driven by a refusal to allow for human imperfection, leading to an inability to empathize with the flaws inherent in our daily struggles and those of others. This belief often results in an inability to for-

give and in an inflexible sense of loneliness, despair, and dis-
trust of others.

This is important: The combination of your core beliefs, playing in tune
with these eighteen flawed worldviews, constitutes what is considered
to be your voice as a writer.

No need to have any fancy definitions; your voice is what makes you
unique in the way you perceive and react to yourself and the world
around you.

And knowing and working with what you have discovered to be your
voice is 90 percent of what it takes to have something to say as a writer.

You do not have to be perfect. Indeed, seeking perfection before
attempting to write is not only impossible (and boring), but is itself one
of the eighteen flawed worldviews listed previously.

Can you see yourself clearly enough to find who you are, what you've
learned, and what still haunts and bedevils you in your daily life?

If so, you are beginning to get a handle on all human struggles, and how
your imperfect life and journey fit in with everyone else.

And this is where all stories begin—with our personal beliefs, struggles,
and flaws.

This is also where all new writers first find their sea legs in the constantly
changing and challenging world that constitutes their lives.

We now know why plot shouldn't be where we look to come up with a
story worth writing about.

Plot situations are limited, incredibly limited.

As mentioned earlier, there are maybe as few as twenty-eight to thirty-
five plot archetypes.

But the beliefs and flaws we bring to the limited plot situations of our
lives are infinitely complicated and limitless.

This is our freedom as writers. We are not limited or defined by the
objective situations we find ourselves in.

In a crucial sense, we are our beliefs. Most importantly, we are the beliefs we are struggling with, along with the life lessons that come with the hard-earned wisdom that's emerged as a result of wrestling with our flaws in an attempt to become better people.

All along the writing process, it's imperative that we know what we want to write about and why.

And knowing our worldviews, flaws, and life lessons is absolutely critical before even thinking about a story we might want to tell, and certainly before starting to type in the words, "FADE IN."

So the necessary preparation before writing is a four-step task, as laid out by Professor Brian Alan Lane:

"All writing begins with inquiry.

> *"Who are you?*
> *(What is your personal paradoxical theme, your temporal worldview, your moral cosmology?)*
>
> *"What do you want to say?*
> *(What is your 'takeaway point' for your audience? What is the present wisdom of your theme?)*
>
> *"Why do you want to say it?*
> *(What is your emotional connection to your story?)*
>
> *"How are you going to write it?*
> *(What medium, format, genre, and voice best serve your message?)*

"These four questions comprise the mantra for any and all writers who aspire to greatness. *If you are going to write something, then you better have something important, resonant, and memorable to say. It is your job to find a way to say the things that everyone else feels but does not know how to express. It is your job to seek the nexus of the human condition and offer insight or wisdom to help your fellow men and women rise above the day to day tasks of mere survival. And you must do it in a singular, signature, distinct, unique narrative voice that is yours and yours alone.*

"Huh?

"The textual, visual, and musical arts all exist to entertain, to entice, to shill an audience, and then sock it to them with something important and real to say. It's not art if you don't have a theme, it's just mastur-bation. In the end, you may well make your living writing 'the usual' commercial movies and television shows, but you won't get 'discovered' and hired in the first place unless you treat your own work as art.

"So, clear your brain. Delve into media aesthetics, criticism, theme, cosmology, in a practical rather than theoretical way. Internalize it all. Then write, and write well.

"The thing is, there is an objective standard to good and bad writing. It is not a matter of opinion. The only subjective issue is your choice of what you like or don't like. You must learn how to appreciate great writing, whether or not it proves to be your cup of tea. Similarly, you are free to like garbage, so long as you recognize the smell.

"The specific goal in a scriptwriting course is to take your theme and your desire and let them lead you to a script. But is this the tail wagging the dog? Yes. Because it is quite possible that the thing you really should be writing isn't a screenplay at all. It may well be that your theme and the metaphors that are juicing you to write would and should lead to a short story, a novel, a song, a screaming diatribe from the top of a building.

"As you map out your script, contemplate how your ideas would play out in various media, how each medium defines both creative content and audience interaction, and how social history delimits the meaning and resonance of what you can say and when you can say it, and make sure that you take advantage of what the script dynamic has to offer that is special and different from all other forms of expression."

From the copyrighted writing, course syllabi and hand-outs, and lec-tures of Professor Brian Alan Lane, 2001–2014, reprinted here per lim-ited license and permission of the author.

There is a process I've developed for ferreting out and describing these personal values and themes that make us the writers that we are.

It's a writing exercise I call "God, Man, and the Moral Rules."

Get out a piece of paper and write out the three categories vertically, with plenty of space between them, so it looks like this:

1. God

2. then, after 1 and 2: [The Moral Rules]

3. Man (Human Nature)

Write down what you've already worked with in this book regarding your concept of God, his/her powers, personality, and purpose in the world.

Be specific—for instance, answer the question of whether your God has the power to intervene on earth, changing people and events in space and time.

If so, what is God's purpose in doing this and how does your God go about doing it? If not, how does your God react to human events—a remote observer, a cosmic judge, or as loving and guiding presence for mankind and all life?

What are your God's purposes? Determine whether your God exercises powers in service of specific spiritual and humanistic values. Write down those most important values your God wishes us to develop in this earthly life.

Next, review your thoughts regarding human nature. Are people generally selfish or selfless? Do you believe humans are born flawed or innocent? Are most people able to grow into wiser, better individuals, or are we all fated to fall significantly far short of our ideals?

Is your general view of human nature optimistic (in what particular way) or pessimistic (specifically how)? And how should we focus our energies on earth, given what you believe to be the inherent virtues and failings of human beings?

After you answer these questions in carefully considered detail, we come to the point of this exercise.

You have now discovered (maybe with the help of answering the 100 questions regarding your core beliefs) two fundamental sides of what you believe to be the human condition: how you view God and human nature.

The point of this writing exercise is to see how these two sets of beliefs shape and define your most important values and come to illuminate your individual imperatives concerning morality.

For it is in the gap between these two sets of beliefs that we find out how we determined our most important individual moral rules and the reasons they exist.

The specific ways that your view of human nature differs from your view of God is the gap to be filled with your writing. What you choose to write about should reflect the moral rules that result from the difference between what your God wants and how human beings behave.

After working through this exercise, what are the most important moral rules you think are necessary for human beings to be closer to what your God wants for us?

Is forgiveness on your list? Courage, compassion, willingness to sacrifice human preferences for what you consider to be a higher purpose?

How do you express the most important moral rules you've learned on your journey through life? What has your life experience taught you are the most difficult moral questions of mankind?

How do we, as humans, find the ability to change ourselves for the better—and in what way?

What do you believe can't be changed in human nature, and in what ways does this cause suffering for others and ourselves?

Fill in the gap between your definition of God and your experience of human nature. What are the most challenging aspects of human life when it comes to reflecting who God is and where you think humans come up short, morally?

Make these moral rules as specific as possible. If forgiveness is on your list, how do you see the impediments to achieving this moral perspective? In essence, how far off are we from what your God intends for us to believe and how we behave?

And most importantly, how do we bridge the gap you've defined between your conception of God and human nature? What is the path you believe best helps us achieve congruence between the spiritual and mortal realms?

You might be thinking that since you are either an agnostic or atheist when it comes to the question of God's existence, this exercise couldn't be helpful.

But that's not the case. Even if you firmly believe that no God exists, you are still left with the question of how to define the most important moral rules you want to communicate, given your view of human nature.

It just makes the process of getting there a little more complicated. In a godless world, humans are still responsible for their choices, and these choices define our morality.

In the absence of God, how we come to believe in and express our moral rules is more of an existential question: In a silent universe, how do we determine what are good and bad values in life?

If you are an agnostic or atheist, you've already had to deal with this question. And whatever your answers are should explain the reasons behind your most important moral rules in a godless universe.

The point of all this introspection is to find your most compelling, individual moral rules and to turn them into the life lessons your flawed, fictional characters come to learn and to embrace over the course of your stories.

Remember, the point of all good storytelling is how people confront their insufficiencies on a story path to become better people, as you define those terms.

This process, along with your core beliefs and the list of flawed character traits, is the gold mine containing everything you find important to say to the world through your writing.

So, whatever you do, and however daunting the task may seem, don't turn away from the necessary challenge to discover your individual moral rules and the path necessary to incorporate them.

Nothing, and I mean nothing, is more important to discover before you come up with any story idea you really want to write. In this vein, it is our conception of life's most important moral lessons that define the purposes behind our writing.

And nothing else matters.

The most dramatic events or situations we come up with, no matter how initially compelling or cinematic, ultimately are not interesting or meaningful.

Remember, it is our (and our characters') reactions to dramatic situations and events that determine the topic and tone of our writing.

This should now be easier to understand, given my contention that there are precious few external plot archetypes that exist in all literature and films.

Our task as writers is to find out who we are and what aspects of life we've struggled with most in the past or even currently. It is our identified and conveyed wisdom that is the only thing of value in the stories we create.

For example, it is my belief that the pursuit of money, power, status, and fame, in and of themselves, constitute the four most morally dangerous values that modern American society has come to worship, often unconsciously, in our popular culture.

It's easy to see. All you have to do is turn on the television and look, really look closely, at the values promoted in its programming and particularly in its advertising.

Now consider how many stories, both real and fictional, you can name where people live in complete despair after achieving or acquiring every possible manifestation of money, power, status, and fame?

We all see countless celebrities suffering serial divorces, addictions, personal disorientations, despair, and even suicide after spending decades obsessively pursuing these four goals they think will make them happy or bring them peace.

Like many of us, have you stood in wonder upon hearing these sad tales afflicting the people our popular culture claims have it all?

There's a reason for this. It's my contention that there exists a pervasive and central confusion in our popular culture about what to pursue in life and why.

And it is this: Money, power, status, and fame are not goals in life. They're empty at their core. There is no ultimate solace in achieving these outward goals.

Humans need more to make their life meaningful, whether they know it or not. Achieving superficial and ultimately selfish goals such as these are often discovered, after the fact, to be isolating and meaningless, causing all manner of confusion and suffering among high-achieving Americans.

It is only when people discover that they've climbed the wrong mountain and look back at their life journey that they discover the unsettling fact that all their efforts for external success have been hollow and meaningless.

Why, for instance, did extraordinarily competitive and driven businessmen like Bill Gates or Warren Buffett reach a point where they decided everything they struggled decades for—all the money, power, status, and fame—is no longer a valuable goal in their lives?

At what point and why did they decide to give away all they've singularly and obsessively pursued in life?

And in the case of people like Gates and Buffett, why is what they're giving away (billions of dollars, their continuing celebrity among other businessmen) exactly what the rest of us still desire for ourselves and envy in the lives of others?

The answer is there's an unconscious conflict of values being exposed in us when we step back and honestly answer these questions of ourselves for the first time.

The fact is almost all of us to some extent are still in the thrall of the illusion that once we've achieved the brass rings of money, power, status, and fame, then—and only then—will our lives be settled and we finally can be completely and truly happy.

You can already guess the insanity of this way of thinking.

Some of the most successful people on earth find themselves in a surprising state of despair after achieving all their external dreams. Others decide to renounce their former goals in favor of a contrary definition success, the kind that really feels good because it fills you up from the inside.

Whatever you do, don't underestimate the capacity for human beings to deny, delude, and lie to themselves about the values they pursue in the real world of their daily lives.

That, in itself, is almost a prerequisite for telling any story—taking characters out of ignorance through creating stories based on your belief about what activities and attitudes make for a sincere and wise life.

At one time or another we're all subject to personal delusions about what really matters—and this is an intrinsic part of what we call the human condition.

And it's essential to know those moments aren't the enemy. They are instead the fertile ground for any meaningful story we hope to write.

Writing is about personal growth, and personal growth comes from determining what really matters in life and in making the decision not to pursue false idols even as the vast majority of people act as if these idols are the totality of what matters.

The answer to the dysfunctional, frantic flailing for external success as the most important goal in life is just to step off the treadmill and observe our behaviors and often-unconscious beliefs.

Part of you already knows this, but we all need to be constantly reminded. If money, status, power, and fame don't deliver what we desperately hope they would, then what are they potentially good for at all?

A more insightful and honest perspective on this question is easy to describe. All you have to come to believe is the objective fact that money, power, status, and fame aren't evil or destructive in and of themselves. No, not even close.

The crucial distinction is reaching the insight that these attributes are not goals in the first place. They are, quite simply, tools, powerful tools that can be used to accomplish goals that really do matter.

Thus, people like Gates decided to utilize their money, power, status, and fame to affect changes that will help others, whether the cause is world health, literacy, conflict resolution, or education available for all.

And there are thousands of other themes and life lessons we can utilize as well. Just be sure that the ones you choose to write about are personally important to you—either as an ongoing struggle or as a life lesson already, often painfully, learned.

Did these powerful and influential people now committed to the well-being of others even realize their early mistaken focus on personal gain would ultimately fail them?

Probably not, as personal anecdotes and history confirm.

Most people achieve this insight just as they realized the goals they originally considered essential to their own well-being.

And that's a great example of how real people can learn profound life lessons through their own life story.

This theme—helping others is more valuable than ego gratification—is a great example of a specific life lesson to employ in your creative writing, if that's what you've learned in your own life.

And now is a good time to explain how new writers can discover and implement the life lessons that should comprise the centerpiece, the internal compass, and true north of their stories.

First is the concept of your worldview, discussed previously. What are your ideas of God and human nature? The answers come to us in vague generalities, and that's fine. That's the base level understanding and awareness of where we hope to go in our fiction, and we can narrow it down from there.

The next step is the discovery of the more particular themes you find you want to write about that derive from our general, if honest, conceptions of our worldview.

An example of a more specific theme (as opposed to a general worldview) is workaholism for external success robs people from what is most precious in life—their human connections and personal relationships with others.

There are thousands of different ways to express a theme, including this one.

But you will be fine as long as you realize however you specifically phrase your theme will define the life lesson you hope to convince your audience is true.

So, more than any other factor, new writers must be constantly aware that for their theme or life lesson to be conceived correctly, it should be a particular message the audience can both understand and take action on in their own lives.

We will get to the means to more easily discover and implement your individual themes and life lessons later in this book.

But for now, and before we move on, there is a third level of understanding what you hope to write that is indispensible for clarity, verisimilitude, and persuasiveness.

And that third level is what I call "Personal Values."

After conceiving your generalized worldview (God and human nature) and after choosing your more particular theme and life lesson comes the matter of values, the most particular aspect of change.

This is most easily explained by the example of a story about a workaholic father.

In the movie *Kramer vs. Kramer*, the main character (Dustin Hoffman) is consumed with rising up the career ladder of his Madison Avenue advertising firm. All the while he appears unconscious of his neglect of his wife (played by Meryl Streep) and their young son.

At the beginning of the film, the wife stuns her husband with the news that she is moving out and leaving both him and their and son behind.

Now, the worldview of this film could be said to proclaim that while we are all flawed humans, we carry within us the potential for growth and change. This is the most general way of describing the change a character undergoes in the course of a story.

The theme of this movie—a more narrow, particular statement—could be said to be that we should never give work precedence over family relationships. Doing so robs us of any truly meaningful experiences in

life—a life wherein family offers the greatest gifts and rewards during our limited time on this planet.

The concept of values is more particular, still. Often, the writer picks a specific dysfunctional behavior the protagonist is unaware of as hurtful in the beginning of the story. And over the course of the story, the protagonist creates a shift in the specific behavior through a change in perspective.

In the case of *Kramer vs. Kramer*, Dustin Hoffman's character starts out as a clueless, incompetent father.

He still values work over family so much that he finds himself unable to even get his son ready for school in the morning.

And how is this dysfunctional value illustrated specifically? At the beginning, we watch a frazzled, but unfocused father burn both himself and the breakfast, in an amusing, if heart-rending, scene in front of his vulnerable son.

And bookending this initial dysfunctional value toward the end of the movie is the scene when Dustin Hoffman's character confidently makes his son breakfast and we see that he values this change as a symbol of having learned his life lesson: family is more important than he ever thought his career to be.

In the most particular world of values, specific behaviors, before and after learning the life lesson, are used as symbolic moments to underscore and remind the audience of the character's change and why it happened.

This is an effective technique to clarify the worldview and theme or life lesson you want to convey as the heart of your story.

So, when thinking of what to write and why, concentrate first on your individual worldview, then find a more detailed theme or life lesson you want your audience to consider important. As a final task, find the specific behavior that changes, symbolizing the success of the character's journey.

Sometimes, but not often, a story can be a reflection on one's worldview regarding God and human nature.

These tend to be more political, philosophical, and one-dimensional, and often pessimistic regarding human nature. Books and movies that are written with the sole intention of painting this point of view include *1984, Brave New World, The Handmaid's Tale, Lord of the Flies*, and *Chinatown*.

However, when starting a career as a new writer, it is best to avoid these one-note stories that leave no room for the growth of your characters. Resolve to stick to a life lesson, positive or even tragic, but one that involves taking your character from an ignorance of the theme to a realization of what should really matter in life.

Remember, so-called tragedies have their life lessons, too. The difference is that your character learns the positive life lesson too late to benefit from it.

Examples of this tragic vision of human nature include *The Godfather* series to the drug-dealing movie *Blow*, to Shakespeare's more famous tragedies, including *Macbeth* and *King Lear*.

In these cases, the intention is for the audience to learn the theme without having to go through all the pain of losing their last chance to change their own lives.

Tragedies can more neutrally be conceived as cautionary tales we present to our audience, with the hidden worldview that the audience can indeed learn from its mistakes in time to save and reclaim what the writer earnestly believes is most important in life.

So, before moving on, remember and start to write out your worldview, then narrow it down, writing your most important themes and life lessons. Finally, find the specific values and symbolic behaviors that change before and after your character grows into that better person.

District Nine

In a sci-fi allegory about apartheid in South Africa, Wikus van de Merwe (Sharlto Copley) is a politically naïve bureaucrat tasked with forcibly relocating a race of aliens marooned on earth. Due to a mishap, Wikus starts to transform into an alien, and while on the run from authorities, he learns both to respect the aliens and to distrust the motives and behavior of his country's military-industrial complex.

CHAPTER

9

BEFORE YOU START WRITING: AVOIDING THE MOST COMMON CHARACTER AND GENRE MISTAKES

I know you're itching to get going and start building your own story. We're almost ready to start, but before we do, it's important to warn you of the most common mistakes new writers make when first imagining their own story ideas.

The first mistake that will ruin a story from the beginning involves the use of toxic characters.

A toxic character is one that is difficult, if not impossible, for the audience to identify with. At base, a toxic character is so unlike us that there is no way to write a believable life lesson that the character learns.

And remember, what the character learns, or doesn't, is all that matters in creating your story.

So when a choosing a character to be the protagonist of your story, it's essential to avoid the hidden dangers lurking under the surface, right from the start.

Are you able to guess what kind of characters these might be? What kinds of characters make it difficult to write about in a convincing way?

The answer may seem counterintuitive, but that's only because you probably have never thought of it before. And that's because new writers have usually approached all storytelling from the point of view of a consumer and a consumer's attention to plot.

Remember, as writers, we have to learn to see a story from the point of view of a creator, not that of a consumer or critic.

The point of view of a creator is seeing a story in terms of a believable character, a relatable flaw, and a particular life lesson or theme writers want to convey to their audience.

So it should not be shocking that I strongly advise new writers never start thinking of a story in terms of toxic characters such as: [NT]

1. Aliens

2. Serial killers

3. Hit men/women

4. Superheroes

5. Vampires

6. Zombies

7. Or similar characters who simply aren't believable, real people

Don't groan and throw your hands up if you enjoy movies, novels, and TV series in the above genres with these types of characters.

That's OK. You can still like them, if as a writer you see them as the extremely limited characters they are.

But for new writers, these types of characters are like quicksand.

They drown the writer in plot and genre beats (typical scenes for each type of story) and delude writers into thinking their stories are meaningful and original.

Don't make it hard on yourself. Don't use characters unlike us as a way to create any dramatically interesting story.

But, you say, aren't these types of characters interesting? No, they're not. Especially if we can't relate to their motivations and beliefs.

I don't have much to say in terms of what kinds of stories are better than others. But I will say this: New writers need to learn what quality writing looks like. There are objective standards to good and bad writing, even if you are drawn to stories about alien, serial killer, hit men.

In essence, it's important to be able to tell good writing from bad, second-rate melodramas.

Why?

Look again at the script evaluation for *Acts of God* in Appendix A. Pay attention to the criteria listed in that analysis.

These are the same criteria your story will be subjected to when submitted to any studio or production company. Coverage tells us what counts from a writer's and buyer's perspective, and it's best to memorize this before setting out to write.

You might initially feel that I'm being too creatively constricting when insisting that certain characters are too shallow to write about. But what I'm really doing is pushing your story into a thematic, not plot-driven, journey.

This is the hardest part for new and young writers to assimilate. But trust me on this. New writers will find themselves writing plot if they can't find a character that is both relatable and flawed in a way an audience would understand.

Does this mean it's impossible to write a quality story using these clichéd, cartoon-like characters? No.

It's just too damn hard for a new writer to pull off. And it lulls the writer into a false sense of security that the story makes sense.

Think of it, the writers on a serial killer TV show like *Dexter* try to humanize the main character, but in the end it's all in service of writing a shocking, serial killer plot.

Is this low-grade writing? Absolutely. Consuming junk food TV is no way to learn how to write meaningful fiction. Just know that.

But don't writers on low-brow television series and movies not only sell their work, but also make lots of money doing it? And isn't this type of writing always on the air or in movie theaters?

The answer to this is "Yes, but"

As my mentor always said to me at the beginning of my writing career, "Aim high." That means reaching for the best and most meaningful stories we can write, working at the top of our creative game, because, in the end, we will all inevitably fall short of our goal.

The point is that if you choose low-grade, plot-driven stories to write yourself, you will be aiming low. The best you can do in these circumstances is to create another low-grade story.

This is an important concept to learn. Use the best-quality, thematically driven stories as your models for your original work. That way, when your project falls short of your ideals, it still has a chance of being both objectively good writing and meaningful to its audience.

But can a movie be meaningful while still incorporating seemingly superficial characters, settings, and genres?

Sure. The movie *District Nine* is a good example. Set in South Africa, and commenting on its history of racial apartheid, the story uses aliens as metaphorically human.

In other words, the story would work just as well using South African, white and black human characters.

And is there a human flaw and life lesson at the core of this story? Indeed. The main character in charge of relocating the aliens in their midst learns that the aliens are, at heart, just like him, and he stops treating them as sub-human. At the end, the main character is helping an alien escape and ends up on the run from the relocation authorities he used to represent.

That's an example of really good writing that still fits in the traditional sci-fi genre.

While writing for the comic book—and thereby difficult—television series *Swamp Thing*, I encountered another example of a potential problem that genre writing represents.

This series premise was about as far from high art as possible, but we writers still had to do the best we could with the restrictions inherent in the series and its sci-fi genre.

Because there was no hope of writing the comic book character of Swamp Thing himself in any meaningful way, we tried to keep him in the background while we told stories about other characters that were relatable and expressed our life lessons.

One of the episodes I wrote was about a teen vampire. Sounds like I'm contradicting myself here, right? But hang on . . .

What I really wrote was the story of a sexually and emotionally abused teenager, who (we find out later) is suffering from so much trauma that he thinks he has become a vampire. As a coping mechanism, the boy believes he is both a hideous, unlovable monster and at the same time an avenging dark angel against his abusive stepfather.

In the end, the teenage boy learns he is not a vampire, and he has to face the reality of the abuse he's suffered at the hands of those who were supposed to love and care for him. Forcing the teen to face the reality of his abuse thus becomes the first step in his internal healing, albeit on his own, and without his parents. That is what the story was about.

But it is also true that finding deep, personal themes in a comic book premise and typical sci-fi genre was difficult.

So it's best for new writers to avoid this type of genre writing altogether when producing a writing sample for potential buyers and employers.

Why?

You get just one chance to make a first impression with your writing. And your work will be judged by the same creative criteria used in the coverage document incorporated in this book. And those criteria are all about making your theme or life lesson clear and believable to readers and potential audience.

There's another problem with working with clichéd story scenes and toxic characters. While working on our comic book-style series, we had to incorporate the demands of the series concept first, before thinking of the life lesson of our characters.

And what's important to learn is that these low-quality demands are always extremely creatively constricting.

All the more reason to think first of a life lesson you really want to write about. Only then can you begin to think of what genre or plot you want to serve as the vessel that holds your theme.

The most important thing to understand is that certain types of characters will make it almost impossible to write a quality script with a meaningful life lesson.

And the more these alien, hit men, super heroes insinuate themselves into your mind and story ideas, the more trouble you will have writing a story that will meet the coverage criteria of any potential buyer.

There is a second trap new writers fall into when first musing about what to write. And that is in choosing anything like the following toxic settings and topics:

1. End-of-the-world, post-apocalypse scenarios

2. Mobster behavior of any sort

3. Death (unless it's your experience with death)

4. Abuse (unless it's your experience with abuse)

5. Addiction (unless it's your experience with addiction)

6. Or any other situation with which you are not personally familiar

Again, this might seem too arbitrarily restrictive. But just as when working with toxic characters, choosing toxic settings and topics will make your writing superficial at best.

What am I saying here about settings and topics is that some are so superficial and clichéd that they will almost always ruin your story.

The danger here is that new writers will cling on to dramatic settings and topics when they should avoid them.

What can be said in a story framed by the setting and characters caught in post-apocalypse story?

Really. Think about it.

What theme or life lesson can come out of this? What comes to mind first? It's how to survive in this hell on earth.

That's basically it, right? Well, once again we can see how little can be said and how insignificant the life lessons are when using certain topics.

What about a mobster story? First of all, you're not one. So you have little or nothing to say about the mobster life. Also, new writers' genre beats (typical iconic scenes in each type of story) are always mere imitations of scenes we've all watched before.

These two problems pretty much leave you with nothing original to say about mobsters. And that's why you should never be seduced into thinking that mob stories, even if you like them, constitute a fertile field for original writing.

But can this type of story ever serve as a frame to hold an important and accurate worldview, theme, and life lesson?

Yes.

But they are few and far between.

The *Godfather* series of movies is a good example of a complex, original, well crafted, and almost operatic staging of a simple premise.

And the premise centers most importantly on its worldview. In the case of the novel and these movies, we are presented with the worldview that virtually any human being can fall prey to becoming evil.

We are also presented with the theme that evil doesn't pay. And we see the flawed values of putting criminal behavior above love and family.

Most other mob movies fall short of this accomplishment, and merely repeat what's common to these stories in general.

An exception to this criticism is the television series, *The Sopranos*. Here is an original, creatively crafted premise: What would it look like if a real mobster also tried to have a normal family life?

The reason this series is filled with such good writing is that we all understand what the problems are in living a normal family life. That's the hook. And it's the opposite of what you might think.

The mobster part of life is something we know nothing about. So that's not the point of contact with the audience. It's the weird and original

insight that even mobsters have families in real life, and their problems are largely the same as ours.

But new writers should avoid this type of genre writing because there are so few original characters and thematic topics to explore.

The same writing problems hold true for stories centered on serial killers, hit men, and super heroes.

Just say no. It's simple but important advice. All new writers should stay away from these genre types until they are paid to write them.

And if someone is paying you, at least you have a proper excuse for not writing at the top of your game.

Again, I've been there. And even for professionals, these apparently dramatic premises turn out to be hollow, merely imitative stories we've all seen before.

The most important thing to understand is that stories with serial killers, hit men, and super heroes choke the creative life out of any theme you hope to use.

One of the reasons is simple: We aren't these types of characters, and we don't know anyone who is.

This sounds funny, but it's not a joke. We've never even met a hit man, serial killer, or super hero. That should be enough right there to stop us from writing about them.

But new writers are often overcome with wishful thinking, hoping these types of stories are interesting and dramatic in and of themselves, and that the rest of the story will take care of itself.

The stark fact is they aren't interesting, and the potential types of characters and themes that can be brought to these types of stories are both shallow and extremely limited in number.

Look at it this way: They would all fail to successfully meet the criteria of evaluation outlined in the coverage example in Appendix A.

And even considering the exceptions to the rule, for a young, new writer, imitating these types of stories leads to a plot-driven, we've-seen-this-all-before piece of writing.

Now, as we move on to the section on how to write the outline of your original stories, make a point to carefully read my script *Acts of God* (in Appendix B) before moving ahead.

Feel free to leaf back and forth as you compare the thematic structural rules to both your original story idea and the example my script illustrates.

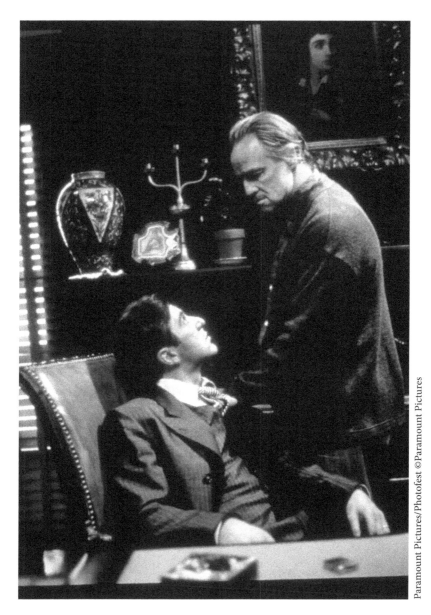

The Godfather

Michael Corleone (Al Pacino), a World War II hero and Ivy League graduate, initially wants nothing to do with the "family business." He learns that his deeper motivations for revenge and power cause him to embrace the mob life and the hidden potential for evil in his heart.

10

LET'S START WRITING!
BASING YOUR STORY STRUCTURE ON THEME,
NOT PLOT

With the above warnings in mind, you are now ready to begin outlining your story idea.

By this point, you have determined your core beliefs, including your worldview, themes and life lessons, and values most important to you.

If you aren't completely familiar with your core beliefs and themes, go back and review your answers to the 100 questions and 18 flawed worldviews earlier in this book.

Once you have reviewed them and feel confident you understand your outlook on life, you are ready to begin.

Take a look at the thematic story structure presented here.

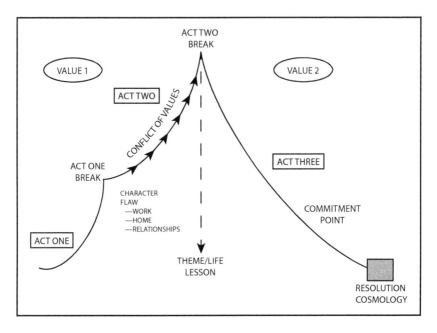

Where to start? As mentioned earlier, we start building our story not from the beginning but *in media res*, in the middle of things.

You may be familiar with the standard three-act story structure (beginning, middle, and end) common to American Hollywood storytelling, first identified and explained as far back as Aristotle.

We get it. We've been exposed our whole lives to filmed entertainment based on a character's problem and journey to a solution. It is true that sometimes we don't see it that way, but only because we've also been trained only to follow the plot to a story.

All stories have some sort of a plot, but let's get to that secondary issue later. My guess is that you already understand the idea of plot but don't know how to build a story based on character and theme.

So, where do we start a thematic three-act story structure?

This is essential to learn before writing your story, even if you think you can write a three-act structure.

And here's the answer. Look at the diagram, and pay particular attention to the high point, in the middle, at the end of act two.

Now follow the arrow down to the bottom of the diagram, labeled as theme/life lesson.

This is where all your writing should begin. It is from this perspective that we can see both the initial character problem in act one and its solution (or failure) at the end of act three.

The end of act two is our internal story compass, and it should invariably be focusing our writing of theme, not plot.

And this is how we start. Pick a theme or life lesson you want to present to your audience. No matter what, this should be your most important goal.

Do you have it in mind?

Find a way to describe your own theme or life lesson in a sentence or two. We will all have different inflections of expressing even the same life lesson, and that's OK. That's part of what makes each good story original.

Now, compare your description of your theme to the ones we will outline here in this chapter.

Does your initial rendition of your theme show both a central character flaw and a life lesson you want the character and audience to learn from your story?

Let's first compare one of the most simple, but illustrative, story ideas: the life lesson learned by a workaholic father.

One way to describe a theme learned by a workaholic father is the following:

> *"A father who gets his satisfaction and meaning in life through over-work comes to learn that career success is ultimately hollow and that what really matters in life is devoting his energies to his family, friends, and community."*

Again, there are a lot of ways to phrase this, and each way leads to telling a uniquely different story. But, as I've mentioned before, that's a good thing.

Your writing will be both original and personally meaningful to the extent that you phrase the theme and outline the character in your own way.

But start with theme we must, or we'll get lost in what we're trying to say.

Now, after having read *Acts of God*, my full-length script in Appendix B in its entirety, turn back to the end of act two (the physical fight and revelation that the two protagonists, Esau and Jacob, are half-brothers).

What is the theme of this script that I first constructed from the end of act two? And how did I start from the middle of the story when I first put this script together?

My thoughts were along these lines:

> *"Two feuding brothers, haunted by the historic legacy and personal neglect of their martyred yet flawed father, learn to see him as human and come to renounce the pursuit of power (Esau) and fame (Jacob) they thought essential to winning their father's love and approval from the grave."*

Sometimes theme takes more than one possible means of description to encompass the full meaning of the life lesson a writer hopes to convey.

The point isn't to have your theme described in only one, comprehensive, and bulletproof sentence. It can be, but it isn't required.

The quest for brevity, however, does force us as writers to think clearly about what we're trying to write and why.

But it's important to understand that there can be main points and sub-points to your theme or life lesson. There also can be additional lessons learned by multiple characters including, but not limited to, the main protagonist(s) over the course of a story.

In *Acts of God*, many characters learn related and overlapping lessons to the main one, articulated above.

Certainly we could say that the community as a whole, as well as Jacob's wife, Esau's girlfriend, the widowed matriarch, Esau's mother, the local defense attorney, and the confessed young and troubled arsonist all learn their respective life lessons in relation to the thematic journey paved by the two brothers.

These separate life lessons work together because they are interrelated. All of them are connected to the notion that money, power, status, and fame shouldn't define us as human beings. This is true even though most of us, if not all of us, fall prey to these temptations in large and small ways throughout our lives.

And these life lessons are learned by the characters and us, the audience, even if some characters come to an understanding of their flaws too late to address them over the limited scope of the story. (Esau's girlfriend, Amanda, is a good example of a character whose ambitions for money, power, status, and fame are ultimately thwarted at the end; thus, she learns the life lesson too late.)

Now is the time to take a shot at fine-tuning the theme or life lesson you want to convey in your original story.

Writing from the structural point of view of theme and character requires us to start thinking of the thematic issue at the end of act two of our story idea, not from page one, where the plot begins.

And the reason for starting here is that the end of act two is the tipping point, where the character is poised precisely between the flaw and the life lesson you want to convey.

Thus, as writers, we can most easily create and envision the overarching structure of what we want to say by focusing on the point of view of the flaw and life lesson, which start at the beginning of act one and act three, respectively.

Whatever you do, don't start thinking about your story idea with a plot problem. I know it's hard to do; old habits die hard.

But I'm assuming by now you believe that starting to think about the structure of your story from the point of view of a plot-driven premise will only lead to focusing on more and more plot. And then, inevitably, plot will take over your thinking about the story idea, and the thematic meaning will get lost by being buried in pointless action.

Yes, it's seductive to start with a plot idea. After all, you've probably been thinking that way as a consumer of filmed stories from the beginning of your life.

But although your script can start on page one with an opening plot issue (as happens in *Acts of God*), know that soon afterward you'll have to start portraying the main character's flaw and thus ignorance of the life lesson that is the heart of your story.

Opening plot sequences are related to the theme to the extent that plot serves as the vessel or set of circumstances in which the character's flaw and life lesson are learned.

But when thinking of your story idea, especially at the beginning of your story, avoid the siren song pulling you to your story's destruction on the jagged reefs of plot. You are creators now, and creators of stories know that plot is only the handmaiden to the meaning inherent in their stories.

Thus, the following ways of describing a story will always be fatally problematic: "This story is about a cop chasing a serial killer," or "a divorced man who can't find love," "a kid who is abused at home," or "a crusading journalist who exposes corruption."

Do you see how starting stories in this way ultimately drives you into a brick wall of writer's block or leads to a superficial and hollow treatment of the heart of the story concept?

The more you think of plot, the more plot takes over the story.

If you still feel some resistance to the idea of starting all story ideas with theme, think back to the limited number of stories that studios consider to be original. The renewed realization that there are only between twenty-eight and thirty-five stories ever told should put your conception of plot back in the proper perspective.

So, after thinking about and writing down your one- or two- sentence theme at the bottom of the graph above, turn your attention to the area marked as "act one."

It is here that we get into the issue of creating and portraying your main character. This is the character that will ultimately learn the life lesson (or not, if it's a tragedy) in act three of your story.

As I mentioned earlier, character can be infinitely variable. No two people are exactly alike in this world.

Since every person is unique, the good news is we will never run out of stories to tell. That's because each person learns a life lesson or theme in a different way and through a different set of life circumstances.

So it's ironic that the bad news is also the fact that character is infinitely variable.

Why is this a problem?

Because with no limitations on what a character can think, do, or believe, it's hard for new writers to come up with a specific character sketch that is comprehensible, relevant to the theme, and also believable to the audience.

I mentioned earlier that new writers almost inevitably stumble when starting to create characters for their stories.

The biggest problem is not the inability of new writers to create interesting character sketches. Virtually all writers have the capacity to describe fictional characters in a way that is unique.

For instance, here's a quick character sketch:

> *An FBI agent who also is a blues guitar player, a mother of two ADHD children, a person who suffers from panic attacks, is bisexual, dyslexic, and who was orphaned at age 5.*

These traits aren't good or bad in themselves.

Rather, the problem with the above character description is twofold.

First, there is the issue of matching character traits to the theme or life lesson. In this case, let's say the theme is the importance of learning how to forgive someone who has hurt the character in the past.

Not every possible character will help demonstrate your life lesson in an equally powerful way.

A character that learns a particular life lesson can't have just any personality. Only those characteristics that help or hinder someone learn the particular life lesson are meaningful. All other traits are either

irrelevant, confuse the audience, or serve as a logical impediment to telling a meaningful, coherent thematic story.

The second problem with new writers' character sketches is their common lack of believability. Believability comes from creating specific character traits that intuitively make sense together to you and your audience.

Remember, every audience member has a lifetime of experience determining what types of characters are believable when watching or reading a story.

So be careful to respect your audience. Even young children have a good grasp on what constitutes a believable character.

For instance, does the character sketch discussed seem credible to you?

If not, why not?

What traits would you delete or change when telling a story about forgiveness? The FBI part? Her dyslexia? Her bisexuality? Something else?

Ask yourself why some aspects of character help build a story with the theme of forgiveness. And then think of what characteristics get in the way of telling a believable, thematically relevant story.

It can all seem overwhelming once we first realize the infinite possibilities of character traits and combinations we can apply to a theme.

Remember, the goal in creating your characters is coming up with traits that are believable together and congruent with learning the life lesson you have chosen to write about.

But what if you are starting to build your story and you find you are unsure which character traits make sense together. What to do then?

How do we go about creating a character that best fits the theme of the story and is also believable to the audience?

The answer is as simple as it is counterintuitive.

First, direct your attention again to the first act in the graph. Notice the word "flaw." It is here that we solve the problem of how to create meaningful and believable characters.

You now know that your main character's challenge and journey in a story is always to learn the specific life lesson you have chosen.

How do you think you can begin to create this centrally important character?

Step back from your story for a minute. Notice that only a specific type of character both needs to and is capable of learning your specific life lesson.

Which among the thousands and thousands of potential character traits seems important to telling your story and why?

Think about the specific nature of your character's flaw. We can also use the example of the workaholic dad or my script's flawed brothers who pursue fame and power to the exclusion of true peace, forgiveness, and reconciliation.

Focusing on the flaw is the key to cracking the problem of creating a thematically relevant and believable set of personality traits for the protagonists in your story.

What does your flawed character always fail to understand at the beginning of the story?

The answer is always the same and easy to apply.

The main character, by definition, never knows and has yet to learn the theme or life lesson you want your story to communicate to your audience.

It's that simple.

The way we determine and build our main character is always by identifying how that person would think, speak, and behave in the absence of knowing the life lesson of the story.

In the example of the workaholic dad, what character traits would best illustrate this central character flaw?

There are lots to choose from. Let's try this sequence: We open our movie with a 35-year-old lawyer, husband, and father at a restaurant, successfully negotiating a multimillion-dollar deal for his client. It involves the

morally and environmentally questionable practice of fracking oil on a pristine piece of wilderness.

It's late, almost midnight, and during the tense bargaining, we see his food is almost untouched. He also checks and quickly ignores several text messages from his wife.

At home, after 1 a.m., we see a birthday cake, also untouched, on a large dining room table. He goes to the bedroom where his tired wife is up reading. In the middle of his attempt to get praise for closing the big deal, his wife reminds him he promised to be home by 8 p.m.

The father then remembers. It was their son's fifth birthday. The wife is hurt and concerned for their son's feelings.

The father then promises to make it up to them and quickly turns the discussion back to his successful deal. He claims the deal will pay off, big time, and that the wife will be able to finally get the dream home she always wanted.

The wife isn't appeased and tries to bring the discussion back to missing their son's birthday. The father cuts off the discussion, saying he'll take care of it.

Then we see him slip into his son's room and leave a "Happy Birthday" message scrawled on a legal pad, along with a hundred dollar bill attached to the note.

We look at the hundred-dollar bill, placed next to the innocent young child's sleeping head. The gesture seems almost cruel to us in its cluelessness—what does a 5-year-old want with a hundred dollar bill?

As the kid sleeps, wrapping his arms around a well-used super hero action figure, we get the impression that what he really wants is something very different from cold cash. He wants a hero in his life and, so far, that hero hasn't been his father.

But the dad smiles, thinking he's off the hook with his family. However, we know better. He passes the uneaten birthday cake without a pang of guilt and heads to bed, where his wife is already asleep.

The next morning, we see him applying the same priorities to his work and family. Only this time, it's a greater disruption of his family life, but

the father still firmly believes his contribution to the family's finances are all that really matters.

OK, we get this example of a character flaw. We know he didn't learn the life lesson of the importance of family in the first two scenes of the script.

His priorities haven't changed, although we feel they should have, given the conflict we witnessed in the opening scenes. Indeed, we see the father is heading down a morally bankrupt path as he sells his soul to the oil company client.

Blinded by raw ambition, the father feels the pressure to compromise his ethics by defending the oil company against an extremely negative environmental impact statement drafted by the government.

The suggested defense? That he used the oil company's knowingly flawed data in support of the prospective drilling.

Taken together, these scenes illustrate the flaw of workaholism in many contexts.

Acts of God starts with a scene that focuses primarily on plot: the fire that burns down the church founded by Esau and Jacob's father.

This will be the start of a plot centering on who, if anyone, burned down the church and why. It also raises the expectation that Esau's Justice Department investigation will ultimately discover if anyone is to blame for the fire.

It's important here to recognize that while plot is clearly secondary in importance in all stories, it sometimes works well to hook the audience with an intriguing question at the beginning.

Why?

As said earlier, audiences—the consumers of stories—have spent their lives focusing on the plot of a story first, if not exclusively.

We can use this proclivity to our advantage as creators, placing the main plot question up front and center at the beginning of our story.

But watch what happens next. The rest of act one is devoted to illustrating the main characters' flaws in relation to the plot.

The next thing we do is to introduce Esau and his character. It's important to notice that the opening character scenes show his flaw.

Esau is shown to be an ambitious, controlled, and successful Justice Department attorney and former JAG (military) lawyer. His condo seems empty and sterile, a sign he spends most of his time at work.

Then we meet him as he awakens and discovers that his career obsession has resulted in his girlfriend, Amanda, leaving him without notice. At that point, Esau tries to balance his career and his faltering relationship, but we see that his career still takes precedence in his thinking and action.

Later in the first act, we also learn that Esau takes a hands-on role in the arson investigation, in spite of the fact that he is a supervisor in the Justice Department's Church Arson Task Force and should be handling his cases back at his desk in Washington.

We get the feeling there's something personal about this decision to be the public face of this investigation, and we watch as Esau positions himself in the limelight of the high-profile case.

No matter what Esau states is his motivation, we see he's going out of his way to be the public's perceived hero in the arson investigation, while still trying to repair his relationship with Amanda. But we don't know why.

Act one is also devoted to demonstrating the character and flaw of Jacob, the pastor of the burned church. We learn that Jacob is the fame-hungry son of a slain civil rights legend and that Jacob is using the fire as an excuse to cause a media circus, centering on him as much as on the real problem of discovering the cause of the church fire.

When Jacob and Esau first meet at the scene, we see that they both are trying to steal the spotlight. And it is here that we notice that their respective flaws put them in pointed conflict. Esau wants to control the public's view of the case, making it seem that the focus should be put on him and his slow, methodical investigation, while Jacob uses the fire as an opportunity to make himself a media victim of an alleged racist act of terrorism.

Meanwhile, the troubled and neglected teen who witnessed the fire allows the town to infer that he might have had something to do with

the incident. He mistakenly hopes that his status will rise in the eyes of others through his ambiguous relationship to the crisis, but the town still views him as the social outcast he is.

From a writer's point of view, Esau and Jacob clash with each other because of their respective flaws—Esau's lust for power and Jacob's need for the fame that surrounded his father's life. And Weasel, the troubled teen, puts himself in the middle of the case in a vain attempt to escape his loser status.

This is all we need to know about the main characters and the plot as it approaches the end of act one.

And here we can now talk about plot, character, and theme in Hollywood terms, without getting confused.

In the screenwriting world, the plot of a script is called the "A story," which can be thought of as what the movie poster to the story might say or show. In this case, the A story revolves around whether the fire was arson and who might be responsible.

The "B story" in a script is what we have been focusing on from the beginning, because that's where the heart of any creative writing is to be found. The B story is the theme or life lesson that unfolds as the A story progresses.

The relationship between the A story and the B story is critical. They must fit together in a way that makes seamless sense to the viewer or reader.

As consumers of stories, the audience first wants to focus on the resolution of the A story plot. But the B story is what the audience comes to find is always the most important element by the end.

Not every A story (plot) will fit well with a given B story (theme or life lesson). In this case, as well as all others, the A story is a situation that is first designed to elicit the flaws of both of the main characters.

That's how you should always be thinking when coming up with a plot/A story. The central question for us as writers is to determine if our A story/plot is a good match for the B story theme or life lesson we want to tell.

Not the other way around. The B story is what must first be determined before even thinking about plot.

But what kind of plot? Yes, the most important thing about plot is coming up with a compelling, believable one that elicits the flaw and leads the main character and the audience to learning the theme/life lesson or not.

And it is here that we can talk about plot with respect to different film genres.

While I don't want to spend too much time talking about the A story (you all have a strong notion of how a plot question has an inherent beginning, middle, and end), we must address the type of A story that you want to use.

And here I'll make a strong suggestion: When it comes to deciding which film genre to use, the answer is that you can generally use any type of A story genre you are most comfortable with.

Acts of God is a mystery and character drama, with no frills and no aspects to the A story that define it further. But could my theme or life lesson fit into another genre?

Sure.

Could the life lessons relating to the hollow values of money, power, status, and fame be found in a sci-fi story, and even one centering on aliens? Of course. My work on *Star Trek, TNG* dealt with many of the same issues, although the theme was phrased specifically in terms of a continuing character (Worf) who accepts public humiliation to honor his father's reputation.

Could it be found in a romantic comedy? Yes, lots of romantic comedies have B stories related to the value of human connection over sterile fame and fortune. I've done that in a couple of TV movies I've written. Specifically, one dealt with a newly blended family that goes through the unexpected marital strains caused by financial difficulties.

How about a children's animation story, maybe involving animals instead of people? Yes, again. A clear understanding of children's animation shows that many of these stories are grounded firmly in the life lessons essential to the moral development of young people. And, yes,

my animation scripts also touched on the same themes. The specific themes dealt with tolerance and acceptance of the homeless in one case, and in the other the theme was the importance of loyalty to old friends in the face of a splashy new friend who tries to usurp that loyalty by providing movie tickets, a free lunch, and passes to a basketball camp.

How about a supernatural story involving ghosts, goblins, vampires, werewolves, and other fanciful creatures? Or how about a mobster A story? Or a serial killer A story? A superhero story? Or a post-apocalyptic plot setting?

Yes—but. I've strongly warned against falling into the trap of being sucked into writing the standard genre plot points of highly unrealistic supernatural, mobster, hit man, serial killer, alien, superhero, and end-of-the-world framing devices.

And the reason is this. New writers, almost without exception, are easily seduced into writing what they think are the sparkling and cool A story genre beats (scenes) that are typical in these highly unrealistic plot settings.

Have I been hired to write a vampire story for television? Yes—but. I mentioned earlier that the only way I could make that script work in terms of a meaningful B story was to create a traumatized character who thought he was a vampire.

And hit men? Yeah, I admit I've used them in my TV series work, but I never thought putting a hit man in a TV series mystery story was a good idea. I quickly saw the failure of creativity that nudged me into accepting the placement of a hit man in my A story. And I'm not proud of that.

I've been lucky to avoid getting trapped into writing A stories with mobsters, serial killers, superheroes, and post-apocalyptic settings. They're just too dangerous to work with when trying to write a believable B story theme or life lesson.

And the reason is this. We all know—whether we realize it or not—the typical scenes that come to mind when thinking of these types of genre-based stories. And the problem is they have a strong tendency to take over the narrative, hijacking the writing into all too familiar, stale A story scenes at the expense of the most important task, writing a believable and compelling B story.

Can you write a meaningful B story theme or life lesson while playing with these dangerous plot genres? Yes, but the chances are you won't succeed, especially because these genres really don't accommodate many types of B stories or life lessons. And the reason is that they don't easily apply to our real lives.

Since it is our task to find an A story or plot that fits the B story that is the centerpiece of our work, it quickly becomes clear that the more unnatural (and thus unrealistic) the setting, the less these A stories allow us to say anything of importance regarding the human condition.

You may think you have a great story idea that just happens to be set in one of these story genres. But let me be clear: New writers all too often are seduced by the format of these emotionally limited genres. I see it all the time in student scripts. And the result is always the same: a dry, derivative A story that has been done to death, and done better, by hundreds of other professional writers.

My advice to all new writers is to avoid these plot genre traps and to always write their stories as straightforward character dramas.

The reason is clear. A simple character drama doesn't presuppose that the type of A story chosen has anything important, new, or interesting to say. It's easier then for new writers to see that their A story is just a convenient vessel in which to place the essential B story theme or life lesson.

Now you might be thinking, "How about all those summer blockbusters that use these supposedly dangerous yet common, if clichéd, plot genres as A stories, often at the expense of any seriously meaningful theme or life lesson?"

When deciding to create and market their own summer hits, studios are wary enough to almost always use well-known screenwriters who are often hired to adapt stories and characters that are already recognized in the popular culture.

Thus the seeming ubiquity of blockbusters that are derived from pre-existing and well-known comic book, TV, and graphic novel stories. Studios know the stories themselves are hollow, so they rely on marketing a new movie based on previously well-recognized stories in other media.

From a marketing point of view, it's the studios' perceived safety net. The thinking is that if a particular genre story is already well-known in the public's mind, then it will also be a hit as a commercial movie.

Hollywood's seeming overreliance on repackaging TV shows or comic books as hit movies often comes across as organizational superstition or wishful thinking.

As consumers of stories, we all have scratched our heads, wondering what the heck Hollywood studios were thinking when assuming we will be drawn to a movie solely because we've heard of the particular derivative material.

Some of the best examples of this wishful thinking in terms of branded entertainment are found in marketing screen adaptations of television series or books from thirty to forty years ago. Who among their targeted demographic (almost always teens) has even heard of these old TV shows and books, much less seen or read them, or even liked them?

The only way to make sense of these marketing decisions is to understand Hollywood's occasional lack of faith in new, original, and most importantly, untested ideas and writers.

We can be sympathetic to studios that quite understandably are wary of spending $30 million, $80 million, or $100 million on filming and marketing an original screen story no one has ever heard of. But, on the other hand, that's part of their job, and original material still always comprises the majority of the stories studios decide to film.

But we, as creators, don't have to fall in the trap of needing to believe there's only a pre-existing audience just waiting for us to write derivative, and thus unoriginal, stories that will sell themselves.

Remember, as creators, we are judged on the skill with which we create meaningful themes and life lessons in our own, original voice. And heavily genre-based script ideas are the enemy of originality.

Our truly original material, judged by the criteria set forth in the coverage document in this book, is how we not only "find our voice" but also develop our own reputation as creators of original material.

At this point I should address the question, asked by many students, "Is it is a good idea to pick a favorite novel, short story, or comic book to adapt into a movie script?"

The answer is a definitive, "No."

No matter what, don't make the mistake of writing a script based on a preexisting TV show, short story, or popular novel. First, it will be a mere copy of a story already told (thus leaving little, if anything, original for the writer to add), and most importantly, and I must emphasize this, new writers almost never own the rights to the underlying material.

If you don't have a properly written contract in hand giving you the rights to write and market a preexisting piece of creative material, stay away from writing a screen adaptation of another's work.

If you ignore this warning, you will be at the mercy of the original writer's subsequent decision to sell or option the screen rights to you or not. And from a practical point of view, no owner of underlying creative material has a motivation to sell the screen adaptation rights to a new, untested writer.

Those are just the hard facts. So never, ever think of adapting another person's creative work. You will only be frustrated and disappointed after spending months or years writing the adaptation yourself, without permission.

Equally important, the point of this book is to help you start your writing career—and Hollywood rightfully demands that new writers be judged on their capacity to write new, original stories themselves.

So the warning is twofold: Stay away from the trap of writing and relying on genre-heavy ideas such as serial killer scripts, and never write scripts based on another person's material.

Now we can return to the task of the thematic structuring of your original idea. We have addressed the concept of starting with theme first and then the character's flaw and the beginning of plot in act one.

This takes us to the problem of ending act one, and spinning the story into the beginning of act two. It is here that both character and plot begin to work together in a coherent and dramatically believable way.

There are many ways to describe both the function and look of the critical act breaks (act endings) of a traditional three-act story. Let me start with the dramatic function of a properly written act one break.

The last scene of act one inevitably turns the story's focus and trajectory in what seems to the audience is a new and unexpected direction. But, while the particular plot change at the end of each act is surprising to the audience, that is not its central purpose.

The act breaks of a story should form the spine of the character changes in the journey of learning the life lesson. And one way to describe the look and feel of a well-written act one break is the following:

A mixture of plot, character, and theme, the act one break should be a reaction to an event that takes the story in a completely new direction. But this new direction should never be arbitrary. It should never look like a random, shocking plot twist.

The way to keep your story on track as an emotional proof of your life lesson is to conceive of the purpose of the initial act break as the first real challenge to your character's flaw.

For the story to avoid repeating itself endlessly, and thus becoming boring as it loses its forward movement toward learning the life lesson (an all-too-common new writer's mistake), the act one break most often functions as the first real pushback to our main character and his flaw.

One way to make sense of this is to recognize that in real life, people don't recognize, address, and change their flaws and flawed beliefs without significant internal and external pressure.

Thus, as the story progresses, the main character(s) must face increasing motivation to change, from both inside and out. Plot mixes with character in each act break, creating a believable change in motivation and thus in subsequent action.

In the case of the workaholic father, we could create the following example of an act one break: The attorney father accepts the firm's promise of a future partnership promotion in return for representing the interests of the corrupt oil company client. At the same time, his neglected wife is left in charge of all the parenting duties of their young son. And at an evening soccer game, the unaccompanied, lonely, and angry wife finds

herself the recipient of the initially unwanted attentions of a recently divorced dad.

We can now see that life is going to be hell for the workaholic dad over act two, both at work and at home.

This is the challenge and pushback to his flawed values in act one.

All of this results directly from his inversion of priorities in his life, in this case valuing work over close family connections. And we worry that he will not only lose his soul at work, but that he will also lose his family as a result of the damage he is inflicting on his wife and son.

Thus we get to know the flaws of our main character in act one, and at the act break we see (although the character doesn't) the dire consequences that await if the character doesn't seriously address his flawed view of what constitutes a successful life.

In *Acts of God*, the act one break centers on the sudden, and somewhat unbelievable, confession of Weasel, the troubled teen, with respect to the church fire.

We get the impression that the socially marginalized teen was motivated to confess to arson because of the swarm of TV cameras and reporters who together created the national media circus in this small, forgotten Virginia town. But both Esau, the attorney, and Jacob, the minister, are equally blinded by the national attention and use this confession to promote their own agendas.

While both men claim they are only pursuing truth and justice, we see that their flawed needs for fame, power, and prestige put them in an escalating personal conflict with each other, with the truth, and with the town's residents.

The act one break in this story raises the stakes for both main characters in a way that threatens to compromise the integrity of both, and that's the pushback to their values that we witness as act two begins.

This brings us to the description of the function of act two, the most notoriously difficult act for new (and seasoned) writers to navigate. But don't worry about the potential threat of second act problems. Once you understand the function of act two, the seeming lack of a spine to the second act becomes much less of an issue.

And here's a compass point to act two that invariably helps guide us over the treacherous waters of this middle act. I explain to my students that the main function of the second act is to create a growing conflict of values inside the character we focus on in the story.

Thus, the relatively large expanse of act two should be designed as the threat of a growing personal price to pay on the part of the character in the absence of learning the life lesson. In the case of the workaholic dad, the growing threat is that he will come to convince himself that he has the right and obligation as a lawyer to promote the interests of his corrupt client. And the personal fallout of this temptation is that it will take him further away from the values that he has yet to learn regarding the critical importance of marriage, fatherhood, and family.

In the case of *Acts of God*, both the attorney and minister press their private ambitions (for power and fame, respectively) over the course of act two, even though they both come to see the growing price to be paid from their flawed personal motivations. And we see their increased willingness to pursue their personal ambitions in the face of growing consequences to the town, the defendant, and to their personal relationships.

But it's important for us and the characters in both examples to also see that the world is pushing back. That is always the function of the theme or life lesson over the course of act two. We all come to see the increasingly negative results of a character failing to address the central flaw that haunts him through this section.

It is important to note here that while both act one and act three are both typically about twenty-five to thirty pages each in a full-length screenplay, the often-feared expanse of act two takes up roughly fifty pages.

And it is the struggle to make thematic sense out of what feels like the excruciatingly difficult and numerous blank pages in act two that humbles many new and seasoned writers. So it is essential that we clear away the impediments to understanding what act two is and isn't about.

First, no matter how it might seem on the surface, act two isn't about creating more plot. It might seem that way to the untutored eye of consumers of stories, but as creators, we need to be guided into the perspective that we must stick closely only to the evolving theme of our story.

More directly, act two must be thought of as the demonstration of a growing conflict of values within the main character, and others, if there are sub-stories involving other more minor players.

If you concentrate on the juxtaposition of the flaw and life lesson over the course of act two, you will see clearly that the path of the story inevitably centers on the growing tension between these conflicting elements.

And yes, act two also gives us room to address whatever subplots and related themes are available by involving the other characters in the story.

In the example of the workaholic dad, we might see the father's flaw beginning to unintentionally affect the behavior and values of the young son. Maybe the son is tempted to cheat in some way during his soccer games, to impress his absent father. Do you see how this not only fills up pages in the relatively long act two, but also resonates and is congruent with the main life lesson of the story?

This simple example shows that a writer can't merely fixate on the challenges and path of the main character. There are always other characters in the story, too, and instead of seeing this as another story impediment, we can and should view their presence as an opportunity to elevate the quality of our writing to the level of serious professionals.

It is my contention that excellent writing always utilizes the subordinate characters to fill out the full meaning of the theme or life lesson. Audiences might not see what we're doing when giving these minor characters a flaw and life lesson of their own, but I guarantee that they will feel it.

This is a highly sophisticated writing technique, but one that my students have proved, over and over again, they can handle well, once the creative challenge is pointed out to them. And so I present this challenge to you.

It is essential to remember two things when facing the daunting specter of fifty blank pages that need to be covered in the second act of a feature-length script.

First, and most importantly, the second act must be constructed in such a way that the protagonist is confronted with a growing price to pay in

the absence of adopting the life lesson of the story and applying it to his flaw.

Remember, another important aspect of the design of act two is showing the character's growing awareness of the personal flaw in his value system. This not only gives the story character credibility, but also increases the tension and the resulting believable and painful nature of choice that must be made in the following act.

Secondly, it is simply good, professional writing to take the more minor characters and create and use their flaws to make the central life lesson resonate across every scene and every interaction of the script.

In the case of *Acts of God*, the townspeople selfishly want to avoid the stigma of being perceived as racist to the outside world, irrespective of the truth. And when Esau refuses to prosecute Weasel (the troubled teen), the town eventually explodes into anger and vandalism as opinion splits regarding Weasel's guilt.

Weasel himself is enraged by Esau's proclamation of his innocence in act two and erupts into an expletive-laden fit in the middle of the courtroom. Subsequently, we see him planning to burn down a church, and as a result he ends up burned in a car wreck on the way to his intended arson.

And the character of the widow of the martyred pastor and civil rights leader not only pushes hard for some kind of conviction, but she makes it clear to Esau that she will do anything to protect the family secret that is the true central conflict between them.

Esau's overly ambitious girlfriend, Amanda, is desperate to create a national news scandal based on her hope and belief that the church fire was a hate crime, and she bets her career on finding evil where none might exist.

Also, the person we come to learn is Esau's biological mother berates Esau for causing the growing conflict in town. She also wants their family secret to remain intact, irrespective of the truth.

And while part of the theme of the piece is that the truth shall set you free, it is clear that all the supporting characters share the flaw of hanging onto their public version of the truth, for personal and selfish reasons.

All these flaws reach a peak when the otherwise peaceful and tolerant townspeople turn against each other because of their flawed needs for differing and self-serving truths.

The result of these growing conflicts is the act two break where the attorney Esau and the minister Jacob are driven to a physical altercation. And it is here that the widow and Esau's mother finally expose the family secret: Esau is the illegitimate older son of the slain civil rights leader.

Mutual enemies Esau and Jacob thus are presented with the realization that they are half-brothers.

This revelation upends Esau and Jacob's blind self-righteousness. They are left with the decision either to follow their flaws to the bitter end or to embrace the fact they have been pursuing private agendas that hurt not only themselves and each other, but also the entire town each claims he is trying to serve.

This takes us to a discussion of the wildly misunderstood nature of the central turn of any story, the act two break.

I've mentioned earlier that the first and second act breaks of a story are places that bring together the growing thematic flaw and conflict of values within the course of the A story or plot.

By now you should have a handle on how the A and B stories weave together over the course of the entire story. So it is a good time to address the central misconception of the act two break among almost all student writers. If you have taken a screenwriting class before, or if you have read other books on the subject before reading this one— beware. Let me gently but firmly guide you away from the most common error in thinking about the nature, purpose, and challenge of the end of act two.

In my teaching experience with hundreds of writing students and thousands of student scripts, I'm constantly amazed by the persistence and breadth of the mischaracterization of the nature of the second act break.

Contrary to the widely held conception of the act two break as the "oh-shit moment" or the "all-is-lost moment," on the part of the main character in the course of pursuing the goal of the A story, we have to reorient ourselves to the compass point of theme or life lesson.

It is here, at the intersection of the highest conflict inherent in both the A and B story that we must make certain the main character consciously confronts his flaw and the opportunity for growth that the life lesson presents.

In essence, this is the point where the protagonist becomes aware of the central flaw in his value system, and this in turn clarifies the nature of the existential challenge to change the flawed belief system in service of becoming a better person.

Thus the first important element of a proper act two break is the moment of self-awareness of the flaw and its consequences, absent learning the life lesson.

And the second element of the act two break is the often-missed moment of realization that the character can't have both the real world results of acting on the basis of the flaw and acting on the basis of the new value system at the same time.

This self-realization, that the character can't have the fruits of both values at the same time, is always the most important and most relevant internal and external conflict in any piece of creative writing.

In the example of the workaholic dad, he might come to see the payoff as well as the moral bankruptcy in promoting the moneyed interests of the corrupt oil company client, while also learning that his neglected wife has developed a friendship and emotional connection with a divorced dad from the soccer league.

The half-brothers Esau and Jacob are forced into the realization that their private, flawed agendas are destroying their families and the otherwise benign, cohesive townspeople.

The act two break, therefore, must serve as a point of self-realization of the toll the characters' respective flaws will take absent a genuine change in what they should truly value in life.

And this leads us to a description of the purpose of act three. Most importantly, the third act is where the main characters and relevant minor ones come to see the path they must take to learning their thematic life lessons.

The good news is that if you have properly envisioned and created the A (plot) and B (theme or life lesson) stories, act three is always relatively easy to write. In essence, the dominoes have all been set up in acts one and two, and all the writer needs to do is let them fall naturally into their inevitable character, plot, and thematic consequences.

But it's important to know that all these essential changes in act three happen slowly.

People in real life don't have a sudden epiphany and turn their lives around in an instant. It's never a radical moment of both clarity and action. So the character changes in act three always should happen deliberately and slowly. The best way to conceive of this is that both real people and fictional characters begin their act three changes in baby steps.

And this brings us to the most critical moment near the end of the story. In fiction writing, it is almost a mathematical fact that the baby steps of personal transformation lead up to what I call the commitment point to a new value toward the end of act three.

Look at any well-crafted story in your movie-watching experience. Almost invariably, the second or third to last story sequence (scene) serves as a way to take the life lesson and put it into action.

Putting their recently learned life lesson on the line, characters should commit to a new value and a new way of looking at themselves and the world toward the end of the story. And make no mistake: audiences, the consumers of filmed stories, always unconsciously expect this commitment scene to occur at this point in the narrative.

And it is here that writers should construct their final interweaving of both plot and theme. The audience comes to realize that both the A and B stories are intimately related. Both were constructed in a way that shows the action and the life lesson had worked together from the beginning. And thus the A story shows itself as a necessary, if surprising, component of the underlying point of the B story.

In the case of the workaholic father, the commitment point might be the character point of leaving his corrupt law firm in an attempt to reclaim his morality and the intimacy and trust of his family life. This is the penultimate scene and also the traditional ending to the A story

(plot). And it is critical that the audience sees some significant external action (plot) that illustrates and defines the nature of the changed value system (life lesson or theme).

In *Acts of God*, the commitment point is where Esau disposes of the evidence of Jacob's infidelity, quits his job at the Justice Department, and gives the arson case to an eager, ambitious FBI agent. Jacob, in turn, abandons his selfish and superficial dream of becoming a televangelist in his first and only broadcast. He also publicly absolves Weasel from any responsibility in the church arson.

Remember, both as creators of stories and critical consumers, we should know the endings of the A and B stories before we write or view them. Otherwise, we either fall into confusion in our own writing or miss the learning opportunity inherent in reading or seeing other writers' work.

It's important to know there are broad and narrow ways of demonstrating the main character has learned the life lesson and has put it into practice. And these are the endings of the A and B story. Along with the baby steps taken in act three leading up to the climatic action-oriented commitment point, there also is an opportunity for a narrow symbolic B story demonstration that the life lesson has been learned.

And this symbolic resolution both ends the entire narrative and is representative of the culmination of the emotional B story.

The way to end the B story is by using a miniscule but symbolically powerful bit of behavior that doesn't usually strike the audience as significant in the beginning of the story.

What we're doing here is taking a small detail in the protagonist's general action and letting it stand as a symbol of the flaw in the first act and as a symbol of the learned life lesson in act three.

In the B story of the workaholic dad, we could utilize part of a scene at the beginning of act one where the neglected son scores two important goals in a soccer game and looks up with disappointment to find his father isn't there to watch.

It's important to know that this need not and should not take up the entire scene. It's always better to mix that symbol with a scene where something else happens as well. In effect, like all good writing—and

we'll get to this later—two things are often going on at once in a particular scene.

The reason for subtlety is that we as writers don't want to direct too much attention to this symbol of the father's flaw. That makes the writing heavy-handed, obvious, and clunky, and audiences react negatively.

Next, we can use the symbol (dad's habitual absence) again in act three, most often in the last scene, after the son scores a winning goal. However, the boy doesn't expect his father to be there to see his success. But as he leaves the field, somewhat dejected, he unexpectedly walks into the loving arms of his father, who had been at the final game from the beginning.

Do you see how emotionally powerful this dynamic can be?

What we're doing with the use of small symbolic actions is to show the audience, in just two partial scenes, the emotional impact of the flaw and of the learned life lesson on the other character(s) in act three.

Believe me, as long as it isn't overly dramatic, and it doesn't show everything that has changed in the main character, the use of symbolism will have a hugely resonant impact on your audience. And like so many other aspects of screenwriting, audiences have (unconsciously) come to expect a symbol of the flaw and the life lesson.

All of this is to be distinguished from the commitment point in act three. The commitment point is big, it involves action, and it's usually tied to the ending of the A story. It also should be prominent in the narrative, and it should show a significant change in the main character's values.

By contrast, the use of symbols (examples) of the flaw and the learned life lesson in the final scene (and the end of the B story) is a small thing, usually no more than a touch of a feather.

In *Acts of God*, the symbol of fraternal discord and Esau's envy is their father's silver cross that hangs around Jacob's neck. In the beginning of the story, Esau instinctively grabs his throat upon seeing the cross on Jacob and becomes enraged each time he sees Jacob wearing it.

At the end of act two, Esau rips the cross off Jacob's neck, and a fight ensues. And at the end of act three we see Jacob hand the cross to his half-brother Esau in the final scene. The ending symbolic act is Esau

burying the cross by his martyred father's headstone, thus ending the fraternal strife.

The proper use of symbols will happily surprise the audience at the end of act three. And it is here, not at the commitment point, where audiences get choked up emotionally. It's the small thing that catches us off guard and bores deeply into our hearts. The symbol says everything about who the person is on the inside both at the beginning and end of the story.

This brings us to the final essential component of the last scene that needs to be in the forefront of your mind as you begin constructing your story.

I call this the cosmological point of a story.

This last question when structuring our stories is asking ourselves, at the beginning, what will be the effect on the main character(s) after having learned the life lesson we presented to them.

In essence, we need to decide whether God or the universe rewards the main character for learning the story's life lesson.

I cannot overemphasize the crucial importance of answering this question before we set pen to paper. Without knowing the effect of learning the theme or life lesson on our main protagonist(s), we leave a hole in the meaning of the story that will make our readers or viewers gravely unsatisfied.

Thankfully, choosing an answer to this final B story question is as easy as it is essential. And it simply comes down to knowing your worldview and resulting values you determined by addressing the 100 question survey of personal beliefs in this book.

If the story happens to be a tragedy, the character learns the life lesson either too late or not at all. As a result, the character comes to personal ruin at the end of the story. The *Godfather* films, as well as many drug-related movies such as *Scarface* are good illustrations of the tragic vision in storytelling. In these types of stories, God or the universe doesn't reward the main character for refusing to learn the life lesson.

It's not as complicated as it sounds. But it does determine whether your story will have a traditionally happy ending or not.

In the example of the workaholic father, you can choose either ending, and the only difference is in the way you write the final story sequence (scene). You can switch back and forth in your thinking about this ending scene until you determine which is emotionally more true and satisfying.

For example, the workaholic father can learn his life lesson in time to save his family unit, but still not avoid the necessity of serving jail time for his shady legal behavior.

This would be an example of a mixed cosmological point, the universe rewarding one aspect of learning the life lesson (valuing his family over work), while not rewarding another aspect (quitting his corrupt law firm).

The story could also have a more typically happy ending by having the life lesson deliver him from losing his family and his law practice. It's all up to you and your deeply held worldview.

In the case of *Acts of God*, God or the universe does reward Esau and Jacob for learning their respective life lessons. But at the same time, Esau's girlfriend, Amanda, is not rewarded for trying to take advantage of the church burning and leverage it for her own personal ambitions and career.

A final example of the possible variations in the cosmological point is demonstrated in the movie *Braveheart*. In the last scene, Mel Gibson's character has become a hero to his people by sacrificing his personal desire for a peaceful life at home and by leading his clan to fight for justice and independence.

But at the end, his character is put on the chopping block and beheaded. It's essential to remember that the character is not afraid of death, precisely because he learned his lesson and became a hero.

So, in the end, and in spite of learning the life lesson, God or the universe does not reward him with a long, peaceful, and happy life.

But as writers, it's important for us to see how the movie could have ended in two completely different ways, in spite of any historical accuracy. The final scene always answers the question of whether a cosmological reward awaits the protagonist at the end of the story.

So where does all this script preparation in this chapter leave us?

Exactly where we should be.

You are now ready to engage in one of the most essential, but often neglected and avoided, steps in the creation of your story: writing the entire scene outline/treatment.

The outline/treatment is a richly detailed prose summary of every aspect of the screenplay you are about to write. Before you even type "FADE IN:" the outline/treatment must detail every single scene and every step of the journey of both the A story (plot) and B story (theme or life lesson).

Whether we want to admit it or not, almost all new writers both fear and loathe this critical phase in the storytelling process.

But all writers, both new and seasoned, skip this essential step at their peril.

It's both necessary and reassuring to know that every studio and production company in Hollywood requires its writers to deliver an outline/treatment before being approved to start writing the actual script. And this is as true for television as it is for feature scripts.

The good news is that once having written the outline/treatment, there should be no holes in the conception of the screenplay. You should be ready to embark on the actual scripting of the story with complete confidence. And, believe me, that degree of confidence is invaluable when you face the blank page every morning you sit down to write.

The bad news is that being forced to write the outline/treatment exposes all the holes that do exist in our stories. And that can be maddening, I know. Our confidence is severely tested at this point in a script's creation.

But there is no substitute for the hard work inherent in creating a meticulously detailed story outline/treatment. When done well, it leaves nothing out, and thus it is the *sine qua non* of all screenplay preparation, even if you are writing the project on your own, with no demands from a studio or production company.

So it is both essential and creatively redeeming to spend the time necessary to write story outline/treatment. It both guides us to the truth of what we want to write and steers us away from kidding ourselves regarding how well prepared we are at this point in the story process.

And there's nothing worse we can do than to fool ourselves about how clearly conceived and complete our story is structured in our heads.

So now that you have thought through what you want to include in your A story (plot) and B story (theme or life lesson), it's time to prove to yourself how much you know about what your story both entails and requires.

But don't worry. You do not have to face this often daunting task on your own.

I've included an outline/treatment of my story idea, "Personal Injuries", in the following chapter.

Read it. Study it. And apply it to the construction of your own story idea.

And once you're done with this hard work, your writing will cease being both frightening and a chore.

Indeed, you will come to thank me for forcing you to take this crucial next step.

I guarantee it.

Michael Clayton

Michael Clayton (George Clooney) is a morally compromised "fixer" in a prestigious New York City law firm who uses his connections and knowledge of legal loopholes to serve his unsavory upscale clients. He learns the need to expose a corrupt and murderous corporate client, and to finally abandon his former lucrative but immoral career.

CHAPTER

11

STORY OUTLINE/TREATMENT:
PERSONAL INJURIES

The following is a full treatment/outline for a feature-length story. Study the specificity of each scene in terms of how the protagonist, Kate O'Donnell, comes to learn her life lesson.

PERSONAL INJURIES

by
W. Reed Moran

Kate O'Donnell is a woman with a past. A past she can't face, can't ignore . . . and fears she can't survive.

But you wouldn't know it to look at her, except maybe in her eyes . . . those deep, dark windows to her soul. She exudes life, armed with a dry, acerbic wit, earthy sensuality, and a passionate commitment to helping those who can't help themselves. A single lawyer in her mid-30s, she still lives and practices in the Boston Irish-Italian neighborhood she grew up in. Kate O'Donnell's a woman devoid of guile or pretense. She knows who she is, knows right from wrong . . . and as a result maintains a zero-tolerance policy for bullshit in herself and others. We love her for that, her clients and colleagues respect her for that, and men find her irresistible. But the downside is this also makes Kate a harsh judge of humanity. Once people have acted badly, they don't get second chances. And as we find out fairly quickly, the person she's hardest on is herself.

And whatever guilt lies in her past that she conscientiously tries to bury in work, scotch, and men, we soon discover that it's a demon she can't control or banish from her memory. It has her by the throat, and the memory is literally killing her.

As the story opens, we see a nanny (Lilia) pushing a stroller with an angelic toddler (Tucker, 2) down a busy Boston street. She seems kind, attentive, stopping to buy the boy an ice cream from a sidewalk vendor. But as she reaches in her purse, she finds herself distracted by the confusion created by a truck suddenly unloading its contents on the sidewalk next to her. And by the time the boxes and the workmen are out of her way, she turns around, horrified, to find the stroller empty.

As Lilia frantically calls for Tucker, clawing her way through the pressing crowd . . . we see the boy crawling under a truck—feet away from certain death awaiting him in the middle of the busy city street. As this drama plays out, we're not sure whether the nanny is to blame for this impending disaster, but we are sure of its inevitable, fatal outcome as the boy crawls out from under the truck—into the direct line of oncoming traffic.

It's at just this horrible moment that Lilia finally sees Tucker, screams to him, and, as the boy turns to her voice, he is grazed by a passing car, falling headfirst into the middle of the street. And as another car bears directly down on him, a pair of strong male hands scoops the boy up at the last second, placing him on the edge of the curb. Lilia rushes to them, but as she does so, the man who saved the boy inexplicably shoves Tucker in the arms of a nearby pedestrian . . . and quickly retreats, disappearing into the crowd.

After being introduced to Kate and her world, we see her newest client, Lilia Martinez, the live-in nanny to the little boy. Her wealthy employers, the Caine family, have not only threatened to fire her, but also to report her to the immigration authorities as well. Lilia seeks Kate's help, claiming she has no idea how the boy could have wandered off so quickly. And as Lilia describes the mysterious behavior of the boy's rescuer, Kate immediately smells something rotten.

Kate visits the family in their expansive suburban home. Frank Caine is a prominent developer, arrogant and controlling. His wife Susan, a housewife, is nervous, brittle, and cowed by her husband. We recognize their adopted and only child, Tucker—the wide-eyed, endearing tod-

dler from the first scene. He seems perfect but we soon sense something is wrong. He's autistic, can't communicate, and seems in a world of his own. And we see that Tucker's problems are a source of continuing tension in the Caine household. Kate finds herself quickly turned away by Mr. Caine but not before persuasively pleading her case on Lilia's behalf and absorbing the dynamics of this seemingly perfect family.

Kate goes to Lilia, reassuring her that since Kate reminded Mr. Caine he hired an illegal worker, he hasn't yet decided to report Lilia's immigration status to the immigration authorities. And then, back at Kate's apartment she shares with her dog Cerberus, we witness the dark veil of pain and guilt that haunts her life. Drinking heavily while working late into the night on a case of a child hurt in a car crash, she is repeatedly drawn to and tortured by the framed photos on her desk of a man and a young boy. In quick flashes, we see a fragmented painful memory of another car crash and its effect on Kate as it tears her apart. In the end, she can't block the rush of guilt and despair. As this sequence ends, she turns down the family photos on her desk, goes into the bathroom, fills the sink to overflowing . . . and puts a menacing straight razor to her wrist. But as she lowers her wrist in the scalding water alongside the flashing blade, Kate is interrupted by the insistent ringing of the phone in the next room. It's Lilia, calling from the local hospital, frantic with the news that Tucker has been taken there in a coma and the doctors have been told that Lilia is responsible for the injuries.

Kate now rushes to the hospital to find Lilia in a hallway next to Tucker's room. The mother reported to the doctors that the boy seemed dizzy a day after his initial fall and Lilia admitted she was the one who later found him unconscious on the bathroom floor. The doctors confirm the greater injury occurred when the boy hit his head the second time, and the extent of the injuries is uncertain. Kate enters the room to see the boy and finds the mother alone with him . . . and at loose ends. It is clear this is one unstable woman. Kate sits by the boy's bedside, and we see a tug of an emotional connection to his helpless condition. As Kate takes the boy's hand and tries to calmly interview the mother, she hears Mr. Caine arrive in the hallway, berating Lilia. Kate tries to intervene and Caine explodes into a rage when he finds her there as well. He threatens Lilia with criminal action and abruptly drags his wife away, without ever seeing his son. And when Lilia arrives home, she finds not only immigration authorities but the local police at her door.

Kate tries to intervene with Colin Jameson, an assistant D.A. filling in that afternoon for the senior prosecutor assigned to the case. He's talented, liberal, and privileged, and while charmed by her, it's clear he's also ambitious. The heat between the two of them is palpable. Kate defends Lilia as a responsible and caring person she has known intimately for over a decade, someone incapable of neglect or abuse. But Kate surprises us by explaining that she knows this because Lilia worked as nanny to Kate's own son for almost seven years. While we wonder how this news fits into the missing pieces of Kate's mysterious past, Kate presents her suspicions that her client was set up from the beginning. While Jameson appears potentially receptive, he reminds her this is not his assigned case. And even if it were, he's forced to conclude that absent some exculpatory evidence, her client is in serious trouble. Lilia admits being with Tucker on the day he disappeared, and even she can't give any explanation as to how it could have happened. Kate concedes that the limited facts don't make for an easy defense, and Jameson is sympathetic to Kate's desire to help her friend. Kate finds herself attracted to Jameson's candor and honesty and she finally manages to enlist his informal support, getting a lead from a witness report to the mysterious man who saved the boy.

Kate posts bail for a distraught but grateful Lilia, and in an emotional scene, reunites Lilia with her young son back at Kate's apartment. Kate has already made up the guest room and insists that Lilia and the boy move in with her at least until the case is resolved. Lilia warmly accepts the offer, but as she hugs Kate, and the boy plays gleefully around them, we see that this room brings back memories for both women—ghosts of times they've shared, both blissful and tragic.

As Lilia takes up her former duties at Kate's home, we learn more about their history and relationship. They loved each other like sisters, socialized with each other's extended families, and shared the most intimate parts of their lives—until something happened three years ago. Kate's husband and son are gone, we don't know how or why, and Kate herself had left Boston and been out of touch until last spring.

So Lilia and Kate have a lot of catching up to do. But the tone of Lilia's conversation, while jovial, is delicate—and Kate's responses are deliberately reserved. As if too many land mines lie buried in those missing years between them, and Lilia is unsure where to tread. One of the land mines that does surface later that night, as they discuss the details of the

case, is Kate's apparently uncharacteristic heavy drinking—and when Lilia diplomatically touches on the subject, it blows up in her face. And while Lilia is slightly hurt by Kate's short response and retreats to her room, we can tell that Kate feels worse, remonstrating herself mercilessly. The night ends with Kate still sitting in the dark, in the company of the swirling demons that appeared uninvited at this otherwise happy reunion.

The next morning, friendship, sunlight, and the natural joy of a child's presence lift the fog of the night before. Lilia isn't easily put off, and Kate's acerbic humor serves as a time-tested apology between them. We see the love and admiration for each other is and always has been rock-solid. Kate takes off, optimistic about a possible lead to the man who rescued Tucker—a man who might be able to explain what drew the boy from Lilia's watchful eye in the first place.

But the lead, while tantalizing (and increasing our belief that Kate is really on to something more sinister than a wandering child) finally comes up dry. The sequence ends with Kate having to break some hard news to Lilia: Jameson's superiors in the D.A.'s office have decided to prosecute her for criminal child endangerment. Lilia is looking at the likelihood of prison, losing custody of her son, and eventual deportation. Kate hates herself for being unable to help, and after a late-night visit to see Tucker (where we see a visceral connection), she once again finds herself home alone, awash in the demons of her past, and perilously close to the edge . . . until Jameson appears at her door unannounced.

We then learn that Jameson, while claiming to have more information on the mysterious man who saved Tucker, has actually arrived for personal reasons. Kate considers this is just what the doctor ordered, and it's not long before she drags him to her room. And here, we see another dark layer stripped from Kate's soul. As they start to undress, Jameson is shocked to find that her beautiful body, from the shoulders to the waist . . . is covered with the finely knitted mesh of scar tissue, the aftermath of massive burns. Kate doesn't care to discuss or explain her condition. But after a night together, Jameson uncovers another layer. Snooping through her things, he stumbles upon a Bible, and the pictures of the boy and man we saw earlier folded inside. Kate catches him, and while furious, bluntly puts the pieces together. Three years earlier, she had an accident while driving home with her family. We flash back

to her jagged memory: a snow-blind night, a whining child, a trivial argument with her husband, her eyes momentarily distracted from the road, oncoming headlights, a swerve, and a fiery crash. Her son and husband died . . . and the fire left her scarred, physically and emotionally. And now we know the source of her torment, and her connection to a helpless boy she cannot seem to help.

Later, when she learns that there's nothing Jameson can do to stop Lilia's prosecution, Kate dives into the case with renewed vigor, investigating the Caine family and searching for any prior history of neglect of their autistic son. The results don't paint a sympathetic picture of the father or a competent one of the mother. But that in itself doesn't prove anything. One thing for sure, the Caine family is extremely connected and influential in the Boston area, and Kate's inquiries and implications are met with substantial resistance and animosity.

Never one to be impressed or intimidated by position or power, Kate decides to follow up on some unanswered questions by making an unannounced visit to the headquarters of Caine's downtown real estate development company. Mixing in inconspicuously in the opulent 42nd floor lobby, Kate studies models of impressive architecture and commercial real estate projects, both current and projected, that the firm has designed across the region. And as Kate inquires about a particular waterfront development she doesn't recognize . . .

We cut to the boardroom, where Caine and his partners are discussing a model of the same project. The design has been approved, the investors are eager to go forward, and they are discussing a needed zoning variance over a speakerphone conference call. All seems normal, until a discussion of the pre-existing development comes up. There's a problem, which Caine tries to dismiss obliquely—but we can tell there's tension in the room. Something is making the partners nervous, even queasy. And if we were to be suspicious by nature, we might be disturbed by recognizing the names and voices of two of the men on the other end of the line.

When the meeting breaks, Kate buttonholes Caine in the lobby with a pointed question about the case. And while Caine brusquely dismisses her, referring Kate to his personal family lawyer . . . we can tell Caine is rattled by her presence and particularly by her proximity to the model of the projected development. Kate quips that if he doesn't have the

time to talk now, she'll be happy to schedule a long, grueling deposition later. She enters the elevator with him, smiling as the doors close, confining them uncomfortably . . . and

Later, Kate with the help of Jameson, does get another lead to the man they're looking for, but before she can follow up on it, the Caine family attorney calls her for a private meeting. At the end of this sequence, in the high-rise office tower of a prominent law firm, Kate is presented with an audacious carrot-and-stick offer. Because Mr. Caine's connections run so deep and wide in government and business, he is able to guarantee the following: Lilia Martinez will go to jail, her son will end up as a ward of the state. But if she is willing to put her son up for private adoption with the Caine family, Mr. Caine can equally guarantee that the charges will be dropped against her, and that her son will live a life of privilege and opportunity that Lilia could never hope to provide. It's a malicious, cold, and simply unethical offer. Kate excoriates the lawyer and promises to take the matter to the bar association. But the lawyer is unmoved, pointing out there's no way Kate can prove the offer was made. The Caine family holds all the cards in this game. And Kate knows it.

Next, we witness a painfully emotional meeting between Kate and her client. Lilia recoils at the reprehensible blackmailing offer to trade her son for her freedom. Kate agrees, but explains the facts: If the case goes to trial, Lilia will not only likely lose her freedom, she'll lose custody of her son to the nightmarish state system. Lilia becomes enraged, claiming even that fate is preferable to the cold comfort of the Caine's financial wealth, emotional poverty, and neglect. And those are just the fighting words, even in a losing cause, that Kate wants to hear.

Back with Jameson, her new lover and confidant, Kate lets all her frustrations, fears, and suspicions spill out. This case has made her more open about the tragedy in her own life than she's ever been. And her personal loss makes her hate the Caine family for what she suspects is going on behind the walls of their perfect privileged home. Tucker was privately adopted, turned out to be autistic, less than perfect in their eyes, and more of a burden than they bargained for. And like a car or computer or other expensive toy that didn't meet up with their expectations, the Caines, when they couldn't legally return the child, simply felt they had the right to trade him in on a new one. Kate suspects that the Caines wouldn't have cared if Tucker never returned from that day

in the city . . . and even more ominously (as in recent news stories) maybe the Caines somehow orchestrated the incident intentionally. Kate's emotional revulsion is almost uncontainable, especially since she would give absolutely anything if her family had survived the accident, no matter how severe the injuries or resulting disabilities. Jameson sympathizes with how this case must resonate with her personally but counsels her that Kate's suspicions are only that. She has no objective indication of the Caines' culpability.

And that warning seems to hold true as Kate continues to pursue the case. Both Frank and Susan Caine were accounted for at work and with friends the day of Tucker's disappearance. But Kate's luck begins to change when she finally learns a potential address for the witness who rescued the boy that day. Kate waits at the scene of a dingy apartment, surreptitiously photographing a man (Jack Marks) as he arrives home. We recognize him as the one she's been looking for. But when she approaches him, Marks refuses to admit he knows anything about the case. He's nervous, abrasive, and defensive, and Kate can sense he's lying. Kate threatens to subpoena him for the trial. Marks almost turns violent, stopping short as Kate stands her ground. At this point in her life nothing and no one scares her, except maybe herself. But the question lingers, what does this guy have to hide?

And the answer is, ominously, more than we think. The night after Kate's encounter with Marks, we find Caine working late in his high-rise office. Caine is on the phone, extremely anxious about the status of the waterfront project. A voice, in which we recognize a heavy Boston accent, reassures Caine that all has gone as smoothly as possible. With what, exactly, we don't know. But Caine is both paranoid and unconvinced. Among other things, we hear he's "worried about Marks" and furious to have discovered that Jameson has apparently developed a personal relationship with Caine's adversary, Kate O'Donnell. Caine demands that Marks be dealt with and that Jameson "be brought into line" immediately. The voice calmly responds that at least a man like Jameson "can be dealt with reasonably." And as we wonder what all this implies . . .

We catch up with Kate at the hospital that night. Tucker is out of his coma, taking food, and as Kate discovers to her delight, he's also taking an immediate liking to her. Although he doesn't talk, Tucker plays with her, laughs, and we see a rekindling of delight in Kate's aban-

doned heart. We get a warm and reassuring glimpse of the wonderful mother she must have been. But as visiting hours come to an end, Kate is slammed with more hard news. The nurse informs her that although Tucker is ready to return home, he's not going to be. The Caines have announced their intention to have Tucker permanently transferred to an institution for the developmentally disabled.

Next, Kate finds herself awash in a sea of emotions. Angry, frustrated, and feeling the self-imposed weight of responsibility for the fates of everyone she cares about (Tucker, Lilia, and Lilia's son) . . . Kate finds herself recognizing Susan Caine at a table outside a posh city restaurant. Kate's frustration gets the best of her. She confronts Susan with her fellow ladies-who-lunch and hotly demands to know what kind of woman would unnecessarily condemn her only son to a life sentence of abandonment and isolation in an institution. Mortified and defensive, Susan admits that while Tucker is special and difficult, she denies that any final decision has been made regarding his long-term care. When Kate makes a reference to trading in Tucker and privately adopting Lilia's son, Susan reacts with equal denial and apparent ignorance. And as she rambles on, we begin to sense how fragile, unbalanced, and entirely dominated by her husband she really is. Maybe she doesn't know, or can't admit to herself, that the decision has already been made for her. And at the end of this difficult encounter, Kate's left confused and guilty at her outburst, somewhat sympathetic to this ineffective mother, and more convinced than ever that the lives of two children lie directly in her hands.

Kate might not have any clear answers, but at least she's got something to fight for now. For the first time in years, the fire's back in her belly, and her heart is slowly being forced open to the possibility of making real connections to other human beings. But as we know, true emotional vulnerability is risky business under the best of circumstances. The next day, Kate discovers an article describing a fire at a public housing project under construction in a run-down part of the city. The architects are a company owned by Frank Caine. Kate discusses the article and her encounter with Marks as she takes Jameson to the hospital to visit Tucker. There's no obvious connection, and Jameson dismisses the incident as they discover Tucker playing quietly outside on the grounds. The boy sees Kate, runs to her arms, and as they roll in the grass, we witness a small miracle: Tucker utters his first words. And as surprised as we are to hear this, we're equally surprised to see

Kate laugh unabashedly for the first time. The moment isn't lost on Jameson. He knows this child is filling a deep hole inside her, and he warns Kate not to get too attached to anything or anyone she can't have. Kate changes the subject, showing Jameson a photo she took of Marks. She's convinced he could help her case, maybe place someone other than Lilia at the scene when Tucker was abandoned, maybe even Caine himself. All she's been able to determine is that Marks is an ex-con (burglary and car theft) with no outstanding warrants and a string of itinerant jobs. Why is he lying about being the one who rescued the child? Jameson's prosecutorial opinion is "once a con, always a con." Marks had probably just committed an unreported carjacking or other theft when he ran across the young boy. But now, after hearing Caine's late-night demand to "get to" Jameson, we're beginning to wonder which side Jameson is really on.

At the end of this sequence, Kate seems to be going nowhere, until she and Jameson are awakened by a 2:00 A.M. call. It's Marks. He's angry, sounds nervous, but wants to talk. He wants to meet her, but it has to be now, and all he needs is enough money to get out of town. Kate tries to put him off, but Marks refuses. He has to leave tonight. He sets a meeting place. And he tells Kate it's now or never if "she wants to know everything about Caine." When Kate hangs up, Jameson insists on joining her. They leave together, rush to pool some quick ATM cash, and hurry to the site of Caine's proposed waterfront development. When they arrive at the scene, they realize that a fire recently razed the existing apartment buildings. And as they cautiously approach a sole vehicle sitting in the apartment's abandoned parking lot, Kate and Jameson discover Marks inside, shot in the head. Kate and Jameson realize that Marks might've taken some dark secrets about Caine to his grave . . . but now the trail is cold, and the trial is set for Monday.

The next sequence opens the night before Lilia's criminal trial, and things look bleak. But things turn even uglier as Jameson and Kate lie in bed together and he breaks the latest news. Jameson got a call that afternoon from the D.A., and in a last-minute change, Jameson has been suddenly and inexplicably reassigned as lead prosecutor on the case. Kate is outraged, accuses the D.A. of the basest political maneuvering. She naturally assumes Jameson told his boss where to go, but the expression on Jameson's face tells a different story. She reacts, incredulous, as Jameson tries to justify his reluctant decision to accept the assignment: his years working his way up from juvenile and misdemeanor cases, the

long hours, low pay, and his own delayed political ambitions. But more importantly, Jameson points out that he doesn't have the authority to pick and choose the cases he works on. The only way he can turn this case down is to quit his job entirely. And it's clear that's exactly what Kate expects him to do. When Jameson balks at her ultimatum, Kate is crushed by the sudden realization that he's not the man she thought he was. It's over, a brick wall drops between them, and Jameson gets up, silently dresses, before walking out alone into the night.

At the trial, in spite of Kate's best efforts, it quickly becomes clear she's got a losing case. And because she'll be damned if she'll concede this injustice without putting up a hell of a fight, the sparring between Kate and Jameson gets acrimonious, and personal. Kate is brilliant, passionate, and eloquent, but the crux of her defense is speculative and inadmissible. It becomes apparent to us that at this trial anyway, there's no way she's going to be able to fight City Hall.

And late at night alone in her study, that's the reluctant conclusion Kate comes to as well. At the end of this sequence she goes to Lilia's apartment, and as Lilia's son sleeps in the next room, Kate tells her it's time to face the reality of her limited options. Kate intuitively trusts in Lilia's innocence, but the jury won't. It's heartbreakingly unjust, but there's only one way to stop the trial, her inevitable incarceration, and to save her son from being condemned to the nightmare of growing up in state custody. Lilia slowly absorbs the choice she's suddenly confronting. She stops at her son's bedroom doorway, looking in on her sleeping son, before turning back to Kate. She asks her to call the Caines' family lawyer and tell them they're willing to agree to the private adoption.

We then witness the emotional aftermath of defeat. In a tense meeting with the Caine family lawyer, Kate forces herself to eat crow as she reluctantly concedes to the coercive terms of this dirty, under-the table deal. And the family lawyer doesn't make it any easier for her, gloating as he lays out piles of pre-signed documents for her. It's all been arranged, all the tangled red tape of city and state bureaucracies neatly cut through ahead of time. As if they knew from the outset that Kate and her client would inevitably have to buckle. And as Kate executes the documents with clenched teeth, we feel that all the wheels of city, state, and personal power have meshed together from the beginning, an unstoppable machine that thinks nothing of rolling over anything or anyone that stands in its path.

Before Kate leaves the clandestine meeting, the Caine family lawyer lets a casual comment slip that digs the knife in even deeper. He unintentionally refers to the moment Tucker uttered his first words—with Kate on the hospital grounds—a moment to which Jameson was the only other witness. And Kate is forced to leave the meeting with the chilling realization that at one point or another, Jameson must've been co-opted into Caine's corrupt circle of cronies.

The next morning, Jameson and the D.A.'s office file a motion dismissing all criminal charges against Lilia . . . and that afternoon, we see Lilia make the excruciatingly painful trip to her former home and employers, dropping off her son in the arms of Frank and Susan Caine. Kate, hitting a new low, retreats to her local church in search of solace as much as absolution, but arrives to find it as cold, empty, and abandoned as her own heart. Alone with her thoughts and despair, her eyes fall on a newspaper with a headline announcing the fire insurance award for the public housing project Caine's architects had designed. As she looks closer, we see the names of the other partners in the project, including Caine's family lawyer, the judge, and other prominent businessmen and officials. And while the appearance of potential impropriety alone doesn't give her enough to act on . . . something else does.

Kate spends a frantic afternoon searching through the city's Hall of Records . . . finally finding what she needs. And a few phone calls later, Kate has Caine, Jameson's boss (the heavily accented D.A.), and the family lawyer assembled at the Caine home. What she's uncovered is that the insurance award grossly undervalued the housing project . . . sending it into bankruptcy, and that a new corporation, with virtually the same partners, purchased the underlying property at a fraction of its value. Why? Because the federal government has just approved a new exit for the Interstate highway adjacent to the property, making it a potentially prime business site. And just before the fire these same partners had helped orchestrate and obtain a zoning variance, making the area open to commercial development. Kate reminds the men that she's been able to find all this out in one day's work. There's no telling what other evidence of arson, bribery and corruption, and even murder might turn up with a full-scale investigation.

The men sitting across from Kate don't respond to her allegations. They simply ask her to name her terms. Kate says that though she can't prove it, she knows Caine paid his mechanic Jack Marks to lose Tucker that

day in the city, with the expectation of blaming the incident on Lilia. Unfortunately, Caine didn't count on Marks' sting of conscience when confronted with the sight of the boy in actual lethal jeopardy. Kate dismisses Caine's heated denial, announcing she wants a written order from the judge dismissing Lilia's case with prejudice, so she can't be recharged at a later date. She also wants them to use the full extent of their influence and contacts in their old-boy network to favorably settle Lilia's immigration status. Finally, Kate asks Caine if he still insists on permanently committing Tucker to an institution. When Caine answers in the affirmative, Kate takes another set of papers from her briefcase, and asks him to sign . . . and as he ultimately complies, we see they're papers permitting the private adoption of Tucker by Kate.

As Kate leaves the Caine estate, Lilia's son and adoption papers in hand, she runs into Jameson coming up the front walk. They stop, he nervously tries to talk . . . but she interrupts, saying she's late for an important meeting. When he inquires, she looks at the papers, calmly replies that it's personal business, and leaves him with a casual, "See you in court." Jameson ponders the implication of that normally cordial professional farewell . . . and as Kate continues down the walk, we hold on her delightfully enigmatic expression, and

<div align="right">FADE OUT</div>

<div align="center">THE END</div>

Some books on creative writing advise writers to find the heart of their story through the process of writing, allowing the plot development to reveal the message of the story.

Nothing could be more dangerous and damaging.

It's the equivalent of advising a traveler to set forth on an important, new journey without a map.

Determining every single scene, from beginning to end (before sitting down to write the script itself) is the only way to ensure you will arrive at a destination that makes sense in terms of the characters and life lesson in your story.

I can't overemphasize this crucial point.

Sure it's difficult, and often frustrating, to do the hard work required to know everything you intend to write in a story outline, before you type "FADE IN:" But it's the only way to trace out a route that is guaranteed to take you where you want to go.

Don't kid yourself. Do all the hard work of building every element and sequence of your story up front. Save your struggles for this essential primary task.

All professional screenwriters are required by studios to deliver a detailed, pinpoint outline of the story before being allowed to start the actual script.

That way, there are no unpleasant (or catastrophic) surprises among writers, their employer, and the creative journey you are about to embark upon.

And it's simply good sense. If you skip over the crucial details of a character's path to learning the life lesson you hope to convey, you will get lost—and trust me, it is infinitely easier to change the elements of a 12-page outline than to toss out 120 incoherent pages and start again from the beginning.

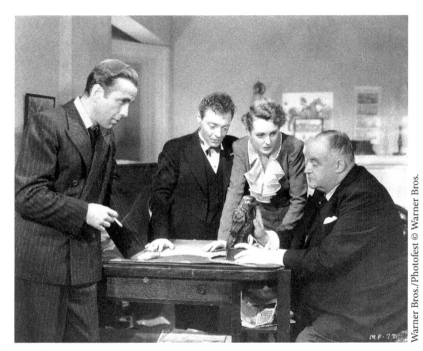

The Maltese Falcon

It's really not about the hunt for the bejeweled black bird. Like all noir stories, it deals with a dark view of human nature. And over the course of the film, amoral detective Sam Spade (Humphrey Bogart) finally learns to confront his cynical worldview and turns in his client/lover Brigid O'Shaughnessy (Mary Astor) to the police for the murder of his partner.

CHAPTER

12

FORMAT

Many students stumble when it comes to writing proper screenplay format, even though its theory is simple.

I'm not saying that format is the most important element for new writers to master. Remember, what's truly important is always theme and character.

But format problems are the first thing that a Hollywood reader/gatekeeper will notice—and it is also true that we writers only have one chance to make a first impression.

Format problems will label you as an uninformed amateur right from the start, and I can't tell you how many scripts are tossed aside after readers see simple but conspicuous format errors marring the first two or three pages.

Proper format is just one requirement that keeps people reading your script and judging it on its creative merits.

First, it's important to know from the beginning that Hollywood requires a standard script template, so that all scripts not only look the same, but also follow the rule that one page of script is equivalent to one minute of running time. Knowing that, say, a 120-page script will run precisely two hours of resulting film is absolutely critical to planning and budgeting every single project that is made.

And there is a standard Hollywood software format that all studios and production companies use. The commercial screenwriting software product that is standard throughout the industry is called Final Draft and is available online or at a writers' store.

It works well but is not inexpensive.

Therefore I advise my students to take advantage of a free script formatting software called Celtx, also available online.

The only downside is that Celtx is not the industry standard, and thus it is not compatible with the software program most writers and studios use. However, if you're just starting out as a writer, this one problem shouldn't matter. The script format looks the same when printed out.

While some elements of format might seem arbitrary, they're not. Proper format is not only essential to having readers consider you a professional writer, it also functions as the critical communicative link between the writer and the director, producers, cinematographer, and other key departments on the set.

The following are the most important aspects of format that are confusing for new writers.

1. SLUG LINE

This is the name for the heading of every scene, and there's only one proper way to do it. It serves as a guide to all the departments involved in preparing your script for shooting.

And it should look like this:

```
INT. LIVING ROOM - DAY

or

EXT. HOUSE - NIGHT
```

INT. and EXT. stand for INTERIOR and EXTERIOR, respectively. And these are the only two options available. This indicates whether the scene to be shot is either inside a building or outside.

Obviously, this information is essential to the camera and lighting crew in terms of preparing the scene and locating their equipment. But notice that it is necessary to know if there are weather issues, as well. If it's raining for instance, and the exterior shots require sunshine, the producers can plan ahead, shoot the interior scenes, and save the exterior scenes for later.

Budgeting is essential. One day of missed filming, even on a television show, can cost hundreds of thousands of dollars. Remember, the crew gets paid for every day worked, no matter what the weather or other variables. The production must therefore go on, no matter what problems the crew faces on a given day.

The same logic applies to whether the scene to be shot is supposed to occur during the day or night. Again, the crew needs to know this to locate and light the scene. If the crew is running behind, day can easily turn into night and ruin the continuity of a scene meant to be filmed to reflect a certain time of the day.

And unless you are given explicit permission, never be more specific regarding the exact time of day or night.

Yes, a more detailed description of time of day is often found in professional scripts, but it is often considered improper format.

So, slug lines that indicate:

~~~~~~~~~~

```
EXT. SCHOOL - SUNSET

or

INT. OFFICE - DAWN
```

~~~~~~~~~~

are too detailed for the purposes of organizing locations that are to be shot together. Producers and crews divide their scenes into DAY and

NIGHT for budget purposes, adding the details of the exact time of day or night is irrelevant to their basic planning. The exact time of day can be indicated, but not in this format element.

Again, this element of the slug line helps the producers and crew plan their shooting day, as scripts are never shot in a linear sequence from the first scene to the last. It is the producers' and director's job to group scenes together that: (1) use the same location, and (2) occur at the same time of day, to save crucially expensive shooting time.

But it's important to know the format of the slug line is also meant to only convey these elements.

The most common mistake new writers make when writing a slug line is putting in other, irrelevant information.

A common example of a slug line that contains extraneous information is the following:

~~~~~~~~

```
INT. HOUSE WHERE BOBBY STANDS OUTSIDE, CRYING, - DAY
```

~~~~~~~~

The information concerning who is in the scene and what they are doing or feeling belongs in another format element. Never include information beyond INT./EXT., THE LOCATION, AND DAY OR NIGHT in your slug line, as extraneous information is not only confusing, but also marks a writer as an amateur.

And remember, as with all these format elements, making these kind of mistakes destroys our ability to make a first impression that we are professionals and know what we are doing.

2. ACTION LINES

Action lines convey what is happening visually in the script that is not covered by dialog and angle calls.

They always occur immediately after writing the slug line that begins each and every scene you write. They also are written throughout the script between pieces of dialog when writers need to describe critical movements we would see if the script were filmed.

Action lines are written like regular prose, upper and lower case, and are restricted to what the audience will see and in some cases hear.

A typical example would look like this:

~~~~~~~~~

EXT. HOUSE - DAY

Katie drops her phone. She picks it up and grimaces with frustration. She looks up from her phone and sees George grinning at her.

~~~~~~~~~

What's most important to emphasize here is the fact that action lines almost never describe what a character is thinking. That's because screenplays are ultimately meant to be performed, not read.

However, action lines can describe what a character is feeling, as long as a potential actor can convey these emotions without telling the audience what's going on inside his or her head.

Thus the following example would not be considered proper format because some of a character's internal feelings can't be expressed either by the character's expressions or by particular actions:

~~~~~~~~~

George walks up to Katie. He's had a rough night, with little sleep, because he was working late on his screenplay that is already two weeks overdue.

~~~~~~~~~

As long as you stick to what we can see as a result of the action lines, you are generally safe, even if it describes a character's facial expressions or actions.

The following action line example would work, even though the character's feelings are important to describe.

~~~~~~~~~~

```
George walks up to Katie. She notices his eyes are bloodshot
and his hair is a mess. He looks upset and as if he's gotten
little sleep.
```

~~~~~~~~~~

In addition, sounds can be written into action lines. This can include a character's noises, as well as external sounds important to the meaning of the scene.

However, this is dangerous ground. Use sounds carefully and sparingly in your action lines, and only if they are important and the characters are meant to react to them.

As a result, sounds and noises are highlighted by underlining them or capitalizing them within the action lines. This shows the reader or actor what would otherwise be buried in a description of the action.

~~~~~~~~~~

```
Katie drops her phone and grimaces. George sees her angry,
frustrated expression, and can't help LAUGHING.
```

```
Or
```

```
George can't help laughing.
```

~~~~~~~~~~

Action lines have one other function, and that is to indicate the camera has moved—in a small, noncritical way in the middle of the scene.

We will get to critical angle calls later. But small, necessary, logical changes in camera direction (like going from a close-up to a wide shot) can be indicated by merely skipping a line in the middle of the action.

〰〰〰〰〰〰

```
Katie's eyes narrow as she looks at her broken phone. She jams
it into her purse and starts to walk away.

George notices her from across the street, and starts following
her.
```

〰〰〰〰〰〰

The last thing to remember when writing action lines is to write them as concisely as possible.

Readers/gatekeepers are overwhelmed with their reading workload each week. They often have as many as five or more screenplays to read and evaluate each day, including weekends. And the cold truth is that overworked readers often ignore the action lines and only focus on the dialog.

So if you have long and important action, it's essential to break it up visually on the page. And the way to do this is by skipping a line after each three lines of description.

Keep lots of white space on the page and don't overuse description. Your reader will not only appreciate it, but will also continue reading without feeling exhausted and overwhelmed.

3. PARENTHETICALS

Any screenwriting software will give you proper margins for charac-
ter, dialog, and parentheticals. But students often misuse and misplace
parentheticals when writing dialog, and this is another red flag to the
readers and gatekeepers.

Parentheticals most often are placed directly under the character name
and can have two functions. They can either tell the actor how a line is
supposed to be read, or they indicate some minor action that also affects
the point of the dialog.

```
                    KATIE
               (angry)
          Great, this is just perfect.
```

Or,

```
                    KATIE
               (taps phone)
          Hello? Anyone in there?
          Dammit, dammit, dammit.
```

Parentheticals can also be used in the middle of a piece of dialog.

```
                    KATIE
          I can't believe this.
               (to George)
          I'm never gonna be able to afford a new
          phone.
```

Another important and common use of parentheticals is to indicate a dramatic, short pause in the dialog. This short pause is called a "beat," and is a common tool in the writer's box.

~~~~~~~~~~~~

                        GEORGE
            I can get that fixed
            for you, no charge.

                        KATIE
                  (beat)
            What? No, I could never ask
            you to do this, really, thanks.

~~~~~~~~~~~~

The most common error new writers make is to bury the parenthetical in the middle of the dialog. And it's another formatting red flag that marks a writer as new and inexperienced.

~~~~~~~~~~~~

                        KATIE
            I'm never gonna be able to afford a new
            phone. Ugh. Dammit!(to George) How am I
            ever gonna pay for this?

~~~~~~~~~~~~

It is also a common formatting error to place the parenthetical after the dialog.

~~~~~~~~~~~~

                        KATIE
            How am I gonna pay for this?
                  (jams phone in purse)

~~~~~~~~~~~~

New writers also make the mistake of using parentheticals to direct on paper.

It's also important to note that parentheticals should only take up one line. Avoid long descriptions.

~~~~~~~~~

```
                    KATIE
          (picks up the phone, walks across
           the room in frustration and screams)
        I hate this damn phone!
```

~~~~~~~~~

Remember, parentheticals are only used to describe how a line is supposed to be read or to describe a small action that is coherent with the dialog.

4. CAMERA ANGLES AND TRANSITIONS

Camera angles are another dangerous but necessary tool in new writers' hands.

The most important advice to new writers is to avoid directing on the page. It's another move that marks a script as written by an amateur.

A writer should indicate the camera angle only if the reader wouldn't otherwise understand the focus of the action.

It is also a matter of courtesy to the director/reader to indicate a particular angle that is necessary to understanding the characters and the story.

Camera angles are written in capital letters, flush left, and are placed on their own lines. Again, screenwriting software will often do this automatically, but it is easy for new writers to do this improperly.

~~~~~~~~~~

ANGLE - IN GEORGE'S CAR

Katie and George get in the car, and George backs out of the
driveway.

                              KATIE
                  How am I gonna ever fix this?

                            GEORGE
                No problem, come with me.

Katie looks dubious, but follows him.

~~~~~~~~~~

It's important to note, above, that action lines always follow an angle
call and always follow dialog.

After writing the necessary action lines, you can either write more char-
acter and dialog, or call a different angle.

~~~~~~~~~~

ANGLE - BY A STOP SIGN

The car starts to roll through the intersection.

ANGLE - IN THE CAR

George turns to Katie.

                            GEORGE
                Katie, I'll take you to a phone repair
                shop where -

George, wide-eyed, suddenly slams on his breaks

ANGLE - WIDE - THE INTERSECTION

His car barely misses a truck barreling right at him.

George takes a deep breath and turns to Katie.

```
                        GEORGE
                  (rattled nerves)
            Sorry. Damn, that was close.

Katie is spooked, but smiles at him. She deliberately buckles
her seatbelt.
```

~~~~~~~~~~~~~

Notice that after the last angle call on the previous page, two other things can happen.

First, notice the skipped line in the action after the final angle call. The skipped line in this instance tells the reader or director that the camera should move again but does not specify exactly what that angle should be.

This helps the story continue moving smoothly, without an excess of distracting angle calls.

Notice also the parenthetical in George's dialog. It not only indicates his facial expression but also the way he should deliver the line.

Writers can use a variety of angle calls, from CLOSE UP, to WIDE ANGLE and many more. But the use of angle calls should be restricted to those essential to the reader's understanding of what's important visually in the script.

Remember, a properly formatted script is designed to run one minute of film time for each page. Overusing angles can make the script seem to run much longer than it really does and can interfere with accurate budgeting and scheduling.

I also want to point out that there is some leeway in how we write our angle calls. If you review my script *Acts of God,* you will see that I indicate my angles somewhat differently.

And that's because I believe that angle calls can drive the flow of the story to a screeching halt for the reader.

To avoid distracting the reader with technical angle calls, I write them in a way to make them an organic part of the storytelling process.

Rather than writing:

~~~~~~~~~~

```
George stops the car and turns his head.

ANGLE - ON THE INTERSECTION

A second car barely misses them.

NEW ANGLE - ON KATIE

We see she has braced herself on the dashboard of the car.
```

~~~~~~~~~~

I can write the angle calls as the end to my action lines in the following way:

~~~~~~~~~~

```
George stops the car, turns his head and sees

A SECOND CAR

that barely misses them. After a beat, we see that

KATIE

has braced herself on the dashboard.
```

~~~~~~~~~~

Do you see how the angle calls in this case become part of the story-telling function of the action lines? I often write this way to avoid the distraction of having angles only function as a note to the director.

When written as part of an ongoing action line, these angle calls help guide the eye into the story instead of stopping the narrative to only indicate that the camera has moved.

How common is this way of calling angles? While I've seen this done in many TV and feature scripts, it's not the most conservative approach.

The best bet is to write angle calls either way when your script is in the reading and marketing phase, and to write them more formally when the script is going into production.

Transitions can also be written in different ways. To start, transitions are written in all capital letters, and flush right.

They also always follow an ending action line at the end of the scene and come immediately before the next scene and its slug line.

And there are only a few transitions that screenwriters need to know.

When an important, logically necessary time difference separates one scene from another, the transition is called a DISSOLVE, and it looks like this:

~~~~~~~~~~

Katie takes her hands off the dashboard and finally relaxes.

                                        DISSOLVE TO:

EXT. REPAIR SHOP - DAY

George's car parks at the front of the shop.

~~~~~~~~~~

A DISSOLVE indicates that one scene doesn't immediately follow another. It's virtually invisible to the eye of most viewers, but subconsciously nearly all viewers understand that when a DISSOLVE occurs, there is time gap between the two scenes.

What amount of time has to pass before using a DISSOLVE? The answer is that the time can be great or small. All that matters is that a DISSOLVE is used when the story is moving to another dramatic point from the previous scene.

In this case, the audience is being told that after the near accident the story is moving on to the next dramatic point at the repair shop.

There is one other transition that is commonly used at the end of scenes. The transitions "CUT TO:" and "HARD CUT TO:" are also all capital letters and flush right.

However, technically speaking, the ending of every scene requires a CUT TO if a DISSOLVE isn't indicated.

A typical example would be the following:

~~~~~~~~~~

```
Katie takes her hands off the dashboard and finally relaxes.

                                                        CUT TO:

INT. KATIE'S APARTMENT - DAY

Katie's dog is chewing up the garbage and spilling it all over
the floor.
```

~~~~~~~~~~

If we want to indicate that the next scene is occurring at exactly the same time without any time break, it should be written like this:

~~~~~~~~~~

```
                                                        CUT TO:

INT. KATIE'S APARTMENT - DAY (CONTINUOUS)

Katie's dog is chewing up the garbage.
```

~~~~~~~~~~

This is an important way of telling the audience that two things are happening at once in the screenplay.

The use of CUT TO is most often used in this sense of describing continuous action. No time has passed, and something else important is occurring simultaneously in the script.

Also, if the two scenes are a jarring contrast with each other dramatically, the use of CUT TO or HARD CUT TO is often employed.

~~~~~~~~~

```
Katie smiles, relaxes and clicks on her seatbelt, and

                                          HARD CUT TO:

INT. KATIE'S APARTMENT - DAY (CONTINUOUS)

Katie's dog starts choking on the garbage and can't breathe.
```

~~~~~~~~~

At this point, I think you understand how to use this transition. But I'm going to offer a bit of advice that will help in your writing.

Don't use it.

Why? Because it has largely been outmoded in most professional screenplays. The logic is that the reader or director already knows there is going to be a cut between each and every scene. Thus the use of CUT TO is redundant.

But the most important reason most screenwriters have abandoned this transition is that it takes up too much space on the page, making the script much longer than intended.

Page count is always the enemy of screenwriters.

Television scripts going into production have to be precisely as long as the airing network allows, making room for commercials.

Feature scripts aren't as hemmed in, but the first thing professional readers do is look at the page count. If it seems too long for them (more than approximately 110 pages) they simply won't read it, and the writer is left out of consideration.

You can still use this transition, but beware—placing it at the end of each scene will eat up pages more than you realize. And if page count is an issue—and I argue it always is—you will find yourself going over the ideal length you had in mind.

5. VOICE-OVER (V.O.) AND OFF-SCREEN (O.S.)

This is a format area that also trips up new writers. The use of V.O. or O.S. is meant to indicate how the director and post-production team are going to deal with actors' lines when the characters aren't on screen.

The simplest example is if your script has a narrator while other action is happening on screen. For instance:

~~~~~~~~~~

```
Daniel runs through the woods, breathing hard, trying to escape
from something.

                    NARRATOR (V.O.)
          Looking back after 20 years, that
          terrifying night would change my life
          forever.
```

~~~~~~~~~~

V.O. is also used when writing phone conversations, playing recorded messages, and also with any dialog where the actor in the scene couldn't normally hear the dialog you want to write. An example of a phone conversation could go like this:

~~~~~~~~~~

```
Brian is on his cell phone while driving his car.

                    BRIAN
               (to phone)
          Jack, thank God. Where the hell have you
          been?
```

```
                        JACK (V.O.)
                   (over phone)
              I don't know. Are you sure you gave me
              the right directions?
```

~~~~~~~~~~

The main point is that voice-overs are recorded later in the filming process and the writer should indicate which pieces of dialog need to be captured after filming is completed.

When in doubt, use V.O instead of O.S., and you'll probably be right.

The function of O.S. is much more simple. As opposed to V.O., this is used when the speaking character is off-screen but is still within hearing distance of another character who is present.

What you are saying when you indicate a piece of dialog is O.S. is that the dialog is recorded at the same time the scene is filmed. And the general rule is that if we were in this kind of scene, we would naturally and normally be able to hear and understand the character's natural voice speaking off-screen.

The most common example is two characters speaking from different rooms in a house.

~~~~~~~~~~

```
Cindy and Jeff are sitting on a couch, watching television. We
hear the news cut to a commercial, and Cindy gets up and walks
off-screen into the kitchen.

                        JEFF
              While you're in there, could you get me
              a beer?

                        CINDY (O.S.)
              What kind do you want?

We hear the television advertise a weight loss program. Jeff
reacts, touches his large belly.
```

```
                    JEFF
          Better make that a light beer.

We hear bottles clanking off-screen.

                    CINDY (O.S.)
          You going on a diet?
```

~~~~~~~~~~~~

What's most interesting about this example is the implication that both voice-over and off-screen dialog is happening at the same time.

Since Jeff can hear Cindy naturally, her dialog is written as O.S.

But what about the television?

The scene, as written, doesn't explicitly indicate how the television news and commercial should be handled.

Think about it. Is the television dialog going to be easy to record on the set? And how do we know exactly what the television will say when filming?

The answer is that the television is recorded as a voice-over because we need to precisely control what we hear while filming.

But because the example of the television dialog is so common, we don't normally have to tell the director or post-production team how to handle it.

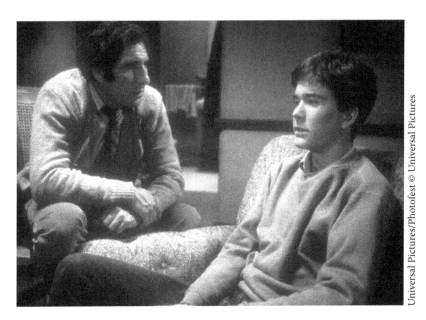

Ordinary People

In this extraordinary novel and adapted screenplay, the big plot elements occur before the movie begins: Conrad Jarrett (Timothy Hutton) has returned home after his attempted suicide following a boating accident that killed his older brother. Conrad learns through his therapist to overcome his survivor's guilt, and to openly grieve the loss of his brother, in spite of his mother's (Mary Tyler Moore) rigid refusal to tolerate any messy emotions in their otherwise picture-perfect suburban life.

CHAPTER

13

COMMON CHARACTER, DIALOG, AND SCENE-BUILDING PROBLEMS

This last chapter is a compilation of the most common and serious errors all new writers make while in the process of writing the script itself. Over the course of my teaching I've come up with a short list of technical writing issues that most bedevil new writers.

Take this as cautionary advice that will help you stay on thematic track and avoid the most common problems I've found in student scripts.

In the end, by avoiding these universal issues almost all writers face, you will save yourself from the hair-pulling frustrations and disappointments of almost all first efforts.

New writers often have trouble creating characters in their scripts that are both believable and relatable to the reader or audience.

It is essential to understand that without credible and relatable characters, writers not only lose the point or life lesson they intend to convey, but they also alienate both readers and their potential audience.

Character credibility is absolutely critical. But how to create it?

The first thing to remember is that in all creative writing, but particularly in dramatic writing (plays and scripts), learning to show your audience the essential elements of your character, without resorting to telling them, is the hallmark of true professional and persuasive writing.

Audiences bristle at being told how the characters think and why they behave the way they do. It's clunky, superficial writing that only skims the surface of a scene. And audiences and readers are thus left unconvinced that the characters are truly how the writer claims they are.

At the outset, characters must coherently convey their flawed values through their action and dialog. We have to be able to know what their flawed values are without having the characters being aware of them.

The best way to illustrate their flawed worldview is by showing how it affects every aspect of their daily lives. Characters manifest their flaw at work, at home, with their friends, children, siblings, and romantic partners.

As indicated earlier, this is the creative task of act one, and before the main character is pressured to change to a new value system over the next two acts.

But new writers often choose a flaw and a life lesson that don't accurately illustrate a character in a believable way. Audiences know character; they deal with it in themselves and in interactions with others every day.

So it's essential for writers to know how people change in a believable way.

One helpful means of delineating a character's flaw and journey to a changed worldview is by studying Abraham Maslow's Hierarchy of Needs.

The most fundamental human needs are shown in the first four layers of the pyramid, following. It is Maslow's theory that each of these most basic needs must be met in turn before a person can focus upon the secondary, higher levels of human development.

So it would not make sense if a character is unemployed and sleep deprived, but focuses all his efforts and attention on the higher level needs of friendship, family, and sexual intimacy.

This is a useful guide when writing a character's journey across all three acts. The theme or life lesson can involve a greater sense of morality, lack of prejudice, or an acceptance of facts in life, but the human journey of change must be believable.

Thus, it is important to use Maslow's theory when mapping out a character's maturation over the course of the entire narrative.

In summary, Maslow's Hierarchy of Needs can be illustrated as follows:

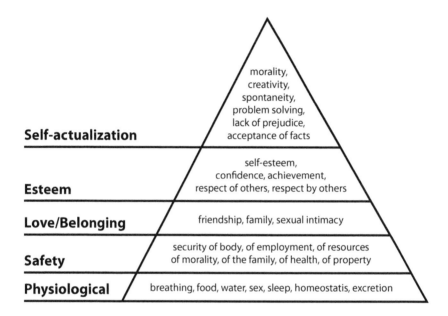

Physiological Needs

These need to be met first, before any other needs can be pursued. They include air, water, food, clothing, and shelter.

Safety Needs

When physiological needs are met, attention can be shifted to the need for personal and financial security, health, and safety from accidents or illness.

Love and Belonging

Deficiencies within this level can include abusive parents, neglect, shunning by peers, and ostracism. When this level is reached, the individual can form emotionally significant relationships, including friendship, intimacy, and family.

Esteem

People with low self-esteem may be depressed and may be obsessed with external validation from others. They may also think they need to seek the external goals of money, power, status, and fame. But these emotionally empty goals will not help characters build self-esteem until they truly accept who they are internally.

Maslow indicated two types of esteem needs. One is the lower need for respect from others, and a higher one is the need for self-respect. The higher version might manifest as the need for self-confidence, strength, and independence.

Self-Actualization

This highest level of needs includes a character's need to reach his or her full potential in life. These include embracing morality, creativity, and acceptance of the facts of an individual's existence. Individuals at this level may focus on specific goals, such as being a good parent, spouse, or friend. This might also include pursuing the goals of personal achievement in writing, art, or music.

There is another important issue in the development of a believable character, and that is illustrated by Erik Erikson's Stages of Psychosocial Development.

As opposed to a hierarchy of needs independent of age, Erikson developed a series of psychological crises and goals over the course of a person's lifetime. This is an invaluable tool when thinking of the main challenges all of your characters face, depending on their age.

Erikson's stages of human development can be used in tandem with Maslow's hierarchy of needs, and often this combination of factors leads to the portrayal of a convincing and meaningful character.

Erikson's stages start in infancy and extend all the way to death. The basic point is that individuals will carry the wound of psychological crises throughout life, unless and until these issues are resolved.

STAGE	BASIC CONFLICT	IMPORTANT EVENTS	OUTCOME
Infancy (birth to 18 months)	Trust vs. Mistrust	Feeding	Children develop a sense of trust when caregivers provide reliability, care, and affection. A lack of this will lead to mistrust.
Early Childhood (2 to 3 years)	Autonomy vs. Shame and Doubt	Toilet Training	Children need to develop a sense of personal control over physical skills and a sense of independence. Success leads to feelings of autonomy; failure results in feelings of shame and doubt.
Preschool (3 to 5 years)	Initiative vs. Guilt	Exploration	Children need to begin asserting control and power over the environment. Success in this stage leads to a sense of purpose. Children who try to exert too much power experience disapproval, resulting in a sense of guilt.
School Age (6 to 11 years)	Industry vs. Inferiority	School	Children need to cope with new social and academic demands. Success leads to a sense of competence, while failure results in feelings of inferiority.

STAGE	BASIC CONFLICT	IMPORTANT EVENTS	OUTCOME
Adolescence (12 to 18 years)	Identity vs. Role Confusion	Social Relationships	Teens need to develop a sense of self and personal identity. Success leads to an ability to stay true to yourself, while failure leads to role confusion and a weak sense of self.
Young Adulthood (19 to 40 years)	Intimacy vs. Isolation	Relationships	Young adults need to form intimate, loving relationships with other people. Success leads to strong relationships, while failure results in loneliness and isolation.
Middle Adulthood (40 to 65 years)	Generativity vs. Stagnation	Work and Parenthood	Adults need to create or nurture things that will outlast them, often by having children or creating a positive change that benefits other people. Success leads to feelings of usefulness and accomplishment, while failure results in shallow involvement in the world.
Maturity (65 to death)	Ego Integrity vs. Despair	Reflection on Life	Older adults need to look back on life and feel a sense of fulfillment. Success at this stage leads to feelings of wisdom, while failure results in regret, bitterness, and despair.

Thus a lack of reliable care and affection by caregivers will leave an infant with serious trust issues throughout life if the problem is not addressed by some form of conscious healing in later relationships.

Early childhood requires the development of physical independence, or the individual will develop feelings of shame and doubt.

During preschool years, children need to assert control over their environment to attain a sense of purpose. A failure to succeed at this level often results in disapproval and a sense of guilt.

During the ages of 6 to 11, children are faced with the challenges of developing social and academic competence. An unresolved crisis at this stage leads to a feeling of inferiority in relation to others.

Adolescence involves the search for individual identity with respect to peers and adults. Success results in a secure sense of self, and failure can lead to a conflicted character and a weak, impressionable character that can be easily manipulated.

The typical challenge for the young adult (19 to 40 years old) is the creation of loving and connected relationships with others. A properly resolved crisis at this age results in a strong emotional support system, and failure often creates a sense of loneliness and isolation.

Between the ages of 40 and 65, individuals are focused on creating accomplishments that will endure after they are gone. Success at this level is often defined as raising children or by selfless acts that will improve the lives of others. Failure to resolve this crisis can result in a superficial, selfish existence.

Finally, the last stage of life involves an evaluation of an individual's entire journey. As life is coming to a close, the challenge is to be able to look back with a sense of equanimity, accomplishment, and acceptance. Failure at this level most often leads to an overwhelming sense of regret, bitterness, and despair.

All of Erikson's psychosocial crises are dependent on one another for personal fulfillment and self-actualization, the feeling of a life well lived.

If one stage isn't properly negotiated, this will continue to cause problems for the individual throughout life. And while deeply personally troublesome, these developmental crises are a great map with which to

discover and understand the typical dysfunctions of the flawed characters we create at the beginning of our stories.

The goal of utilizing both Maslow's and Erikson's developmental stages is to create a sense of verisimilitude in our fictional characters. Readers and audiences feel whether a character is both identifiable and coherent, even if they can't express why that is the case.

And it is our job as creators of fiction to have the insight into our characters' emotional and developmental state in a way that is convincing and relatable to the reader throughout the entirety of our stories. If we fail at this core task, it's guaranteed that our audience will stop caring and will put our stories aside.

There are other points to be emphasized with respect to dialog and scene building that only come up when you are in the midst of writing the script.

Remember as you write that the ultimate goal of your efforts is always to create believable characters that have relatable flaws and come to learn a life lesson important to you and the audience.

The following issues are the most common errors that new writers make in their dialog and scene building.

The most important thing to keep in mind about professional dialog writing is that characters should never say exactly what they mean. Professional writers call this avoiding "on-the-nose" dialog.

Well-written dialog is always a matter of communicating what characters think and feel through subtext. The goal is to have the audience understand what characters mean without having to lay it all out like sworn court testimony.

Don't worry. This takes practice, lots of it. The point is to always strive for replicating how human beings speak to each other in real life. And how humans speak to each other is always in a roundabout way.

A simple example could be a woman cancelling a date with her boyfriend because, as we would have seen earlier in the script, she is angry that he flirts with other women in public.

The dialog might go like this.

~~~~~~~~~~

                    MARY
        About tonight, I'm not feeling so
        well.

                    JOSH
        You look fine.

                    MARY
        Yeah, well looks can be deceiving.

                    JOSH
        What's wrong?

                    MARY
        Nothing, nothing important.
        Don't worry about me.

                    JOSH
            (disappointed)
        That's OK, we can reschedule for
        next week.

                    MARY
        Good. Next week is good.

~~~~~~~~~~

We know that next week isn't good for Mary. And it doesn't take a rocket scientist to figure out that there's trouble between these characters, even if we weren't alerted to the woman's real concern in a previous scene.

It makes sense. We get it.

And so will your audience. Never be afraid to take your obvious dialog and make it more obscure. Never say exactly what's going on emotionally inside each character. As long as the underlying emotion (subtext) is clear and relatable, your audience can follow your characters' dialog because that's how people behave in real life.

But one exception is that in all scripts there come moments where the writer has to convey important, accurate information (exposition) to the audience through dialog.

In this case, it is a mark of a good writer if the exposition is buried under other, more obvious events that are going on in the scene. That way the exposition doesn't seem as painfully artificial and forced.

I call these other events that distract us from expositional, artificial dialog the exposition monkey.

I once wrote a television script in which it became necessary to explain to the audience how the main characters solved the mystery (A story) in the episode.

It was awkward and terrible. Real people just didn't talk like that. But we ran out of time and had to end the episode with the solution to the A story mystery.

And then the director came up with a brilliant way to take attention away from the unnatural exposition in the dialog.

While the detectives were explaining the solution to the police lieutenant, the director circled the actors with the camera. At the end of every loop, we could see through the glass to the desk sergeant in the other room.

As the necessary dialog droned on, the audience saw a parade of petty criminals entering the police station. It was a colorful, engaging group of crazy characters.

And then it happened. The director intentionally positioned an organ grinder and his monkey in front of the desk sergeant.

That got the audience's attention. And over the next three loops of the camera, the audience saw the monkey jump on the desk, tear the sergeant's papers to pieces, and finally take the organ grinder's cigar, and set fire to the booking desk.

It was a gleefully absurd, attention-grabbing idea. The audience got the information it needed to understand the mystery, while at the same time the vast majority of its focus was on the entertaining monkey.

So when you find yourself in a tight spot, and expositional dialog is absolutely necessary, find your own exposition monkey to distract your

audience from the clunky, unnatural tone of dialog meant to directly convey information to your audience.

A related dialog issue is avoiding exposition delivered to the audience by having your character talk to him or herself. This common strategy among new writers never works and results in the audience losing faith in the characters because they are behaving in an unrealistic manner.

Just take this as an example and see how it feels to you.

~~~~~~~~~~

```
Bobby watches as his girlfriend angrily walks out of the
apartment and slams the door.
                    BOBBY
               (to himself)
          God, I hate it when she does that.
          Doesn't she understand I have feelings,
          too?
```

~~~~~~~~~~

That dialog sounds forced and artificial, doesn't it? Bobby clearly isn't speaking to himself, because people normally just don't talk that way.

What's really going on is the writer is trying to use dialog as a way to speak to the audience. And as common as this tactic is in new writers' scripts, it is always jarring and leaves the audience feeling that the character has suddenly become unbelievable.

Another common expositional problem occurs when new writers use photographs to tell the audience what the character is thinking. This means of attempting to show a character's inner state also never works, because real people simply don't need photographs to help them think about a given person, ever. And audiences don't buy it.

When this happens in a script, the audience knows what's really going on is another awkward, unbelievable attempt to show a character's thoughts.

One example of this should suffice.

~~~~~~~~~

```
Jeff walks down a rainy street, looking depressed. He stops
at a corner, waiting for the light, and pulls a photograph
out of his pocket.

CLOSE UP - THE PHOTOGRAPH

His ex-girlfriend, Barbara, smiles in the photo, looking
radiant. Jeff really misses her and can't stop thinking about
her.

Jeff sighs, puts the photo back in his pocket and crosses the
street, still with Barbara on his mind.
```

~~~~~~~~~

This is almost silly and is clearly not how real people behave. When this tactic occurs to you, just say no. No matter what, avoid the use of photographs in an attempt to show what your characters are thinking.

A similar issue occurs when new writers use voice-over to explain what a character is thinking or feeling.

~~~~~~~~~

```
Jeff walks down a rainy street, looking depressed.

                    JEFF (V.O.)
          Every time it rained, I couldn't help
          but think of Barbara and her glowing
          smile. How I managed to ruin that
          relationship ate at my guts. Our walks
          together in the rain were our special
          time.
```

~~~~~~~~~

This voice-over is a completely unbelievable attempt to convey what is in the character's head. It's important to emphasize that in good screen-

writing we should not be able to read a person's thoughts. "Show, don't tell," is the mantra when writing dialog.

Another problem occurs when dialog merely repeats an emotional reaction that has happened earlier in the script. In this case, the audience gets bored because it has already determined how the characters are feeling in a given scene. When this happens, the momentum of the story stops, and the audience inevitably begins to lose interest.

In this example, imagine we have learned in the previous scene that Maria's mother cancelled a lunch date with her because she's in a bad mood.

A following scene that repeats the emotional point might look like this.

~~~~~~~~~

```
Maria sits in a restaurant with her friend, Amanda.
                    AMANDA
          So, tell me again why your mom
          couldn't come to lunch today.

                    MARIA
          Oh, you know how she gets.

                    AMANDA
          Moody, right?
```

~~~~~~~~~

What's wrong with this dialog?

The problem is that while Amanda might not know what happened in the previous scene between Maria and her mother, we the audience do know.

And this repetition of an emotional moment brings forward movement to a halt. An essential goal when organizing the scenes in a script is to avoid all repetition of emotional moments and thereby keep the audience interested in what happens next.

232 Chapter 13 Common Character, Dialog, and Scene-Building Problems

Another problem with unbelievable dialog and behavior is having your character overreact emotionally to the situation. Again, it just doesn't fit with how we expect real people to behave, and when characters overreact this way, we also cease to believe in them.

~~~~~~~

```
Jeff is let out of the car by Barbara. He walks down the
street, looking depressed, and as she drives away he begins
to cry.
```

~~~~~~~

Beware of your characters over-emoting in an attempt to describe their feelings and thoughts. Subtlety is always a hallmark of good writing. Learn to trust your audience, and don't let your characters react so strongly they lose all credibility.

Another way to lose the credibility of the author and characters is by the use of flashbacks.

Simply put, don't use them, ever. I know this is hard for new writers, but they must learn how to express how their characters are feeling without stopping everything and going back in time.

As discussed in the first chapter of this book, flashbacks in the hands of new writers become crutches for sloppy writing. They are used to explain what a new writer is unable to show through the linear use of dialog and action. Flashbacks also stop the forward movement of the story and thus halt reader and viewer interest.

Most importantly, flashbacks in the hands of new writers become excuses for telling the audience exactly what the characters are feeling in the present moment, and why. This makes the writing awkward and amateurish.

It takes practice, but in the end good writing depends on telling a story from beginning to end in a linear fashion where characters don't say or reveal exactly what they mean and why.

By now you get the point. While conveying our characters' inner states is difficult, it is always essential to find a way to show this, without telling, and without repeating ourselves.

A final note relates to the subject of scene writing throughout the script.

The most important thought to keep in mind is to beware of the plot (A story) driving the action of the B story/life lesson. Remember, nothing that merely happens is inherently dramatic or interesting.

Instead, in all good storytelling, plot follows character, not the other way around. What's always essential to the audience is how characters react to what is happening, not the particular plot events themselves, no matter how dramatic you might think a piece of plot may be.

Remember, only twenty-eight to thirty-five plot archetypes have ever been written, and your audience has seen them all, over and over again. What the audience pays attention to, and craves, is an honest emotional reaction to the events themselves on your character's journey to learning the life lesson you have selected.

Everything else, believe me, is secondary.

EPILOGUE

Now the time has come to leave you to embark on your own journey as a writer.

Over the course of this book I hope to have helped you discover the themes and values in life that are most important to you.

Learn to trust your instincts when it comes to selecting the life lessons you wish to communicate to your audience.

Trust that the quality of the artist's life hinges on your emotional honesty and insight into the human condition.

Know that while commercial success is an honorable goal on the artist's path, it's not the only goal.

Good, professional writing is its own reward, because the writing process leads to self-revelation.

The process of writing helps us to understand our own flaws and the path to their resolution.

Never be afraid to write about what you believe in, because the courage to tell your emotional truth is ultimately your visceral connection to your audience.

Know that your audience is depending on you to show it what it feels inside but doesn't know how to express.

And know that no matter how lonely the writing life may seem at times, you are never alone.

You are a writer, and in the writing process, we hold all humanity in our hands.

Enjoy the journey.

APPENDIX

SCRIPTSHARK COVERAGE/STORY ANALYSIS FOR ACTS OF GOD

Type of Material:	Script		Title:	ACTS OF GOD
Number of Pages:	10 + Title Page		Author:	W. Reed Moran
Submitted by:	Author		Circa:	1995
Submitted To:	Script Shark		Location:	Virginia; Washington, DC
Analyst:	EK		Genre:	Drama
Coverage Date:	07/12/12			

LOG LINE: Investigating a suspicious church burning as part of a string of hundreds of arsons, a Deputy Assistant Attorney General must confront small-town prejudice, racism, and dark secrets intertwined with his own past--including his corrupt pastor half-brother.

	EXCELLENT	GOOD	FAIR	POOR	BUDGET	
Idea	X				High	
Story Line	X				Medium	X
Characterization	X				Low	
Dialogue	X					
Production Value	X					

COMMENTS: A shocking, provocative, and surprisingly underexplored true story serves as the basis and backdrop for a plot, in the foreground, that becomes, over the course of this script, not only a riveting mystery but also a poignant, elegant, and quite compelling character story. Dovetailing its underlying narrative architecture with biblical themes and undertones and the careful, measured development of its central characters, the script seems, almost effortlessly, to fashion a combined overall impact that proves engaging, emotional, and thoroughly successful from start to finish.

Structurally, the discovery of a fire that levels a church owned by renowned attention-seeking preacher Jacob by several teens serves as a prologue to the central story before, cutting forward, the first act proceeds to flesh out protagonist Esau in his engagingly flawed status quo. The conflicts and cracks in his relationship with girlfriend Amanda are

made clear instantly through such cunning details as her absent confrontation with him via smashing his alarm clock before, assigned to the church case, Esau's journey home becomes a trip almost biblical in scope and dimension.

The meat of Esau's investigation comprises the central thrust of the story, taking a sharp turn with suspect Weasel's surprising confession. From this point forward, a fascinating dynamic emerges, Esau's morals and convictions tested as he winds up confronting and dismantling his own potentially career-making case. Amanda's self-centered desertion of Esau arrives with a gut-wrenching impact at the close of the second act, combining with Weasel's dread-inspiring decision to follow through on his earlier false confession, only to be smashed off the road in a fiery accident.

Moments such as Esau's discovery of the first true clue, via mail belonging to his erstwhile father's widow, supply sharp twists, turns, and escalations to the story, funneling toward what becomes a quite poignant and emotional redemption on both central characters' parts within the third act. Jacob's on-air vindication of Weasel becomes almost as gripping and affecting as Esau's subsequent decision to bury the scandalous tape producer Heather supplies, at last bridging the gap between the long estranged half-brothers. Here, even minute details such as the fact that Isaac had intended to bestow his legacy upon Esau, rather than Jacob, create sharply compelling emotional twists to continue supplying the story with new, fresh degrees of revelation.

From its first page, but indeed throughout its subsequent unfolding execution, this script demonstrates a more or less immaculate written style. Deeply cinematic sensibilities are established within the first few scenes, combining, in parallel, Jacob's sonorous sermon with the teens' discovery of his burning church. Every minute detail has been carefully addressed in each scene, creating vivid, well-textured, atmospheric images and locales, while at the same time never succumbing to dense descriptive prose or unnecessary information. Rather, the script continues to supply the precise minor visual flairs and carefully constructed details to bring its world to life in as efficient and expeditious a fashion possible.

At a conceptual level, the story feels innately compelling. Channeling what seem, unfortunately, to remain relevant cultural and societal themes of racism, media grandstanding, and uneasy mistrust between various classes, the plot, though set more than 15 years in the past, feels unnervingly timely and topical. Added to this, it seems in some ways an almost natural decision to play out a dramatic narrative such as this one featuring the church-burning spree, contributing to the sense of veracity, authenticity, and relevance within the basic premise of the plot.

To its credit, the script seems loath to simply leverage or exploit the basic underpinnings of its story. Rather than playing out a pat and predictable or flatly unemotional investigative police story, there is, instead, a gratifying layer of depth, dimension, and emotional resonance throughout the movie. The characters in many ways elevate the source material they populate, creating a sense of genuine dimension and emotional sincerity throughout the story.

Indeed, whether it is the deeply complex and fascinating Esau, replete with his sense of resentment toward Jacob and his past as well as his relationship problems with Amanda and his constant burden of proving himself, or more ancillary characters such as Amanda, Judith, or even Weasel and his unpleasant friends, the script manages to create, in each of the character voices it features, a rewardingly nuanced, provocative, and riveting sense of depth and realism.

Atop these solid narrative pillars, the script also manages to generate a variety of quite compelling undertones that serve as thematic backbones throughout the story. Although racism itself becomes a constant feature within the narrative, creating and channeling an unfortunately vivid and believable portrait of the small-town tensions that surface throughout the case, the script also manages to forge several secondary sets of concepts and conflicts that feel every bit as effective in orchestration and delivery.

The brotherly dynamic between Esau and Jacob becomes in many ways as prevalent as the bigotry that defines the story on the surface, but even more subtly are layered in aspects of social commentary driven home by the derisive fashion in which Weasel's friends outline, for Esau, the social strata of modern high school life.

Throughout the development of the plot, the script manages to continue furnishing fresh pieces of information and new details to escalate its story at virtually every turn. Weasel's confession presents a moment that is shocking not only to the characters who hear about it but also to the audience, thanks, in part, to the seamless fashion in which it is delivered, within the story. Jacob's "newly found" kerosene can supplies another such moment, coupled with the subsequent implication that Amanda might have been responsible, while later revelations regarding Esau's youth and the turning point at which he then discovers the clue that links the church fire to past cases of arson are also driven home in an eminently effective fashion.

As an extremely minor, fairly trivial note, there are times, throughout the script, in which the character of Rebekah Freeman is occasionally referred to by her first name, only to, at other times, speak under the name of Widow Freeman. Ensuring a consistency in presentation by picking one or the other moniker by which to refer to her at all times might simply contribute to the streamlined, smoothly flowing delivery of the story.

Clearly, though, this is a more or less superfluous, nitpicking note. Beginning, as it does, with a riveting concept, this script supplements its compelling subject matter with a plot and cast of characters that feel deeply nuanced, artful, and evocative in-presentation. The result is a finished product that seems poised to leap from the written page to the big screen.

SCRIPT: RECOMMEND

THE SHARK GRID:

TITLE:	ACTS OF GOD
AUTHOR:	W. Reed Moran
READER:	EK

MECHANICS	Excellent	Solid	Needs Work	Re-Think	N/A
Action lines clearly and concisely manifest visual action and literal context.	X				
Scenes avoid the problem of continuing beyond optimal length.	X				
Spelling, grammar, and proofreading.	X				
Page count.	X				
The script's physical presentation.	X				
Dialogue.	X				
The script effectively manifests a compelling theme and adheres to it throughout the story.	X				

CHARACTER	Excellent	Solid	Needs Work	Re-Think	N/A
The protagonist clearly manifests both internal and external goals.	X				
The protagonist has consistent opposition to his/her goals.	X				
The protagonist is sympathetic and/or engages our emotional investment.	X				
The protagonist clearly changes / has an arc.	X				
The supporting characters are unique and add value to the story.	X				
All of the characters are authentic to their backgrounds.	X				
The script has an effective antagonistic force, direct or indirect.	X				

STRUCTURE	Excellent	Solid	Needs Work	Re-Think	N/A
The script has a strong structural foundation that serves the story, classic three-act structure or otherwise.	X				
Plots and subplots work together.	X				
The set-up is concise, and effective.	X				
The story has well-designed reversals.	X+				
Transitions are effective and appropriate to the story.	X				
Every scene has relevance.	X				
The story includes an effective dramatic climax payoff.	X				
The setup is resolved effectively.	X				
A catalytic situation drives the plot.	X				
Dramatic conflict and tension build across scenes, throughout the plot.		X+			

MARKET VALUE	Excellent	Solid	Needs Work	Re-Think	N/A
Originally/freshness.		X+			
The story has a clearly defined target audience.	X				
The story clearly has mass audience (universal) appeal.	X				
The story includes a conceptual "hook" that could potentially be used to effectively market the film.	X				

PRODUCTION VALUE	Excellent	Solid	Needs Work	Re-Think	N/A
The lead character is castable / has star appeal.	X				
The visual arena of the script is stimulating.	X				
The project has International appeal.		X			

B

FULL FEATURE SCREENPLAY, *ACTS OF GOD*

ACTS OF GOD

Written by

W. Reed Moran

ACTS OF GOD

FADE IN:

EXT. VIRGINIA BLUE RIDGE MOUNTAINS - SUNSET

Last light. A thin band of fiery yellow and watercolor blue
on the snaking ridge, bleeding down toward us in smoky grays,
pooling on the valley floor

IN THE BLACKNESS OF BARE, TANGLED TREE-TOPS

folded in on each other like the fingers of gnarled,
overworked hands, raised in supplication.

CLOSE ON A PAIR OF OAKS

their "fingers" closed tightly in prayer. Behind them, the
day's last light blurring into diamonds of fire.

OVER THIS SCENE:

A MONTAGE-- BURNING CHURCHES ACROSS THE SOUTH

In cities, small towns, the countryside. Plain, ornate...
wood, brick, cinder block. Sparking, flaming, smoldering in
ashes. Building after building, state after state...then--

Outraged ministers, shattered congregations. Some rich, many
poor, mostly black, and all looking for answers...then--

Headline after headline screaming "Arson", "Hate Crimes",
"Conspiracy?" "23rd Black Church Burns"....

Finally, the headlines "FBI, Justice Dept. Investigation",
"President Appoints Church Arson Task Force", and "Arrests
Made...".

But then, the headline "Burnings Continue...". FREEZE FRAMES
in our mind and on the screen.

And as the celluloid frame melts and burns before our eyes...

DISSOLVE TO:

A FURY OF RISING SPARKS

flying up into focus. We hear the sharp CRACKLING of something
burning, rising up from a whisper to a menacing and finally
cataclysmic ROAR. After the initial shock, our attention is
drawn to

A VOICE: commanding, resonant, paternal... a polished
public speaker in the tradition of the great Southern black
preachers. But the voice is also weighed down by sadness and
guilt. This is the voice of the **REV. JACOB FREEMAN.**

 JACOB (V.O.)
 My name is Jacob, son of Isaac, grandson
 of Abraham.

The sparks envelop the night, but the roar of the flames
becomes muted as Jacob's voice looms over us.

 JACOB (V.O.)
 I am a man of God, as was my father and
 his father before him.

 CUT TO:

EXT. ADJACENT WOODS - DUSK

Feet racing through dry November leaves, the heavy BREATHING
of a young man, and an eerie GLOW pulsing across the entire
woods behind him.

As if the sky itself were set ABLAZE.

 JACOB (V.O.)
 But I am also a man who has shunned God,
 as I turned away from my brother Esau,
 and all my brethren...

EXT. CUT CORN FIELD - DUSK

The silhouettes of SEVERAL TEENS and a pickup truck against a
BONFIRE on the edge of the road. Was this the fire we found so
menacing?

CLOSE SHOTS - THE KIDS

Marilyn Manson wannabees. Really farm boys and their
girlfriends, no older than 16.

RUPERT - THE YOUNGEST KID

kicks the open tailgate of his truck, where DERRICK and his
girl CHRYSTAL are making out on the truck bed.

 RUPERT
 Okay, bar's closin'...
 (nothing)
 Let's go.

Still nothing. He looks at the ice-filled cooler on the edge
of the tailgate. Reaches for it, as

EXT. ADJOINING WOODS - CONTINUOUS

Feet stumbling in the darkness, BILLOWING CLOUDS OF
FRIGHTENED BREATH in the cold night air...

EXT. BONFIRE - CONTINUOUS

Rupert douses the fire with the beer cooler, aims a SPLASH
into the truck. Derrick sits up, HOWLS.

 RUPERT
 (to everyone)
 We're goin'...

Rupert gets in the driver's door SLAMS it shut. Chrystal
angrily, buttons her blouse.

 DERRICK
 Says who?!

 RUPERT
 Says me. The one with the license and
 the truck.

INT. DARKENED CHURCH PEW - CONTINUOUS

Hymnals lined against the pew begin to blacken, char, then
burst into flames before our eyes...

BACK AT THE TRUCK

Rupert fires up the engine, turns on the lights. The girl gets
in front. Derrick jumps in, car moving.

 DERRICK
 It's your mom's truck, peckerhead.

Rupert turns to the back seat, still driving.

 RUPERT
 Fuck--you...

The guys get into it, until the Chrystal SCREAMS

 CHRYSTAL
 Stop!!!

EXT. - THE PICKUP

JOLTS to a stop. The driver stares at her.

 CHRYSTAL
 Where's "Weasel"?

The others react, what the hell happened to him?

EXT. A LARGE CHURCH STAINED GLASS WINDOW

Abraham in despair, about to sacrifice his only son, Isaac,
to God. The flames appear inside the church illuminating the
window with an eerie beauty.

 JACOB (V.O.)
 I fear that cold November night will
 evermore chill my soul and burn my heart
 like the flames of purgatory itself...

A beat, before the heat EXPLODES the STAINED GLASS INTO
SHARDS before us, as

EXT. WOODS - CONTINUOUS

We see WEASEL, a young, white bony teen--the one who's been
tearing through the woods. Alone, scared and breathing hard.

HIS POINT OF VIEW

The pickup's headlights a hundred yards off. An angry HORN
blares at him through the darkness.

INT. PICKUP

Derrick interrupts the driver's HONKING.

 DERRICK
 Screw 'im, man. It's only Weasel.

The others seem to agree. The truck keeps going.

NEW ANGLE - WEASEL

appears in the headlights, anxiously trots alongside.

 WEASEL
 Wait!!

 DERRICK
 Not for someone who can't piss in the
 woods without gettin' lost!

Weasel grabs the Derrick by the shirt, desperate.

 WEASEL
 Man, there's somethin' you gotta see!!

Derrick knocks Weasel's arm away, then reacts to the orange
GLOW behind him.

EXT. BETHEL FIRST BAPTIST CHURCH - NIGHT

Half-burned to the ground--flames ROARING out of windows and
steeple--spitting heat and fire from the depths of hell to the
heavens above.

 JACOB (V.O.)
 And the question I always ask myself as
 I lay awake at night is, "Did this have
 to happen?" Was this all meaningless
 suffering, or necessary to light the
 path for the blind to see God's infinite
 grace and love...?

Weasel turns to the others, flames reflected in his wide, empty
eyes.

 WEASEL
 What'd I tell ya?!!

The Marilyn Manson tribe react to the conflagration with
complete awe. Rupert sucks on a joint, turns to Weasel.

 RUPERT
 I can't believe you did this, man...

And then he hands Weasel the joint and high-fives him.
Weasel's shock slowly melts to confusion, then as he looks at
their approving faces, he suddenly feels like he's on top of
the world.

 DISSOLVE TO:

EXT. GEORGETOWN, WASHINGTON, D.C. - NEXT MORNING

High rise condos with a panoramic, if somewhat pricey view of
Washington's gleaming monuments. Super: "November, 1995."

INT. ESAU HUNTER'S CONDO - CONTINUOUS

Water's running somewhere, as we take QUICK PANS of
THE LIVING ROOM

masculine, spare but expensive. Washingtonian, Esquire and
Sports Afield arranged perfectly next to a coffee-table book
on West Point signed, "To Esau--Best Wishes, Colin Powell"--

THE KITCHEN

Spotless counters, empty sink. No sign of human habitation.

THE DEN

Law books. Laptop. An army of neatly arranged photographs,
signed by Washington's elite, surround the desk.

The photos: all center on

A TAUT, SHARP-EYED BLACK MAN

with close-cut beard poses with Senators, Generals, Cabinet
Members. Other shots show him in uniform, Captain's bars,
clean-shaven, same drill.

INT. HIS BEDROOM - CONTINUOUS

ESAU HUNTER, the man in question, opens his eyes, looks at
the electronic clock: BROKEN. Blinking 12:00 A.M. He sits
bolt upright, checks his watch. 8:47 A.M. What the hell--?

 ESAU
 Dammit!

He hears the water running. Sees a cloud of steam coming from
the bathroom. He's up in a flash.

 ESAU (CONT'D)
 Amanda...my alarm! Amanda?! I told you I
 had a 7 o'clock breakfast meeting with
 the--

INT. BATHROOM

Nobody staring back at him but his monogrammed towels. By the
sink, a beeper and cell phone lie SHATTERED next to a small
hammer.

 ESAU
 ...Attorney General...

Written on the mirror, by his reflection: "Now that I've got
your attention... What's missing from this picture?"

Esau's just stunned. No irony. No anger. No Amanda.

EXT. WASHINGTON METRO STOP - DAY

Esau fights through the crowd in his Brooks Brothers suit. It
starts to rain. He starts to run. It doesn't help.

EXT. JUSTICE DEPARTMENT - DAY (ESTABLISHING)

INT. CHURCH ARSON TASK FORCE CENTER - CONTINUOUS

Chaos. Church arson news clippings, arson reports, Wanted
posters taped to the walls. STAFF cramped among computers,
phones and a blizzard of paper. A hassled and unhappy Esau
walks a gamut of LAWYERS and PARALEGALS.

INT. ASSISTANT ATTORNEY GENERAL'S OFFICE - DAY

He's waiting as Esau enters. Middle-aged, heavy-set, career
government... in full damage control mode.

7.

 ASST. ATTORNEY GEN.
 Where were you?!
 (interrupts)
 You got a pager, right? A cell phone?
 What the hell happened?!

Esau's privately mortified, but reacts stiff-jawed.

 ESAU
 Act of God.

 ASST. ATTORNEY GEN.
 "God"?! Fine. You know who you just
 stood up? Our boss. A cabinet member.
 A woman who's called with five cups
 of coffee on an empty stomach. Who's
 got the President, Congress and the
 press waiting for their weekly briefing
 on these church burnings! What am I
 supposed to tell her?!

 ESAU
 Sir, I'll take care of it.

 ASST. ATTORNEY GEN.
 You'd better. I got a career to think
 of.

He waves a video cassette as Esau turns to leave.

 ASST. ATTORNEY GEN. (CONT'D)
 In case you slept through the morning
 news. Number one hundred and thirty
 eight...

Esau reacts, grabs the cassette, and

Esau's SECRETARY reads his mood as he walks into his office
marked: DIRECTOR, NATIONAL CHURCH ARSON TASK FORCE.

 ESAU
 Karen, get me the AG's office. And would
 you try Amanda's desk at the Post?

The secretary picks up the phone, and

INT. ESAU HUNTER'S OFFICE - CONTINUOUS

Spartan, spotless. West Point and Yale degrees. All the
touches of home. He puts the cassette in a VCR, paces...

 ESAU
 Then lock in the rest of my schedule. I
 don't care if the sky is falling.

ON THE MONITOR

The news clip comes up midstream.

 LOCAL TV ANCHOR
 ...coming up, another possible church
 arson ravages a small Virginia town.

Esau fast-forwards through the commercials, while OUTSIDE his
secretary contacts

INT. ATTORNEY GENERAL'S OFFICE - CONTINUOUS

An ASSISTANT answers the phone. The boss isn't exactly eager
to be taking any calls from Esau at this point.

Esau's secretary reacts, takes a note, dials

INT. WASHINGTON POST OFFICES - DAY

The door reads: "Food Section". Where we find AMANDA PHILLIPS,
ANGULAR, BLONDE(32) in a hectic conference with other
REPORTERS. She's handed a phone, listens, eyes wide with
rage... and slams it back down.

INT. ESAU HUNTER'S OFFICE - DAY

On the monitor, a TV REPORTER stands amid the charred ruins
of the Bethel First Baptist Church.

 TV REPORTER
 Last night in the Piedmont area, another
 tragedy, another mystery, another church
 burning...bringing to well over one
 hundred the number of unexplained...

Esau's secretary wryly pops her head in OVER the report.

 SECRETARY
 Neither woman wants to speak with you.
 (off his reaction)
 May I make a suggestion? Send her a
 dozen roses.

 ESAU
 Which one?

That's it, she's gone. He paces, as the TV Reporter
continues, OVER:

 ESAU (CONT'D)
 We got another torching. Send in a team
 ready to get the hell out there. Pronto.

 TV REPORTER (V.O.)
 Adding particular significance to this
 tragedy is the pastor of Bethel First
 Baptist Church.
 (MORE)

 TV REPORTER (V.O.) (CONT'D)
 He is Reverend Jacob Freeman, the only
 son of Reverend Isaac Freeman, famed
 civil rights leader slain in 1967.

Esau freezes the tape-- suddenly riveted by the image of
JACOB FREEMAN, slick and handsome, filling the TV screen.

A distinctive SILVER CROSS hangs from his neck. Esau
reflexively grabs where it would be if he were wearing it.

 SECRETARY (O.S.)
 Out where, exactly?

 ESAU
 Outside Lynchburg.

Esau tips his coffee on his pristine desk, oblivious. Jacob's
smooth, heartfelt voice fills the room...

 REV. JACOB FREEMAN
 My father's ghost is crying out from the
 grave... Crying, not because the church
 he built has come to ashes, but because
 of the tragedy that hatred and racism
 still burn in men's hearts...

Esau FREEZES Jacob's image with the remote.

 SECRETARY (O.S.)
 A church burning outside of "lynch-
 burg". Why doesn't that surprise me...?

The secretary enters, reacts to the spilled coffee, the
ruined papers, Esau's haunted face.

 SECRETARY (CONT'D)
 Hey... you alright?

 ESAU
 Huh? Yeah. Actually, I hear Lynchburg's
 a nice place to visit. Make my
 arrangements.

The secretary reacts to him, the image of Jacob on the
screen.

 SECRETARY
 What about your schedule?!

 ESAU
 (snaps)
 Screw my schedule--

The secretary reacts, stunned as Esau storms out.

A crack of THUNDER, and we're

INT. PUDDLE JUMPER AIRLINE - DAY

Bouncing like a balsa plane in the storm. Esau's impassive.
Esau's wise-ass STAFF LAWYER and young female PARALEGAL
sitting beside him are scared stiff.

 ESAU
 I guess you guys want me to tell you why ·
 I'm coming along...

 WISE-ASS STAFF LAWYER
 Fine. Why not entertain us, while
 gremlins rip the wings apart.

 ESAU
 You know who Isaac Freeman was?

 YOUNG PARALEGAL
 Civil rights leader. Voting rights
 activist.

 ESAU
 More than that.

Esau pulls out a dossier on Freeman: a well-worn collection
of articles, photos, reports.

 ESAU (CONT'D)
 Philosopher, minister, author, artist,
 poet, father... A giant, one of my
 heroes. Did my senior thesis on him. And
 somebody just burned down his church.

The small plane lurches. The staff lawyer winces.

 ESAU (CONT'D)
 I'm gonna personally make sure we find
 out who that somebody is. And damn fast.

The junior Staffers share a look. There's more goin' on here
than he's letting on. Esau turns to the Paralegal.

 ESAU (CONT'D)
 The FBI containment team. Where're they
 on this?

 PARALEGAL
 I don't know. They decided it'd be safer
 to drive.

The Staff lawyer groans, fatalistic. A THUNDER CLAP, then

EXT. COUNTRY CHURCHYARD GRAVE SITE - DAY

A granite headstone: "REV. ISAAC FREEMAN, 1928-1967, 'And ye
shall know the truth...and the truth shall make you free.'
John 8:32"

REBEKAH FREEMAN (67), Isaac's widow, crouches down silently
in prayer, misted by a light drizzle.

Behind her, the charred ruins of Isaac's church lay like
bones scattered on the mud. A beat, then

Rebekah looks up, sees her son Jacob bending over her.

The SILVER CROSS dangling around Jacob's neck between them.
Jacob squeezes her hand, softly, concerned.

 JACOB
 Mama... you're getting soaked. It's
 time.

 REBEKAH
 I was telling your father what happened
 to his church.

Jacob nods, listens quietly...

 REBEKAH (CONT'D)
 He says it'll be all right... but it's
 up to you now Jacob, to rebuild and ask
 God's help in healing--

 VOICE (O.S.)
 Reverend Freeman? We're ready...

 JACOB
 (interrupts gently)
 I will, Mama. I'm sorry, it's time.

Jacob helps his mother up, and

NEW ANGLE - THE CONGREGATION

Waits silently in the soft rain by the ruined church. But,

PAN TO reveal a CROWD OF REPORTERS and TV CAMERAS impatiently
gesturing for Jacob and Rebekah to move it along.

WITH JACOB

Jacob smiles winningly at them-- the cameras-- suddenly on
stage. We realize it's the press that has his full attention.

 JACOB
 (overly deferential)
 Thanks for your patience. Now if
 you'd just follow me to the site of
 the tragedy... we can set up and I'll
 deliver my prepared statement.

Jacob wades through the wreckage, the REPORTERS trampling
behind him, curiously picking through the soggy rubble.
Jacob cleans mud off his hands, self-consciously asks his
mother...

 JACOB
 Any mud on my collar...?

Before Rebekah can respond, they all react to

TIRES

rolling up through puddles on the dirt road, and

A BULLHORN

pointing out through the window at them, blaring

 ESAU'S VOICE
 Alright, hold it right there!

NEW ANGLE

Jacob reacts, motions the reporters to continue with him.

 ESAU'S VOICE
 Step away from the scene!

Jacob's irritation is evident. He stops but holds his ground.
Esau steps out of the car with his two Staffers. Lowers his
bullhorn.

ESAU AND JACOB

stare each other down like two generals across a Southern
battlefield. He sees the silver cross.

 ESAU
 Reverend Freeman? Reverend Jacob
 Freeman?
 (off reaction)
 I'd appreciate it if you got these
 people away from the area immediately
 before they can destroy any more
 evidence.

 JACOB
 And just who do you think you are?

 ESAU
 Esau Hunter, Department of Justice.

 JACOB'S MOTHER - THE WIDOW FREEMAN

slowly comes into view behind him, as...

 JACOB
 Well, Mr. Hunter, these people happen
 to be my congregation, and this area
 happens to be my church.

 ESAU
 I understand. But I need to have
 everyone removed immediately so we can
 start investigating this incident.

Jacob can't quite believe what he's just heard. During this,
REBEKAH studies Esau, and WE SEE her stabbed with a sudden,
painful recognition. But what?

> JACOB
> By 'incident' you mean 'arson'...this
> latest example of an evil conspiracy by
> hate-mongering white supremacists...?

> ESAU
> (controlled)
> That's one theory we're looking into.

Esau catches the Widow Freeman's tortured expression,
distracting him, and us, from Jacob's dramatic, if heartfelt,
performance before the cameras.

> JACOB
> Just how far do you Government 'experts'
> have to look before you can see what's
> right before your eyes?

THE CRUSH OF REPORTERS

take this as an opening to pepper Esau with questions.

> VARIOUS REPORTERS
> Mr. Hunter, how long will this
> conspiracy of hate continue?/Do you
> have any suspects from previous church
> arsons?/Has a profiler been called in?

Esau already hates Jacob for allowing this ambush. He snaps
at the reporters...

> ESAU
> At this point, we can only state that
> arson is a possibility.

The Reporters smell blood, and Esau's about to publicly go
off on Jacob, when he catches Rebekah Freeman's eye, and
pulls Jacob aside, preempting a potential public outburst.

WITH ESAU AND JACOB

a simmering, visceral distaste growing between them.

> ESAU
> Let's get one thing clear, Reverend.
> This is an open, ongoing Federal
> investigation. Stay out of my business.

 JACOB
 Mr. Hunter, God's work is my business.
 Truth is my business. And where it goes,
 I humbly follow.

 ESAU
 In my experience, Truth and God rarely
 speak through sound bites and over-
 moussed TV reporters.

 JACOB
 I'm not sure I understand your point--

 ESAU
 The point is I refuse to be coopted into
 a precipitous assessment of this case
 by an egotistical, media-hungry, wannabe
 civil rights hero.

That's it. Those are fighting words. Jacob's apoplectic.

 JACOB
 I'll have you know I am the only son of
 Isaac Freeman, a giant and martyr in the
 struggle for peace and justice for all
 people.

 ESAU
 And no matter what you think, you, sir,
 are no Isaac Freeman.

Esau's final blow strikes Jacob mute with loathing. Esau
leaves this first round triumphant, and

NEW ANGLE

Esau's expression shifts from gloating to guilt as he feels
the sting of Rebekah Freeman's reproachful gaze upon him....

As we wonder what unspoken business hangs between them...

 DISSOLVE TO:

EXT. LYNCHBURG MOTEL - DAY

A old, forgotten way-station, covered in red dust... and
filled to bursting with identical, dusty Government sedans
with Government plates.

INT. ESAU'S MOTEL ROOM - CONTINUOUS

A makeshift headquarters, buzzing with cell phones and fax
machines.

Esau's livid as he watches

THE TV

where Jacob continues his PASSIONATE INDICTMENT of the
alleged, but unidentified white arsonists.

 ESAU
 Goddammit!! I told that bastard he's got
 no right to spout these irresponsible
 allegations. We don't even know if it's
 arson yet.

The room is silent for a beat, underscoring Esau's reaction.

 STAFF LAWYER
 Ah, Chief... this may be Virginia, but I
 think the First Amendment still applies
 here.

 ESAU
 I'm gonna have a witch hunt and a riot
 on my hands.

 STAFF LAWYER
 I doubt there're enough people in
 Mayberry here to cause a ruckus or even
 a full-scale commotion. If that makes
 you feel any better...

It doesn't. Esau glowers at his top assistant. The paralegal
gently interjects--touches the lawyer's arm.

 PARALEGAL
 Brad, you know what Esau means. The
 whole world is watching...

 ESAU
 I want every piece of dirt you can find
 on this guy. And I want it now!
 Something good I can bury this bastard
 with if I have to.

His staff reacts, what's with the boss? Then,

FBI AGENTS

fling open the door, enter the already crowded room. Two guys
and a tight lipped woman who elbows her way toward Esau.

You can smell turf war. But Esau smiles congenially at her.

 AGENT MEYERS
 What idiot contained the incident scene?
 The evidence looks like it was trampled
 by a herd of elephants.

Esau smiles, offers his hand.

 ESAU
 Deputy Assistant Attorney General
 Hunter. Pleasure to meet you, miss...?

 AGENT MEYERS
 Special Agent Meyers.

 ESAU
 Glad you finally made it.

 AGENT MEYERS
 We got here as fast as we could. But
 apparently not in time to stop the
 amateurs from letting the civilians run
 amok.

The paralegal turns to the staff lawyer, not so sotto.

 PARALEGAL
 If she thinks she's such a hero, why
 didn't she fly the friendly skies with us?

 AGENT MEYERS
 What?

Esau shoots his paralegal a remonstrative glance.

 PARALEGAL
 Nothing.

 ESAU
 The scene was partially contaminated
 when we arrived. As a courtesy,
 we exercised what I thought to be
 appropriate damage control.
 (then, in charge)
 As Chief of this investigation,
 it's just part of my policy of full
 cooperation between our departments.

The message is loud and clear. Esau's the boss, and he's not
going to take any baiting or bullshit from this broad.

 AGENT MEYERS
 (to Esau, stiff)
 Right.

Chastised, the FBI Agent burns as she sees the female
paralegal gloating in the background.

 ESAU
 What's your preliminary assessment?

 AGENT MEYERS
 In terms of immediate hard evidence of
 arson--fucking nada.
 (off reaction)
 (MORE)

 AGENT MEYERS (CONT'D)
 I got bags of stuff going to the lab in
 Quantico, but you know this could take
 months. Or longer.

 ESAU
 Not what I wanted to hear. I got a
 public relations time-bomb ticking out
 there.

 AGENT MEYERS
 (shrugs, your problem)
 C'est la guerre...

Esau takes the barb. It is his problem. As she leaves,

 PARALEGAL
 What an asshole...

Esau shoots her a look. No catfights.

EXT. STONEWALL JACKSON HIGH SCHOOL - DAY

A racially mixed group of rural kids pile inside the buses
waiting outside. PICK UP AND FOLLOW Weasel and his loser
shaved-head buddies, as they get in, take a seat.

VARIOUS ANGLES - SOME WHITE KIDS

Nudging and whispering to each other, and pointing back to
Weasel and his cohorts. The diminutive

WEASEL

sits back smugly, basking in the misconceived glory of
whatever's making the rounds in the high school rumor mill.

We get the clear impression that, although Weasel can't
tell the difference, the other kids are more shocked and
incredulous than impressed. Then,

EXT. LYNCHBURG STREET- SUNSET

A remote but prosperous farm-town feel. New pickups, old-
timers, even a few kids on skateboards. But when

ESAU'S CAR

pulls up, and he steps out with his staffers, heads turn. A
black man in a Brooks Brothers suit still sticks out like a
sore thumb.

INT. LYNCHBURG DINER - CONTINUOUS

Esau and his staffers enter, take a booth.

The PATRONS try not to stare. The Wise-Ass Lawyer quips,

 STAFF LAWYER
 Guess who's coming to dinner--

 ESAU
 (not amused)
 Go see what the papers are doing to
 us. Everything from the Richmond Times
 Dispatch to the Post.

The lawyer grudgingly takes off. The Paralegal peeks over her
menu, wary of the general vibe. A YOUNG WAITRESS appears next
to them. Esau looks up over his reading glasses.

 ESAU (CONT'D)
 Hi, got any specials?

 YOUNG WAITRESS
 Y'all not from around here, are you?

 ESAU
 No.
 (then, light)
 Think the lady'd here like the grits?

The waitress regards her yuppie counterpart, shakes her head.

 YOUNG WAITRESS
 Y'all with the TV?

 ESAU
 Afraid not. How're the pork chops?

 YOUNG WAITRESS
 Wouldn't recommend it, if that's what
 you mean.

The paralegal stiffens at the perceived cold shoulder.

 PARALEGAL
 (acerbic)
 Fine. I'll just have some pasta
 primavera and nice glass of chardonnay.

 YOUNG WAITRESS
 Sorry. Are you guys with the press?

Uh, oh. Is this building to one of those Denny's Restaurant
disasters?

 PARALEGAL
 If I tell you, can we order?

The eyes of the diner are all on them.

 PARALEGAL (CONT'D)
 Mr. Hunter and I are with the Justice
 Department, investigating the Bethel
 church burning.

Esau lets this settle into the room, then

 ESAU
 I'll have the meatloaf and mashed
 potatoes. Or whatever else you
 recommend.

 YOUNG WAITRESS
 What I recommend, what we all
 recommend...
 (slams down pad)
 is that you hurry up and catch those
 sonsofbitches who did this, then lock
 'em up and throw away the key.

This takes the wind out of the paralegal's sails.

 YOUNG WAITRESS (CONT'D)
 We don't need any more reporters
 treating Lynchburg like some hillbilly,
 racist version of Walton's Mountain, all
 because of one psycho redneck with a
 gasoline can.

The diner explodes into spontaneous APPLAUSE.

The staff lawyer walks in with the papers, has no idea what
the hell's going on.

 ESAU
 Pleasure meeting you, Ms--?

 YOUNG WAITRESS
 Shiflett, Emily Shiflett.

 ESAU
 You wouldn't happen to know who that
 psycho'd be?

The waitress shakes her head. No.

 YOUNG WAITRESS
 But small towns are full of nothin' but
 rumors. You're free to ask around.
 (to paralegal)
 This may not be Washington, D.C. honey,
 but we got VH1, HBO and an outlet mall
 that'd knock you out of your Ferragamo
 shoes.

The waitress spins around as the staff lawyer takes his seat,
incredulous.

 STAFF LAWYER
 What was that all about?

 ESAU
 We've been invited to debrief the whole
 town. Order the meatloaf. You're gonna
 need your strength.

Esau ignores the lawyer's reaction, reaches for the papers.

 JUMP CUT TO:

WEASEL

floating through the night sky, hooting in ecstatic, drunken
reverie -- PULL BACK to see we're

EXT. DAIRY QUEEN PARKING LOT - NIGHT

where Weasel stands on the roof of a moving pick up, "car
surfing" - holding open beers in each of his outstretched
hands. Rupert driving, Derrick and Chrystal sitting with

A CROWD OF LAUGHING, DRINKING TEENS

egging Weasel on through a cloud of bugs under the neon
lights. They laugh as Weasel slips, lands on his butt, then
pops up again.

 DERRICK
 (laughing)
 Weasel, you're wasted, man--

Weasel lets loose an idiotic, drunken laugh. He tosses his
half-empty beer cans into the Dairy Queen crowd...

 WEASEL (CONT'D)
 I command my subjects to bring me--
 burgers, beer, and... huh, huh--
 bitches!!

The GIRLS bunched in the crowd recoil at the suggestion. A
Chubby Girl winces, pulls a burger out of her mouth.

 CHUBBY GIRL
 God in heaven, what a loser--

Derrick grabs the Girl's burger and a beer from his date.

 CHUBBY GIRL (CONT'D)
 Hey--!

 DERRICK
 Your Highness, your wish is our command.

Derrick tosses them-- Weasel catches the burger in one hand,
and a beer in the gut--almost knocking him off the cab again.

THE OTHER TEENS

soon follow suit, tossing everything they can find at Weasel
as he circles them.

Weasel's in heaven, oblivious to the fact he's actually being
JEERED and pelted by his peers.

EXT. LYNCHBURG MOTEL - NIGHT

Quiet. Crickets. No Vacancy. The fleet of identical Government
sedans parked outside.

INT. ESAU'S MOTEL ROOM - CONTINUOUS

Cluttered with fax machines, phones, makeshift tables and
various papers with HEADLINES reading: "138th Church Fire",
"Arson, Conspiracy?", "No Arrests".

A Phone RINGS. Esau angrily fumbles through 4 or 5 before
finding the right one... picks it up.

 INTERCUT:

JUSTICE DEPT. OFFICE - CONTINUOUS

Esau's boss chomps on a cigar, pissed... watching Ted Koppel
on the TV.

 ASST. ATTORNEY GENERAL
 What the hell's going on down there? Ted
 Koppel's cleaning our clock! He's got
 this Reverend talking like it's Selma!!

And I don't even have an arson report!

Esau flips on the TV. As it burns in, Ted SOMBERLY RECOUNTS
the latest church burning, and when the image shifts to a
ranting Rev. Jacob Freeman,

Esau pours himself a stiff drink.

 ESAU
 (to phone)
 Don't worry... I'll get him under
 control.

 JACOB
 (overlapping, on TV)
 Our people have once again confronted
 the face of Evil. An evil that does not
 sleep...

 ASST. ATTORNEY GENERAL
 (over phone)
 Since you decided to take this field trip
 without consulting me -- why don't you
 do just that!!

Esau's boss SLAMS down the phone. Esau picks up another phone
dials, his eyes burning into Jacob's on the TV.

 ESAU
 (to phone)
 Amanda, it's me--don't hang up. Please.

 INTERCUT:

INT. AMANDA'S WASHINGTON POST OFFICE - NIGHT

Where Amanda's still at work, tired, pissed but beautiful,
twirling her blonde hair around a pencil.

 AMANDA
 (to phone)
 Esau, it's over.

Esau's hit by the finality of the pronouncement.

 ESAU
 Amanda, let me talk--

 AMANDA
 I don't have time for this. I've been
 here 16 hours, it's nearly midnight, and
 I still have this damn calamari and feta
 cheese recipe--

 ESAU
 I just want to tell you that I...

Amanda waits for some assurance, some declaration of love.

 JACOB
 (on TV)
 And what is the nature of this Evil that
 walks among us?

But it's all to much for Esau. His pride and jumbled feelings
stick the words in his throat.

 AMANDA
 (impatient)
 Yes?

 ESAU
 I'm...

But his thoughts cut short by

 JACOB
 (on TV)
 It is the face of white America.

Esau chokes on his drink. What is this maniac doing?!

 JACOB (CONT'D)
 (overlapping, on TV)
 It is the face of corporate America,
 it's government and media who sit by
 tacitly condoning the racist conspiracy
 of eradication, of intimidation and
 conflagration against our black churches
 and black children across the South--

 AMANDA
 Esau...?

 ESAU
 Oh, brother. Amanda, I'm in Lynchburg.

 AMANDA
 What?

 ESAU
 The church burning. Put on Nightline.

Amanda switches on the TV in her office, steaming.

 AMANDA
 (incredulous)
 You called at midnight just to tell me
 you're in Lynchburg?!

 ESAU
 No, of course not--

Amanda can't hold back, finally lets loose her pent-up rage.

 AMANDA
 I thought you'd at least be calling to
 grovel. For standing me up at the Food
 Writers Awards, for treating my career
 like some amusing hobby, while you're
 off on some mission from God that--

 ESAU
 (interrupts, overlapping)
 Actually, I called to ask you a favor.

Deathly silence on Amanda's end of the line, before

 AMANDA
 A favor.

 ESAU
 This guy's dangerous. Grandstanding--
 inciting the country into some kind
 of racial uproar. Look, you know some
 of the big boys at the National desk.
 Suggest they do a story on how we're
 handling the matter. Get some of the
 media heat off this jerk.

 AMANDA
 You're asking a member of the free press
 to serve as private PR flack for the
 Justice Department?

 ESAU
 Amanda, that's not fair... I just want
 to calm people down, get an even-sided--

But Esau's left talking to himself. She's hung up on him.
Esau knows he's blown it with Amanda, sits alone with Jacob
on the TV... and

 DISSOLVE TO:

A MONTAGE:

EXT. LYNCHBURG AREA - VARIOUS LOCATIONS - DAY

To the beat of a handclapping GOSPEL SONG, we see the
conflicting styles of 'good cop' and 'bad cop' being played
out at cross purposes:

1. The FBI AGENTS fanning out over the area, interviewing
townspeople, store owners, teachers, students.

Intimidation seems to be the tactic of choice,

And while this 'take no prisoners' approach is possibly
effective, it's clearly not going well with the local
population.

2. In contrast, ESAU'S STAFF take the low key, "Good Ole'
Boy" approach.

It's slower, but from the smiles and handshakes, seems to be
building more trust with everyone.

3. Finally, we see ESAU supervising the FBI's wrap-up of the
evidence-gathering from the fire scene, and

END MONTAGE, AT

EXT. REV. ISAAC FREEMAN HOMESTEAD - DAY

Where we see the GOSPEL SONG is coming from Jacob's
congregation... assembled under a giant white tent pitched
next to the dignified wooden farmhouse.

NEW ANGLE

Esau drives beyond the tent revival, parking in front of the
farmhouse.

He gets out, passing a brass marker reading, "Birthplace of
the Rev. Isaac Freeman, 1928-1967 'And the Truth Shall Set
You Free'".

WITH ESAU - AT THE FARMHOUSE DOOR

Esau is clearly uncomfortable. He straightens his tie,
brushes off his jacket, clears his throat, but before he can
knock, the door OPENS, and he faces

THE WIDOW REBEKAH FREEMAN

a tall, imposing and regal presence. She studies him
critically through the screen door, before announcing,

> WIDOW FREEMAN
> Come in, Esau.

'Esau'? The tone is strangely cold but familiar. She turns
into the house, and Esau follows.

INT. FREEMAN HOMESTEAD - CONTINUOUS

The Widow Freeman takes a seat, as Esau warily moves around
the living room like a burglar at the Vatican.

HIS POINT OF VIEW - MOVING

Photos. Awards. Mementos. (like Esau's office at home) Rev.
Isaac Freeman with Dr. King, J.F.K., Heads of State, at
rallies with the NAACP, receiving a Congressional Medal of
Honor.

The silver cross draped around Isaac's neck.

And with him everywhere he went, Jacob, Jacob, Jacob...

NEW ANGLE

Esau gently picks up a photo of Isaac and Dr. King, when TWO
CHILDREN run screaming through the room.

ESAU

drops the photo. It clatters to the floor.

He lunges for it, wiping it off, but the Widow Freeman hasn't
even flinched in her seat.

> ESAU
> Mrs. Freeman, I'm...

> WIDOW FREEMAN
> Esau, you should know this house isn't
> a museum to my husband's memory or a
> mausoleum for me.

Another TRIO OF KIDS come flying through the room, followed by
RACHAEL, Jacob's pretty, harried and shy wife. She abruptly
stops, deferential to the matriarch and her guest.

 RACHAEL
 Excuse me...

The Widow Freeman nods, and Rachael quickly continues after
the pack of kids. We know who rules the roost here. The Widow
Freeman turns back to Esau, smiles.

 WIDOW FREEMAN
 It's a living, breathing home where life
 goes on, as God intended. That's also
 the way Isaac and I wanted it.

Esau still stands apart, an unwelcome guest or an aloof
Government official?

 ESAU
 Mrs. Freeman, I want you to know how
 sorry I am, about what happened to his
 church.

 WIDOW FREEMAN
 It's Jacob's church now. He'll rebuild
 it.

Esau reacts like he's been jabbed in the gut. What is it
between these two?

 WIDOW FREEMAN (CONT'D)
 You seem to have done very well for
 yourself.

 ESAU
 Last year I was appointed Deputy
 Assistant Attorney General for the
 Justice Department.

 WIDOW FREEMAN
 Indeed? Your mother must be very proud
 of you.

God, you could cut the tension in this room with a chain saw,
even as the GOSPEL MUSIC continues to waft inside.

 ESAU
 (nervous laugh)
 I don't know. I hope so.
 (then)
 Mrs. Freeman, I'm currently Director of
 the DOJ Task Force investigating the
 string of church burnings across the
 South.

 WIDOW FREEMAN
 I see. So you're here in a strictly
 professional capacity?

Esau reacts like that's an extremely loaded question.

 ESAU
 Excuse me...?

 WIDOW FREEMAN
 Nothing. Nothing personal, I mean?

'Personal' between her and Esau? Between him and Jacob?

Esau turns toward the window where Jacob's choir cuts between
them.

 ESAU
 Nothing personal...
 (opens a notepad)
 I have just a few questions.

She gestures for him to sit, but he prefers to pace.

 ESAU (CONT'D)
 Do you know anyone who'd want to do you
 or your family harm?

 WIDOW FREEMAN
 No.

 ESAU
 Any disagreements, arguments, threats,
 feuds, vendettas or ongoing unresolved
 conflict within or without the
 congregation?

 WIDOW FREEMAN
 You cast a pretty wide net, Mr. Hunter.

 ESAU
 Certainly, Mrs. Freeman, this family
 had some enemies. Your husband was
 murdered...

The Widow Freeman raises her full frame toward him.

 WIDOW FREEMAN
 That was over 30 years ago. Look
 around you, Mr. Hunter. No one does my
 husband's work without making powerful
 friends and formidable enemies.

She points to a pile of UNOPENED CORRESPONDENCE on a center
table.

 WIDOW FREEMAN (CONT'D)
 See this? Over 100 letters a week,
 still, from all over the world.
 Contributions, criticisms, prayers,
 requests for family appearances and
 interviews... and one way or another, I
 try to answer them all.

Esau joins her at the table, inspects the boxes of letters.

> ESAU
> Anything in these you'd characterize as
> more than mere 'criticism'?

> WIDOW FREEMAN
> Wherever you shine a bright light, you
> find many shadows.
>> (re correspondence)
> You're certainly free to look through
> them yourself.

> ESAU
> Thank you.

Esau starts to take the boxes of correspondence, when

> WIDOW FREEMAN
> Exactly what evidence do you have that
> the fire was arson?

> ESAU
> The FBI lab is still working on that.

> WIDOW FREEMAN
> But, like my son, you're convinced it
> was a hate crime...

> ESAU
> My position at Justice requires complete
> objectivity. Jacob Freeman doesn't
> appear to be bound by such restraints.

Esau's last remark fell just short of insolent.

> WIDOW FREEMAN
> Sounds like he's stepping on your toes,
> Mr. Hunter.
>> (off his silence)
> As you know, my late husband was
> extremely passionate about his
> mission. His son Jacob inherited that
> disposition.

> ESAU
> So did I.

And with oceans implied but left unspoken, Esau exits.

EXT. FREEMAN HOMESTEAD - DAY

Esau walks to his car with the boxes -- distracted by the
LARGE TENT where Jacob and his congregation are testifying
their faith-- while his cell phone rings incessantly.
Finally, he drops the boxes by his sedan, answers and hears-

 STAFF LAWYER
 (over phone)
 Maxwell, sir. We've got a development
 going down at the local police station.

 INTERCUT:

EXT. LYNCHBURG POLICE STATION - CONTINUOUS

A fleet of sedans pulls up. The lead FBI Agent escorts 4
Skinhead Teens including Weasel up the steps.

 STAFF LAWYER
 Witnesses and a potential suspect coming
 in.

 ESAU
 To the police station?! You know better
 than that--

 STAFF LAWYER
 It's a bonehead Bureau move, sir. That's
 why I thought you'd wanna get down here.

Esau fires up the car, screeching off towards town, and

INT. LYNCHBURG POLICE STATION - DAY

REPORTERS mob Esau as he bursts inside, while his staff runs
interference.

INT. POLICE STATION BACK ROOM - CONTINUOUS

FBI Agents fill the room. Rupert and Derrick sit at a table,
silent, cuffed and terrified. Chrystal sits off to the side,
shaking and sobbing. Weasel's conspicuously absent.

The female FBI Agent smiles as Esau and his staff enter.

 AGENT MEYERS
 Mr. Hunter, seems these three heroes
 have been bragging a lot to their
 friends, lately.

 ESAU
 Well, the Justice Department and the FBI
 are always willing to listen.

 RUPERT
 Hey, we didn't do anything!

 AGENT MEYERS
 You told everyone you saw the fire.
 That's because the four of you set it.

 DERRICK
 No way. No friggin' way, lady!

 ESAU
 (to Agent)
 Four?

 AGENT MEYERS
 I got the other one in isolation.

Chrystal suddenly breaks down, hysterical.

 CHRYSTAL
 (sobbing)
 What the hell you want with us?!

 ESAU
 I want to know who did it.

Rupert turns to the others, desperate.

 RUPERT
 They want Weasel...
 (to Esau)
 You want Weasel?

 AGENT MEYERS
 (off Esau's reaction)
 The other kid--

 ESAU
 Well, that all depends on what happened.

Derrick looks to the others... then

 DERRICK
 We'll tell you anything you wanna know.

His two friends nod in quick agreement.

 RUPERT
 Just one thing...

 ESAU
 What?

Rupert balks, spills what's on all their minds.

 RUPERT
 Are you gonna have to tell our parents
 about any of this?

Esau's blown backwards by the cluelessness of that one, and

 CUT TO:

INT. POLICE STATION HALLWAY - LATER

Esau steps out of the room, looking troubled. The FBI Agent
is close on his heels, falsely optimistic.

 AGENT MEYERS
 Let's just see what the kid has to say.

She reaches for the other door, but Esau forcefully gestures
her to stay out of it.

Esau enters the isolation room alone, and on her reaction--

MONTAGE: MOS

IN THE ISOLATION ROOM

Esau calmly interviews Weasel, occasionally pointing in the
direction of the other kids across the hall.

IN THE HALLWAY

The FBI Agent paces, concerned, in front of the closed door,
reporters milling in the background.

IN THE BACK ROOM

The 3 Kids, surrounded by a crush of authorities, whisper
nervously among themselves, while

BACK IN THE ISOLATION ROOM

Weasel, strangely, doesn't seem interested, or even
intimidated by the story Esau is recounting.

Esau reacts as Weasel stares blankly out the window.

INT. POLICE STATION HALLWAY - DAY

Esau grimly approaches the hopeful FBI Agent.

 AGENT MEYERS
 What'd he say?

 ESAU
 Nothing. He just sat there like I was
 telling him horseshit. Which I was,
 'cause his 'friends' in there were
 tripping all over themselves feeding us
 the same thing.

 AGENT MEYERS
 They're scared, that's all.

 ESAU
 So scared, all they can think about is
 not getting grounded, and being home in
 time for dinner--?

 AGENT MEYERS
 Meaning--?

 ESAU
 You've already got three statements, and
 they don't even come close to matching
 up. Take a fourth now and you'll
 completely poison the well.

 AGENT MEYERS
 So what do you suggest we do? Send him
 home to mama?

 ESAU
 Til we get some evidence--anything
 objective to measure his response
 against. I'm not risking--

NEW ANGLE

Jacob bursts through the door with a press of cameras, lights
and citizens behind him.

 JACOB
 The people have come to serve as witness
 that justice be served!

Esau looks daggers at his FBI counterpart.

 ESAU
 (sotto, to Meyers)
 Your grandstanding's going to get
 someone killed.

Follow Esau's large frame as he attempts to force the
intruders back.

 ESAU (CONT'D)
 Okay, everybody out. Now!

 JACOB
 We have the right to see the faces of
 hate that walk among us!

The reporters press in on Esau.

 REPORTER 1
 Is it true the FBI has 4 suspects in
 custody?

 ESAU
 No.

 BLACK CITIZEN
 We know you've got 'em--

 ESAU
 There are no suspects.

 WHITE CITIZEN
 Those kids've never been nothin' but
 white trash and trouble. And you finally
 got 'em right here where they belong.

 REPORTER 2
 Mr. Hunter, are you ready to make an
 official statement?

 ESAU
 Yes. Go home--

The crowd grumbles. It's close quarters and getting ugly.

 ESAU (CONT'D)
 (smooth)
 Before you do, I also want to thank
 everyone in this community, including
 the young people who've helped us here
 today, for their eager and concerned
 assistance in this investigation.

Esau pulls Jacob aside, while his staff tries to move the
crowd back towards the door.

 ESAU (CONT'D)
 Those kids are going home too. If
 anything, anything happens to them
 because of this, I swear I'm going to
 hunt you down.

 JACOB
 You can't hold me responsible--

 ESAU
 Watch me.

Esau turns, but Jacob grabs his arm. Esau spins back, and as
the men get into some INTENSE, SOTTO HEAD-BUTTING--

PAN THE HALLWAY

following a growing BUZZ among the crowd, stopping

CLOSE ON WEASEL

who's stepped out of the isolation room, squinting under a
blaze of camera lights.

BACK WITH ESAU AND JACOB

poking each other in the chest, going at it like umpire and
batter, oblivious to the growing BUZZ...

until Esau's Paralegal takes his elbow, insistently.

 ESAU
 (shakes it off)
 Not now!

 PARALEGAL
 (takes it again)
 Sir--?

 ESAU
 What is it--?!

 PARALEGAL
 The kid just confessed.

Esau just stares at her. For the first time in his life,
even Jacob is speechless. The paralegal isn't sure she got
through.

 PARALEGAL (CONT'D)
 To the TV reporters. He's saying he set
 the fire himself.

The men try to absorb the enormity of this development, as

ANGLE - WEASEL AND THE REPORTERS (MOS - SLOW MOTION)

Weasel answers reporters' questions amid a blur of camera
flashes, slowly warming to them and actually beginning to
smile, reveling in the heat of the media spotlight,

HOLD on this disconcerting, dreamlike spectacle, then

 HARD CUT TO:

INT. POLICE STATION ISOLATION ROOM - DAY

A staccato SERIES OF ANGLES--

with a strangely cooperative and exuberant Weasel caught in
the middle of the crossfire of interrogation.

 STAFF LAWYER
 ...do you understand these rights?

Weasel lights a cigarette, smiles. Esau's not sure he gets
it.

 ESAU
 Son, do you want us to get you a lawyer?

 WEASEL
 (no, exhales)
 Let's rock 'n roll...

Agent Meyers jumps in, eager for the trophy kill.

 AGENT MEYERS
 Your name?

 WEASEL
 Weasel--
 (off reaction, formal)
 Wesley-David-Foster.

QUICK ANGLES

Meyers, Esau and the others swirl around him, firing
questions, CAMERA centering on Weasel's glib reactions.

 ESAU
 You acted alone?

 WEASEL
 What of it?

 AGENT MEYERS
 What about the others --your 'friends'?

 WEASEL
 They got no imagination.

 ESAU
 Why'd you confess?

 WEASEL
 You had me. I didn't wanna drag it out.

 ESAU
 How'd you pull it off?

Weasel balks, what do you mean?

 AGENT MEYERS
 Your plan. To torch the church.

 WEASEL
 'Plan'? I kerosened the pews--
 (strikes another match)
 and Poof! It ain't rocket science.

Esau sags in reaction to the ease of Weasel's admission.

 ESAU
 Why?

Agent Meyers jumps in again, trying to grab the lead.

 AGENT MEYERS
 Tell us which nationalist/ supremacist
 organizations you're affiliated with.

 WEASEL
 What...?

Esau spins Weasel around in his chair, facing him.

 ESAU
 Reverend Jacob Freeman. What exactly
 do you have against him and his
 congregation?

 WEASEL
 (thinks, then)
 They're all black...?

 ESAU
 Do you know who Reverend Freeman's
 father was?
 (obviously not)
 Do you even know Reverend Freeman
 himself?

 WEASEL
 Yeah. Of course. Well, not personally.
 You can't turn on the TV lately without
 hearing his sorry-ass complaining.

Esau motions Agent Meyers with him towards the door. Weasel
calls after them.

 WEASEL (CONT'D)
 I mean, why should that loudmouth nigger
 get all the publicity?

INT. POLICE STATION HALLWAY - CONTINUOUS

Esau closes the door, confers with Meyers.

 ESAU
 Okay, we got a situation here.

 AGENT MEYERS
 We sure do. But you can save the roses
 and commendation till I get back to
 Washington.

 ESAU
 Before we go any further, I want you to
 make sure the kid has a public defender.

 AGENT MEYERS
 Are you crazy? He was Mirandized
 properly, and I didn't hear him ask for
 one.

 ESAU
 Do it anyway.

 AGENT MEYERS
 It's not our job. And I got a lot more I
 want to--

 ESAU
 Exactly. But if this kid has a screw
 loose, his waiver of counsel is
 nullified. Everything he says to you's
 inadmissible.

 AGENT MEYERS
 Do you want to get this cracker bastard
 or not?!

Esau pulls himself up stiffly.

 ESAU
 I want it done right. That means no
 rumors of what this kid said leaked
 to the media vultures... and no one
 parading around his scalp for her
 personal glory--

 AGENT MEYERS
 I know what this is about... this is
 nothing more than a dick-measuring
 contest for you.

She pumps her fist crudely in the air. Esau reacts to this
unladylike display, miles above her in class.

 ESAU
 Let me put it this way, Miss Meyers: if
 it were about what you think it is--
 you've already lost, big time.

On Meyer's barely-contained insubordination,

 DISSOLVE TO:

SERIES OF SHOTS:

ON A LYNCHBURG STREET,

The Richmond Times-Dispatch proclaims: "Skinhead Confesses to
Church Arson".

IN A FARMHOUSE LIVING ROOM,

a relieved black family watches a tape of Weasel and his
cohorts being led into the local police station.

OUTSIDE THE FREEMAN HOMESTEAD,

Jacob gathers his wife and children for a photo-op marking
various corporate donations for the Bethel First Baptist
Church Rebuilding Fund.

And finally, but more ominously

IN THE WASHINGTON POST BUILDING,

Amanda's editing another recipe, picks up a ringing phone. As
she answers, we INTERCUT:

THE NEW YORK OFFICE OF PEOPLE MAGAZINE

where a slick, YUPPIE EDITOR leans back in his chair, holding
a small Post article on the arrest.

 YUPPIE EDITOR
 Amanda, Chuck Dearborn. How's life on
 the "linguine" beat?

 AMANDA
 (irritated)
 Never as fascinating as your life in the
 "Lamborghini lane".

 YUPPIE EDITOR
 Maybe I can change all that--

He lets it hang. Amanda finally bites, warily.

 AMANDA
 Since when are you suddenly so concerned
 about me or my career?

 YUPPIE EDITOR
 We have history. I'm always concerned.
 How're things going with the new guy,
 "Justice Man"?

 AMANDA
 (lies)
 Fine. Why?

 YUPPIE EDITOR
 Seems he personally arrested a redneck
 kid who torched one of those black
 churches. Isaac Freeman's old church.
 Now, these church arsons are becoming a
 big story. Isaac Freeman's a big name.
 And I like the angle of a black man in
 a white hat, riding into town with his
 six guns and subpoenas... setting things
 right. Make hell of a People profile--

 AMANDA
 Why're you telling me this?

 YUPPIE EDITOR
 He won't talk to us. "Not a 'legitimate'
 news source." I just thought he might
 talk to you, Ms. Washington Post.

 AMANDA
 I work in the "Salad Section".

 YUPPIE EDITOR
 Not if you get me this story. There's
 an opening here for Assistant Features
 Editor.

 AMANDA
 You're asking me to lie to him. And any
 under-the-table freelancing could get me
 fired.

 YUPPIE EDITOR
 Look, Amanda... all I can tell you is
 if you can't take a little heat--you'll
 never get out of the kitchen.

Amanda considers the offer, unsure if it's plum or poison. We
leave her like Eve holding the apple, and

EXT. VIRGINIA BLUE RIDGE MOUNTAINS - SUNRISE

A sparkling, clear November morning, with the hills ablaze
with the glorious colors of fall. God in his heaven and all
right with the world.

EXT. FREEMAN HOMESTEAD - MORNING

A bustle of activity. Trucks, vans and volunteers mill at the
staging area of a massive rebuilding effort.

INT. FREEMAN HOMESTEAD KITCHEN - CONTINUOUS

The Widow Freeman stirs a bowl of pancake batter over the
stove.

Jacob's pretty wife, Rachael, sits at the table in her
bathrobe, vainly trying to keep her 5 boys focused on their
breakfast. Two strain to get a view at the commotion outside,
while the other 3 abandon the table and hang out the kitchen
window.

 RACHAEL
 Ruben, Simeon, Levi--sit back down here
 and finish your breakfast...

No response. The middle boy, Ruben, points out the window.

 RUBEN
 Look, a cement truck!

That's all it takes to send one of the little ones flying from
the table.

 JUDAH
 Let me see!

The smallest kid looks plaintively at his mother. She
relents, and he bolts to join his siblings.

THE WIDOW FREEMAN

smiles indulgently at the boys, then approaches her flustered
daughter-in-law.

> RACHAEL
> I swear I don't know what to do with
> them! They've got to eat. They've got
> school.

> WIDOW FREEMAN
> (laughs)
> For me, one Freeman boy was a handful.
> But against five Freeman boys and a
> cement truck, I figure a mother's got no
> chance at all.

Rachael bristles at the implied reproach.

> JACOB (O.S.)
> Rachael--Rachael!

> RACHAEL
> Now maybe if he only spent any time with
> his own sons, they wouldn't be running
> 'round like wild Indians...

Rebekah reacts defensively.

> RACHAEL (CONT'D)
> What?

Jacob rushes in, beaming, plants a quick kiss on his wife's
forehead.

> JACOB
> Quick, how'd you like to be on cable
> television?

> RACHAEL
> At seven-thirty in the morning?! Jacob,
> no...

> JACOB
> (laughs)
> Now Rachael--

> RACHAEL
> I'm not even dressed! You know how
> I hate being ambushed by these news
> people. I thought you said you were done
> with these interviews--?

Over the above, Jacob folds his arms paternalistic. When
she's done, he flings his arms open to his mother.

 JACOB
 Mom, I did it! My own cable television
 show. Five days a week, starting next
 month!

His mother tries to hide her shock, and dismay.

 WIDOW FREEMAN
 Oh, my Lord...

 JACOB
 (to his sons)
 Boys, your ole' man's gonna be a TV
 star!

One boy gives a tepid CHEER. Little Judah grabs his leg.

 JUDAH
 Come see the cement truck!

Jacob ignores his plea, drops another bomb on Rachael.

 JACOB
 And your Mom's gonna be a star too!
 Sitting up there every day with me in
 front of the camera.

Rachael's dumbfounded. Jacob turns her chin, cajoling.

 JACOB (CONT'D)
 Producers said she looks just like Halle
 Berry--and who am I to disagree?

But Jacob's not going to smooth-talk his way by this one.
Rachael stands, radiating enough chill to cause frostbite.

 RACHAEL
 Judah, tell your brothers to get ready
 for school.

And leaves the room. Jacob chuckles, turns to his mother.

 JACOB
 I figure it'll take her a while before it
 all sinks in.

On his mother's inscrutable reaction,

 CUT TO:

INT. FREEMAN HOMESTEAD LIVING ROOM - LATER

The Widow Freeman sits on the couch, working on her
correspondence. A knock at the door distracts her.

AT THE DOOR

She scrutinizes two perky, Southern-preppy BLACK GIRLS in
their early twenties. One gushes, star-struck.

 HEATHER
 Mrs. Freeman? Mrs. Rebekah Freeman...?

 WIDOW FREEMAN
 Who's asking?

Jacob slides in between them, flings open the door. Some
WORKMEN with heavy equipment wait outside.

 JACOB
 It's alright, Mama.
 (to the men)
 Come in, come in.

Heather sweeps in with the other girl, unctuously takes
Rebekah's hand.

 HEATHER
 Heather Hotchkiss. This is indeed a
 pleasure...
 (introduces girl)
 My colleague, Mindy Martindale....
 (officious, to men)
 Okay boys, come on, let's load it in
 here...

NEW ANGLE

Heather smiles broadly at Jacob, breezes passed Rebekah--in
star-fucker heaven. The workmen follow, pushing dollies piled
high with expensive COMPUTER EQUIPMENT.

 REBEKAH
 Where do you think you're going?
 (no response)
 Jacob, who are these people?

The people in question roll into a back room like they
already own the place.

 JACOB
 Heather is my producer for my broadcast
 ministry. And Mindy is your new Personal
 Assistant.

 REBEKAH
 "Personal Assistant"--I don't think so.

 JACOB
 Heather and Mindy are honor roll
 students at the University in
 Charlottesville. They'll also be
 computerizing all your correspondence
 files.

The Widow Freeman crosses the room, calls out.

 WIDOW FREEMAN
 Well you just tell the Doublemint Twins
 we won't be needing their 'assistance'.

 JACOB
 I can't do that Mama, see--

 HEATHER (O.S.)
 Reverend Freeman, you gotta see this--
 your Website is up!

 JACOB
 Mama, well, they're just part of the big
 picture.

 WIDOW FREEMAN
 (wary)
 And what picture is that, pray tell?

 JACOB
 "Isaac Freeman World-Wide Ministries".
 That's also the name of the TV show.

Rebekah is shocked by his audacity.

 JACOB
 Mom, sit down...

Rebekah suddenly realizes he's serious. She's stunned.

 JACOB (CONT'D)
 Lots of companies, big companies
 like Nike, Coca-Cola, are just dying
 to become part of this. I see their
 contributions paying for education, day-
 care, social justice programs, all in
 Daddy's name. Across the country. Even
 overseas!

Rebekah tries to process this onslaught of ambition before
responding.

 WIDOW FREEMAN
 I guess I don't understand.... Why would
 these big companies be so eager to do
 all this?

 JACOB
 (humorous)
 Because they see your son as a charming,
 dynamic moral visionary who's recently
 achieved a certain national profile.
 (then)
 And also for the exposure.

 WIDOW FREEMAN
 'Exposure'?

 JACOB
 You know--advertising.

 WIDOW FREEMAN
 Advertising...

 JACOB
 You can't have a show without sponsors.
 Let me tell you the celebrity interviews
 I'm trying to line up--

 WIDOW FREEMAN
 (raises her hand)
 Hold it right there!

Dark clouds gather behind her eyes. Jacob's seen this look
before, and it puts a chill down his spine.

 WIDOW FREEMAN (CONT'D)
 Now let me get this straight. What
 you're telling me, Jacob, is that you've
 sold your father's legacy and good name
 to soda pop and shoe manufacturers-- in
 order to finance some fantasy of becoming
 some kind of "televangelist"?

 JACOB
 To finance my 'On Air Ministry' You make
 it sound like that's something dirty.

 WIDOW FREEMAN
 It usually is.
 (pointedly)
 And your father would agree.

Invoking Isaac like that hits Jacob like a low blow.

 JACOB
 Daddy would understand--

 WIDOW FREEMAN
 Don't tell me what he'd think. Or what
 he'd do if he were here--

 JACOB
 (chastised)
 Mama, he was preaching during the Civil
 Rights era. That was his stage. It
 became a world stage. And the world had
 to pay attention to him.

Jacob wrings his hands, pleading for understanding.

 JACOB (CONT'D)
 It's different today. There's still hate,
 still people burning down churches.
 (MORE)

 JACOB (CONT'D)
 But now we've also got a world filled
 with computer games, the internet, VCRs,
 DVD's--
 (sighs)
 All I'm saying it's not that easy to get
 people to pay attention any more.

Jacob reaches for his mother's hand... but it stays on her
lap, frozen like black ice.

EXT. LYNCHBURG MOTEL - DAY (ESTABLISHING)

INT. ESAU'S MOTEL ROOM - CONTINUOUS

Milling with Government types. Some packing up and moving out.
Esau, wearing reading glasses, sits at a desk amid mountains of
paper. The Staff Lawyer drops a paper on his desk.

 STAFF LAWYER
 Status Report: 3 Justice staff heading
 back to D.C., suspect's arraignment set
 for Monday with a Judge Lafferty, and the
 public defender, named uh, Richardson,
 wants to meet with you tomorrow at 9
 before any further questioning.

Esau looks at the paper, grunts. The Paralegal comes up to
him, smiling.

 PARALEGAL
 Woman here to see you--

 ESAU
 (groans, rubs eyes)
 ...ugh, not that goddamn gloating
 Bureau- bitch....

The Paralegal doesn't answer, steps away to reveal

AMANDA PHILLIPS

in all her blonde, tailored Donna Karan glory. Esau's face
drops.

 AMANDA
 (teasing)
 Disappointed...?

Esau reflexively hides his reading glasses. She twirls her
hair coquettishly, and

EXT. MOTEL ROOM - DAY

Esau steps outside with Amanda. Her shiny white BMW coupe in
glaring contrast to gun metal Government sedans.

Esau nervously tries to assess her sudden appearance.

 ESAU
 Amanda, what're you doing here?

 AMANDA
 (kisses his cheek)
 Always knew how to charm a girl. I just
 thought I'd surprise you.

 ESAU
 Well, I'm surprised...

Amanda spins around sensuously, but with an ironic edge.

 AMANDA
 Come on, Mr. Spontaneity... this is the
 part where you make your abject apology,
 take me in your arms and we kiss and
 make up.

Esau doesn't know where to begin. He's terrible at this
stuff.

 ESAU
 Amanda, I've missed you so much...

 AMANDA
 That's a start, anyway...

Amanda wraps her arms around his neck, kisses him long and
passionately, as

INSIDE THE MOTEL ROOM

The staffers press against the window, taking in the scene.

 STAFF LAWYER
 All work and no play makes Jack a dull
 boy...

The Staffers giggle like school children. The female
paralegal playfully punches the lawyer in the shoulder.

 PARALEGAL
 God, what grade are you kids in? Leave
 the man alone.

She tries to pull the drapes, but they push her aside,
wailing in protest, and

BACK WITH ESAU AND AMANDA

Amanda breaks off the embrace, looks him in the eye.

 AMANDA
 Okay, I forgive you. For standing me up
 at my award ceremony, for being a slave
 to your G-man job, and for being an all-
 round insensitive guy.

Esau finally breaks into a smile. Their banter is back to normal.

 ESAU
 Thanks... I think.

 AMANDA
 (sighs)
 I guess love is blind. Or is that
 ambition... I never get that straight.

Esau takes her by the shoulders, pulls her close.

 ESAU
 I thought you were gonna stop bustin' my
 chops...

 AMANDA
 Okay, tough guy.
 (touches his lips)
 I took the whole weekend off. How do
 ya show a girl a good time in this one
 horse town?

 CUT TO:

INT. ESAU'S MOTEL ROOM - NIGHT

Esau and Amanda wrestling on the bed. It's loud, physical;
great "make up" sex.

Still, it's full of frustration, longing and unresolved
struggle between them.

 DISSOLVE TO:

EXT. ESAU'S MOTEL ROOM - LATER THAT NIGHT

No sign of it letting up any time soon inside. And no sign of
any clear victor, either.

Yet something about the unrelenting noises inside seems
unsettling, desperate...

INT. ESAU'S ROOM - THE NEXT MORNING

Peaceful at last, the combatants curled in neutral corners
of the bed. Light and the warble of song birds, suddenly
punctuated by a determined KNOCKING on

THE MOTEL DOOR

Esau startles, and only half awake, wraps a sheet around his
waist, flings open the door.

NEW ANGLE - OUTSIDE THE DOOR

Esau finds himself face to face with a DEMURE SOUTHERN BLACK
WOMAN, JUDITH RICHARDSON (35). She's dressed in a simple
business suit and clutches a briefcase to her chest.

 JUDITH
 (mortified)
 Oh, oh--I'm so sorry.

And she starts to turn away. Esau looks at himself, the naked
woman lying in bed behind him. Oh, no...

 ESAU
 Can I help you?

 JUDITH
 (walking away)
 No, no--my mistake. Please forgive me.

The gears click in Esau's head. He checks his watch: 9:30. He
winces.

 ESAU
 Ms. Richardson--?!
 (as she stops)
 I'm Esau Hunter.

Judith slowly turns around. Confronts Esau in his sheet. This
is a horrible moment for both of them.

 ESAU (CONT'D)
 I, uh, must've overslept. Just give me
 a moment.

Esau closes the door, leaving a ruffled Judith outside.

INT. ESAU'S CAR - MOVING

Esau stares straight ahead, driving Judith down a leaf-
dappled country road. The rush of the air outside the only
sound between them.

Finally, Judith's Southern civility overcomes.

 JUDITH
 How long you been at Justice, Mr.
 Hunter?

 ESAU
 Six years.

Another rush of air. Esau realizes it's his turn.

 ESAU (CONT'D)
 And you, with the Public Defender...?

 JUDITH
 Six years.
 (a shorter beat)
 And before that?

 ESAU
 Arnold & Porter. Five years.

Judith is majorly impressed.

 JUDITH
 Arnold & Porter...

 ESAU
 (forced humor)
 Yeah. What people in Washington like to
 call a 'white shoe' law firm.

That sort of breaks the ice. Judith grins slightly...

 JUDITH
 You must've gone to a hell of law
 school. No, let me guess. Harvard...
 Yale...
 (off his look)
 I knew it. How--

Esau quickly tries to change the subject.

 ESAU
 What about you, Ms. Richardson?

 JUDITH
 George Mason. Night program.

 ESAU
 Uh, huh. Got family here in Lynchburg?

 JUDITH
 Roanoke.

 ESAU
 Nice place...

 JUDITH
 (slight edge)
 Nice place to be from.

 ESAU
 Get back often? To see your family?

 JUDITH
 Not after spending 20 years trying to
 escape them, no thank you.

Esau reacts more than we expected at that one... before the
conversation veers off again into other uneasy territory.

 JUDITH (CONT'D)
 Look, we're almost there. Maybe we
 should talk about my client.

 ESAU
 Right. Look, about what happened back at
 the motel...

 JUDITH
 Mr. Hunter, it's my recollection that
 you met me at the motel office at 9, just
 as we planned.

And in that one gracious gesture, Judith puts the entire
embarrassing episode to rest. Esau relaxes, and

EXT. LYNCHBURG STREET - EARLY MORNING

Deserted. Shops closed. No cars on the street. Esau's sedan
passes alone... parks by the Police Station.

Esau and Judith get out of the car. Esau seems distracted.

 JUDITH
 I'm going to be asking for minimum bail.
 Wesley's a minor, and Mrs. Foster's a
 single parent on relief.

 ESAU
 I'm afraid I can't go along with that...
 (looks around)
 Where the hell is everybody...?

 JUDITH
 Not from around here, are you?
 (off reaction)
 It's Sunday. People are in church.

Esau GRUNTS disapprovingly. Judith turns to him.

 JUDITH (CONT'D)
 Why, Mr. Hunter?

 ESAU
 About the bail?

 JUDITH
 No, church. You don't seem to approve.

Esau's caught off guard by her ingenuousness. But he answers
a serious question directly.

 ESAU
 Well, personally, I don't feel people
 need church to tell them right from wrong.
 And too many people ask God for things
 they should be getting on their own.

 JUDITH
 I see. "God helps those who help
 themselves"...

 ESAU
 I didn't say God helps anybody.

That gets Judith's attention. They enter the building, and

INT. LYNCHBURG POLICE STATION - CONTINUOUS

Judith cheerfully waves to the Desk Sergeant as they pass.

 ESAU
 You met with your client yet?

 JUDITH
 Oh, yeah...
 (then)
 Somehow that FBI Agent getting me
 assigned to him doesn't strike me as
 random or coincidental.

 ESAU
 Knowing her, probably not.

ANGLE - LOCK UP AREA

A middle-aged white OFFICER stands to greet them.

 JUDITH
 Which brings me to our next problem...
 (to officer)
 Morning Bertram... how's our boy doing?

 OFFICER
 I'm afraid you've got your hands full
 with this one, ma'am.

The Officer unlocks the door. Judith flatly tells Esau--

 JUDITH
 He doesn't want me to represent him.

 ESAU
 Do I have to ask why?

 JUDITH
 Why don't I let him tell you...

INT. LOCK UP - DAY

Esau and Judith enter and react to

THEIR POV - THE WALLS AROUND WEASEL

covered in an angry block-lettered and pathetically
misspelled scrawl: 'NATZEE PARTY TIME', 'ARYEN NATION UNDER
GOD', 'JUSTISS FOR ALL--WHITE MEN'.

The Officer apologizes before leaving.

 OFFICER
 Sorry about the mess. I gave him the
 pen. Said he wanted to make a statement.

The door closes. Esau takes in the scene, then Weasel's smug
adolescent defiance.

 ESAU
 Well Mr. Foster, I see you did just
 that. Anything you care to add to all
 this...?

 JUDITH
 Wesley, you don't have to answer any of
 Mr. Hunter's questions.

 WEASEL
 It's 'Weasel', and I already told you,
 bitch, you're not my fuckin' lawyer!

A step up in aggression for Weasel. Esau towers over him.

 ESAU
 Ms. Richardson reminds me this is the
 Sabbath. So we'll refrain from any
 profanity or disrespect of our elders.
 Am I being absolutely clear?

Esau's tone is commanding, almost scary. Judith almost steps
in... before Esau shifts, suddenly softer.

 ESAU (CONT'D)
 So, you don't want Ms. Richardson
 representing you because of her race?

 WEASEL
 You don't fuh- friggin' get it, do you?
 I'm guilty. I don't need a lawyer. I'm
 representing myself!

 JUDITH
 The judge will decide that. Until then
 you're stuck with me, whether you like
 it or not.

 WEASEL
 Whatta you guys want from me?! I've
 already confessed!

Esau sits on the bed next to Weasel, looks up at the wall.

 ESAU
 You and your friends members of the
 Aryan Brotherhood?

 WEASEL
 (stops Judith)
 I am. What of it--?

Esau and Judith exchange a glance. He continues.

 ESAU
 Did you plan the Bethel Baptist Church
 burning with them?

 JUDITH
 Wesley, as your attorney I have to
 advise you--

 WEASEL
 (interrupts, angry)
 Yes. No--not my loser friends. Just me.
 And the Aryans...

 ESAU
 Where? Here in Lynchburg? Somewhere
 else? How'd you meet these people?

Weasel looks blank for a moment, then answers proudly...

 WEASEL
 The Internet.

Esau reacts thoughtfully, then tosses him a manila file.

 ESAU
 Take a look at that--
 (off suspicion)
 It's a list of the black church arsons,
 across the South, my office is currently
 investigating. Over ninety of them.

Weasel flips through the pages nonchalantly.

 ESAU (CONT'D)
 Which of these, to your knowledge, was
 the Aryan Brotherhood involved in?

Weasel flips the pages back and forth... looks up, pissed.

 WEASEL
 Why should I tell you?

 ESAU
 It could go easier for you at
 sentencing.

 JUDITH
 Mr. Hunter, you know the terms of any
 prospective deal should be discussed
 between us first.

 WEASEL
 Any deal's gonna be made, lady, is gonna
 be made by me!
 (then, to Esau)
 I got some demands.

Esau folds his hands, listens.

 WEASEL (CONT'D)
 Back at my Mom's place, I got a boom
 box, some CD's...

 JUDITH
 Bail hearing's tomorrow. Chances are
 I'll have you home by--

 WEASEL
 I also got some posters, a guitar and,
 oh yeah... my porn collection.

 ESAU
 What's in it for me?

Weasel tauntingly flips through the church arson list.

 WEASEL
 An answer to your question. If I have one.

 ESAU
 Okay...

 WEASEL
 Not so fast. It's gonna cost you one
 more thing.
 (locks eyes)
 I want a buncha those TV reporters in
 here, pronto, so I can give 'em all
 interviews.

 ESAU
 Sorry. I can't do that.

 WEASEL
 Bullshit!
 (off reaction, defiant)
 Bull-shit!! You can do whatever--you're
 'The Man'.

 ESAU
 And I make rules how these cases
 proceed.
 (explains)
 (MORE)

 ESAU (CONT'D)
 So, among other things, I'm not going
 to provide a confessed arsonist media
 access to promote any hate-mongering
 personal agenda.

Most of Esau's discourse flew a foot over Weasel's head.

 WEASEL
 That's 'no'...?

 ESAU
 No.

 WEASEL
 Then you don't get dick--

Weasel flings the arson list across the room, and

EXT. RUN-DOWN TRAILER HOME - DAY

In a garbage-strewn hollow. Not fit for human habitation.

POV - TELEPHOTO LENS:

Camera CLICKING, film motor WHIRRING, while PUSHING IN TO

the front porch where a thin, BEDRAGGLED WOMAN, (36) rocks
alone on a porch swing.

In a series of STILL SHOTS, we see her chain smoking,
drinking straight from a quart whisky bottle. Then she looks
up, surprised, as

Jacob Freeman enters the frame... dressed in clerical garb.
She lowers the bottle to her lap, and

CLOSE - THE PORCH

Jacob smiles ingratiatingly, extends his hand.

 JACOB
 Mrs. Foster.

She squints up at him, just plain-ass drunk.

 MRS. FOSTER
 I already told you fuckin' Feds
 everything, three times ...
 (studies him, then)
 Wait, I know you-- You're all over the
 TV--

 JACOB
 May I sit down?
 (sits quickly)
 I'm the Reverend Jacob Freeman.

She sees his collar, snaps out of her haze, panicked.

 MRS. FOSTER
 Jumpin' Jesus--you! I shoulda known! Get
 outta here! Out!

 JACOB
 Please, calm yourself.

 MRS. FOSTER
 It's not my fault! I raised him
 Christian. Don't you hurt me--

 JACOB
 'Hurt you'? Mrs. Foster, we're here to
 help...

NEW ANGLE - THE PHOTOGRAPHER

lowers her camera. It's Amanda. Apparently she's made her
decision. She's incongruous amid the squalor, circling like a
shark, intrusively snapping photos.

 AMANDA
 Just act natural... you look great.

POV - HER CAMERA LENS

deliberately framing in the whiskey bottle along with Mrs.
Foster's angry, addled expression.

 MRS. FOSTER
 What is this...?

WIDE - THE SCENE

Jacob poses as he leans closer to Mrs. Foster.

 JACOB
 This lady's from People magazine. Came
 all the way from New York City, just to
 talk to us.

Mrs. Foster assesses them carefully, pulls the bottle
defiantly to her mouth. Then calmly replies...

 MRS. FOSTER
 Get the fuck off my property--

Amanda reacts, this is gonna be a hard sell. Jacob motions
her with his eyes to make the pitch.

 AMANDA
 The magazine's offering you five thousand
 dollars.

Mrs. Foster is clearly stunned, and really wary.

 JACOB
 For a single interview.

 MRS. FOSTER
 Nobody walks up and hands someone a sack
 of money, just to hear 'em talk.

 AMANDA
 We do. This is a national story. I've
 got over three million readers who need
 to know why people like your son are
 burning down these places of worship.

 MRS. FOSTER
 Look at me--do I look like some kinda
 fuckin' head doctor?

 JACOB
 No. You look like his mother.
 (off her reaction)
 A mother who held him as a baby, saw
 him grow up, get into trouble. Who
 knows exactly how hard it must've been,
 raising a boy like Wesley...

 MRS. FOSTER
 On my own.

 JACOB
 That's right. That's not easy.

She starts to reconsider. Maybe this ain't a bad deal.

 MRS. FOSTER
 You got no idea.
 (to Amanda)
 The boy's no fuckin' good. Just like his
 father, who left us here to rot in this
 shithole in the first place.

Amanda sees her chance, hands over a paper and pen. Mrs.
Foster looks at it uncomprehendingly. She can't read it.

 AMANDA
 It's a standard release. Just sign at
 the bottom.

 MRS. FOSTER
 (considers, then)
 I don't take no out a state checks. It's
 gonna hafta be cash up front or nothin'
 doin'.

Amanda reacts, okay. Mrs. Foster feels like the country mouse
has driven a hard bargain.

 MRS. FOSTER (CONT'D)
 Will my mark do?
 (off nod, to Jacob)
 Outside of my bad-mouthing Wesley,
 what's in this for you?

> JACOB
> A lot. See, knowing you gives me a
> chance to know him better. To know is to
> understand; to understand is ultimately
> to forgive. It's all about healing...

She reacts, 'yeah-right'. Jacob smiles softly, leans in.

POV - AMANDA'S CAMERA

Jacob positions himself, blocking the bottle, places a Bible
on her lap under the release. He puts his hand over her hand,
covering the pen...and CLICK, CLICK, CLICK. Cover shot.

EXT. LYNCHBURG COUNTRYSIDE - DAY

Esau driving Judith back from town through a blaze of autumn
color.

INT. CAR

Esau's hassled, it's been a bad day. Judith hesitates, then

> JUDITH
> Listen, thanks...

> ESAU
> The ride? No problem.

> JUDITH
> That too. Rumor has it you're the
> one who insisted that kid have
> representation.

> ESAU
> He's got the same rights as anyone else.

> JUDITH
> I understand. But he was Mirandized
> properly. You didn't have to--
> (off his reaction)
> I'm just saying, not many prosecutors I
> know would've done that.

> ESAU
> The job of the Justice Department
> is justice. Not playing God with the
> results of any case.

The pronouncement sits there between them... til his cell
phone RINGS. Esau picks up.

> INTERCUT:

ESAU'S BOSS, THE AAG

at the Justice Dept. office. He looks dyspeptic.

 ASST. ATTORNEY GEN.
 (to phone)
 Whattaya think of the arson report?

 ESAU
 (to phone)
 What arson report?

Judith turns an ear to the conversation, intrigued.

 ASST. ATTORNEY GEN.
 Agent Meyers hasn't briefed you?

 ESAU
 (an edge)
 She will...

 ASST. ATTORNEY GEN.
 Damn arraignment's tomorrow.

 ESAU
 I know.

 ASST. ATTORNEY GEN.
 Okay, field trip's over. Now get your ass
 back here. You've got 20 other cases and
 8 trials to supervise.

 ESAU
 Miss you too, sir--

Esau hangs up, shares an ironic smile with Judith.

EXT. LYNCHBURG MOTEL - DAY

Esau pulls up next to Judith's mud-caked Toyota.

 JUDITH
 Thank's again. Could I at least buy you
 lunch?

 ESAU
 Can't. Assistant Attorney General's all
 over me.

NEW ANGLE - AMANDA'S BMW

flanking them as they exit the car. The women regard each
other, Esau introduces them.

 ESAU
 Amanda Phillips, Washington Post...
 Judith Richardson, defense counsel...

 JUDITH
 How do you do?

Amanda only deigns to give Judith a perfunctory nod, while
holding up a picnic basket and bottle of wine for Esau.

 AMANDA
 Get in, you're missing the Sunday
 picnic...

Somehow this gesture doesn't strike us as a suggestion, and

EXT. COUNTRYSIDE - DAY

Idyllic views of bucolic farmland in the Blue Ridge
foothills. Amanda and Esau having their picnic on a blanket
by her car.

She pours him a glass of wine, but Esau seems distracted.

 AMANDA
 Hey, I know it's only Ernest & Julio,
 but trust me, it's the best I could
 dredge up in the middle of Palookaville.
 (yuppie laugh)
 You know that dirty little country store
 had a big, fat jar of pig knuckles on
 the counter?! I actually saw a redneck
 reach in and--
 (suddenly pissed)
 Are you even listening to me?!

 ESAU
 Sorry. Just thinking about work.

Amanda cuddles up to him, hands him his glass.

 AMANDA
 Well, don't. Stop and smell the roses.
 If I can do it, so can you.

Esau takes the glass. Amanda turns bubbly, announces

 AMANDA (CONT'D)
 You know that article you wanted the
 Post to do on the Government's side of
 the investigation? They agreed to run
 it.

 ESAU
 Thanks anyway. But it's over. Case
 closed.

 AMANDA
 (entices him)
 What they really want to run is a story
 about you. Your life history, your
 career.

But her solicitation backfires. Esau recoils at the news.

 ESAU
 Wait a minute. I only wanted to get the
 facts out. This was never about me--

 AMANDA
 God, you really don't ever think about
 anyone but yourself, do you?!!

Amanda gets up, sets off in a huff. What's this about?

NEW ANGLE

Esau catches up to her, as she walks stiffly down the road.

 ESAU
 What?!

 AMANDA
 (spins around)
 I got the assignment. I did this for
 you--

 ESAU
 I'm sorry. I--
 (reacts)
 but you work for the Food Section...

 AMANDA
 (wipes a tear)
 Right. That's why it's such a big break.
 I had to beg the Feature Editor to give
 me this chance.

Now he understands, but feels whipsawed by conflicting
emotions.

 ESAU
 Amanda, honey...
 (holds her)
 It's just that I'm not interested in
 anybody doing the story of my life.

 AMANDA
 I'm doing the story, Esau.

QUICK ANGLE - POV OLD PICKUP

The same one we've seen earlier, coming slowly at them.

 AMANDA
 ...whether you like it or not.

Amanda stiffens again, walks away. Esau follows.

 ESAU
 Amanda, please...

Esau runs ahead of her, turns, blocking her way, not seeing

THE PICKUP

is right on them, chugging slowly forward

ANGLE - WITH ESAU

walking backwards, a step ahead of Amanda's ire.

 ESAU
 Just talk to me--

 AMANDA
 (walking at him)
 Talk to you? Okay, let's talk about
 what I'm doing with an insanely selfish,
 arrogant, career-driven sonofabitch who
 thinks all my needs, desires-

In the middle of Amanda's rant--ESAU FREEZES--seeing the
pickup - the PERSON behind the wheel - eye to eye,

 AMANDA (CONT'D)
 -and dreams in life pale compared to
 his lofty calling of being an underpaid,
 over- titled, egotistical government
 bureaucrat--

NEW ANGLE

Amanda walks right into Esau as she finishes. He grabs her,
pulling her to the shoulder. Amanda resists.

 AMANDA
 Esau!

ESAU'S POV (SLOW MOTION)

The truck passes. A simply dressed, PLUMP BLACK WOMAN (60),
staring unblinkingly back at him.

Esau is riveted by her gaze... walks into the road, watches
the old pickup drift over a rise.

 AMANDA (CONT'D)
 Esau? What is it?

Esau turns, completely lost in another world.

 ESAU
 ...I think I should be getting back to
 work...

Now Amanda's pissed and confused. What's wrong with him?!

INT. LYNCHBURG DINER - DAY

Meyers sits alone, eating at a booth, while working on a
stack of papers spread across the table.

Esau enters, and the Young Waitress flies up to him.

> YOUNG WAITRESS
> (gushing)
> Mr. Hunter--so nice to see you!
> Congratulations. On the arrest and all.
> Now you just sit down, anywhere you
> like. Anything you want, any time, owner
> says it's on the house.

Esau reacts like a reluctant rock star. Smiles tightly.

> ESAU
> Thank you. But I'll just be a minute.

Esau sits with Meyers. She eyes him, supercilious.

> AGENT MEYERS
> Aren't we the local hero...

> ESAU
> The preliminary Arson Report--

> AGENT MEYERS
> (shrugs)
> Not much there, but it's just
> 'preliminary'.

> ESAU
> I haven't seen it.

> AGENT MEYERS
> (bluffing)
> Better have a talk with that cutsie-poo
> paralegal of yours.

> ESAU
> Just give it to me.

Meyers makes a show of looking through the papers on the
table, before reaching in her briefcase, handing it to him.

Esau scans it quickly, looks up at her.

> ESAU (CONT'D)
> It says 'electrical'...

> AGENT MEYERS
> It's just preliminary.

> ESAU
> You weren't planning to show me this til
> after the arraignment?

> AGENT MEYERS
> (controlled burn)
> Hey, it was an oversight--

 ESAU
 Like having Judith Richardson assigned
 defense counsel?

 AGENT MEYERS
 What about it?

 ESAU
 She's black. The suspect won't talk to
 her.

 AGENT MEYERS
 Too bad. It's his funeral.

Esau POUNDS the table with his fist. The WHOLE DINER jumps,
turns to Esau and Meyers. Esau leans in, sotto...intense.

 ESAU
 It's yours, if I can prove you're trying
 to railroad this case--

 AGENT MEYERS
 You're questioning my probity?

The Young Waitress appears at the table, concerned, overly
cheerful.

 YOUNG WAITRESS
 How's everything?

 AGENT MEYERS
 (eyes on Esau)
 Check, please.

The Waitress reacts to her rudeness, leaves.

 ESAU
 I want everything you got from
 interviewing those other kids. And where
 I can find them.

Meyers shrugs, whatever, opens her briefcase, and

EXT. BETHEL FIRST BAPTIST CHURCH SITE - DAY

Esau pulls up to the ruins of the burned out church.

INSIDE THE CAR

a very nervous and fidgeting Rupert, Derrick and Chrystal eye
the wreckage, each other, then Esau.

 DERRICK
 I don't understand. I thought we were
 off the hook.

Esau turns to them, barks

 ESAU
 Out!

They scramble out, a motley crew of dyed hair, piercings.

NEW ANGLE - INCLUDING ISAAC FREEMAN'S GRAVE

Decorated with piles of new flowers. Rupert freaks.

 RUPERT
 Check it out, man. Somebody must'a
 died--

 ESAU
 Murdered.
 (off frozen looks)
 In 1967. His name was Isaac Freeman.
 Ever hear of him?
 (nothing)
 Civil rights hero, march on Washington,
 Nobel Peace Prize?

 CHRYSTAL
 This have anything to do with Vietnam?

Esau's stung as runs straight into the wall of ignorance
between them.

 ESAU
 Jesus. Jesus Christ.

The kids react, wary. What the hell'd they do?

INSIDE THE CHURCH RUINS

Esau walks the kids among the charred remains.

 ESAU
 The night of the fire. What'd you see,
 exactly?

The kids balk, then

 RUPERT
 We were kinda wasted...

 DERRICK
 Chrystal and I were making out in the
 back of the truck...

 ESAU
 Did you see it burning?

 DERRICK
 Not from where we were, nah. We're
 parked on the other side of those trees.

Derrick points to a thick stand of pines across the field.

 RUPERT
 See, what happened was it was late,
 freezin' cold--we thought Weasel
 disappeared to take a pee or puke or
 something, and we're gettin' ready to
 ditch him, when he comes tearin' ass
 through the woods, all sweaty and wild-
 eyed, sayin' we gotta see this thing--so
 we drive around that way, hit the corner
 (throws arms wide)
 and Boom! Never seen anything like it
 in my life! Fire spewin' out everywhere.
 The windows, the doors, the roof--

 DERRICK
 (nervous laugh)
 It was pretty intense--

It chills Esau these kids are reliving the event like it was
a movie or a video game. They just don't get it.

 ESAU
 This Wesley, uh Weasel... would you call
 him a racist? He have any black friends?

The kids look at Esau like he asked a really dumb question.

 CHRYSTAL
 You really don't know how high school
 works, do you..?
 (off Esau's reaction)
 First there's the rich kids. Then the
 wannabes, the Papagallo preppies. Below
 that there's the jocks, the 4-H farm
 boys, the black kids...then us.

 DERRICK
 And at the very rock bottom of the loser
 pile, there's Weasel. In a class by
 himself.

 CHRYSTAL
 Point is, mister, you don't mix.

 ESAU
 Weasel was with you--

 RUPERT
 I make an exception when he steals beer
 from his mom.

Esau takes this in, picks up a charred prayer book.

 ESAU
 Now this is real important. Can you
 tell me if he knows anything about
 electronics?

 DERRICK
 He couldn't program a VCR, even if he
 had one. Which he don't.

 ESAU
 I mean, could he have learned anything
 about wiring, like maybe from shop
 class? .

The boys think, shake their heads no.

 ESAU (CONT'D)
 You know if he ever studied it on his
 own--maybe picked it up from magazines,
 or over the Internet?

The kids start to laugh. Esau wonders what's so funny.

 CHRYSTAL
 It's his third year in 9th grade! Weasel
 can't read the label off a box of corn
 flakes.

ESAU

is hit hard with that piece of news. His mood visibly darkens
as he mulls over the implications.

He puts on his sunglasses, and

 MATCH DISSOLVE TO:

EXT. VIRGINIA HILLSIDE - SUNSET

Esau alone, stares out through his sunglasses to what looks
like the horizon. But what rivets his gaze is

A SMALL, SIMPLE FARMHOUSE

laundry strung outside, catching the last rays of light. Esau
stands on a rise by his car a quarter mile away.

CLOSE - THE FARMHOUSE

with the old pickup truck that's been following him, parked
conspicuously in front.

The Old Plump Woman we saw driving it appears outside, starts
gathering in the laundry in a wicker basket.

WITH THE OLD WOMAN

As she takes the clothes off the line. Her face is kind, but
lonely and creased by worry. Not the stalker type.

She unhooks a large billowing sheet, and as it drops

HER POV

Esau appears, a small silhouetted figure on the rise above her.

The Woman stops working, stares back... neither surprised nor threatened. As if she were expecting this.

CLOSE - WITH ESAU

hands in pockets, looking back down at her. The Woman makes a small gesture of acknowledgement.

Esau doesn't respond... and after a beat, she retreats back into the house with her half-filled basket.

A cold wind picks up behind Esau, as we PULL BACK

and up, leaving Esau alone with his thoughts, as the night starts falling down upon him.

 DISSOLVE TO:

EXT. LYNCHBURGH COURT HOUSE - THE NEXT MORNING

A fair sized crowd of reporters, townspeople has gathered.

INT. COURT HOUSE ANTE ROOM - CONTINUOUS

Judith waits alone, holding a man's jacket, shirt and shoes. She reacts as Weasel appears with an Officer, wearing the same t-shirt and jeans he was arrested in.

 JUDITH
 I got these down at the Wal-Mart.
 (hands him clothes)
 May not be your style, but they'll make
 a good impression.

Weasel doesn't even bother insulting her. He blows past her into the courtroom, and

INT. COURT ROOM - DAY

Closed to the public. Just Esau, Judith, Weasel, a few court Officials, and a white-haired, soft-spoken JUDGE LAFFERTY.

 JUDGE LAFFERTY
 Morning, everyone. The matter of United
 States vs. Wesley David Foster...

 ESAU
 Esau Hunter for the Justice Department,
 your honor.

 JUDGE LAFFERTY
 I know Ms. Richardson... you're
 appointed counsel for Mr. Foster?

Weasel jumps up before she can respond.

 WEASEL
 That's what she thinks...

 JUDGE LAFFERTY
 And what is the nature of your
 objection, young man?

 WEASEL
 I can take care of myself.

 JUDITH
 Your honor, this boy--

 WEASEL
 I'm not a boy! And I'm guilty, okay?!
 Stop trying to get me out of this--

Judge Lafferty gavels Weasel's outburst to a stop.

 JUDGE LAFFERTY
 The court notes defendant is a minor. As
 such, he'll continue to be represented
 by counsel.
 (cuts off Weasel)
 Mr. Hunter, the nature of the
 Government's charges if you please...

Judith sits Weasel down, as Esau approaches the bench.

 ESAU
 Your honor, I'd like a moment to
 determine just that...

 JUDGE LAFFERTY
 This is an arraignment, not an
 investigation...

 ESAU
 I beg the court and counsel's
 indulgence...
 (holds up paper)
 The charges in this case depend in
 part on the elements of defendant's
 transcribed confession.

Esau whips around, and places the confession on the desk in
front of Weasel. He pushes the paper into Weasel's hands.

NEW ANGLE - FAVORING PAPER

It's upside down in Weasel's hands. Judith notices.

 ESAU
 Read it to us if you will, Mr. Foster.

 JUDITH
 Objection. Your honor--

Esau turns the paper around in Weasel's hands.

 ESAU
 It's easier -this- way.

 JUDGE LAFFERTY
 Mr. Hunter--

 ESAU
 Can you read at all, Mr. Foster?

This gets Judith's attention.

 WEASEL
 Bite me.

 JUDGE LAFFERTY
 Mr. Hunter!

Esau's made his point. He takes the paper from Weasel.

 ESAU
 Very well. I'm sure counsel will
 stipulate to the general elements of
 defendant's confession. To wit: that
 about 11 P.M. on October 15th, defendant
 broke into the Bethel First Baptist
 Church. That he deliberately poured out
 a gallon can kerosene on several of the
 pews and set them on fire--

 JUDITH
 Counsel isn't seriously asking us
 stipulate as to the cause of the fire--?

Esau pointedly waves a bound report in the air.

 ESAU
 That's alright. I have the FBI arson
 report.

 JUDITH
 I'd like to see that--

Esau places it on his desk, just out of her reach.

 JUDGE LAFFERTY
 (impatient)
 Mr. Hunter, proceed. What are the
 charges?

 ESAU
 I just ask counsel to stipulate the
 confession indicates an association with
 the Aryan Brotherhood, conducted through
 defendant's research over the Internet...

Judith gets it. Looks to the arson report on the desk, the
confession in Esau's hand.

 JUDITH
 Your honor, it's not my job to make the
 Government's case for him.

 ESAU
 But your client's already confessed.

 JUDITH
 A confession without, apparently, any
 corroborating evidence from the arson
 report as to the cause of the blaze--
 and no way to connect my functionally
 illiterate client to any hate group or
 propaganda over the Internet.
 (to Esau)
 Am I getting warm?

Esau doesn't answer, but is privately pleased she got the
message.

 JUDITH (CONT'D)
 Your honor, I move the Government simply
 present the indictment, if it can indeed
 do so in good faith, and we go on to the
 matter of bail.

 JUDGE LAFFERTY
 'Good faith' is indeed a standard to
 which the Government must hold itself.
 Motion granted.
 (to Esau)
 Final opportunity, Mr. Hunter. Use it or
 lose it...

Esau makes a show of being flustered, paces the room, then

 ESAU
 Very well. First of all, I'm afraid the
 bail issue is moot--

 JUDGE LAFFERTY
 And why is that?

 ESAU
 Because, your honor, as the defense has
 so aptly pointed out... the Government
 is not currently prepared to prosecute
 this case. And therefore the indictment
 will have to be postponed at this time.

Judge Lafferty and Judith can't believe their ears. Weasel simply doesn't understand.

> JUDGE LAFFERTY
> Well, that's all extremely
> interesting...
>> (taps his gavel)
> Defendant is free to go.

> WEASEL
> What?!

<div align="right">CUT TO:</div>

INT. COURTHOUSE LOBBY - MOMENTS LATER

Judith strides to catch up with Esau on his way out.

> JUDITH
> What's in that arson report?

> ESAU
> Can't say. It's privileged.

> JUDITH
> You using me for something?

> ESAU
> That's a strange thought, considering
> your client is a free man...

> JUDITH
> Are you saying he's no longer a
> suspect?!

Esau looks at her but doesn't answer... opens the front door and confronts

EXT. COURTHOUSE STEPS - CONTINUOUS

A milling crowd of reporters, citizens set on him as he pushes his way down the steps. Judith is cut off behind.

> VARIOUS REPORTERS
> What are the charges?/Did the suspect
> make bail?/Is there a national
> conspiracy?

> ESAU
> No charges have been filed at this time.

An angered BUZZ of QUESTIONS rises among the crowd surrounding him. What? Why? How? Esau deflects them with

> ESAU (CONT'D)
> Look, Ms. Richardson's a good lawyer,
> why don't you ask her?

ANGLE - WITH JUDITH

as the reporters press in on her... firing the same shots.

> REPORTER
> What about the confession?

> JUDITH
> The Government has no independent
> evidence connecting my client to the
> crime.

ANGLE - WITH MRS. FOSTER

standing with Amanda as the news reaches her. She panics.

> MRS. FOSTER
> (to Amanda)
> We still got a deal. Five grand. I got a
> contract!

ANGLE - COURTHOUSE DOORS

Weasel exits pissed, head hung low... fighting his way down
the steps and through the crowd.

> WEASEL
> Leave me the fuck alone!

FOLLOW WEASEL

trying to break away, when his mother assaults him--

> MRS. FOSTER
> What did you do?! What'd you say in
> there, you stupid shit?!

She continues to beat him about the head and shoulders, as

WIDER

The entire town's degenerated into a mean-spirited chaos.

We FIND the Older Plump Woman looking on with sadness and
disapproval, and

INT. LYNCHBURGH DINER - DAY

A black hand SLAMS palm-down on a table.

> SARAH (O.S.)
> What are you doing back here?

Esau looks up, sees SARAH WHITE. The same older woman in the
pickup... outside the court, the farmhouse...

Now they're face-to-face.

> ESAU
> My job. That's all...

Sarah sits down...folds her hands, composes herself.

> SARAH
> From the day you showed up here, seems
> you've spent more time fighting Jacob
> than finding out who burned his church.

The Young Waitress appears, livid, tears a check off her pad.

> YOUNG WAITRESS
> You can pay up front--

So much for the free meals. Esau defensively answers Sarah.

> ESAU
> We had a suspect. It turned out to be
> the wrong one.

Sarah scrutinizes Esau thoroughly, but she's really not ready
for what comes next.

> ESAU
> Sarah, it might not even be a hate
> crime, or even arson for that matter...

That remark sits like a bomb between them. Sarah snuffs out
the burning fuse... answers evenly.

> SARAH
> What?

> ESAU
> Accident. Act of God. It's possible.
> Of the 138 church fires we've
> investigated...

> SARAH
> The boy admitted doing it.

> ESAU
> All I can tell you is that in my
> experience, people often confess to
> crimes they didn't commit.

> SARAH
> (dubious)
> Why would he want to lie about a thing
> like that?

> ESAU
> (shrugs)
> I don't know. The attention? He's sure
> gotten a lot of that lately...

Sarah doesn't buy a word of it.

 SARAH
 You're trying to drag this out as long
 as possible. Aren't you? Just to see us
 bleed...

 ESAU
 This case is going to be resolved. But
 it's going to happen my way, and in my
 time. And if that's inconvenient for
 some people, too bad--

Sarah sits back with a look of maternal disapproval.

 ESAU (CONT'D)
 I got a national crisis on my hands.
 When the President hired me, he called
 these black church arsons 'a potential
 Civil Rights backlash that could have us
 all living right back in the 50's...' if
 I didn't do something about it--

But Esau doesn't get the awed reaction he was hoping for.

 SARAH
 I see. So Esau's come back the
 conquering hero. To save us. The whole
 country. With his white horse, fancy
 suit... moral authority. The biggest
 thing to hit this town since Isaac
 Freeman himself.

Sarah's scored a bulls-eye with that one. Esau sulks.

 SARAH (CONT'D)
 Those are pretty big shoes to fill, don't
 you think?

 ESAU
 Why don't you ask Jacob?

The bitterness of Esau's response hangs between them.

 SARAH
 Maybe I was wrong. Maybe this isn't -
 just- about Jacob.
 (as Esau braces)
 Maybe after 30 years you came here to
 get back at all of us.

 ESAU
 That's absurd. No one else even knows
 about me, besides Rebekah.

The accusation hits Sarah hard.

 ESAU
 ...you both made sure of that...

 SARAH
 I can't stop you from judging her... or
 me. But I can ask you to leave everyone
 else out of it. Including Jacob.

Esau bites his tongue... won't answer.

 SARAH (CONT'D)
 Esau, no matter what you're scheming--
 no matter what you've planned to take
 back after all these years-- in the end,
 Jacob will still keep it all, anyway.

Esau looks away from her. Sarah becomes insistent.

 SARAH (CONT'D)
 Maybe that's not right, maybe that's not
 fair... but that's the way it is. And
 that's the way it's gonna be.

 ESAU
 (biting)
 Because it's God's will...?

 SARAH
 (smiles, lying)
 It was Isaac Freeman's will...
 You and I know Isaac isn't God, but
 Rebekah still insists on having him
 remembered that way.

Sarah gets up... deliberately but shyly touches his hand.

 SARAH (CONT'D)
 Better decide what it is you're after.
 And when you do, make sure you make
 peace with your God...

Esau can't bring himself to look her in the eye. And when he
finally does, Sarah is gone.

 CUT TO:

MODIFIED MONTAGE:

with a GOSPEL CHORUS, building to an ominous, strident
threatening pitch OVER the following:

INT. ESAU'S MOTEL ROOM - DAY

A troubled Esau paces his room alone. Stares at a mug shot of
Weasel tacked to the wall.

He comes upon the box of unopened correspondence he took from
the Widow Freeman. Starts opening the letters.

INT. WEASEL'S TRAILER HOME - DAY

Mrs. Foster 'snoozing' on a ratty couch. Ricki Lake on the
tube. Bottles scattered across the floor.

Weasel, with a newly bruised face, sneaks by her with a case
of beer. At the door, his foot tips over an empty bottle.

 MRS. FOSTER
 Where you think you're goin?

 WEASEL
 Church. I'll say a prayer for ya...

The screen door slams behind him. His mother rolls over.

INT. FREEMAN HOMESTEAD KITCHEN - DAY

An angry Jacob sits writing at the kitchen table.

Heather, his star-struck assistant, walks in as he scrawls,
crosses out, then SNAPS his pencil in frustration.

 JACOB
 How could he?! How could he have the
 temerity to let that hate- mongerer walk
 free among us?

 HEATHER
 (takes his hand)
 Come here... I've got something that'll
 make you feel better.

Jacob takes his pad, his broken pencil, and

EXT. WEASEL'S TRAILER HOME - DAY

Weasel siphons gasoline from his mom's car into an empty
whiskey bottle. He jumps in the car with the firebomb and the
beer, takes off, and--

INT. ESAU'S MOTEL ROOM - DAY

Amanda enters with a suitcase. Esau looks up...

 AMANDA
 I'm moving to a hotel. In
 Charlottesville.

Esau doesn't understand.

 AMANDA (CONT'D)
 My editor says it's the right thing to
 do.

And she calmly starts packing. All business. All ice.

INT. WEASEL'S CAR - DAY

Weasel calmly drives down a country road. With a beer, a
cigarette... and the gas-filled bottle riding shotgun.

Behind him, a car seems to be following in the distance.

After a beat we see it is. But who?

EXT. LYNCHBURG MOTEL - DAY

Esau follows Amanda out. She throws the bag in her car.

 ESAU
 Your editor? Your editor said to move
 out...?

Amanda hops in her BMW, unperturbed.

 AMANDA
 He said it looks unprofessional to be
 sleeping with my research subject...

'Research subject'? Her priorities are clear. She backs out,
leaving Esau in the dust, and

INT. FREEMAN HOMESTEAD 'OFFICE' - DAY

Heather leads Jacob by the hand into the room.

It's refurbished into a mini-studio, with a talk show type
set, video cams and a banner proclaiming "Isaac Freeman
World- Wide Ministries". She turns to him, coquettish.

 HEATHER
 Reverend Freeman, your pulpit to the
 world....

Jacob's impressed with her work -- and with her. But he's
still hesitant, wary, preoccupied -- and, as always,
vulnerable to approval and adulation.

 HEATHER
 (off his scowl)
 What's wrong?

 JACOB
 The guilty can't go unpunished.

 HEATHER
 (takes his other hand)
 You're a famous and powerful man. I'm
 sure you'll think of something...

She starts to pull herself closer to him. After a moment's
hesitation, Jacob lets her...

INT. WEASEL'S CAR - DAY

Remote countryside. Weasel flies past the small, wooden Zion

A.M.E. Church. He reacts, slams the brakes and

INT. FREEMAN HOMESTEAD 'OFFICE' - DAY

Jacob and Heather locked in a passionate embrace. He drags
her to the couch, they tear at each other's clothes...

INT. WEASEL'S CAR - DAY

Weasel spins the car around. Heads back towards the church.

The gas-filled bottle rolls to the floorboards. He bends over
to pick it up, bumps the wheel, then

HIS POV - THE OTHER CAR

that may have followed him's directly in his path. Weasel
swerves, runs off the dirt road, and rolls.

After a beat, his car bursts into flames, and

INT. FREEMAN HOMESTEAD 'OFFICE' - DAY

Jacob and Heather in the throes of ecstacy. The underlying
GOSPEL CHORUS reaches a feverish pitch, and we notice one of
the production video camera rolling, taking this in, before

END MODIFIED MONTAGE, AND

 HARD CUT TO:

EXT. RURAL HOSPITAL - DAY

The media vultures have already descended. Amanda among them,
on a cell phone.

Behind them, an ugly crowd gathers slowly, almost
imperceptibly.

 AMANDA
 (to cell phone, over crowd)
 Okay, there's been a situation. An
 accident.
 (over growing din)
 The redneck kid's all burned up, in a
 coma. He might not make it.

Amanda turns around. And she's shocked by what she sees...

HER POINT OF VIEW - THE CROWD

A group of formerly tolerant, patient, black Lynchburg
citizens... now at the end of their rope. Enraged.

Ugly and irrational. Carrying placards condemning whites, racism, and Weasel in particular.

NEW ANGLE

Farm vehicles streaming into the crowd. White families, berating their black friends and neighbors... cutting off the demonstration.

> AMANDA
> (to cell phone, excited)
> Forget the profile. Hunter's irrelevant.
> This kid's going to make my career.

Amanda snaps the phone shut and

INT. HOSPITAL - CONTINUOUS

Esau rushes down a hall, while briefed by his staff.

Judith, Weasel's lawyer, stands by a door, blocking reporters from her client's room.

> STAFF LAWYER
> He ran off the road, right by the Zion
> A.M.E. Church.

> ESAU
> How?

> PARALEGAL
> There was another set of tracks. But no
> witnesses. Honestly? We don't know what
> happened.

> STAFF LAWYER
> There was a truck load of bottles in his
> car. Beer, and from what we can tell--

He hesitates... this is gonna turn their whole case around again. And Esau's gonna have to untangle it.

> PARALEGAL
> Gasoline... His clothes reeked of it
> too...

That stops Esau in his tracks. Right in front of Judith.

> PARALEGAL (CONT'D)
> Afraid there's not much doubt what was
> going down this time.

Judith raises her voice, directed to the reporters.

 JUDITH
 Right. The boy was run off the road and
 nearly killed in an act of vigilante-
 style retribution, spawned by the media
 and by this community's appalling lynch
 mob mentality.

A last-ditch defense, maybe, but an inflammatory one.

 ESAU
 Now wait a minute, before we make
 any unfounded accusations that might
 exacerbate the situation--

But before Esau can finish,

JACOB

bursts into the room waving a KEROSENE CAN over the heads of
the swarming reporters.

 JACOB
 I hold before you the instrument of
 destruction!

This gets the intended reaction. Stunned silence, as all eyes
fall on Jacob.

 JACOB
 Found in the woods outside my burned
 church this very morning. A kerosene
 can, bearing the name of the very same
 person who's confessed to committing
 this vicious and hateful crime. Wesley
 David Foster!

Camera FLASHES go off in all directions. Dozens of hands grab
for the kerosene can before it makes its way to

ESAU

who stares at it, and the word "FOSTER" scrawled in black
paint across the side of the can.

Across the room, Jacob stares back defiantly. Esau flares with
anger, and the sea of reporters parts as he strides forward.
He thrusts the can into Jacob's gut.

 ESAU
 (growls)
 How dare you..

 JACOB
 Feeling a little upstaged, Mr. Hunter?

 ESAU
 My people went over every square inch of
 those woods.

 JACOB
 And 'your people' don't make mistakes?
 Well I'm sorry if this tarnishes your
 image of infallibility, but my people
 deserve to see the evidence, no matter
 who uncovers it.

Esau loses it, GRABS the CAN and sends it CLATTERING to the
floor... the sound echoing around the expressions of the
silenced onlookers. Jacob seems to revel in the results of
his provocation.

 ESAU
 This "evidence" is bullshit, and you
 know it. Not only moved from wherever
 you found it, but now handled, and
 contaminated, by dozens of other people.

Jacob gives a Cheshire grin, he's made his point, scored and
stolen the scene. But then, they ALL react to a sharp CRASH--

Esau and Judith rush first to the nearest window.

THEIR POINT OF VIEW - THE STREET

In chaos. Store windows being broken. Fists being thrown. A
full scale, hate and fear-filled small town riot.

PAN the inside room to the various reactions, and

OUTSIDE - AMANDA

running her telephoto on automatic, grabbing shots of the
nightmare, as she backs herself out of harm's way.

TELEPHOTO POV - MRS. FOSTER

trying to fight her way to the hospital. She suddenly finds
herself caught between clashing crowds of black and white
friends and neighbors. She panics, not knowing where to turn
and

Click, click, click. Cover shot. But not one anyone in this
sleepy town ever imagined they'd see.

CLOSE - OUTSIDE 3RD FLOOR HOSPITAL WINDOW

Esau and Jacob take in the stomach-turning scene below,
silently blaming each other.

 QUICK DISSOLVE TO:

EXT. LYNCHBURGH COUNTRYSIDE - DAY

A determined Sarah White in her weary pickup, making her way
along a ribbon of country road.

EXT. REV. ISAAC FREEMAN HOMESTEAD - DAY

Sarah's pickup stops out front. The widow Rebekah Freeman already standing on the porch. Their eyes meet.

ON THE PORCH - THE TWO WOMEN

regard each other silently... across an unbridgeable gap of pride, hurt, and time.

Finally, Rebekah grudgingly opens the screen door, and

 LINGERING DISSOLVE TO:

INT. FREEMAN HOMESTEAD LIVING ROOM - LATER

Half-empty cups from Rebekah's best tea service. Barely touched slices of pound cake on the coffee table: evidence of a long, tense talk...

PAN across a wall of Rev. Isaac Freeman mementos, stopping at a phone receiver in Rebekah's hand... with Sarah close by.

 WIDOW FREEMAN
 (to phone)
 Jacob, best you come home. Right now.

Rebekah lowers the phone, regards Sarah with apprehension.

 WIPE TO:

INT. FREEMAN HOMESTEAD LIVING ROOM -DAY

Jacob rushes in the front door, but is stopped by

 WIDOW FREEMAN'S VOICE
 Sit down.

REVERSE ANGLE - JACOB'S POINT OF VIEW

Rebekah and Sarah staring back at him, braced for a storm.

 WIDOW FREEMAN
 There's someone I want you to meet...

But before Jacob can get a word out, Esau comes INTO VIEW.

 JACOB
 What's that man doing here?

 WIDOW FREEMAN
 (controlled)
 This is Miss Sarah White. Miss White, my
 son--

Jacob virtually ignores her, staring at Esau.

 WIDOW FREEMAN
 Miss White is--

 ESAU
 Ms. White is my mother.

His MOTHER. Esau puts a tentative hand on her shoulder.

 JACOB
 I don't care who she is or why she's
 here.
 (to Esau)
 This is my house, and you're not welcome
 here.

 WIDOW FREEMAN
 This is still my house, Jacob. This war
 between you has gone too far, and it's
 bringing our community to its knees.
 (then)
 Ms. White and I brought you here
 together to--

Jacob is enraged at being blind-sided by Rebekah, but he
turns his wrath on Esau.

 JACOB
 You disgust me -- stooping to using
 old women to insinuate your arrogant,
 outsider's agenda and--

 ESAU
 Will you shut your egomaniacal trap long
 enough to listen to people who might
 actually know more than you?!

 JACOB
 You could've done your job and left.
 Instead, you've dragged this out for your
 own glory... and look what's happened!

Esau steps up to Jacob... prods a finger in his chest with
each beat of...

 ESAU
 What's happened is a two-bit wannabe
 televangelist's stirred up enough hate
 and misinformation to cause a riot and
 put a troubled kid in ICU.

Jacob pushes Esau back an arm's length.

 JACOB
 He's guilty.

 ESAU
 That's not for you to judge.

ANGLE

Over the above, Rebekah and Sarah react to the physical escalation. They start to move between them, as

 JACOB
 (coolly seething)
 "Mr. Hunter," this is my community, my
 people who've been violated -- My church
 that's been desecrated and burned to the
 ground.

Jacob makes a big mistake. He grabs the <u>silver cross</u> around his neck, and thrusts it out into Esau's face.

 JACOB
 I represent a Higher Authority -- a
 mantle that's been legitimately passed
 down to me by none other than the great
 Rev. Isaac Freeman himself!

CLOSE - ESAU'S POV - THE CROSS

provoking him like a red flag in front of a bull.

 ESAU
 You represent nothing! You're a fraud, a
 thief a liar, and a whore!

Esau RIPS the cross off Jacob's neck... and in the same flash, Jacob's fist swings around, knocking Esau against the couch.

THE MOTHERS

YELL at them to stop - It's too late.

Jacob RAMS Esau to the floor. The much more powerful Esau UPENDS Jacob and the two men fly against the wall - SMASHING

THE SHRINE OF ISAAC FREEMAN MEMENTOS

shattering everything around them as they fall to the floor.

Both women SCREAM in horror, dive in to save the treasures -- but Esau and Jacob are oblivious, pummeling each other in the wreckage.

CLOSE - ESAU AND JACOB

bloody each other with unrestrained fury.

The mothers frantically work to salvage the broken pieces of Isaac Freeman's history.

QUICK SHOTS - THE MELEE

Esau uses his strength and size to brutally punish Jacob...
venting a lifetime of resentment in a flood of rage.

Jacob fights back, defiant, but he's clearly getting the worst
of it.

They stand, nearly toppling the women as they try to
intervene.

 WIDOW FREEMAN
 Stop it now! You're brothers!

Jacob wrests his mother's hands off his shoulders.

 JACOB
 Stay out of this!!

Jacob swings at Esau, misses, and Esau SMASHES him hard
against

ANOTHER WALL OF ISAAC FREEMAN PHOTOS AND PORTRAIT

which all comes tumbling down in shards of broken glass --
his historic alliances and peace-making achievements shattered
under the feet of the struggling men.

The scene is killing both women. And the men are killing each
other.

 SARAH
 Esau!!

 WIDOW FREEMAN
 Brothers--!

Jacob gets knocked down into the broken glass. He pulls Esau
down by his legs - and Esau hits his head hard.

 JACOB
 Brothers my ass--

Jacob grabs the frame of the large oil portrait, and is about
to bring it down, when

THE WIDOW FREEMAN

throws her old body across Esau, holds the frame and stays
Jacob's hand.

 WIDOW FREEMAN
 Brothers.
 (a breath, re Esau)
 Isaac Freeman's his father too. Esau's
 your older brother.

JACOB

searches his mother's face. This can't be true. But the
weariness, guilt and despair in Rebekah's eyes say it is.

The fire visibly drains from Jacob's visage. The emotional
blow is incomprehensible, unbearable...

He looks at Sarah, his father's former mistress, back to his
mother. Rebekah can only nod.

Esau and Jacob slowly stand.

WIDER - THE ROOM

silent amid the destruction.

Jacob finds their father's silver cross, self-consciously
picks it up.

He turns to face Esau. Isaac's portrait face-up on the floor
between them...

Isaac's stern expression looking like he reproaches both his
sons from the grave.

EXT. REV. ISAAC FREEMAN HOMESTEAD PORCH - SUNSET

Esau sits on the front steps in his shirtsleeves,
disconsolately watching the setting sun.

The screen door creaks behind him, but he doesn't move. Jacob
walks down the steps, faces him obliquely. Then,

 JACOB
 How long have you known?

 ESAU
 My whole life...

For once, Jacob's without words. He watches the sun sink.

 JACOB
 Where did -- I mean what happened to
 you-- why--?

 ESAU
 You don't remember?
 (off his reaction)
 They sent me away the day after my
 father-our father- died. I was eight.
 You were four and a half.

Jacob doesn't remember. Or can't bring himself to.

 ESAU
 He called us to his bedside, one after
 the other, to give us his blessing. And
 to pass on his mission, his calling.

Jacob carefully pulls the silver cross with its broken chain
from his pocket. It glistens with the last rays of light.

 DISSOLVE TO:

MUTED FLASHBACK SEQUENCE:

Isaac on his deathbed... and as in the Bible, he's blind in
his failing hours. He calls to Rebekah who stands over him.

 ISAAC
 Rebekah...

 REBEKAH
 Yes...

Isaac clutches the silver cross around his neck.

 ISAAC
 I've decided.

Rebekah smiles painfully... tentatively.

 REBEKAH
 Yes?

 ISAAC
 Send in Esau.

Rebekah can't believe it. She feels doubly betrayed. First by
infidelity, now by disloyalty. Isaac knows her feelings.

 ISAAC
 It's for the best.

Rebekah's anguish and anger are pushed beyond her limits.

OUTSIDE THE BEDROOM

A shattered Sarah sits with the two boys who play nervously
on the floor.

Rebekah stiffens her resolve, then

 REBEKAH
 (lying, to Sarah)
 He wants to see Jacob.

Sarah knows it's not true -- but as Jacob jumps up, she can't
bring herself to have it out with her here. Rebekah wins.

Rebekah leans over, whispering a SECRET in Jacob's ear, and

She picks up Esau's overly large woolen sweater, pulls it over Jacob's small frame, pushes him into Isaac's room.

Young Esau looks bewildered, but Sarah knows the exact deceit Rebekah has in mind.

SHOT - AT ISAAC'S DEATHBED - (MOS)

Jacob nervously reaches his arm, covered in Esau's woolen sweater, to Isaac's blind face.

A deceived Isaac smiles with relief... mouths the name "Esau."

> ESAU (V.O.)
> Our father called for Esau, his
> firstborn, to pass on his legacy, his
> church. But Rebekah sent you instead.

Young Jacob is afraid the ruse will be discovered, recoils slightly from his father's touch. But he lets Isaac's hand lay on his covered arm - a damnable lie to a dying man.

Isaac, weak and blind, blesses Jacob as Esau and releases the cross into Jacob's hand.

> ESAU (V.O.)
> You took his blessing, and stole my
> future. And as of that day, I became an
> orphan, sent away without even my own
> name.

> END MUTED FLASHBACK

EXT. REV. ISAAC FREEMAN HOMESTEAD PORCH - LAST LIGHT

Jacob can't deny the accusation, but tries to anyway, while cupping the silver cross.

> JACOB
> He gave this to me. He chose me.

The lie, or wishful thinking, hangs in the air between them.

Esau pointedly looks up at the house, where both women watch out separate windows. Jacob isn't willing to have his face rubbed in the truth.

> JACOB
> Whatever happened then doesn't matter.
> We were boys. It worked out the way God
> intended.

Esau flashes with anger.

> JACOB
> (laughs)
> Is that what this is all about?

Jacob can't believe it... but it's true.

> JACOB
> Mister big shot Washington attorney
> feels cheated out of a burned-down
> church in the middle of nowhere and the
> adulation of the couple hundred farmers
> and shopkeepers in its congregation.

> ESAU
> I want my name.

Silver-tongued Jacob knows how to kill with a feather.

> JACOB
> (devastatingly soft)
> I think you simply wanna destroy
> everything and everyone you can't have.

Esau just took a direct hit - a stake through the heart.
Jacob stands, victorious, turns toward the porch door.

> ESAU
> What about the boy?
> (as Jacob stops)
> I know he's innocent... I can tell you
> kerosene didn't cause that fire.

That hits Jacob just as hard. A beat. He turns, visibly
pained.

> JACOB
> Someone's guilty.

> ESAU
> You're absolutely right.

Esau's accusation digs into Jacob's heart, then

> ESAU
> But if you're talking about the church
> burning... I don't know about that yet.
> (as this settles in)
> What I do know is there's an innocent
> kid who could easily die in ICU... and
> meanwhile your 'farmers and shopkeepers'
> are at each other's throats. Lifetime
> friends and neighbors suddenly distrust
> and even hate each other.
> (pats Jacob's shoulder)
> But hey-- you got headlines, your
> face on national TV -- made a name for
> yourself. You got to figure it was worth
> it...

Jacob's swamped by guilt. But even after that devastating
blow, Esau still feels the combined responsibility hang in
the air between them, and

EXT. LYNCHBURG STREETS - NIGHT

Esau slowly walks through the wreckage of the small-town
riot. What's odd is how safe and peaceful this piece of
postcard Americana looks... until we're jarred by the open
wound of a shattered store window or the remnants of a
smoldering police flare.

ANGLE

A small group of locals walks by. They recognize Esau, lower
their heads in shame and anger. Esau stops as they pass,
stung by their reaction.

Is this what he came here to accomplish?

INT. HOSPITAL ROOM - NIGHT

A distraught Mrs. Foster sits at her son's bedside. Weasel's
burned and still unconscious. She steals a drink, as

Judith, Weasel's lawyer, walks in the room. Judith takes a
seat next to Mrs. Foster - silently touches her arm.

Weasel's mother is too tired and lonely to object.

INT. NEWS PHOTO PROCESSING ROOM - NIGHT

Amanda gets the prints from her day's work.

CLOSE - THE PRINTS

a permanent reminder of a town gone mad. Amanda smiles,
smelling Pulitzer. She opens a cell phone.

 AMANDA
 (smug, to phone)
 Chuck, they're even better than I
 thought. And, frankly, so am I.

Amanda revels in the pain she documented, and maybe even
caused herself (if she planted the kerosene can) and

EXT. REV. ISAAC FREEMAN HOMESTEAD - NIGHT

A woman's legs, rocking on a porch swing. Widen to show
Rebekah Freeman staring out into the dark.

Pull back to reveal Sarah White sitting on the same porch,
reading a Bible in her lap. The women are in their own
worlds, but confined by the same pain.

INT. JACOB'S CHILDREN'S BEDROOM - NIGHT

Jacob's innocent and neglected brood sleep together, piled on
each other for comfort.

INT. RUINS - BETHEL FIRST BAPTIST CHURCH - NIGHT

Jacob sits below in the rubble, worrying the silver cross in
his hand. He stares up at the sky, lost in the dark night of
his soul. Hold on Jacob's anguished expression, then

 INTERCUT AND DISSOLVE TO:

EXT. SMALL, SIMPLE FARMHOUSE - NIGHT

The only movement - the ghost-like billowing of sheets
hanging on the clothes line in the night breeze.

Even eerier, lonelier and more desolate than the burned out
skeleton of Jacob's church.

A pair of headlights approach up the dirt road. It's Sarah.
And we fear she may be in for an ominous encounter. And as

THE HEADLIGHTS

sweep across the front porch, they suddenly illuminate

ESAU'S FACE

sitting alone in the darkness. Sarah doesn't blink... leaves
the headlights on him... steps out of the car.

 ESAU
 I'm... I'm sorry about today.

Sarah doesn't bite. Meanwhile, we're reminded there's another
party to this conflict: JACOB sitting alone in the ashes of
his church.

 SARAH
 What is it you really want, Esau?

 ESAU
 Solve this case...
 (off dubious reaction)
 All right-- all of them.

Sarah waits... the wind blows between them.

 ESAU
 Then stand up in public and take my
 rightful name back: Esau Freeman. First-
 born son of Isaac.
 (off her reaction)
 I'll have earned it. And it will finally
 be clear who didn't.

Now Sarah's angry. She stands.

 SARAH
 Well, you just go and do that!! Punish
 us all...
 (MORE)

 SARAH (CONT'D)
 let none of us live past our mistakes.
 Spit on your father's grave with your
 "truth." Destroy Rebekah, Jacob... me.
 Burn down the whole damn county while
 you're at it. Because you suffered...

 ESAU
 (unconvincing)
 It's not about destroying you or--

 SARAH
 You think we haven't suffered too? All
 of us, every day live in the shadow of
 that one big lie. .
 (off his reaction)
 That shadow would've smothered you,
 Esau. I knew your only chance to have a
 future was if I sent you away. You think
 that was easy for me, then or now?

 ESAU
 (petulant)
 It seemed pretty damn easy at the time.

Sarah slaps him, hard.

 SARAH
 Grow up, and join the human race. You
 were adopted into a home that wiped your
 snotty nose with silk, and hired people
 like me to press your underwear.
 (as Esau reacts)
 You think I don't know? Or Rebekah? Do
 you know it was that woman who got you
 off the waiting list at Yale, paid all
 your tuitions,and--

 ESAU
 Stop. Please.

Esau is not happy to be losing the moral high ground now.

 SARAH
 You know what I think? And I'm talking
 here as your mother. I think you and
 Jacob are both wasting your lives,
 fighting over the love of a ghost.

Esau looks up at her... loneliness escaping his eyes. While,

In the roofless church, JACOB looks up into the night...
equally bereft.

 SARAH
 A ghost can't love you back, Esau.

Sarah gestures to the open sky... the billowing sheets.

 SARAH
 A ghost can be all around you, following
 you around day and night. Sometimes you
 feel him right next to you in your car,
 in church... in bed at night. There are
 times I can even smell him...
 (holds back tears)
 But he can't love you, not the way you
 want... or fix the pain he caused while
 he was here.

Sarah turns around... we can tell she feels Isaac's presence.

 SARAH
 Your father loved Mankind, his mission,
 his place in history. I couldn't compete
 with that - nor, I suspect, could anyone
 else. He never really saw us... never
 trusted enough to love any of us...
 maybe 'cause he was blinded by the
 light.

Esau can't absorb this fact: his raw and final abandonment. He
stands and starts away into the night.

 ESAU
 I've still got a job to do.

 SARAH
 Your job is to have the strength to do
 what your father couldn't.

Esau melts into the darkness.

 SARAH
 You don't protect your heart by
 enslaving it in chains...

Sarah stays behind... while

Inside the burned church, JACOB breaks down, drops his head
in his hands.

 END INTERCUT AND DISSOLVE TO:

INT. RUINS - BETHEL FIRST BAPTIST CHURCH - MORNING

The same charred spars now frame a brilliant sun.

Below, no Jacob. The ruined church is empty.

EXT. LYNCHBURG MOTEL REAR COURTYARD - LATE MORNING

Esau sits alone at a table by an empty, drained swimming
pool.

He's got boxes of unopened correspondence to Rebekah Freeman
and her late husband's Foundation arranged at his feet.

ON THE TABLE

we see typed and handwritten letters arranged in piles. Some
have checks, some have small amounts of cash.

Esau is more concerned with the personal letters.

ESAU'S POINT OF VIEW - THE LETTERS

We can read them as Esau flips through them:

A plea for a prayer for a sick child;
A grateful note for books given to a rural grade school;
A request for Rebekah to speak at a women's prison;
A father looking for solace after his son's murder.

And more...

All particular, private pains and successes. All evidence
that Isaac Freeman's legacy is still very much alive, and
Rebekah is the keeper of that flame.

NEW ANGLE

The point isn't lost on Esau. He regards the stack of
correspondence on the table -- in boxes below him.

Esau begins to silently reproach himself, when he opens
another letter, deep in the box.

CLOSE - THE LETTER

As it unfolds -- and we see the cut out letters pasted on the
page: ISAAC FREEMAN BURNS IN HELL. GOD WILLING, HIS CHURCH
WILL FOLLOW.

Esau quickly checks the postmark.

 ESAU
 Damn!

INT. LYCHBURGH MOTEL - MOMENTS LATER

Esau enters his room, comes face-to-face with his staff
lawyer.

 STAFF LAWYER (O.S.)
 Sir, we got something. It's arson.
 Confirmed. We've seen this M.O. before--

 ESAU
 In Charleston.
 (shows the letter)
 Look familiar? We've got our first
 interstate conspiracy. We've finally got
 it!!

ANGLE - THE FEMALE PARALEGAL

rushes into the room. Turns on the tv, flips the remote.

> PARALEGAL
> We just got word. Reverend Freeman's
> making his first address on his cable
> ministry.
>> (off their reaction)
> What?

> STAFF LAWYER
> It's arson. And it's tied to the
> Charleston case. It's showtime.

> JACOB
>> (on the tv)
> Welcome to the first broadcast of Isaac
> Freeman's World Wide Ministries...

INT. FREEMAN HOMESTEAD 'BROADCAST OFFICE' - CONTINUOUS

Heather basks in the reflected glory. You can tell she thinks
this is gonna be bigger than Judge Judy.

> JACOB
> Let us pray...

Jacob closes his eyes... but Heather's gleam with the
prospect of fame and lucre.

INT. LYNCHBURG MOTEL - CONTINUOUS

Jacob intones his benediction. Esau smiles wickedly.

> ESAU
> You better -- 'cause you've just lost
> your spotlight, you bastard!

Esau tosses his suitcase on the bed, starts to pack his bags.

> INTERCUT:

INT./EXT. VARIOUS LOCATIONS - CONTINUOUS

As people we've met are alerted to the broadcast, and one by
one tune in: Traumatized Lynchburg citizens, in diners, homes
and in cars - doctors and nurses in Weasel's hospital room,
Agent Myers and the FBI, the Widow Freeman, Jacob's wife and
children, Judith and Mrs. Foster...

> JACOB
> God, in His infinite wisdom, does not
> allow us to pick and choose how we will
> be tested --or what the outcome will be.
>> (a beat, for effect)
> I did not expect when or where my test
> would come.
>> (MORE)

 JACOB (CONT'D)
 But then my father's historic church was
 burned to the ground. One of scores and
 scores and scores of sacred places which
 have succumbed to conflagration across
 the South in the past two years. And
 even with a Federal investigation --no
 answers...

ANGLE - IN ESAU'S MOTEL ROOM

Esau reacts to the implied accusation. He goes to the
cupboard, gleefully pours himself three fingers of whiskey...
"toasts" Jacob's image, OVER:

 JACOB
 (on the tv)
 My own congregation and community are
 torn apart by these events. How do we
 react? What do we do? What would my
 father Isaac Freeman have us do?

 ESAU
 (simmering, to tv)
 Take advantage of the situation, like
 everyone else? Foster hatred, pursue
 personal vendettas... trample the truth-
 in order to become a tele-fucking-
 evangelist-rock-star charlatan--?!

 JACOB
 (on the tv)
 Well, I'll tell you...

 ESAU
 ("reverential")
 Oh do tell us, Brother Freeman!!

Esau's quip is embarrassing. His staff tries not to react.

 JACOB
 (on the tv)
 If my father Isaac Freeman embodied one
 principle, it was Truth.

Esau chokes on the irony...

 JACOB
 (on the tv)
 Because above all else, he believed the
 passage in John 3:18 that tells us "And
 ye shall know the truth, and the Truth
 shall make you free." Today I bring you
 part of that Truth...

Jacob slams the kerosene can on his desk... the name "Foster"
scrawled across the side in white paint.

> JACOB
> (on the tv)
> that this...did **not** start the fire that
> burned my father's church. And the boy
> who claimed he set that fire, Wesley
> David Foster, is innocent.

Esau is momentarily without words.

 INTERCUT:

VARIOUS ANGLES - THE VIEWERS' REACTIONS

Across the spectrum... people suddenly caught on shifting
sand.

> JACOB
> (on the tv)
> I'm not at liberty to say how I learned
> this truth... nor can I understand or
> explain what ineluctable suffering led
> this boy to confuse personal infamy for
> the adulation of others. But I can tell
> you this...

Esau warily pushes closer to the screen.

> JACOB
> (on the tv)
> While the authorities struggle to
> decipher what happened here at this
> church, and others,the rest of us have
> our own task -- to heal ourselves from
> the hurt we've caused each other.

VARIOUS SHOTS - HIS VIEWERS' REACTIONS

as Jacob comes to his emotional conclusion.

> JACOB
> (on the tv)
> As I look inside myself, and at my
> broken and divided community, I now
> see that my anger, my distrust, my
> ambition and self- righteous zeal were
> responsible for most of the pain I see
> around me... and for that I am truly
> sorry.

Esau doesn't know what to make of this.

> JACOB
> (on the tv)
> I can't ask any of you to forgive me,
> until I've had the opportunity to wipe
> the blood from your brow. And I will.
> (MORE)

> JACOB (CONT'D)
> But I can implore you now to reach out
> and forgive each other for all that's
> been said and done -- because God already
> has. And know that each act of kindness
> and understanding we are able to give
> each other is truly, an act of God.

That leaves his audience with an unexpected and unwanted
challenge. And seemingly as an afterthought, Jacob adds:

> JACOB
> This is not only the first broadcast of
> Isaac Freeman's Worldwide Ministries...
> it is also the last.

Heather, his lovely "producer," just about has a stroke.

> JACOB
> At least until such time as the
> reconciliation and rebuilding of
> our parish and community are firmly
> established. That may take a lifetime,
> but you have no idea how lucky a man I
> am to do this work in Isaac Freeman's
> name. God bless.

Esau, in his room, suddenly has the wind taken out of him.

INT. JACOB'S BROADCAST STUDIO - CONTINUOUS

An infuriated Heather lets the titles run then shuts off the
broadcast. So much for her fame and fortune.

> HEATHER
> What the hell was that?!

> JACOB
> It seemed to go well. Any thoughts?

> HEATHER
> Yeah. You just cut off my balls. I
> busted my hump for this...

Rough words from a seemingly demure girl. Jacob reacts.

> JACOB
> I understand. I'm sorry it didn't work
> out.

> HEATHER
> We could've been bigger than Oprah. And
> you throw it away?!

> JACOB
> Look, you're a talented young girl.
> I'm sure you'll have even bigger
> opportunities--

 HEATHER
 You <u>fucked</u> me!!

That sets up a double-edged guilt.

 JACOB
 That, that was a mistake...

 HEATHER
 Professionally, you idiot!
 (composes herself)
 Now, we're going back on air just long
 enough to clarify that World Wide
 Ministries will continue to--

 JACOB
 No.

 HEATHER
 "No"...

 JACOB
 Of course, you're welcome to stay on
 as director of my community rebuilding
 project.

Jacob smiles hopefully and leaves the room. Heather <u>smashes</u>
everything off his desk in a rage... then remembers

THE VIDEO SET UP

in corner. She pulls an unmarked cassette hidden behind the
others, puts it in the machine...

And her office tryst with Jacob plays on a wall of monitors.
Heather crosses her arms, and

EXT. ESAU'S MOTEL ROOM - DAY

Heather knocks on the door. Esau opens, doesn't know her.

 HEATHER
 Esau Hunter - Justice Department? I hear
 you hate Jacob Freeman's ass as much as
 I do.

Heather hands Esau the damning videotape, and

INT. HOSPITAL ROOM - DAY

Weasel's finally come to, and Mrs. Foster feeds him. Judith
hasn't left their sides. It's as if Jacob's exculpating
speech never happened, until

The door opens, and the kids Derrick, Rupert, and Chrystal
sheepishly walk in. Chrystal holds flowers. Judith gently
takes them, silently undoes the wrapping, and

INT. AMANDA'S CAR - MOVING

She speeds down a country road. Her cell phone rings.

> AMANDA
> Yeah. Look, I got the photos. Not much
> destruction, but I can crop 'em, make it
> look like a real good city riot.
> (then, shocked)
> What?!

 INTERCUT:

INT. PEOPLE MAGAZINE OFFICE - DAY

The yuppie editor gives it to her cold.

> YUPPIE EDITOR
> The story's dead. The minister's pushing
> for some kinda love-fest. I tried to
> twist the cracker kid's mom, but the
> kid's lawyer now says the mom's not
> talking.

Amanda jerks her car to the side of the road.

> AMANDA
> She's holding out for more money. Fine.
> I'm telling you it's worth it.

> YUPPIE EDITOR
> No can do. I'm cutting bait. Sorry kid,
> better luck next time. Got another call.

The yuppie editor hangs up,

leaving Amanda screaming by herself into the phone.

INT. ESAU'S MOTEL ROOM - CONTINUOUS

Esau's alone. He curiously puts the tape in the VCR. We don't
need to see what he sees, but the expression on his face says
that vengeance is finally, finally his...

He picks up the phone, and

INT. FREEMAN HOMESTEAD - CONTINUOUS

Rachael picks up the ringing phone, while behind her

IN THE HALLWAY - A FURIOUS HEATHER

packs up her laptop, files -- and storms out of the house,
SLAMMING the screen door behind her.

 INTERCUT:

 RACHAEL
 (to phone)
 Hello?

 ESAU
 (over phone)
 Mrs. Freeman? Esau Hunter. Is your
 husband home?

Rachael noticeably stiffens, but her voice is calm.

 RACHAEL
 He's outside. Working on the church.

 ESAU
 I have some news for him. I'll be right
 over.

 RACHAEL
 I'll be happy to take a message...

But before she can get the words out, Esau's hung up. We hold
on Rachael's concerned expression, wondering how much she's
aware of the destruction that looms over her home, and

EXT. ROAD -DAY

Esau is in his car... out of town and on to the Freeman
Homestead. We fear what dark ambition might be on his mind.

INT. CAR - CONTINUOUS

The incriminating tape --labeled "Isaac Freeman Ministries"
sits on the passenger seat-- a ticking bomb. Esau briefly
reacts ambivalently to his impulsive plan -- and to the
destructive power that lies next to him-- then drives on.

EXT. FREEMAN HOMESTEAD - DAY

Rachael stands on the porch... sees Esau's car approaching.

AT THE FRONT OF THE HOUSE

Rachael stands in the narrow driveway. Jacob works high in
the rafters of the new church behind the house.

CLOSE ANGLE - THE CAR

As Esau slows down, Rachael meets his gaze -- then sees the
tape sitting on the passenger seat.

She knows, but she can't stop him. Esau drives by her.

EXT. SCAFFOLDING OF JACOB'S NEW CHURCH - DAY

In a new location, next to the Freeman Homestead. The frame
is in place, and it's the first tangible sign of hope for a
battered congregation. We find

JACOB

hanging up high in the spars, banging nails with the power
and purpose of new-found determination.

We like this new Jacob, unpretentious, not playing to a
crowd, at ease in his work. We share in this, until

HIS POINT OF VIEW - BELOW

Esau appears directly under him. And we know he now has
everything he needs to bring Jacob down for good.

CLOSE -WITH ESAU

Esau hesitates, reacting to the rebirth of the church he's
coveted for so long.

HIGH ANGLE

Jacob sees Esau, stops working -- the moment broken.

 ESAU
 Where'd you learn to do that?

 JACOB
 (a beat, then)
 You're saying it looks like I know
 exactly what I'm doing...

 ESAU
 I always thought you did -- until now.

ANGLE - WITH ESAU

looking up at a man he, and we, thought we knew.

 JACOB
 Well, one thing for sure... I didn't
 learn this from our daddy.

Their father. He said it. Esau's eye's blink.

 JACOB
 He wasn't dumb enough to ever hang his
 ass off any church steeple.

 ESAU
 Maybe he should've. Just for laughs.

BACK WITH JACOB

Gauging his brother down below. A long beat, then

 JACOB
 I could use a hand...

No reaction from Esau. Jacob reacts, then louder...

> JACOB
> I said I could use a hand here, brother
> Esau.

Esau strips off his jacket, carefully climbs up the wooden
scaffolding. Is he going to drop the bomb in person?

VARIOUS ANGLES - THE SCAFFOLDING

As Esau, very warily, makes his way up. Jacob can't contain
his amusement, suddenly realizing Esau's terrified of heights.
And he starts talking...

> JACOB
> (as Esau climbs up)
> You know, there's an old story -- about
> the seventh day of creation. God's
> resting, and He and his angels're up
> there in the clouds, looking waaayy down
> below at the magnificent beauty of the
> mountains, rivers and valleys. And, as
> it says in the Good Book, God is quite
> pleased with all this -- and so are the
> angels, Seraphim and Cherubim and all
> that, admiring his divine handiwork.
> Except one -- Lucifer.

Esau loses his footing... recovers. Jacob smiles.

> JACOB
> Now God looks over and sees Lucifer who
> He knows is gonna go bad on Him sooner
> or later, knockin' his knees and shaking
> with fear as he looks down at the Earth
> waaayy down below...

Esau finally makes it up alongside Jacob, ill with vertigo,
and heavy with the weight of his power to destroy his
brother.

> JACOB
> And God smiles and says, 'Lucifer,
> behold the beauty of all my creation.'
> But Lucifer's got a bit of the vertigo.
> So God puts his arm around him and says,
> 'Trust me, Lucifer, you got no reason
> to be afraid of heights. It's the fall
> that's gonna kill you--'

Jacob grins. The silver cross flashes in Esau's eyes.

> ESAU
> Shut up and give me a hammer.

Jacob pulls a hammer out of his tool belt, and

REVERSE ANGLE - ON THEIR FACES

as they work, and Esau wrestles with his decision.

 JACOB
 Any particular reason you came by?

The only sound is banging nails, until, finally...

 ESAU
 Saw your broadcast.

 JACOB
 Uh, huh.

The hammering continues... Jacob warily waits for more. It's
a long time coming, and not anything he expects.

 ESAU
 It was arson.

More hammering.

 JACOB
 Is that so...?

 ESAU
 Pretty sure. Found a threat in the
 Foundation correspondence. Looks like
 it matches one that preceded a case in
 South Carolina. And we have suspects in
 that one. Old-style racist boneheads.

 JACOB
 So, you finally got yourself a pattern
 and conspiracy...

 ESAU
 Looks like. I've been waiting years for
 this break. But it's still only two.

 JACOB
 And the rest of your hundred - odd
 church burnings?

 ESAU
 I've got guilty people in jail. And more
 on their way...
 (exhales his frustration)
 But as far as proving any overall,
 organized, national conspiracy of racial
 animus..?
 (shrugs his shoulders)
 Each arson seems to be sparked by
 different shadows in a person's heart.
 The seven deadly sins, and then some.

Jacob tries hard to take this in.

 JACOB
 Different reasons, and always churches
 -- why?

 ESAU
 That's your department, padre.

They're interrupted as they react to...

 RACHAEL (O.S.)
 Jacob!!

The men look down to see Jacob's wife calling below. Esau
reacts. Does he lower the boom now?

 ESAU
 There's something else...

 RACHAEL
 Jacob!!

But Jacob starts down, reacts as Rachel's children swirl
around her feet, and she waves animatedly behind her.

WIDE - THE SCENE

People start appearing, out of the Freeman house, from the
edge of the field, in cars up the small country road.

Black parishioners with baskets of food, white shopkeepers
with lumber, tools and supplies --

JACOB

scurries down, joins his wife and children, as the community
presses in from all sides...

Even the Widow Freeman steps out -- takes in the scene. As
Jacob gleefully embraces his wife...

ESAU AND RACHAEL

lock eyes. Esau shakes his head slightly. It's clear Esau
hasn't done anything, yet.

We hold tight on Rachael's dignified expression, and

 CUT TO:

ESAU'S CAR TRUNK

It opens, and Esau's hand reaches into the darkness.

He pulls out the incriminating video tape, seems to weigh it
in his hands, before turning to

RACHAEL

Esau hands her the tape. Rachael looks at him... drops the
tape to the ground...

...and crushes it under her feet.

 RACHAEL
 Thank you... Mr. Hunter.

There's no more to be said between them.

Esau closes the trunk, gets in his car, and drives away.

INT. LYNCHBURG DINER -DAY

FBI agent Myers is alone at a table, eating. She startles as
a heavy case file drops down by her plate.

She looks up to see Esau, but before she can lay into him,

 ESAU
 We got a pattern. Threat matching that
 Klan arson in Charleston. Gonna make
 national headlines for sure.
 (then)
 It's yours.

Agent Myers reacts with disbelief.

 ESAU
 I'm taking a leave of absence from the
 Department.

 AGENT MEYERS
 Why me?

 ESAU
 Someone's gotta do the work.

Esau walks away. When he's out the door, Agent Myers dives
into the file like an ego-driven, ravenous animal.

 CUT TO:

EXT. RUINS - BETHEL FIRST BAPTIST CHURCH -DAY

Esau's car rolls just past the charred frame, stopping at
Isaac Freeman's grave site.

BY THE GRAVE

Esau stands at the headstone... alone with the wind and
trees. He doesn't hear Jacob appear across from him.

 JACOB
 Rachael told me what you did for us...
 we're gonna be okay.

Esau looks up - a long silence - he doesn't respond.

 JACOB
 Also heard you're suddenly taking a
 'leave of absence'?
 (shrugs)
 Small town. Where you off to?

Now Esau shrugs. The brothers regard each other across their
father's grave.

 JACOB
 Well, you can't go empty-handed...

Jacob easily removes Isaac's silver cross from around his
neck, hands it to Esau...

CLOSE ON THE CROSS

glistening in Jacob's dark hand. Esau's hand covers his, and

TWO HANDS

make a hole at Isaac's headstone. Widen to see Esau on his
knees, digging.

He takes the silver cross, drops it in, covers it with soft
earth.

AT THE CAR

Esau opens the passenger door to Jacob, who demurs.

 JACOB
 Nice day for a walk. Join me?

Jacob turns. Esau watches... then closes the passenger door.
A beat, then slowly joins Jacob as he walks towards home.

 JACOB
 You sophisticated city boys sure aren't
 much on exercise, are you? Unless you're
 jogging to the Starbucks or chasing a
 cab, or running from some mugger. Not
 a healthy lifestyle from what I can
 see. Bad for the heart, and the immune
 system. Now me... I've never been sick
 a day in my life. It's the country air,
 clean living...
 (laughs at himself)
 You know who showed up at the house?
 That pretty defense lawyer lady. She's
 staying for lunch. You hungry?
 (MORE)

> JACOB (CONT'D)
> Rachael says she's got a really nice
> practice here in Lynchburg... nothing
> fancy like you're used to. But it's
> growing... probably could use some
> pointers, maybe a little help... maybe
> a lot. I don't know much about the law.
> I do know she asked about you, wondered
> where you're going. I said I didn't
> know, but you'd probably wanna tell her
> in person...

They walk away from us as Jacob talks on... and Esau lets
him.

And as the ruined spars of Isaac's church frame the two
brothers, we see Jacob put his arm around Esau's shoulder,
before we

 FADE OUT.

FADE IN:

OVER BLACK--

> "President Clinton's National Church
> Arson Task Force investigated 429
> incidents between 1995 and May of 1997,
> including fires at 162 African American
> churches."
>
> "199 arrests were made, and 35% of the
> cases were solved - double the rate for
> general arsons."
>
> "No organized, national conspiracy was
> ever uncovered."

 FADE OUT.

 THE END

CPSIA information can be obtained
at www.ICGtesting.com
Printed in the USA
LVHW010507130520
655496LV00017B/1483

9 781465 281739